DAVID BUSCH'S NIKON® J1

GUIDE TO DIGITAL MOVIE MAKING AND STILL PHOTOGRAPHY

David D. Busch

Course Technology PTR

A part of Cengage Learning

 COURSE TECHNOLOGY
CENGAGE Learning·

Australia, Brazil, Japan, Korea, Mexico, Singapore, Spain, United Kingdom, United States

COURSE TECHNOLOGY
CENGAGE Learning·

David Busch's Nikon® J1 Guide to Digital Movie Making and Still Photography

David D. Busch

Publisher and General Manager, Course Technology PTR:
Stacy L. Hiquet

Associate Director of Marketing:
Sarah Panella

Manager of Editorial Services:
Heather Talbot

Senior Marketing Manager:
Mark Hughes

Executive Editor:
Kevin Harreld

Project Editor:
Jenny Davidson

Series Technical Editor:
Michael D. Sullivan

Interior Layout Tech:
Bill Hartman

Cover Designer:
Mike Tanamachi

Indexer:
Katherine Stimson

Proofreader:
Sara Gullion

For product information and technology assistance, contact us at **Cengage Learning Customer & Sales Support, 1-800-354-9706.**

For permission to use material from this text or product, submit all requests online at **cengage.com/permissions**. Further permissions questions can be emailed to **permissionrequest@cengage.com**.

Nikon is a registered trademark of Nikon, Inc. in the United States and other countries.

All other trademarks are the property of their respective owners.

All images © David D. Busch unless otherwise noted.

Library of Congress Control Number: 2012930803

ISBN-13: 978-1-133-59711-7

ISBN-10: 1-133-59711-4

Course Technology, a part of Cengage Learning
20 Channel Center Street
Boston, MA 02210
USA

Cengage Learning is a leading provider of customized learning solutions with office locations around the globe, including Singapore, the United Kingdom, Australia, Mexico, Brazil, and Japan. Locate your local office at: **international.cengage.com/region**.

Cengage Learning products are represented in Canada by Nelson Education, Ltd.

For your lifelong learning solutions, visit **courseptr.com**.

Visit our corporate website at **cengage.com**.

Printed in the United States of America
1 2 3 4 5 6 7 14 13 12

For Cathy

Acknowledgments

Once again thanks to the folks at Course Technology PTR, who have pioneered publishing digital imaging books in full color at a price anyone can afford. Special thanks to executive editor Kevin Harreld, who always gives me the freedom to let my imagination run free with a topic, as well as my veteran production team including project editor Jenny Davidson and technical editor Mike Sullivan. Also thanks to Bill Hartman, layout; Katherine Stimson, indexing; Sara Gullion, proofreading; Mike Tanamachi, cover design; and my agent, Carole Jelen, who has the amazing ability to keep both publishers and authors happy.

Back cover photo by Nancy Balluck: http://www.nancyballuckphotography.com/

About the Author

With more than a 1.5 million books in print, **David D. Busch** is the world's #1 selling digital camera guide author, and the originator of popular series like *David Busch's Pro Secrets, David Busch's Compact Field Guides,* and *David Busch's Quick Snap Guides.* He has written dozens of hugely successful guidebooks for digital camera models, including the all-time #1 best-sellers for many Nikon models, additional user guides for other camera models, as well as many popular books devoted to digital cameras, including *Mastering Digital SLR Photography, Third Edition* and *Digital SLR Pro Secrets.* As a roving photojournalist for more than 20 years, he illustrated his books, magazine articles, and newspaper reports with award-winning images. He's operated his own commercial studio, suffocated in formal dress while shooting weddings-for-hire, and shot sports for a daily newspaper and upstate New York college. His articles and photographs have appeared in *Popular Photography & Imaging, Rangefinder, The Professional Photographer,* and hundreds of other publications. He's also reviewed dozens of digital cameras for CNet and *Computer Shopper,* and his advice has been featured on NPR's *All Tech Considered.*

When About.com named its top five books on Beginning Digital Photography, debuting at the #1 and #2 slots were Busch's *Digital Photography All-In-One Desk Reference for Dummies* and *Mastering Digital SLR Photography.* During the past year, he's had as many as five of his books listed in the Top 20 of Amazon.com's Digital Photography Best-seller list—simultaneously! Busch's 150-plus other books published since 1983 include best-sellers like *David Busch's Quick Snap Guide to Using Digital SLR Lenses.*

Busch is a member of the Cleveland Photographic Society (www.clevelandphoto.org), which has operated continuously since 1887.

Visit his website at http://www.dslrguides.com./blog

Contents

PART I: GETTING STARTED WITH YOUR NIKON J1

Chapter 1
Nikon J1: Thinking Outside of the Box 5

Chapter 2
Nikon J1 Quick Start 19

Chapter 3
Nikon J1 Roadmap 37

PART II: BEYOND THE BASICS

Chapter 4
Shooting Stills and Movies 57

Chapter 5
Understanding Exposure 69

Chapter 6
Advanced Features 91

Chapter 7
Movie Making with Your Nikon J1 113

PART III: ADVANCED TOOLS

Chapter 8
The Playback, Shooting, and Setup Menus 139

Chapter 9
Working with Lenses 197

Chapter 10
Making Light Work for You 215

PART IV: ENHANCING YOUR EXPERIENCE

Chapter 11
Accessories and Add-Ons 235

Chapter 12
Useful Software for the Nikon J1 243

Chapter 13
Nikon J1: Troubleshooting and Prevention 255

PART V: REFERENCE

Preface

Although the new Nikon J1 is as simple to use as any snapshot camera, if you bought this book you won't be satisfied with simply taking good pictures—you want *outstanding* photos. After all, the J1 is more than just the entry-level camera in the new Nikon 1 mirrorless interchangeable lens camera line. It boasts the same 10 megapixels of resolution, blazing-fast automatic focus, and innovative features like Motion Snapshots and Smart Photo Selector as its sibling, the Nikon V1. Like the V1, it can shoot 20 pictures in a fraction of a second and choose the best one for you, capture vivid slow-motion video at 400 and 1200 frames per second, and grab *full resolution* still photographs at up to an amazing 60 frames per second.

But your gateway to pixel proficiency is dragged down by the slim little book included in the box as a manual. You know everything you need to know is in there, somewhere, but you don't know where to start. In addition, the camera manual doesn't offer much information on photography or digital photography. Nor are you interested in spending hours or days studying a comprehensive book on digital camera photography that doesn't necessarily apply directly to your J1.

What you need is a guide that explains the purpose and function of the J1's basic controls, how you should use them, and *why,* written for someone who has selected this easy-entry introduction to the new Nikon 1 line of cameras. Ideally, there should be full discussions of every advanced feature, but you'd prefer to read about those topics only after you've had the chance to go out and take a few hundred great pictures with your new camera. Why isn't there a book that summarizes the most important information in its first two or three chapters, with lots of illustrations showing what your results will look like when you use this setting or that?

Now there is such a book. If you want a quick introduction to the J1's focus controls, flash, how to use the focal lengths available with the various interchangeable lenses offered for this camera, or which exposure modes are best, this book is for you. If you can't decide on what basic settings to use with your camera because you can't figure out how more advanced features like ISO sensitivity or white balance will affect your pictures, you need this guide, with its simple explanations of what you absolutely must know.

Introduction

I love the new Nikon 1 line of cameras! When they were first introduced, I purchased both the Nikon V1 and the Nikon J1, and all four lenses available for them. There's a tiny, flat 10mm wide-angle lens that's perfect for everyday photography—even under low light conditions. The J1 comes in a kit with a versatile 10-30mm zoom lens, and if that doesn't have enough zoom in "reach" for you, Nikon offers a relatively inexpensive ($250) 30-110mm telephoto lens. All these lenses are easy to snap on and snap off with the press of a button and a twist. However, if you don't want to change lenses all the time, Nikon also offers a 10-100mm super zoom with an 11X magnification range. It's more expensive (at $750), but it makes a lot of sense if you're shooting movies with the J1, as its long range (the equivalent of 27-270mm) virtually silent voice-coil motor and three-speed power zoom are perfect for video with the camera locked down on a tripod. But, of course, you don't need a tripod or an expensive super zoom to use the J1 camera. It does a great job with the components in the box you walked out of the store with. (It even has a built-in flash, while the V1 requires a supplementary flash unit.)

My love of the Nikon 1 cameras, after using both of them extensively, is that Nikon has been daring in carving out a new niche. These cameras weren't simply designed to compete with other compact mirrorless cameras. The true audience for the Nikon 1 cameras are people like you. If you opted for the J1 over the V1, you're probably someone who is enthusiastic about photography, but, up until now, has not been enthusiastic about the complexity of digital cameras. You wanted a small camera that's expandable, very easy to use, with a selection of options. Both Nikon 1 cameras provide flexibility and advanced features without the need to fuss as much with settings. Can you benefit from Scene modes, with the camera making all the adjustments based on the type of subject you're shooting? The Nikon J1 has Scene modes for Portrait, Landscape, and other typical subjects, but doesn't make you decide which Scene mode you're shooting. In Still Image mode the camera defaults to automatic scene selection. You can still choose more advanced modes like Program, Shutter-priority, Aperture-priority, or Manual. (I'll explain these clearly in Part I of this book.) But if you want to stick to Scene modes, you don't have to choose which mode to use.

There's a Smart Photo Selector mode that will take a bunch of pictures for you, and choose the sharpest, best-composed image, plus four alternates. You no longer have to

wonder, "Is this the best I could have done?" Smart Photo Selector mode looks at your work and chooses the best images for you.

If you love movies, the J1 is ideal for you, too. You can shoot HD video or slow-motion movies without bothering to learn the mechanics of how they work. Can't decide whether to shoot a still image or a video clip? The Motion Snapshot mode will give you a still image and a one-second slow-motion movie with each press of the shutter. Best of all, you can take still pictures while you're in the middle of shooting a movie (without losing any of your movie footage), or capture a movie on a whim while you're occupied shooting still pictures. There's no need to switch back and forth if you don't want to.

The J1 offers the kind of control you'll want as you gain knowledge and experience. It has semi-automatic and manual exposure, manual focus, and a decent lens selection. It's a great and affordable camera for the more traditional enthusiast niche as well as the new breed of avid photographers who don't want or need to learn every single photographic technique and tool available. That's why I think the Nikon 1 cameras will be successful, even though they're not the cameras that some Nikon users had expected. They're something better.

But once you've confirmed that you made a wise purchase decision, the question comes up, *how do I use this thing?* All those cool features can be mind numbing to learn, if all you have as a guide is the manual furnished with the camera. Help is on the way. I sincerely believe that this book is your best bet for learning how to use your new camera, and for learning how to use it well.

If you're a Nikon J1 owner who's looking to learn more about how to use this great camera, you've probably already explored your options. There are DVDs and online tutorials—but who can learn how to use a camera by sitting in front of a television or computer screen? Do you want to watch a movie or click on HTML links, or do you want to go out and take photos with your camera? Videos are fun, but not the best answer.

There's always the manual furnished with the J1. It is compact and filled with information, but there's really very little about *why* you should use particular settings or features, and its organization may make it difficult to find what you need. Multiple cross-references may send you flipping back and forth between two or three sections of the book to find what you want to know. The basic manual is also hobbled by black-and-white line drawings and tiny monochrome pictures that aren't very good examples of what you can do.

Also available are third-party guides to the J1, like this one. I haven't been happy with some of these guidebooks, which is why I wrote this one. The existing books range from skimpy and illustrated by black-and-white photos to lushly illustrated in full color but too generic to do much good. Photography instruction is useful, but it needs to be related directly to the Nikon J1 as much as possible.

I've tried to make *David Busch's Nikon J1 Guide to Digital Movie Making and Still Photography* different from your other J1 learn-up options. It's designed especially for someone like you. I've come up with a special format for this book that will help you hit the ground running with your camera, without a lot of the technical detail that bogs down users of entry-level cameras like this one. Yet, knowing that many buyers of this camera will already be fairly accomplished photographers who want to learn more—or will reach that point very soon—I'm also including some more in-depth discussions in Appendix A at the end of the book. The organization of the book works like this:

- **Part I: Getting Started with Your Nikon J1.** The three chapters in this section get you started right away, unpacking your camera, setting it up, taking a quick tour that shows you exactly how to make the settings needed to begin taking great pictures, and a roadmap of the camera's layout, buttons, dials, and controls. Even if you've already been using your J1 before you purchased this book, you'll discover a lot of useful, new information in these chapters.

- **Part II: Beyond the Basics.** These four chapters provide a more in-depth look at those four approaches to shooting stills and movies found on the J1's mode dial: Motion Snapshot, Smart Photo Selector, Still Image mode, and Movies. You'll learn everything you need to know to create great photos, obtain spot-on exposures, use autofocus to get sharp images every time, and get the best movie clips possible with your Nikon J1.

- **Part III: Advanced Tools.** The three chapters in this Part lead you through every menu selection and option, telling you not only what each feature does, but why you should—or should not—use it. You'll discover how to get the most from your lenses—even if you own just one—and work with available light and flash.

- **Part IV: Enhancing Your Experience.** Here you'll find three chapters dealing with exciting options and accessories, including tablets and Wi-Fi memory cards, an introduction to the software you'll choose from for your camera, and tips on troubleshooting your J1.

- **Part V: Reference.** The material here includes a Nuts and Bolts appendix with more detailed discussions of some of the topics explored in the main book. This is the kind of information you'll be ready to master once you've learned all the features and settings of your camera. Putting this stuff here avoids bogging the main book down with things that can wait until you're ready to learn them. There's also a handy glossary to explain terms you'll encounter as you use your Nikon J1, and an index to help you navigate specifically to a particular item.

As you'll see, this book is not a lame rewriting of the manual that came with the camera. Some folks spend five minutes with a book like this one, spot some information that also appears in the original manual, and decide "Rehash!" without really understanding the differences. Yes, you'll find information here that is also in the owner's

manual, such as the parameters you can enter when changing your J1's operation in the various menus. Basic descriptions—before I dig in and start providing in-depth tips and information—may also be vaguely similar. There are only so many ways you can say, for example, "Hold the shutter release down halfway to lock in exposure." But if you need advice on when and how to use the most important functions, you'll find the information here.

David Busch's Nikon J1 Guide to Digital Movie Making and Still Photography is aimed at both Nikon and digital camera veterans as well as newcomers to digital photography and digital cameras. Both groups can be overwhelmed by the options the J1 offers, while underwhelmed by the explanations they receive in their user's manual. The manuals are great if you already know what you don't know, and you can find an answer somewhere in a booklet arranged by menu listings and written by a camera vendor employee who last threw together instructions on how to operate a camcorder.

Why the Nikon J1 Needs Special Coverage

I think that's a mistake. The Nikon J1 does share many of the features of the V1, but they are two different cameras, aimed at two different types of photographers. You didn't buy the Nikon J1 because it cost less—you purchased this camera because it had the features you wanted, and wasn't weighed down with features you didn't need. I've always felt that digital photographers deserve books tailored specifically to *their* equipment.

When I started writing some of the first digital photography books (ever) in 1995, digital cameras cost as much as $30,000 and few people other than certain professionals could justify the most advanced models. Most of my readers a dozen years ago were stuck using the point-and-shoot low-resolution digital cameras of the time—even if they were advanced photographers. I took tons of digital pictures with an early digital camera with 1024 × 768 (less than 1 megapixel!) resolution, and which cost about $1 a pixel.

Today, a smaller amount buys you a sophisticated model like the Nikon J1. The digital camera is no longer the exclusive bailiwick of the professional, the wealthy, or the serious photography addict willing to scrimp and save to acquire a dream camera. Digital cameras have become the favored camera for anyone who wants to go beyond point-and-shoot capabilities. And Nikon cameras have enjoyed a dominating position among digital cameras because of Nikon's innovation in introducing affordable cameras with interesting features and outstanding performance (particularly in the area of high ISO image quality).

You've selected your camera of choice, and you belong in the Nikon camp if you fall into one of the following categories:

- Individuals who want to get better pictures, or perhaps transform their growing interest in photography into a full-fledged hobby or artistic outlet with a J1 and advanced techniques.

- Those who want to produce more professional-looking images for their personal or business website, and feel that the J1 will give them more control and capabilities than the typical fully automatic point-and-shoot camera.

- Small business owners with more advanced graphics capabilities who want to use the J1 to document or promote their business.

- Corporate workers who may or may not have photographic skills in their job descriptions, but who work regularly with graphics and need to learn how to use digital images taken with a Nikon J1 for reports, presentations, or other applications.

- Professional webmasters with strong skills in programming (including Java, JavaScript, HTML, Perl, etc.) but little background in photography, but who realize that the J1 can be used for sophisticated photography.

- Graphic artists and others who already may be adept in image editing with Photoshop or another program, and who may already be using a film camera (Nikon or otherwise), but who need to learn more about digital photography and the special capabilities of the J1 digital camera.

Who Am I?

After spending years as the world's most successful unknown author, I've become slightly less obscure in the past few years, thanks to a horde of camera guidebooks and other photographically oriented tomes. You may have seen my photography articles in *Popular Photography & Imaging* magazine. I've also written about 2,000 articles for magazines like *Petersen's PhotoGraphic* (which is now defunct through no fault of my own), plus *Rangefinder*, *Professional Photographer*, and dozens of other photographic publications. You might have caught my advice on National Public Radio's *All Tech Considered*. But, first, and foremost, I'm a photojournalist and made my living in the field until I began devoting most of my time to writing books.

Although I love writing, I'm happiest when I'm out taking pictures, which is why I invariably spend several days each week photographing landscapes, people, close-up subjects, and other things. I spend a month or two each year traveling to events, such as Native American "powwows," Civil War re-enactments, county fairs, ballets, and sports (baseball, basketball, football, and soccer are favorites). I actually wrote several chapters of this very book—including these words—in a room in Salamanca, Spain,

where I spent 14 days on a solo visit, armed with the J1 you see on the cover (and "backup" Nikon V1 and D7000 cameras), shooting photographs of the people, landscapes, and monuments that I've grown to love. And in the months prior to starting on this book, I spent time in Puerto Rico's Old San Juan, and in Arizona, catching up on baseball Spring Training and natural wonders like the Sedona Red Rocks and the Grand Canyon. I can offer you my personal advice on how to take photos under a variety of conditions because I've had to meet those challenges myself on an ongoing basis.

Like all my digital photography books, this one was written by someone with an incurable photography bug. I bought my first Nikon camera back in the 1960s, and I've used a variety of newer models since then. I've worked as a sports photographer for an Ohio newspaper and for an upstate New York college. I've operated my own commercial studio and photo lab, cranking out product shots on demand and then printing a few hundred glossy 8 × 10s on a tight deadline for a press kit. I've served as a photo-posing instructor for a modeling agency. People have actually paid me to shoot their weddings and immortalize them with portraits. I even prepared press kits and articles on photography as a PR consultant for a large Rochester, N.Y., company, which shall remain nameless. My trials and travails with imaging and computer technology have made their way into print in book form an alarming number of times.

Like you, I love photography for its own merits, and I view technology as just another tool to help me get the images I see in my mind's eye. But, also like you, I had to master this technology before I could apply it to my work. This book is the result of what I've learned, and I hope it will help you master your J1 digital camera, too.

As I write this, I'm currently in the throes of upgrading my website and blog, which you can find at www.dslrguides.com/blog. I'll be adding more tips and recommendations (including a list of equipment and accessories that I can't live without) in the next few months. I hope you'll stop by for a visit. You can send me e-mail from one page at that website, and there's another listing any typos that you sharp-eyed readers may report. Your input is the best tool I have to make these books even better.

Part I

Getting Started with Your Nikon J1

This first part of the book, consisting of just three short chapters, is designed to familiarize you with the basics of your Nikon J1 as quickly as possible, even though I have no doubt that you've already been out shooting a few hundred (or thousand) photographs with your pride and joy.

After all, inserting a memory card, mounting a lens, stuffing a charged battery into the base, and removing the lens cap to fire off a shot or two isn't rocket science. Even the rawest neophyte can rotate the mode dial (located at middle right of the camera back panel) to the Still Image mode green camera icon. By default, the J1 will use Automatic Scene Selection, and will choose an appropriate exposure mode. Point the J1 at something interesting and press the shutter release. Presto! A pretty good picture will pop up on the color LCD on the back of the camera. It's easy!

But in digital photography, there is such a thing as *too* easy. If you bought a J1 and this book, you certainly had no intention of using the camera as a point-and-shoot snapshooter. After all, although it can function as a snapshot camera, the J1 is also suitable for more advanced photographic pursuits, with an extensive array of customization possibilities. As such, you don't want the camera's operation to be brainless; you want *access* to the advanced features to be easy.

You get that easy access with the Nikon J1. However, you'll still need to take the time to learn how to use these features, and I'm going to provide everything you need to know in these first three chapters to begin shooting:

- **Chapter 1:** This is a "Meet Your J1" introduction, where you'll find information about what came in the box with your camera and, more importantly, what *didn't* come with the camera that you seriously should consider adding to your arsenal. I'll also cover some things you might not have known about charging the J1's battery, choosing a memory card, setting the time and date, and a few other pre-flight tasks. This is basic stuff, and if you're a veteran (point-and-shoot, dSLR, superzoom, or other type of digital camera), you can skim over it quickly. A lot of this first chapter is intended for newbies, and even if you personally don't find it essential, you'll probably agree that there was some point during your photographic development (so to speak) that you wished this information was spelled out for you. There's no extra charge!

- **Chapter 2:** Here, you'll find a Quick Start aimed at those who may not be old hands with cameras having this level of sophistication. The J1 has some interesting new features, including one of the most advanced and speedy autofocus systems ever seen in a mirrorless camera body. But even with all the goodies to play with and learning curve still to climb, you'll find that Chapter 2 will get you shooting quickly with a minimum of fuss.

- **Chapter 3:** This is a Streetsmart Roadmap to the Nikon J1. Confused by the tiny little diagrams and multiple cross-references for each and every control that send you scurrying around looking for information you know is buried somewhere in the small and inadequate manual stuffed in the box? This chapter uses multiple large full-color pictures that show every dial, knob, and button, and explains the operation of each in clear, easy-to-understand language. I'll give you the basics up front, and, even if I have to send you deeper into the book for a full discussion of a complex topic, you'll have what you need to use a control right away.

Once you've finished (or skimmed through) these three chapters, you'll be ready for Part II, which explains how to use the most important basic features, such as the J1's exposure controls, nifty autofocus system, and the related tools that put advanced still shooting and movie making tools at your fingertips. Then, you can visit Part III, the advanced tools section, which explains all the dozens of setup options that can be used to modify the capabilities you've learned to use so far, how to choose and use lenses, and introduces the Nikon J1's add-on flash capabilities. I'll wind up the main part of this book with Part IV, which covers image software and transfer options and includes some troubleshooting that may help you when good cameras (or memory cards) go bad. Part V is a bonus of sorts, with an Appendix A "nuts and bolts" discussion of some technical points more advanced J1 users will enjoy, and a Glossary of common terms you'll encounter while using your Nikon 1 camera.

1

Nikon J1: Thinking Outside of the Box

Whether you subscribe to the "my camera is just a tool" theory, or belong to the "an exquisite camera adds new capabilities to my shooting arsenal" camp, picking up a new Nikon J1 is a special experience. Those who simply wield tools will find this camera as comforting as an old friend, a solid piece of fine machinery ready and able to do their bidding as part of the creative process.

Other photographers see the compact size, selection of interchangeable lenses, an extra-sensitive sensor with low-light capabilities, and full HD movie-making capabilities, and gain a sense of empowerment. For those coming from less versatile models, *here* is a camera with fewer limitations and more capabilities for exercising renewed creative vision. In either case, using less mawkish terms, the J1, like its Nikon 1 companion the V1, is one of the coolest cameras Nikon has ever offered. Whether you're upgrading from another brand, from another Nikon compact model (like the Nikon P7100), or your J1 is your first digital camera and/or interchangeable lens camera, welcome to the club.

But, now that you've unwrapped and recharged the beast, mounted a lens, and fueled it with a memory card, what do you *do* with it? That's where this chapter—and the chapters that follow—should come in handy. Like many of you, I am a Nikon user of long standing. And, like other members of our club, I had to learn at least some aspects of my newest camera for the very first time at some point. Experienced shooter, or Nikon newbie, you bought this book because you wanted to get the most from a very powerful tool, and I'm here to help.

There's a lot to learn, but you don't have to master every detail all at once. Some of the other camera guides I've seen winnow this information down to about one-third as many pages. Indeed, I find it odd that those guidebooks use the same basic template for the advanced cameras as for a resolutely amateur-level point-and-shoot model. A camera like the J1 has a lot more depth than that, and deserves the in-depth coverage you'll find here.

Whether you've already taken a dozen or twelve hundred photos with your new camera, now that you've got that initial creative burst out of your system, you'll want to take a more considered approach to operating the camera. This chapter and the next are designed to get your camera fired up and ready for shooting as quickly as possible. After all, the J1 is not strictly a point-and-shoot camera, even though it does boast an easy-to-use Automatic Scene Selection mode and other automated options.

So I'm going to provide a basic pre-flight checklist that you need to complete before you really spread your wings and take off. You won't find a lot of detail in these first two chapters. Indeed, I'm going to tell you just what you absolutely *must* understand, accompanied by some interesting tidbits that will help you become acclimated to your J1. I'll go into more depth and even repeat some of what I explain here in later chapters, so you don't have to memorize everything you see. Just relax, follow a few easy steps, and then go out and begin taking your best shots—ever.

Even if you're a long-time shooter, I hope you won't be tempted to skip this chapter or the next one. I realize that you probably didn't purchase this book the same day you bought your camera and that, even if you did, the urge to go out and take a few hundred—or thousand—photos with your new camera is enticing. As valuable as a book like this one is, nobody can suppress their excitement long enough to read the instructions before initiating play with a new toy.

No matter how extensive your experience level is, you don't need to fret about wading through a manual to find out what you must know to take those first few tentative snaps. I'm going to help you hit the ground running with this chapter, which will help you set up your camera and begin shooting in minutes. You won't find a lot of detail in this chapter. Indeed, I'm going to give you the basics, accompanied by some interesting tidbits that will help you become acclimated. I'll go into more depth and even repeat some of what I explain here in later chapters, so you don't have to memorize everything you see. Because I realize that some of you may already have experience with cameras that have some features similar to those found in the J1, each of the major sections in this chapter will begin with a brief description of what is covered in that section, so you can easily jump ahead to the next if you are in a hurry to get started.

First Things First

This section helps get you oriented with all the things that come in the box with your Nikon J1, including what they do. I'll also describe some optional equipment you might want to have. If you want to get started immediately, skim through this section and jump ahead to "Initial Setup" later in the chapter.

The Nikon J1 comes in an impressive white box filled with stuff, including connecting cords, booklets, a CD, and lots of paperwork. The most important components are the camera and lens, battery, battery charger, and, if you're the nervous type, the neck strap. You will need a memory card as one is not included. If you purchased your J1 from a camera shop, as I did, the store personnel probably attached the neck strap for you, ran through some basic operational advice that you've already forgotten, tried to sell you a memory card, and then, after they'd given you all the help you could absorb, sent you on your way with a handshake.

Perhaps you purchased your J1 from one of those mass merchandisers that also sell washing machines and vacuum cleaners. In that case, you might have been sent on your way with only the handshake, or, maybe, not even that if you resisted the efforts to sell you an extended warranty. You save a few bucks at the big box stores, but you don't get the personal service a professional photo retailer provides. It's your choice. There's a third alternative, of course. You might have purchased your camera from a mail order or Internet source, and your J1 arrived in a big brown (or purple/red) truck. Your only interaction when you took possession of your camera was to scrawl your signature on an electronic clipboard.

In all three cases, the first thing to do is to carefully unpack the camera and double-check the contents with the checklist on one end of the box, helpfully designated under a "This package includes" listing. While this level of setup detail may seem as superfluous as the instructions on a bottle of shampoo, checking the contents *first* is always a good idea. No matter who sells a camera, it's common to open boxes, use a particular camera for a demonstration, and then repack the box without replacing all the pieces and parts afterwards. Someone might actually have helpfully checked out your camera on your behalf—and then mispacked the box. It's better to know *now* that something is missing so you can seek redress immediately, rather than discover two months from now that the video cable you thought you'd never use (but now *must* have) was never in the box. I once purchased a brand-new Nikon mirrorless camera kit that was supposed to include a second focusing screen; it wasn't in the box, but because I discovered the deficiency right away, the dealer ordered a replacement for me post haste.

At a minimum, the box should have the following:

- **Nikon J1 digital camera.** It almost goes without saying that you should check out the camera immediately, making sure the back-panel LCD isn't scratched or cracked, the memory and battery door opens properly, and, when a charged battery is inserted and lens mounted, the camera powers up and reports for duty. Out-of-the-box defects like these are rare, but they can happen. It's probably more common that your dealer played with the camera or, perhaps, it was a customer return. That's why it's best to buy your J1 from a retailer you trust to supply a factory-fresh camera.

- **Rechargeable Li-ion battery EN-EL20.** You'll need to charge this 7.2V, 1020mAh (milliampere hour) battery before use, and then navigate immediately to the Setup menu's Battery Info entry to make sure the battery accepted the juice and is showing a 100% charge. You'll want a second EN-EL20 battery as a spare (trust me), so buy one as soon as possible. It includes a terminal cover to protect the electrical contacts on the battery (and prevent short circuits).

- **Quick charger MH-27.** This charger plugs directly into a wall outlet.

- **USB cable UC-E15.** You can use this cable to transfer photos from the camera to your computer, although I don't recommend that because direct transfer uses a lot of battery power.

- **AN-N1000 neck strap.** Nikon provides you with a neck strap emblazoned with your camera model. It's not very adjustable, and, while useful for showing off to your friends exactly which nifty new camera you bought, the Nikon strap also can serve to alert observant unsavory types that you're sporting a tempting model that's worthy of their attention. I never attach the Nikon strap to my cameras, and instead opt for a more serviceable strap from UPstrap (www.upstrap-pro.com). An UPstrap is shown in Figure 1.1, with its patented non-slip pad that keeps your J1 on your shoulder, and not crashing to the ground. If you order one of these, tell inventor-photographer Al Stegmeyer that I sent you.

- **BF-N1000 body cap.** The body cap keeps dust from infiltrating your camera when a lens is not mounted. Always carry a body cap (and rear lens cap) in your camera bag for those times when you need to have the camera bare of optics for more than a minute or two. (That usually happens when repacking a bag efficiently for transport, or when you are carrying an extra body or two for backup.) The body cap/lens cap nest together for compact storage.

- **User's manuals.** Even if you have this book, you'll probably want to check the user's guide that Nikon provides, if only to verify the actual nomenclature for some obscure accessory, or to double-check an error code. The reference manual is available on a CD supplied with the camera. You can store a copy on your laptop or

Figure 1.1
Third-party
neck straps like
this UPstrap
model are often
preferable to the
Nikon-supplied
strap.

other media in case you want to access this reference when the paper version isn't handy. If you have an old memory card that's too small to be usable on a modern mirrorless camera (I still have some 128MB and 256MB cards), you can store the PDF on that. But an even better choice is to put the manual on a low-capacity USB "thumb" drive, which you can buy for less than $10. You'll then be able to access the reference anywhere you are, because you can always find someone with a computer that has a USB port and Adobe Acrobat Reader available. You might not be lucky enough to locate a computer with a memory reader.

- **Quick Start guide.** This little booklet tucked away in the camera's paperwork offers a reasonable summary of the Nikon J1's basic commands and settings, and can be stowed in your camera bag.

- **Software CD-ROM.** Here you'll find the Nikon ViewNX 2 software, a useful image management program, and the Short Movie Creator utility. I'll cover a variety of other software offerings later in Chapter 12 of this book.

- **Warranty and registration card.** Don't lose these! You can register your Nikon J1 by mail or online (in the USA, the URL is www.nikonusa.com/register), and you may need the information in this paperwork (plus the purchase receipt/invoice from your retailer) should you require Nikon service support.

Don't bother rooting around in the box for anything beyond what I've listed previously. There are a few things Nikon classifies as optional accessories, even though you (and I) might consider some of them essential. Here's a list of what you *don't* get in the box, but

might want to think about as an impending purchase. I'll list them roughly in the order of importance:

- **HDMI cable.** Although the J1 can be connected to a high-definition television, you'll need to buy a high-definition multimedia interface (HDMI) cable to do that. No HDMI cable is included with the camera.

- **Secure Digital card.** First-time digital camera buyers are sometimes shocked that their new tool doesn't come with a memory card. Why should it? The manufacturer doesn't have the slightest idea of what capacity or speed card you prefer, so why should they pack one in the box and charge you for it? That's especially true for the Nikon J1, which is likely to be purchased by avid photographers who have quite definite ideas about their ideal memory card. Perhaps you want to use tiny 4GB cards—and lots of them. I've met many paranoid wedding photographers who like to work with a horde of smaller cards (and then watch over them *very* protectively), on the theory that they are reducing their chances of losing a significant chunk of the event or reception at one time (of course, that's why you hire a second shooter as backup). Others, especially sports photographers, instead prefer a 16GB or 32GB card with room to spare. If you are shooting fast action, movies at full HD resolution and 60fps, or transfer lots of photos to your computer with a speedy card reader, you might opt for the speediest possible memory card. Buy one (or two, or three) of your own and have your flash memory ready when you unpack your J1.

- **Extra EN-EL20 battery.** I mentioned the need for an extra battery earlier, and I'll mention it here, again. Even though you might get 230 or more shots from a single battery, it's easy to exceed that figure in a few hours of shooting sports. Batteries can unexpectedly fail, too, or simply lose their charge from sitting around unused for a week or two. Buy an extra.

- **ML-L3 infrared remote.** The J1 has an infrared sensor on the front that can receive signals from this optional remote control.

- **CB-N1000-series case.** Nikon offers leather "never-ready" cases in both black and white leather for those who feel their camera needs some extra protection at the cost of availability for grab shots. They consist of a camera sling that attaches to the J1's tripod socket, and a fold-over snap-off cover. The pros are that such a case does protect your camera from bumps, scratches, and the weather, and may be a good choice if you want to carry your J1 around with you everywhere, don't want to use a traditional shoulder bag, own only a single lens that happens to fit inside the case, and are spending most of your time doing something other than taking photos. However, if you're constantly bringing your camera to your eye to shoot something, and want to be able to swap lenses quickly, you'll find the J1 works quite well "naked" with only a sturdy neck strap, such as an UPstrap, to protect it.

■ **EP-5c power connector/AC adapter.** This optional component allows you to operate the J1 without a battery inserted. You might want to use this power source when shooting movies or stills for lengthy periods of time, longer than battery power is likely to last.

Initial Setup

This section familiarizes you with multi selector and several other important buttons. You'll also find information on charging the battery, setting the clock, mounting a lens, and making diopter vision adjustments. If you're comfortable with all these things, skim through and skip ahead to "Changing Default Settings" in the next section.

Once you've unpacked and inspected your camera, the initial setup of your Nikon J1 is fast and easy. Basically, you just need to charge the battery, attach a lens, and insert a memory card. I'll address each of these steps separately, but if you already are confident you can manage these setup tasks without further instructions, feel free to skip this section entirely. While many buyers of a J1 tend to be experienced photographers, I realize that some readers are ambitious, if inexperienced, and should, at the minimum, skim the contents of the next section, because I'm going to list a few options that you might not be aware of.

Mastering the Multi Selector

I'll be saving descriptions of most of the controls used with the Nikon J1 until Chapter 2, which provides a complete "roadmap" of the camera's buttons and dials and switches. However, you may need to perform a few tasks during this initial setup process, and most of them will require the MENU button and the multi selector pad. The MENU button is easy to find: it's located to the lower right of the LCD. It requires almost no explanation; when you want to access a menu, press it. To exit most menus, press it again.

The multi selector pad may remind you of the similar control found on many point-and-shoot cameras, and other digital SLRs. It consists of a thumbpad-sized button with labels at the north, south, east, and west positions, plus a button in the center. It can also be pushed in diagonal directions to give you northeast, southeast, southwest, and northwest orientations, and rotated to cycle among menu options. (See Figure 1.2.)

With the J1, the multi selector is used extensively for navigation, for example, to navigate among menus on the LCD, choose one of the focus points, or advance or reverse the display of a series of images during picture review. The center button is used to select a highlighted item from a menu. So, from time to time in this chapter (and throughout this book) I'll be referring to the multi selector and its left/right/up/down buttons, and center button.

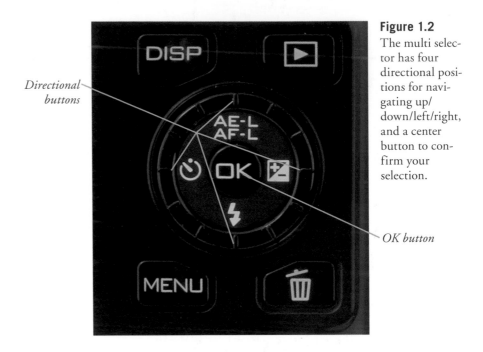

Directional
buttons

OK button

Figure 1.2
The multi selec-
tor has four
directional posi-
tions for navi-
gating up/
down/left/right,
and a center
button to con-
firm your
selection.

Each of those left/right/up/down positions also has secondary functions when you're not using the Automatic Scene Selection mode, which I'll detail in Chapters 2 and 3. They include exposure/focus lock (up button), focus modes (down button), exposure compensation (right button), and self-timer function (left button).

Setting the Clock

It's likely that your Nikon J1's internal clock hasn't been set to your local time, so you may need to do that first. You'll find complete instructions for setting the four options for the date/time (time zone, actual date and time, the date format, and whether you want the J1 to conform to Daylight Savings Time) in Chapter 8. However, if you think you can handle this step without instruction, press the MENU button, use the multi selector (that thumb-friendly button I just described, located to the immediate right of the back-panel LCD) to scroll down to the Setup menu (represented by a yellow wrench icon), press the multi selector button to the right, and scroll down to Time Zone and Date choice, and press right again. The options will appear on the screen that appears next. Keep in mind that you'll need to reset your camera's internal clock from time to time, as it is not 100-percent accurate.

The first time you use your J1, you may be asked to choose a language in the Setup menu. Use the up/down buttons on the multi selector pad to select a language and press the OK button to confirm.

Battery Included

Your Nikon J1 is a sophisticated hunk of machinery and electronics, but it needs a charged battery to function, so rejuvenating the EN-EL20 lithium-ion battery pack furnished with the camera should be your first step. A fully charged power source should be good for approximately 230 shots, based on standard tests defined by the Camera & Imaging Products Association (CIPA) document DC-002. You'll want to keep track of how many pictures *you* are able to take in your own typical circumstances, and use that figure as a guideline, instead.

A BATTERY AND A SPARE

I always recommend purchasing Nikon brand batteries (for about $50) over less-expensive third-party packs, even though the $30 substitute batteries may offer more capacity at a lower price. My reasoning is that it doesn't make sense to save $20 on a component for a $650 camera, especially since batteries have been known to fail in potentially harmful ways. You need only look as far as Nikon's own recall of its earlier EN-EL3 batteries, which forced the company to ship out thousands of free replacement cells. You're unlikely to get the same support from a third-party battery supplier that sells under a half-dozen or more different product labels and brands, and may not even have an easy way to get the word out that a recall has been issued.

If your pictures are important to you, always have at least one spare battery available, and make sure it is an authentic Nikon product.

All rechargeable batteries undergo some degree of self-discharge just sitting idle in the camera or in the original packaging. Lithium-ion power packs of this type typically lose a few percent of their charge every few days, even when the camera isn't turned on. The small amount of juice used to provide the "shots remaining" figure on the top-panel monochrome LCD when the J1 is turned off isn't the culprit; Li-ion cells lose their power through a chemical reaction that continues when the camera is switched off. So, it's very likely that the battery purchased with your camera is at least partially pooped out, so you'll want to revive it before going out for some serious shooting.

Charging the Battery

When the battery is inserted into the MH-27 charger properly (it's impossible to insert it incorrectly), a Charge light begins flashing, and remains flashing until the status lamp glows steadily indicating that charging is finished, in about 2 hours. (See Figure 1.3.) When the battery is charged, flip the lever on the bottom of the camera and slide the battery in, as shown in Figure 1.4. Check the Setup menu's Battery Info entry as I recommended earlier to make sure the battery is fully charged. If not, try putting it in the charger again. One of three things may be the culprit: a.) the actual charging cycle sometimes takes longer than you (or the charger) expected; b.) the battery is new and

Figure 1.3 Charge the battery before use.

Figure 1.4 Insert the battery in the camera; it only fits one way.

needs to be "seasoned" for a few charging cycles, after which it will accept a full charge and deliver more shots; c.) you've got a defective battery. The last is fairly rare, but before you start counting on getting a particular number of exposures from a battery, it's best to make sure it's fully charged, seasoned, and ready to deliver.

Final Steps

Your Nikon J1 is almost ready to fire up and shoot. You'll need to select and mount a lens and insert a memory card. Each of these steps is easy, and if you've used any Nikon before, you already know exactly what to do. I'm going to provide a little extra detail for those of you who are new to the Nikon world.

Mounting the Lens

As you'll see, my recommended lens mounting procedure emphasizes protecting your equipment from accidental damage and minimizing the intrusion of dust. If your J1 has no lens attached, select the lens you want to use and loosen (but do not remove) the rear lens cap. I generally place the lens I am planning to mount vertically in a slot in my camera bag, where it's protected from mishaps, but ready to pick up quickly. By loosening the rear lens cap, you'll be able to lift it off the back of the lens at the last instant, so the rear element of the lens is covered until then.

After that, remove the body cap by rotating the cap towards the release button. You should always mount the body cap when there is no lens on the camera, because it helps keep dust out of the interior of the camera, where it can settle in the interior box, and potentially find its way onto the exposed sensor. (While the J1's sensor cleaning mechanism works fine, the less dust it has to contend with, the better.) The body cap also protects the vulnerable sensor from damage caused by intruding objects (including your fingers, if you're not cautious).

Once the body cap has been removed, remove the rear lens cap from the lens, set it aside, and then mount the lens on the camera by matching the alignment indicator on the lens barrel with the white dimple at the top of the lens mounting flange on the body. (See Figure 1.5.) Rotate the lens toward the shutter release until it seats securely.

Figure 1.5
Match the indicator on the lens with the white dot on the camera mount to properly align the lens with the bayonet mount.

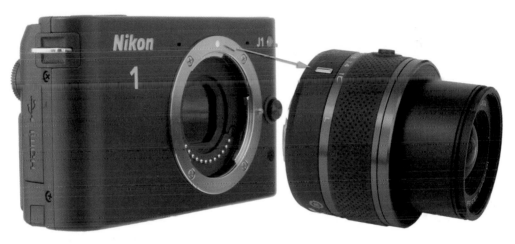

If the lens hood is bayoneted on the lens in the reversed position, which may be the case for the Nikon 1 10-100mm and 30-110 Nikkor zooms (this makes the lens/hood combination more compact for transport), twist it off and remount with the front edge facing outward. (See Figure 1.6.) A lens hood protects the front of the lens from accidental bumps, and reduces flare caused by extraneous light arriving at the front element of the lens from outside the picture area.

Some lenses (specifically the 10-30mm and 30-110 zooms initially offered when the J1 was introduced; others may be offered after this book is published) can retract into themselves. When you power up the camera, you'll receive an on-screen reminder to extract the lens by pressing the large button on the lens barrel, and rotating the zoom ring to move the lens elements out to the shooting position.

Figure 1.6
A lens hood protects the lens from extraneous light and accidental bumps.

Inserting a Secure Digital Memory Card

You've probably set up your J1 so you can't take photos without a memory card inserted. (Learn how to do that in Chapter 8.) So, your final step will be to insert a memory card. Slide the lever on the door on the bottom of the body (where the battery is inserted) toward the tripod socket to release the cover, and then open it. (You should only remove a memory card when the camera is switched off, or, at the very least, the yellow-green memory access light on the back of the camera indicating the camera is writing to the card is not illuminated.)

Insert the memory card with the label facing the back of the camera oriented so the edge with the contacts (the metallic "fingers" of a Secure Digital card) goes into the slot first. Close the door, and, if necessary, format the card. A Secure Digital card can be removed just by pressing it inward; it will pop out far enough that you can extract it.

Formatting a Memory Card

There are three ways to create a blank memory card for your J1, and two of them are wrong. Here are your options, both correct and incorrect:

- **Transfer (move) files to your computer.** When you transfer (rather than copy) all the image files to your computer from the memory card (either using a direct cable transfer or with a card reader, as described later in this chapter), the old image files are erased from the card, leaving the card blank. Theoretically. Unfortunately, this method does *not* remove files that you've labeled as Protected (using the Protect

Figure 1.7
The memory card is always inserted with the label facing the back of the camera.

feature in the Setup menu, as described in Chapter 8) while viewing the image on the LCD, nor does it identify and lock out parts of your memory card that have become corrupted or unusable since the last time you formatted the card. Therefore, I recommend always formatting the card, rather than simply moving the image files, each time you want to make a blank card. The only exception is when you *want* to leave the protected/unerased images on the card for awhile longer, say, to share with friends, family, and colleagues.

■ **(Don't) Format in your computer.** With the memory card inserted in a card reader or card slot in your computer, you can use Windows or Mac OS to reformat the memory card. Don't! The operating system won't necessarily install the correct file system. The only way to ensure that the card has been properly formatted for your camera is to perform the format in the camera itself. The only exception to this rule is when you have a seriously munged memory card that your camera refuses to format. Sometimes it is possible to revive such a corrupted card by allowing the operating system to reformat it first, then trying again in the camera.

■ **Setup menu format.** To use one of the recommended methods to format a memory card, press the MENU button, use the up/down buttons of the multi selector (that thumb-pad-sized control to the right of the LCD) to choose the Setup menu (which is represented by a wrench icon), navigate to the Format Memory Card entry with the right button of the multi selector and select Yes from the screen that appears. Press OK to begin the format process.

HOW MANY SHOTS?

The J1 provides a fairly accurate estimate of the number of shots remaining in the view-finder, as well as at the lower-right edge of the viewfinder display when the display is active. (Tap the shutter release button to activate it.)

It is only an estimate, because the actual number will vary, depending on the capacity of your memory card, the file format(s) you've selected, and the content of the image itself. (Some photos may contain large areas that can be more efficiently compressed to a smaller size.)

For example, an 8GB card can hold about 1,150 JPEG Fine shots in full resolution (Large) format. When numbers exceed 1,000, the J1 displays a figure and decimal point, followed by a K superscript, so that 3,100 shots (or thereabouts) is represented by 3.1^K in the LCD. The J1 offers three different resolution settings that provide different numbers of exposures: Large (3872 × 2592; 10.1 megapixels), Medium (2896 × 1944; 5.6 megapixels), and Small (1936 × 1296; 2.5 megapixels).

Using RAW/NEF format (more on that later) reduces the number of shots. An 8GB card has enough room for about 460 RAW photos in Nikon's NEF format or 330 pictures if you're shooting RAW+JPEG Fine pairs.

Table 1.1 shows the typical number of shots you can expect using an 8GB memory card, specified using the Image Quality and Image Size settings in the Shooting menu.

Table 1.1 File Capacity of an 8GB Card

	Large	Medium	Small
JPEG Fine	1,150	1,800	3,100
JPEG Normal	2,250	3,550	5,950
JPEG Basic	4,450	6,950	11,400
RAW	N/A	N/A	N/A
RAW+JPEG Fine	330	353	402
RAW+JPEG Normal	115	227	262
RAW+JPEG Basic	129	136	142

Nikon J1 Quick Start

Now it's time to fire up your Nikon J1 and take some photos. The easy part is turning on the power—the Off-On button is on the top side, just southwest of the large shutter release button. Turn on the camera, using either the power switch on the top panel, or by unretracting the lens (with the 10-30mm and 30-110mm lenses), and, if you mounted a lens and inserted a fresh battery and memory card you're ready to begin. You'll need to select a release mode, exposure mode, metering mode, focus mode, and, if need be, elevate the J1's built-in flash.

All Those Modes!

Your Nikon J1 has four distinctly different shooting modes: Motion Snapshot, Smart Photo Selector, Still Image mode, and Movie mode. Of course, as we move along, you'll discover that other settings are also described as modes, such as exposure modes, focus modes, and the like. But I intend to keep this Quick Start as simple as possible, so I'll have you use just Still Image mode and Movie mode in this chapter, and save full descriptions of using the other shooting modes for Chapter 4. For the incurably curious, I'll do nothing more than provide a quick description of these shooting modes, each of which can be selected by rotating the mode dial, shown in Figure 2.1:

- **Motion Snapshot.** This mode lets you record movie clippettes of about a second in length, played back in slow motion over about 2.5 seconds, along with a still photograph. This is a great feature for grabbing special moments. You can choose a background music "theme" from Beauty, Waves, Relaxation, and Tenderness motifs.

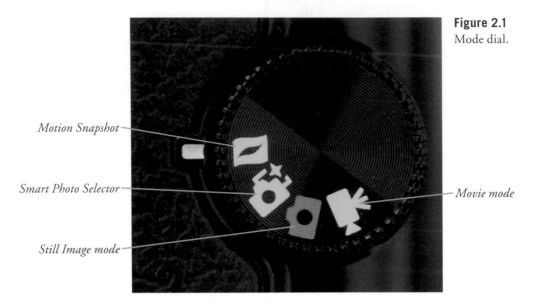

Figure 2.1
Mode dial.

Motion Snapshot

Smart Photo Selector

Still Image mode

Movie mode

- **Smart Photo Selector.** The J1 takes no fewer than 20 pictures, examines them, and uses its built-in smarts to choose the best composed and sharpest image, plus four additional candidates. Just press the shutter release down halfway to begin storing images temporarily in your camera's memory. The camera will refocus as necessary to follow a moving subject. Press the shutter button down all the way to end capture (the J1 will stop grabbing pictures all by itself after about 90 seconds). Ten pictures taken just before and just after you stop capture are retained. You will then be given the opportunity to choose your favorite from these, and the others can be deleted. I'll show you how to do this in Chapter 4.

- **Still Image mode.** This is the general purpose photography mode you'll use most of the time. The rest of this chapter after the introduction to movies that follows this section will be devoted to using Still Image mode to take your first pictures.

- **Movie mode.** Use this mode to take either high-definition (HD) movies or slow-motion movies (at 400 or 1200 frames per second, played back at about 7.5 percent of normal speed). Learn how to get started quickly shooting HD movies next.

Shooting Movies

If you'd like to shoot some movie clips right off the bat, nothing could be simpler. Your J1 can shoot regular movies or slow-motion movies, and I'll explain how to do both in more detail in Chapters 4 and 7. However, for conventional movies, just follow these steps:

1. **Select Movie mode.** Rotate the mode dial on the back right of the back panel to the white movie camera icon. The camera will examine the scene and choose an exposure mode automatically.

2. **Frame the shot.** Choose your subject using the LCD.

3. **Begin recording.** Press the red Movie recording button at the top-right edge of the camera. A red dot will appear in the LCD showing that video is being recorded, and the elapsed time appears in the lower-right corner.

4. **Take a still photograph (optional).** You can take a still photograph using the 16:9 HDTV proportions without interrupting your movie by pressing the shutter release button down all the way. The J1 will save a 2-megapixel image.

5. **Stop recording.** Press the red button a second time to stop recording the movie. You can shoot a movie up to 20 minutes in length or 4GB in size.

The rest of this chapter will deal with an introduction to shooting still images. For more guidance in shooting stills and movies and using the special modes, read Chapter 4.

Choosing a Still Image Release Mode

> This section shows you how to choose from Single frame, Continuous mode, Self-timer mode, and select other options, including mechanical or electronic shutter. Unless you have need of burst shooting or the self-timer, you can set your camera to Single frame mode and skip ahead to "Selecting an Exposure Mode" (next).

The release mode determines when (and how often) the J1 makes an exposure. If you're coming to the mirrorless camera world from a point-and-shoot camera, you might have used a model that labels these options as drive modes, dating back to the film era when cameras could be set for single shot or "motor drive" (continuous) shooting modes. Your J1's available modes are as follows:

■ **Single frame.** In Single frame mode, the J1 takes one picture each time you press the shutter release button down all the way. You can take as many photographs in this mode as you have room for on your memory card. To choose Single frame mode, just follow these steps:

1. Press the MENU button (see Figure 2.2), located at the lower-right edge of the J1.

2. When the menu screen pops up (see Figure 2.3, left), use the multi selector down button to scroll to the Shooting menu, represented by a camera icon in the left-hand column.

3. Next, press the multi selector right button to move into the middle column, and scroll down to Continuous, then press the multi selector right button to select the entry.

4. When the Continuous screen appears (see Figure 2.3, right), use the up/down buttons to select Single Frame, and then press the OK button to confirm.

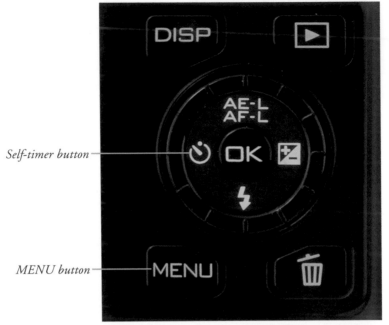

Figure 2.2
Press the MENU button to access the Shooting menu, or the Self-timer button to select the Self-timer settings screen.

Self-timer button

MENU button

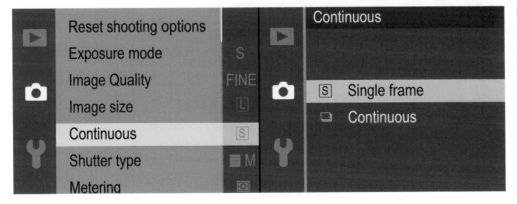

Figure 2.3
In the Shooting menu, choose Continuous to set Single frame or Continuous shooting modes (left), then select Single Frame or Continuous.

- **Continuous.** This shooting mode can be set to produce bursts of up to 5 frames per second while the shutter release button is held down. You can take up to 100 pictures in a row in this mode if your memory card has sufficient storage space. Choose Continuous by following Steps 1-3 above.

- **Continuous—Electronic (Hi).** This is a special mode that's available when you choose the J1's Electronic (Hi) shutter mode. You can take still photographs at rates of 10, 30, or 60 frames per second. I'll explain how to use this specialized feature in Chapter 4, rather than in this Quick Start.

■ **Self-timer.** You can use the self-timer as a replacement for a remote release, to reduce the effects of camera/user shake when the J1 is mounted on a tripod or, say, set on a firm surface, or when you want to get in the picture yourself. You can specify delays of 2, 5, or 10 seconds. To choose a self-timer mode, just follow these steps:

1. Press the Self-timer button (shown earlier in Figure 2.2), located at the left side of the J1's control pad.

2. When the setting screen pops up (see Figure 2.4), use the multi selector down button to scroll to 10s, 5s, or 2s, depending on the delay you want.

3. Press OK to confirm your setting. To turn off the self-timer, use Steps 1-2 and select OFF.

■ **Remote control.** The ML-L3 remote control can be used in two modes: Delayed Remote (shutter releases two seconds after you press the button on the ML-L3 IR remote); and Quick Response Remote (the shutter trips immediately when the button is pressed). To choose the Remote control mode, use steps 1-3 above, and select the 2-second delayed remote, or quick response icons.

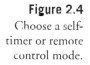

Figure 2.4
Choose a self-timer or remote control mode.

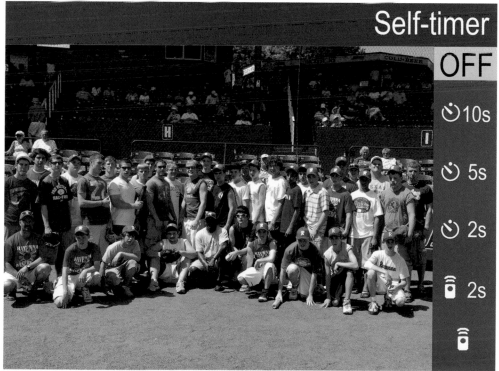

> **Note**
>
> If you plan to dash in front of the camera to join the scene when working with the self-timer, consider using manual focus so the J1 won't refocus on your fleeing form and produce unintended results. (Nikon really needs to offer an option to autofocus at the *end* of the self-timer cycle.) An alternative is to use the ML-L3 IR remote, because the camera focuses when you press the button (after you've ensconced yourself safely in the frame).

Selecting an Exposure Mode

> This section shows you how to choose an exposure mode. If you'd rather have the J1 make all of the decisions for you, just rotate the mode dial to the Still Image mode position with Scene Auto Selector active (described next). If you'd rather choose one of the Scene modes, tailored to specific types of shooting situations, or try out the camera's semi-automatic modes, continue reading this section after the Scene Auto Selector instructions.

Choosing Scene Auto Selector

The Nikon J1 can select an exposure mode for you from among a modest selection of automatically chosen settings. The available Scene modes the camera will opt for include Portrait, Landscape, Night Portrait, Close-Up, and Auto (for other types of subjects). Unlike other cameras, you can't choose these scene modes yourself. To shift into Scene Auto Selector mode (in case some other mode has been chosen), just follow these steps:

1. Rotate the mode dial to the green Still Image mode icon.

2. Press the MENU button (shown earlier in Figure 2.1).

3. When the menu screen pops up, use the multi selector down button to scroll to Exposure Mode, then press the multi selector right button to select the entry.

4. When the Exposure mode screen appears (see Figure 2.5), use the up/down buttons to select Scene Auto Selector, and then press the OK button to confirm.

The Scene modes chosen by the Scene Auto Selector take full control of the camera, making all the decisions for you. They are most useful while you're learning to use the camera, because you can just fire away. You'll end up with decent photos using appropriate settings, but your opportunities to use a little creativity (say, to overexpose an image to create a silhouette, or to deliberately use a slow shutter speed to add a little blur to an action shot) are minimal.

Figure 2.5
Choose an
exposure mode.

Choosing an Advanced Mode

Your J1 also has four semi-automatic and manual modes. These advanced modes include Programmed auto (or Program mode), Shutter-priority auto, Aperture-priority auto, and Manual exposure mode. These are the modes you'll use most often after you've learned all your J1's features, because they allow you to specify how the camera chooses its settings when making an exposure, for greater creative control.

If you're very new to digital photography, you might want to set the camera to P (Program mode) and start snapping away. That mode will make all the appropriate settings for you for many shooting situations. If you have more photographic experience, you might want to opt for one of the semi-automatic modes. To access these modes, just follow these steps:

1. Rotate the mode dial to the green Still Image mode icon.

2. Press the MENU button (shown earlier in Figure 2.1).

3. When the menu screen pops up, use the multi selector down button to scroll to Exposure Mode; then press the multi selector right button to select the entry.

4. When the Exposure mode screen appears (see Figure 2.5), use the up/down buttons to select one of the four modes described next, and then press the OK button to confirm.

- **P (Program).** This mode allows the J1 to select the basic exposure settings, but you can still override the camera's choices to fine-tune your image, while maintaining metered exposure, as I'll explain in Chapter 4.

- **S (Shutter-priority).** This mode is useful when you want to use a particular shutter speed to stop action or produce creative blur effects. Choose your preferred shutter speed by pressing the zoom bar (just to the right of the F button) when the meter is active, and the J1 will select the appropriate f/stop for you.

- **A (Aperture-priority).** Choose when you want to use a particular lens opening, especially to control sharpness or how much of your image is in focus. Specify the f/stop you want using the zoom bar when the meter is "awake" (tap the shutter release to activate the meter, if necessary), and the J1 will select the appropriate shutter speed for you.

- **M (Manual).** Select when you want full control over the shutter speed and lens opening, either for creative effects or because you are using a studio flash or other flash unit not compatible with the J1's automatic flash metering. Press the zoom bar upwards to select a faster shutter speed/downwards to choose a slower shutter speed. Rotate the multi selector dial clockwise to choose smaller apertures, and counter-clockwise to select larger f/stops. (See Figure 2.6.)

Shutter speed

Aperture

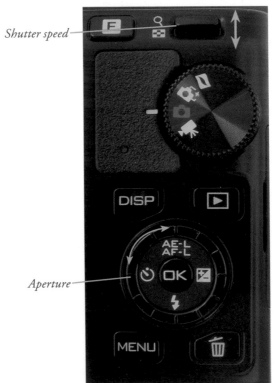

Figure 2.6
Press the zoom bar up/down to change shutter speed; rotate the multi selector dial to change aperture.

Choosing a Metering Mode

This section shows you how to choose the area the J1 will use to measure exposure, giving emphasis to the center of the frame; evaluating many different areas of the frame; or measuring light from a small spot in the center of the frame.

The metering mode you select determines how the J1 calculates exposure. The metering method is chosen for you when using Scene Auto Selector; the options described next are applied only when using PASM exposure modes. You might want to select a particular metering mode for your first shots, although the default Matrix metering is probably the best choice as you get to know your camera. I'll explain when and how to use each of the three metering modes later. To change metering modes, just follow these steps:

1. Rotate the mode dial to the green Still Image mode icon.

2. Press the MENU button (shown earlier in Figure 2.1).

3. When the menu screen pops up, use the multi selector to navigate to the Shooting menu in the left column (it's marked with a camera icon).

4. At the Shooting menu, use the right multi selector button and then the down button to scroll to Metering, then press the multi selector right button to select the entry.

5. When the Metering screen appears (see Figure 2.7), use the up/down buttons to select one of the three modes described next, and then press the OK button to confirm.

■ **Matrix metering.** The standard metering mode; the J1 attempts to intelligently classify your image and choose the best exposure based on readings from a broad span of the sensor area, a database of thousands of patterns.

■ **Center-weighted metering.** The J1 meters the entire scene, but gives the most emphasis to the central area of the frame, measuring about 4.5mm.

■ **Spot metering.** Exposure is calculated from a smaller 3mm spot, about 2 percent of the image area, using the center focus area, except when working with Face priority AF mode (discussed shortly), which meters from a focus area spot closest to the center of the selected face.

You'll find a detailed description of each of these modes in Chapter 4.

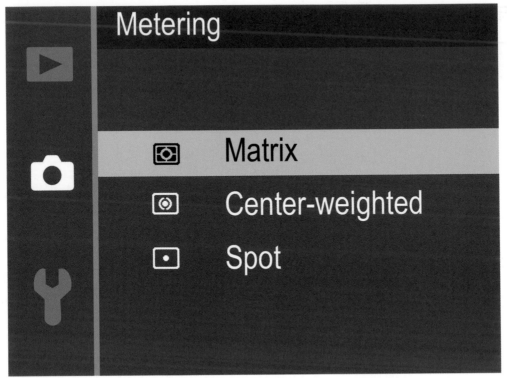

Choosing a Focus Mode

This section shows how to select *when* the J1 calculates focus: all the time (continuously), only once when you press a control like the shutter release button (single autofocus), or manually when you rotate a focus ring on the lens.

You can easily switch between automatic and manual focus modes using the menu system, as described several times previously in this chapter. You can select the autofocus mode (*when* the J1 measures and locks in focus) and autofocus pattern (*which* of the available autofocus points or zones are used to interpret correct focus). To specify when the J1 locks in focus when using PASM exposure modes (focus modes cannot be chosen when using Scene Auto Selector), follow these steps:

1. Rotate the mode dial to the green Still Image mode icon.

2. Press the MENU button (shown earlier in Figure 2.1).

3. When the menu screen pops up, use the multi selector to navigate to the Shooting menu in the left column (it's marked with a camera icon).

Figure 2.8
Choose an auto-
focus mode.

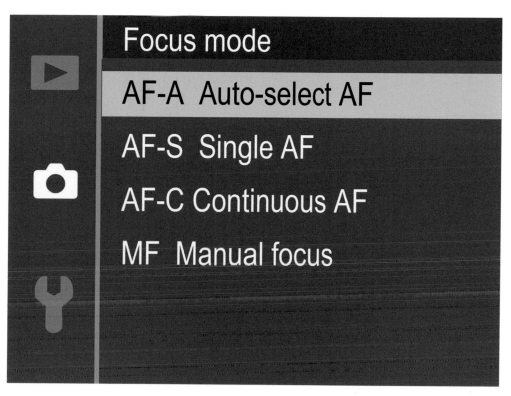

4. At the Shooting menu, use the right multi selector button and then the down button to scroll to Focus Mode, then press the multi selector right button to select the entry.

5. When the Focus mode screen appears, use the up/down buttons to select one of the modes described next, and then press the OK button to confirm.

The five focus modes are described below. The first three are available when shooting stills; when shooting movies, only AF-S, AF-F, and M can be selected:

■ **(AF-C) Continuous-servo autofocus.** This mode, sometimes called *continuous autofocus*, or AF-C, sets focus when you partially depress the shutter button but it continues to monitor the frame and refocuses if the camera or subject is moved. This is a useful mode for photographing sports and moving subjects. Note that in this mode, photos can be taken even if the camera has not quite locked in focus. The J1's hybrid focus system is very fast, so this won't happen very often.

■ **(AF-S) Single-servo autofocus.** This mode, sometimes called *single autofocus*, or AF-S, locks in a focus point when the shutter button is pressed down halfway. The focus will remain locked until you release the button or take the picture. This mode is best when your subject is relatively motionless.

- **(AF-A) Automatic autofocus.** In this mode, the J1 will select from AF-S or AF-C, depending on whether your subject is stationary or moving.

- **(AF-F) Full-time autofocus.** This mode is available only when shooting movies, and replaces the AF-C and AF-A options. (Only AF-S, AF-F, or Manual focus can be selected in Movie mode.) When using AF-F, the camera focuses continuously, and images can be captured even if sharp focus is not quite locked in.

- **(M) Manual focus.** In this mode, you can adjust focus manually. I'll describe the procedure next.

Manual Focus

When you've set the camera to manual focus, you can adjust the zone of sharpness visually using a focus indicator that appears on the LCD. Just follow these steps:

1. **Activate focus guides.** Press the multi selector OK button to produce an enlarged view of the center of the frame, as shown in Figure 2.9. A focus scale and navigation window appear at the right of the screen. The outer box represents the entire frame, and the yellow box within it shows the relative portion of the frame currently being magnified.

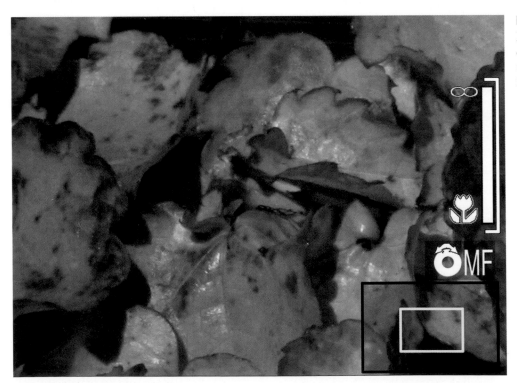

Figure 2.9
Manual focus can be done using a zoomed-in view.

2. **Zoom in or out.** You can increase/decrease the amount of magnification by pressing the zoom bar in the upper-right corner of the back panel up or down. The size of the yellow box changes to indicate the zoom magnification. Up to 10X magnification can be achieved.

3. **Position magnified area.** Although you can adjust the framing of the camera to relocate the magnified area, if you've mounted the J1 on a tripod, you might want to "lock down" the setup. In that case, you can press the multi selector directional buttons to move the yellow box around in the navigation window, and, thus, the magnified area.

4. **Focus.** Rotate the multi selector dial to focus the image. The focus indicator bar at the right of the screen will show the approximate distance.

5. **Confirm focus.** Press the OK button to lock in focus when you're satisfied.

Choosing the Focus Area Mode

You can specify *where* automatic focus is applied by choosing a focus area mode. The Nikon J1 can detect the subject and select the area to focus; you can do that yourself; the camera can follow a subject as it moves; or it can be directed to look for human faces and focus on them. To choose a focus area mode, follow these steps:

1. Rotate the mode dial to the green Still Image mode icon.

2. Press the MENU button.

3. Scroll down to the Shooting menu and then to AF-Area Mode, and press the right button to produce the screen shown in Figure 2.10.

4. Use the multi selector up/down buttons to select one of the focus modes described next, and then press the OK button to confirm.

5. If you want to activate Face-priority (a separate setting), return to the menu and scroll down one additional entry to Face-priority AF. Press the right multi selector button, select On, and press OK to confirm.

The focus modes are described below.

■ **Auto-area AF.** The J1 chooses a focus point. This setting is especially useful for grab shots, because the camera can usually select the subject and lock in focus for you very quickly.

■ **Single-point.** The camera focuses on a point you select. This mode is best for subjects that aren't moving when you know exactly where you want to focus. Press the multi selector OK button to reveal the focus area selection display, then position the focus area over your subject with the directional buttons. Press OK to confirm focus. Press the AE-L/AF-L button (the up directional button) to lock focus even when the shutter button is released.

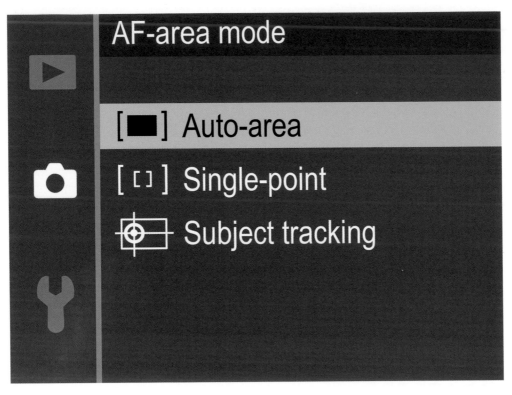

Figure 2.10
Choose the AF area.

- **Subject tracking.** The camera focuses on a point you select, then follows your subject as it moves. Press the multi selector OK button to reveal the focus area selection display, then position the focus area over your subject with the directional buttons. Press OK to confirm your subject. The camera will follow the subject, and then lock in focus on that subject when you press the shutter release halfway. This mode is great for subjects that move erratically, especially children or pets. Press the AE-L/AF-L button (the up directional button) to lock focus even when the shutter button is released.

- **Face-priority.** When active (in PSAM exposure modes, you can activate it in the Shooting menu), the J1 looks for human faces that are looking at the camera and places a double yellow border around the closest face. (Up to five faces may be detected.) Press the shutter release button down halfway to lock focus on that face.

Other Settings

This section describes some optional features you can select if you feel you need to choose the white balance, or change the camera's sensitivity setting.

There are a few other settings you can make if you're feeling ambitious, but don't feel ashamed if you postpone using these features until you've racked up a little more experience with your J1.

Adjusting White Balance and ISO

If you like, you can custom-tailor your white balance (color balance) and ISO sensitivity settings. To start out, it's best to set white balance (WB) to Auto, and ISO to A400 Auto. Each can be specified using the menu system, in much the same way as described for other functions earlier in this chapter. Here's a recap of the steps:

1. In PSAM exposure modes, rotate the mode dial to the green Still Image mode icon.

2. Press the MENU button.

3. When the menu screen pops up, use the multi selector to navigate to the Shooting menu, and then to White Balance or ISO Sensitivity, then press the multi selector right button to select the entry of your choice.

4. From the White Balance and ISO Sensitivity screens, choose your setting:

 ■ For White Balance select Auto to let the J1 detect and set the white balance for you. Or, you can choose from Incandescent, Fluorescent, Direct Sunlight, Flash, Cloudy, Shade, or Preset. I'll explain how to use these and to fine-tune each of them in Chapter 4.

 ■ For ISO, choose A400 (settings from 100-400 will be selected automatically), A800 (for ISO 100-800), A3200 (for ISO 100-3200), or individual fixed values of 100, 200, 400, 800, 1600, 3200, or Hi 1 (ISO 6400 equivalent).

5. Press OK to confirm your choice.

Reviewing the Images You've Taken

Read this section when you're ready to take a closer look at the images you've taken, and want to know how to review pictures and zoom in.

The Nikon J1 has a broad range of playback and image review options, and I'll cover them in more detail in Chapter 3. For now, you'll want to learn just the basics. Here is all you really need to know at this time, as shown in Figure 2.11:

 ■ **View image.** Press the Playback button (marked with a white right-pointing triangle) at the center of the right edge of the back panel to display the most recent image on the LCD.

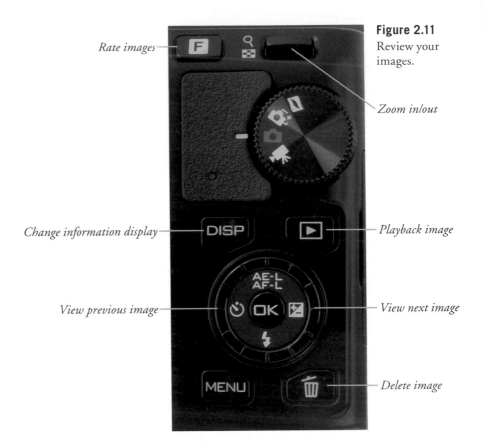

Rate images

Zoom in/out

Figure 2.11
Review your
images.

Change information display

Playback image

View previous image

View next image

Delete image

■ **View additional images.** Press the multi selector left or right to review additional images. Press right to advance to the next image, or left to go back to a previous image.

■ **Change information display.** Press the DISP button to change among overlays of basic image information or detailed shooting information. I'll show you the photo information's screens in the next chapter.

■ **Change magnification.** Press the zoom bar up or down to zoom in and out of an image. A thumbnail representation of the whole image appears in the lower-right corner with a yellow rectangle showing the relative level of zoom. At intermediate zoom positions, the yellow rectangle can be moved around within the frame using the multi selector directional buttons.

■ **See thumbnail versions.** When viewing an image full screen, pressing the zoom bar down produces thumbnail views with 4, 9, or 72 images per screen, or a calendar view. (See Figure 2.12.) Pressing the zoom bar up again while in thumbnail view reduces the number of thumbnails until you reach the full screen display, where zooming begins again. While viewing thumbnail "contact sheets," you can use the multi selector directional buttons to move from one thumbnail to another.

Press the OK button to view the selected image in full size. I'll explain more about using thumbnails and calendar view (retrieving all pictures taken on a certain date) in Chapter 3.

- **Rate your images.** Press the F button, located at the top of the back panel next to the AE-L/AF-L button, to apply one to four stars. You can use these ratings to sort and search for images later, or mark them for deletion.

- **Delete current image.** Press the Trash button to delete the currently displayed image.

- **Exit image review.** Press the Playback button again, or just tap the shutter release button to exit playback view.

Figure 2.12
Viewing thumbnails.

Transferring Photos to Your Computer

The final step in your picture-taking session will be to transfer the photos you've taken to your computer for printing, further review, or image editing. Your J1 allows you to print directly to PictBridge-compatible printers and to create print orders right in the camera, plus you can select which images to transfer to your computer. I'll outline those options in Chapter 8.

I always recommend using a card reader attached to your computer to transfer files, because that process is generally a lot faster and doesn't drain the J1's battery. However, you can also use a cable for direct transfer, which may be your only option when you have the cable and a computer, but no card reader (perhaps you're using the computer of a friend or colleague, or at an Internet café).

To transfer images from the camera to a Mac or PC computer using the USB cable:

1. Turn off the camera.

2. Pry back the cover that protects the J1's USB port on the right side of the camera (when held in the shooting position), and plug the USB cable furnished with the camera into the USB port. (See Figure 2.13.)

3. Connect the other end of the USB cable to a USB port on your computer.

4. Turn on the camera. The operating system itself, or installed software such as Nikon Transfer or Adobe Photoshop Elements Transfer usually detects the camera and offers to copy or move the pictures. Or, the camera appears on your desktop as a mass storage device, enabling you to drag and drop the files to your computer.

To transfer images from a memory card to the computer using a card reader, as shown in Figure 2.14:

1. Turn off the camera.

2. Open the memory card door and extract the Secure Digital card.

3. Insert the memory card into your memory card reader. Your installed software detects the files on the card and offers to transfer them. The card can also appear as a mass storage device on your desktop, which you can open and then drag and drop the files to your computer.

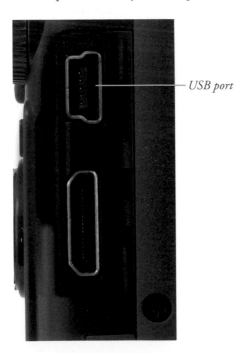

Figure 2.13 Images can be transferred to your computer using a USB cable connected to this port.

Figure 2.14 A card reader is the fastest way to transfer photos.

Nikon J1 Roadmap

Most of the Nikon J1's key functions and settings that are changed frequently can be accessed using either the menu system or the array of dials, buttons, and knobs that populate the camera's surface. While it might take some time to learn the position and function of each of these controls, once you've mastered them, the J1 camera is remarkably easy to use. That's because dedicated buttons with only one or two functions each are much faster to access than the alternative—a maze of menus that must be navigated every time you want to use a feature. The advantage of menu systems—dating back to early computer user interfaces of the 1980s—is that they are easy to *learn*. The ironic disadvantage of menus is that they are clumsy to *use*.

Imagine that you are familiar with digital cameras in general, but know virtually nothing about the Nikon J1. You've decided that you want to initialize, or *format* the memory card to make it ready for use. A-ha! There's a big ol' MENU button just to the lower right of the LCD on the back of the camera. Press it, and you'll see a series of different menu icons, which, when you scroll through them, have titles like Playback menu, Shooting menu, and Setup menu. You might guess that the Setup menu is the likely repository for a Format command, but even if you guess wrong, it takes only a minute or two to check out the other menus and discover the Format command tucked away within the Setup menu. A couple more button presses and you've successfully formatted your memory card.

You didn't really need instructions—the menu system itself led you to the right command. If you don't format another card for weeks and weeks, you can come back to the menus and discover how to perform the task all over again. The main cost to you was the time required to negotiate through all the menus to carry out the function; while menus are easy to learn, the multiple steps they call for can be cumbersome to use.

So, if you want to operate your J1 most efficiently, you'll need to learn the location, function, and application of all these menu entries and controls. What you really need is a street-level roadmap that shows where everything is, and how it's used. But what Nikon gives you in the user's manual is akin to a world globe with an overall view and many cross-references to the pages that will tell you what you really need to know. Check out the Parts of the Camera pages in Nikon's manual, which offer a handful of tiny black-and-white line drawings of the camera body that show front (see Figure 3.1), back, two sides, and the top and bottom of the J1. There are about six dozen callouts pointing to various buttons and dials. If you can find the control you want in this cramped layout, you'll still need to flip back and forth among multiple pages (individual buttons can have several different cross-references!) to locate the information.

Most other third-party books follow this format, featuring black-and-white photos or line drawings of front, back, and top views, and many labels. I originated the up-close-and-personal, full-color, street-level roadmap (rather than a satellite view) that I use in this book and my previous camera guidebooks. I provide you with many different views and lots of explanation accompanying each zone of the camera, so that by the time you finish this chapter, you'll have a basic understanding of every control and what it does.

Figure 3.1

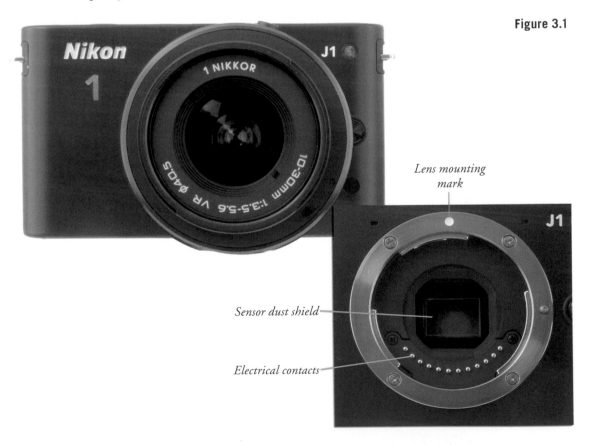

Lens mounting mark

Sensor dust shield

Electrical contacts

I'm not going to delve deeply into menu functions here—you'll find a more complete discussion of your Playback, Shooting, and Setup options in Chapter 8. Everything here is devoted to the button pusher and dial twirler in you.

You'll also find this "roadmap" chapter a good guide to the rest of the book, as well. I'll try to provide as much detail here about the use of the main controls as I can, but some topics (such as autofocus and exposure) are too complex to address in depth right away. So, I'll point you to the relevant chapters that discuss things like setup options, exposure, use of electronic flash, and working with lenses with the occasional cross-reference.

Nikon J1: Full Frontal

This is the side seen by your victims as you snap away. For the photographer, though, the front is the surface your fingers curl around as you hold the camera, and there are really only a few buttons to press, all within easy reach of the fingers of your left and right hands. There are additional controls on the lens itself. You'll need to look at several different views to see everything.

Figure 3.1 shows the front of the camera with the 10-30mm "kit" lens installed and, at lower right, removed. Figure 3.2 shows a view of the left side of the Nikon J1, as seen from the front. The main components shown in these two views that you need to know about are as follows:

- **Lens mounting mark.** Align this mark, shown in Figure 3.1, with the matching indicator on the lens to mount a lens on the camera.

- **Electrical contacts.** These mate with matching contacts on the lens and allow the camera and lens to communicate. The J1 controls the aperture and focus (all CX-mount lenses lack a focus ring) through these contacts.

- **Sensor dust shield.** Note that the sensor dust shield, located a few millimeters in front of the sensor itself, is exposed at all times, so you should be careful not to touch it when the lens is removed.

- **Hand grip.** Figure 3.2 shows other components, such as this hand-grip, which also contains the J1's battery.

- **Stereo microphone.** One of the two stereo microphones on the front of the camera that hug the lens mount.

- **DC adapter port.** If you have the optional AC adapter, it connects to the camera's battery chamber through this flip-up door.

Microphone

Figure 3.2

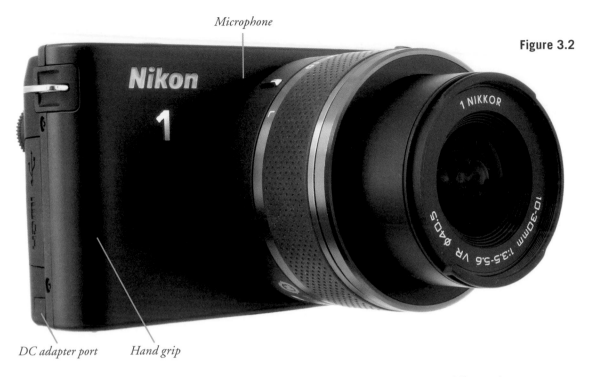

DC adapter port *Hand grip*

You'll find more controls on the other side of the J1, shown in Figure 3.3. The main points of interest shown include:

- **Stereo microphone.** The other stereo microphone resides here.

- **AF-assist illuminator/Red-eye reduction/Self-timer lamp.** This LED provides a blip of light shortly before a flash exposure to cause the subjects' pupils to close down, reducing the effect of red-eye reflections off their retinas. When using the self-timer, this lamp also flashes to mark the countdown until the photo is taken. It can also illuminate to provide assistance for the J1's autofocus mechanism at fairly close distances.

- **Infrared receiver.** This is the IR sensor that detects signals from the optional Nikon ML-L3 infrared remote control while you're standing in front of the camera (say, when you want to get in the picture yourself).

- **Lens release button.** Press this button to unlock the lens, then rotate the lens away from the shutter release button to dismount your optics.

- **Neck strap eyelet.** It comes with a split-ring attached that can be used to fasten a neck strap to the J1.

Figure 3.4 shows the right edge of the camera (as seen when you're holding the J1 in the shooting position), with the port cover open.

Figure 3.3

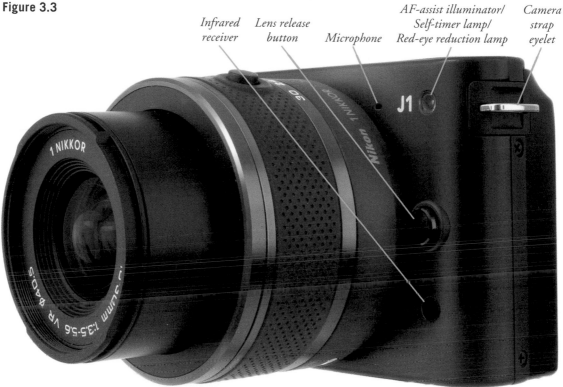

Infrared receiver *Lens release button* *Microphone* *AF-assist illuminator/ Self-timer lamp/ Red-eye reduction lamp* *Camera strap eyelet*

Figure 3.4

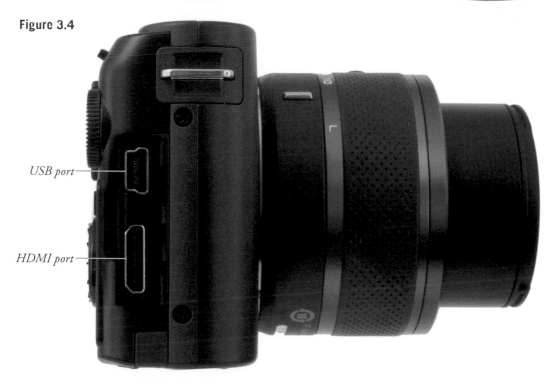

USB port

HDMI port

Inside the port cover you'll find:

- **USB port.** Plug in the USB cable furnished with your Nikon J1 and connect the other end to a USB port in your computer to transfer photos.

- **HDMI port.** You need to buy an accessory cable to connect your J1 to an HDTV, as one to fit this port is not provided with the camera. If you have a high-definition television, it's worth the expenditure to be able to view your camera's output in all its glory.

The Nikon J1's Business End

The back panel of the Nikon J1 bristles with more than a dozen different controls, buttons, and knobs. That might seem like a lot of controls to learn, but they are easy to use. Figure 3.5 shows the built-in flash release button (press it to pop up the flash), and the expansive LCD screen.

The most important controls are concentrated on the right side of the back of the camera, as shown in Figure 3.6. The key buttons and components and their functions are as follows:

- **F (Feature) button.** This button performs different functions, depending on whether you're using Still Image, Movie, Motion Snapshot, or Playback camera modes:

 - **Still Image mode.** Press to produce a screen that allows you to choose Mechanical, Electronic, or Electronic (Hi) shutter operation. I'll explain the use of each of these in Chapter 4.

 - **Movie mode.** Press the F button to pop up a screen that lets you toggle between HD movie and Slow Motion movie modes, as described in Chapters 4 and 7.

 - **Motion Snapshot mode.** The F button produces a screen that allows you to choose from Beauty, Waves, Relaxation, and Tenderness themes.

 - **Playback mode.** When reviewing pictures, the F button pops up a scale that allows you to embed a star rating in an image's file, ranging from 0 stars to 5 stars, plus a "trash" (negative) star you can apply to mark an image for deletion.

- **Zoom bar.** This bar can be pressed up or down to zoom in and out of an enlarged image, or to increase/decrease the number of thumbnail images shown on the screen during review. In exposure modes it can be used to change f/stops or shutter speeds.

- **Mode dial.** Changes from Motion Snapshot, Smart Photo Selector, Still Image, and Movie modes. I'll explain all these photo modes in Chapter 4, and describe how and when to use them.

Figure 3.5

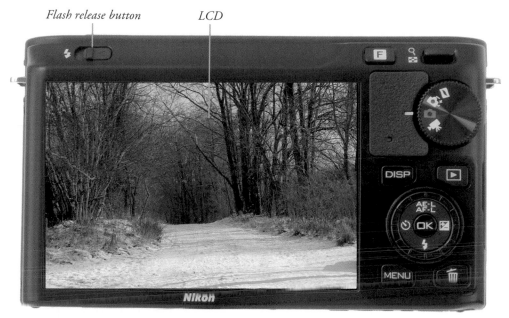

Flash release button

LCD

Figure 3.6

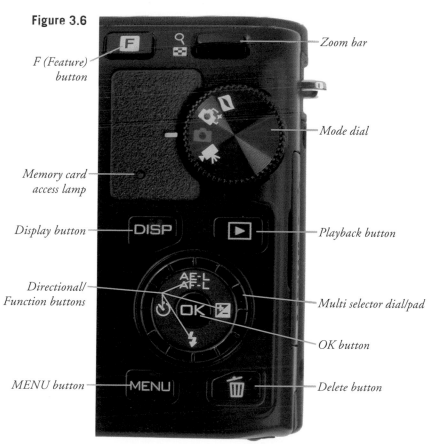

F (Feature) button

Zoom bar

Mode dial

Memory card access lamp

Display button

Playback button

Directional/ Function buttons

Multi selector dial/pad

OK button

MENU button

Delete button

- **Playback button.** Press this button to review images you've taken, using the controls and options I'll explain in the next section. To remove the displayed image, press the Playback button again, or simply tap the shutter release button.

- **MENU button.** Summons/exits the menu displayed on the rear LCD of the J1. When you're working with submenus, this button also serves to exit a submenu and return to the main menu.

- **OK button.** The button in the center of the multi selector can be pressed to choose a highlighted selection in a menu and to confirm choices.

- **Display (DISP) button.** Use this button to change the amount and type of information shown on the screen in both Playback and Shooting modes. I'll show you how this data can be changed in the next section.

- **Multi selector.** This joypad-like button can be shifted up, down, side to side, and diagonally for a total of eight directions, or rotated. In navigational mode, it can be used for several functions, including AF point selection, scrolling around a magnified image, trimming a photo, or setting white balance correction. Within menus, pressing the up/down arrows moves the on-screen cursor up or down; pressing towards the right selects the highlighted item and displays its options; pressing left cancels and returns to the previous menu.

- **Directional/Function buttons.** The N, S, E, and W positions on the multi selector have secondary functions in shooting (non-Playback) mode. The up button can be used to lock focus/and or exposure; the right button produces an LCD pop-up that dials in exposure compensation when working in Program, Aperture-priority, or Shutter-priority modes (but not automatic scene selection or manual exposure). The down button lets you specify an electronic flash mode.

- **Delete button.** In Playback mode, press once to delete the picture currently being reviewed. Press a second time to confirm the deletion, or the Playback button to chicken out and cancel.

- **Memory card access lamp.** Illuminates when the J1 is saving an image to the memory card.

What's on the Screen?

If you're accustomed to working with a digital SLR or a point-and-shoot digital camera, you'll find that the informational display on the Nikon J1 is probably a bit different from what you're used to. Its LCD viewing system is used to show you everything you need to see to operate your camera, from a live view preview of your frame before you take the picture, to the menus used to make settings, to the picture review that displays your photos after they've been taken.

You can choose the data shown on the LCD using the DISP button, as described next.

- **Shooting mode.** In shooting mode, there are two different displays for the back-panel LCD, a Simplified Display (see Figure 3.7) and a Detailed Display (Figure 3.8). You can alternate between them by pressing the DISP button on the back of the camera.

- **Grid display.** An additional grid display option is available for any of the shooting mode views. The grid divides the frame into quarters horizontally and vertically with an overlay. It's not a "Rule of Thirds" layout, and so is of more use in checking the alignment of horizontal lines (such as the horizon) and vertical lines as you compose the image. Activate the grid in the Setup menu, using the Grid Display entry to turn it On or Off. (See Figure 3.9.)

- **Picture review/Playback mode.** When reviewing your images after they've been taken, the DISP button can be used to cycle among three different views: Picture only (just a "clean" image with no information overlay; this allows you to view your photo with no distractions) (see Figure 3.10); simple photo info (see Figure 3.11), with basic data arrayed along the bottom and upper left/right corners of the image); and detailed photo information (see Figure 3.12), which displays a reduced size thumbnail of your image along with complete shooting information, including a histogram display). I'll show you how to work with histograms in Chapter 5.

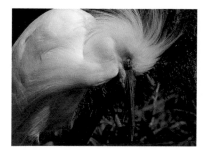

Figure 3.7 Simplified shooting mode display.

Figure 3.8 Detailed shooting mode display.

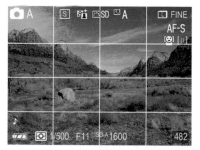

Figure 3.9 Optional grid display.

Figure 3.10 Image only photo playback.

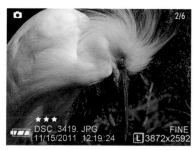

Figure 3.11 Simple photo info playback.

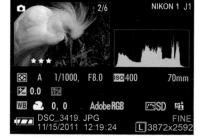

Figure 3.12 Detailed photo info playback.

Figure 3.13 provides a "roadmap" of the information shown in the shooting mode LCD display.

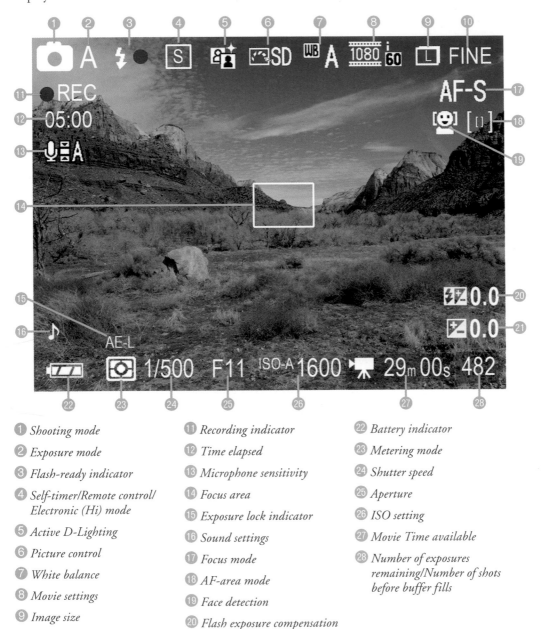

1 Shooting mode
2 Exposure mode
3 Flash-ready indicator
4 Self-timer/Remote control/ Electronic (Hi) mode
5 Active D-Lighting
6 Picture control
7 White balance
8 Movie settings
9 Image size
10 Image quality
11 Recording indicator
12 Time elapsed
13 Microphone sensitivity
14 Focus area
15 Exposure lock indicator
16 Sound settings
17 Focus mode
18 AF-area mode
19 Face detection
20 Flash exposure compensation
21 Exposure compensation
22 Battery indicator
23 Metering mode
24 Shutter speed
25 Aperture
26 ISO setting
27 Movie Time available
28 Number of exposures remaining/Number of shots before buffer fills

Figure 3.13 Detailed shooting mode display roadmap.

Playing Back Images

Images can be reviewed on the Nikon J1's big 460,000-dot three-inch LCD. Here are the basics involved in reviewing images on the LCD screen (or on a television/HDTV screen you have connected with a cable). You'll find more details about some of these functions later in this chapter, or, for more complex capabilities, in the chapters that I point you to. This section just lists the must-know information.

- **Start review.** To begin review, press the Playback button located northeast of the multi selector pad on the back of the J1. The most recently viewed image will appear on the LCD.

- **View thumbnail images.** To change the view from a single image to four, nine, or 72 thumbnails, or calendar view, follow the instructions in the "Viewing Thumbnails" section that follows.

- **Zoom in and out.** To zoom in or out, press the zoom bar up (zoom in) or down (zoom out), following the instructions in the "Zooming the Nikon J1 Playback Display" in the next section. (It also shows you how to move the zoomed area around using the multi selector keypad.)

- **Move back and forth.** To advance to the next image, press the right edge of the multi selector pad; to go back to a previous shot, press the left edge. You can also rotate the multi selector dial clockwise (next image) or counterclockwise (previous image). When you reach the beginning/end of the photos in your folder, the display "wraps around" to the end/beginning of the available shots.

- **See different types of data.** To change the type of information about the displayed image that is shown, press the DISP button. To learn what data is available, read the "Using Shooting Data" section later in this chapter.

- **Remove images.** To delete an image that's currently on the screen, press the Trash button once, then press it again to confirm the deletion. To select and delete a group of images, use the Delete option in the Playback menu to specify particular photos to remove, as described in more detail in Chapter 8.

- **Cancel playback.** To cancel image review, press the Playback button again, or simply tap the shutter release button.

Zooming the Nikon J1 Playback Display

The Nikon J1 zooms in and out of preview images using the procedure that follows:

1. When an image is displayed in any of the three playback modes (image only, simple photo information only, or detailed photo information only), press the zoom bar up to fill the screen with a slightly magnified version of the image.

2. A navigation window appears in the lower-right corner of the LCD showing the entire image. Keep pressing to continue zooming in to the maximum of approximately 25X enlargement (with a full resolution large image).

3. A yellow box in the navigation window shows the zoomed area within the full image. (See Figure 3.14.) The entire navigation window vanishes from the screen after a few seconds, leaving you with a full-screen view of the zoomed portion of the image.

4. Up to 5 faces will be detected by the J1, indicated by white borders in the navigation window. Rotate the multi selector dial to move highlighting to the individual faces.

5. Use the zoom bar to zoom back out of the image.

6. Use the multi selector buttons to move the zoomed area around within the image. The navigation window will reappear for reference when zooming or scrolling around within the display.

7. To exit zoom in/zoom out display, tap the shutter release button halfway.

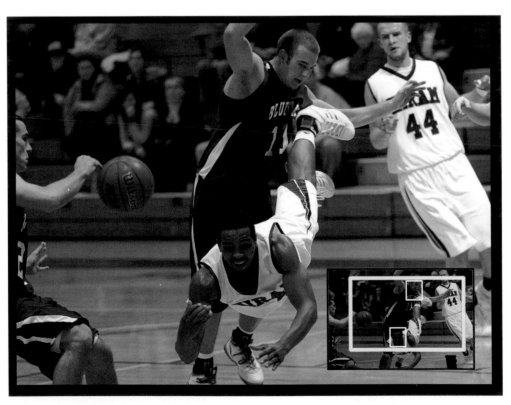

Figure 3.14
The Nikon J1 incorporates a small thumbnail image with a yellow box showing the current zoom area.

Viewing Thumbnails

The Nikon J1 provides other options for reviewing images in addition to zooming in and out. You can switch between single image view and four, nine, or 72 reduced-size thumbnail images on a single LCD screen. There's also a calendar view that shows images grouped by the date they were shot.

Pages of thumbnail images offer a quick way to scroll through a large number of pictures quickly to find the one you want to examine in more detail. The J1 lets you switch quickly from single- to four- to nine- to 72-image views, with a scroll bar displayed at the right side of the screen to show you the relative position of the displayed thumbnails within the full collection of images in the active folder on your memory card. Figure 3.15 offers a comparison between the three levels of thumbnail views. The zoom bar is used to move from one level of thumbnails to the next.

- **Add thumbnails.** To increase the number of thumbnails on the screen, press the zoom bar down. The J1 will switch from single image to four thumbnails to nine thumbnails to 72 thumbnails, and then on to calendar view, described next. (The display doesn't cycle back to single image again.)

- **Reduce number of thumbnails.** To decrease the number of thumbnails on the screen, press the zoom bar up to change from calendar view to 72 to nine thumbnails to four thumbnails, or from four to single-image display. Continuing to press the zoom bar up once you've returned to single-image display starts the zoom process described in the previous section.

- **Switch between thumbnails and full image.** When viewing thumbnails, you can quickly switch between thumbnail view and full image display by pressing the OK button in the center of the multi selector. If you want to return to thumbnail views instead, press up on the zoom bar.

- **Change highlighted thumbnail area.** Use the multi selector to move the yellow highlight box around among the thumbnails.

- **Rate the highlighted image.** Press the F button, and then rotate the multi selector dial to assign one to five stars to the highlighted image, or mark it for deletion.

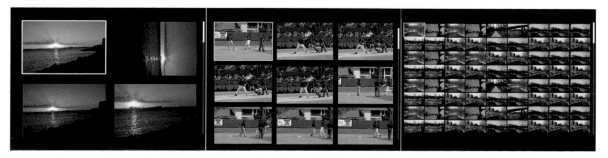

Figure 3.15 Switch between four thumbnails (left), nine thumbnails (center), or 72 thumbnails (right), by pressing the zoom bar.

■ **Delete images.** When viewing thumbnails or a single page image, press the Delete button to erase it. Press a second time to confirm deletion, or press the Playback button to cancel.

■ **Exit image review.** Tap the shutter release button or press the Playback button to exit image review. You don't have to worry about missing a shot because you were reviewing images; a half-press of the shutter release automatically brings back the J1's exposure meters, the autofocus system, and, unless you've redefined your controls or are using manual focus, cancels image review.

Working with Calendar View

When you're in 72 thumbnail mode, pressing the zoom bar down one more time takes you to calendar view, where you can sort through images arranged by the date they were taken. This feature is especially useful when you're traveling and want to see only the pictures you took in, say, a particular city on a certain day.

■ **View dates and images taken on that date.** A yellow highlight box appears around a selected date in the date list calendar, as shown in Figure 3.16.

■ **Change dates.** Use the multi selector keys or rotate the multi selector dial to move through the date list.

■ **View a date's images.** Press the OK button to view the first picture taken on the selected date. You can then press the multi selector left/right buttons to advance or move back among the stored images starting from that image. Press the zoom bar up to return to the 72-image thumbnail display.

■ **Other functions.** Once you begin viewing images starting with a particular calendar date, you can perform the other functions described in the viewing thumbnails section, including rating images, deleting images, or exiting image review.

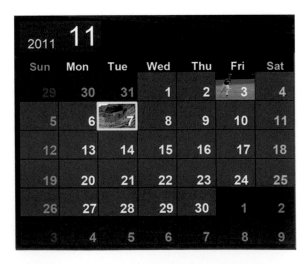

Figure 3.16
Calendar view allows you to browse through all images on your memory card taken on a certain date.

Going Topside

The top surface of the Nikon J1 (see Figure 3.17) has its own set of frequently accessed components.

- **Focal plane indicator.** This indicator shows the *plane* of the sensor, for use in applications where exact measurement of the distance from the focal plane to the subject is necessary. (These are mostly scientific/close-up applications.)

- **Speaker.** Your J1 emits sounds, such as your movie audio track during playback, through this device.

- **Shutter release button.** Partially depress this button to activate the exposure meter and lock in exposure and focus. Press all the way to take the picture. Tapping the shutter release when the camera has turned off the autoexposure and autofocus mechanisms reactivates both. When a review image is displayed on the back-panel color LCD, tapping this button removes the image from the display and reactivates the autoexposure and autofocus mechanisms.

- **Power switch.** Press this button to turn the J1 on or off. The green LED to the left of the button will glow briefly as the camera powers up or down.

- **Movie record button.** When the mode dial is set to Movie mode or Still Image mode, press once to begin recording a video clip; press again to stop recording. A recording indicator, elapsed time, and amount of time remaining appear on the display. You'll find more about movie making in Chapters 4 and 7.

Figure 3.17

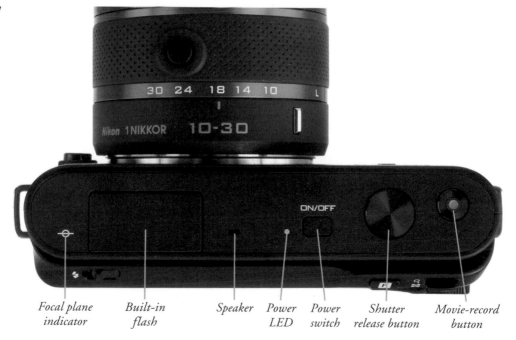

Focal plane indicator *Built-in flash* *Speaker* *Power LED* *Power switch* *Shutter release button* *Movie-record button*

Lens Components

As I write this, there are four lenses available for the Nikon 1 system, making it easy for me to purchase them all. I expect more lenses will be available during the life of this book, and any new lenses will probably contain some combination of the features shown in Figure 3.18. Pictured at left is the Nikkor 10-100mm zoom lens, and at right is the Nikkor 30-110mm zoom. The 10-100mm has some features not found in its smaller sibling, because it has been optimized for movie shooting. Conversely, the 30-110mm lens is a general purpose optic that has a few features you won't see on the larger lens. You'll find more about working with lenses in Chapter 9.

- **Lens hood.** The hood serves to shield the lens from extraneous light outside the picture area, and also protects the front glass element from knocks and dings. For that reason alone, I never shoot without a hood.

Figure 3.18

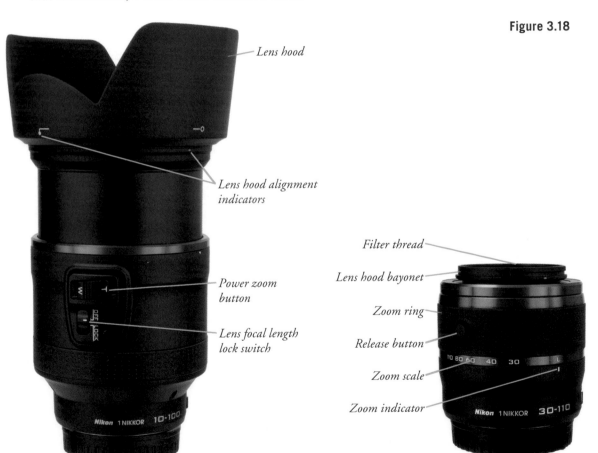

Lens hood

Lens hood alignment indicators

Power zoom button

Lens focal length lock switch

Filter thread

Lens hood bayonet

Zoom ring

Release button

Zoom scale

Zoom indicator

- **Lens hood alignment indicators.** A dot on the outer edge of the lens is lined up with a second dot on the lens hood, and then the hood rotates to a third position where it locks in place.

- **Power zoom button.** The 10-100mm lens has a power zoom button, providing a smooth zoom that's especially useful while shooting movies. (Although zooming within a shot should be used carefully, or in moderation.) Press the T position to zoom in, and the W to zoom back out. The harder you press, the faster the zoom.

- **Lens focal length lock switch.** The 10-100mm lens retracts automatically when the J1 camera is powered down, making the camera/lens more compact. If you want the lens to remain extended so you can begin shooting more quickly when the camera is powered back up, move this switch to the lock position.

- **Lens hood bayonet.** Lenses like the two shown use this bayonet to mount the lens hood. Such lenses generally will have a dot on the edge showing how to align the lens hood with the bayonet mount.

- **Filter thread.** Most lenses have a thread on the front for attaching filters and other add-ons, including non-bayoneting lens hoods.

- **Zoom ring.** Turn this ring to change the zoom setting. Lenses that use a power zoom lack this ring, and cannot be zoomed manually.

- **Zoom scale/zoom indicator.** These markings on manually zoomable lenses show the current focal length selected. Oddly enough, when using a power zoom lens, you never know the actual focal length, because the zoom setting is not shown on either camera display. After you've taken the shot, the lens focal length is shown in the detailed picture display, however.

- **Release button.** Some lenses can be manually retracted and extended. Press this button to allow the zoom ring to be rotated to the retract/extend positions. If the camera is off, extending the lens powers up the J1.

The back end of a lens intended for use on a Nikon 1 camera has other components that you seldom see (except when you swap lenses), shown in Figure 3.19, but still should know about:

- **Lens bayonet mount.** This is the mounting mechanism that attaches to a matching mount on the camera.

- **Electronic contacts.** These metal contacts pass information to matching contacts located in the camera body allowing a firm electrical connection so that exposure, distance, and other information can be exchanged between the camera and lens.

- **Lens mount alignment indicator.** Match this raised ridge on the lens barrel with the index dot on the camera body to mate the lens with the body when changing optics.

Figure 3.19

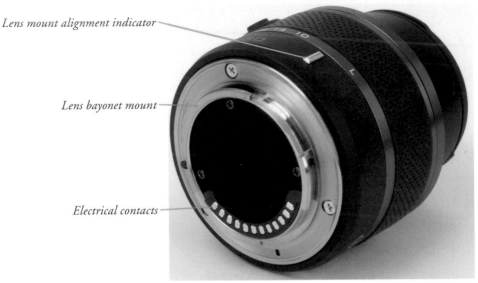

Lens mount alignment indicator

Lens bayonet mount

Electrical contacts

Underneath Your Nikon J1

There's not a lot going on with the bottom panel of your Nikon J1. You'll find the battery compartment access door, and a tripod socket, which secures the camera to a tripod. The socket accepts other accessories, such as quick release plates that allow rapid attaching and detaching the J1 from a matching platform affixed to your tripod. Figure 3.20 shows the underside view of the camera.

Figure 3.20

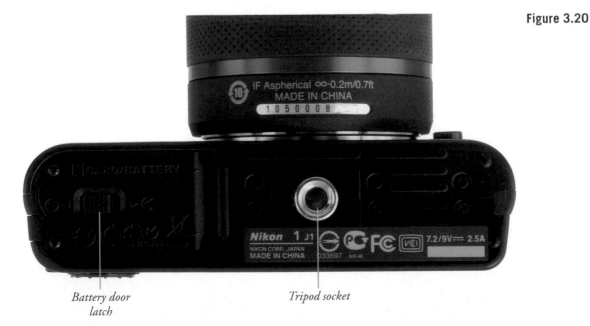

Battery door
latch

Tripod socket

Part II

Beyond the Basics

So, why do you need the four chapters in Part II: Beyond the Basics? I think you'll find that even if you've mastered the fundamentals and controls of the J1 in Part I, there is lots of room to learn more and use the features of the camera to their fullest. Even if you're getting great exposures a high percentage of the time, you can fine-tune tonal values and use your shutter speed, aperture, and ISO controls creatively. Your camera's high performance autofocus system may zero in on your subject in most situations— but you still need to be able to tell the J1 *what* to focus on, and *when*. Other tools at your disposal let you freeze an instant of time, record a continuous series of instants as a movie, and improve your images in other imaginative ways. The chapters in this part will help you move your photography to the next level by understanding exposure, mastering the mysteries of autofocus, and using the Nikon J1's advanced features.

Chapter 4 provides a more thorough explanation of the Nikon J1's four shooting modes; Motion Snapshot; Smart Photo Selection; Still Image mode; and Movie mode. Chapter 5 explores techniques for getting the best exposure, and using techniques like high dynamic range (HDR) photography. Chapter 6 gives you the inside story on advanced shooting, including the mastery of autofocus and continuous shooting. In Chapter 7, you'll find tips for more advanced movie-making techniques.

4

Shooting Stills and Movies

In many respects, the Nikon 1 cameras are a new type of tool, with some special features designed to appeal both to the point-and-shooter and to the veteran photographer who wants to explore new ways of capturing stills and movies. The Nikon J1, in particular, gives you the automated shooting you want in an easy-to-use camera, the full control over settings that allow adding a creative touch, and, as a bonus, some interesting new capabilities like motion snapshots and slow-motion movie shooting.

This chapter will introduce you to the full range of J1 shooting modes. I'm going to cover each of the four shooting modes in a bit of detail, but to avoid trying to cram everything about every topic in one humongous chapter, I'm going to save advanced shooting techniques in each mode for later in Part II. For example, you'll find exposure tips in Chapter 5, continuous shooting in Chapter 6, and movie making in Chapter 7.

Using Motion Snapshot Mode

Regardless of your level of expertise and experience, you've enjoyed taking still snapshots for as long as you've been using a camera. Snapshots are those grab shots you take to capture a moment and preserve a memory, usually with no artistic planning ahead of time, nor even intent to be especially creative. Your camera may be set on Automatic or Program mode, you switch it on, compose your shot, and click away. The captured image has its own charm simply because it's an unposed, unplanned snapshot.

The Nikon J1's Motion Snapshot mode brings the same concept to movie making, providing short, slow-motion glimpses of moments you capture in easy-to-digest bites.

If your "home movie" or "vacation movie" nights put everyone to sleep, your Nikon J1 motion snapshots should prove to be much more enjoyable and palatable.

What Are Motion Snapshots?

When you spin the mode dial to the Motion Snapshot position, the J1 is poised to capture a one-second clip whenever you specify. Here's a brief rundown of how it works:

1. **Start "buffering."** When you're almost ready to capture a motion snapshot, press the shutter release button down halfway. The J1 will begin capturing motion in your scene, *but will not store it to your memory card.* The video instead is temporarily stored in the camera's memory, or *buffer,* waiting until you decide to actually save a moment in time. This buffering process continues for about 90 seconds, or until you decide to take the motion snapshot.

2. **Capture the sequence.** When you choose to record a sequence, press the shutter release the rest of the way down. At that instant, about one second of the video currently in the buffer is saved, embracing the moments *just before* you press the button to *just after.* That is, you don't have to worry about "just missing" the decisive moment; the J1 will forgive your human "lag time" and grab the motion you were looking at when you chose to take the snapshot.

3. **Save to the memory card.** The motion snapshot, along with a still photo of the moment, is then saved to your memory card permanently for you to enjoy later.

4. **Review the snapshot.** The J1 next displays the motion snapshot you just shot in 2.5X slow motion, accompanied by theme music, and finishing with the still photograph of your scene.

You can view your motion snapshots individually, or as a montage/slide show. The next sections provide more details on how to shoot and display killer mini-videos.

Shooting Motion Snapshots

Follow these steps to record your own motion snapshots.

1. **Shift to Motion Snapshot mode.** Rotate the mode dial to the Motion Snapshot position, shown in Figure 4.1.

2. **Select a theme.** Press the F button to the left of the zoom bar. The screen shown in Figure 4.2 appears. Use the directional buttons to choose from Beauty, Waves, Relaxation, or Tenderness theme music. No audio preview is available. However, since there are only four themes, it's easy enough to shoot tests using each theme (just one time) and then evaluate them to decide which should be used in the future.

3. **Choose settings.** When in Motion Snapshot mode, you can select from an array of adjustments, including exposure mode and metering modes, white balance, ISO sensitivity, Picture Controls, and autofocus options (see Figure 4.3) just as you can in Still, Smart Photo Selector, and Movie modes (although the choices available in each may vary slightly). I introduced many of those options in Chapter 2, and you'll find more details in the other chapters in Part II.

Figure 4.1
The mode dial with the four shooting modes.

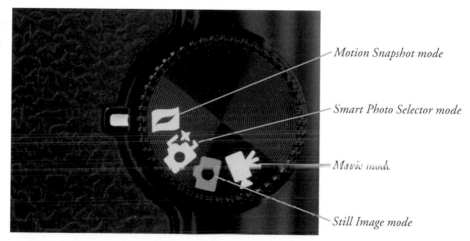

Motion Snapshot mode

Smart Photo Selector mode

Movie mode

Still Image mode

Figure 4.2
Select a musical theme for your motion snapshot.

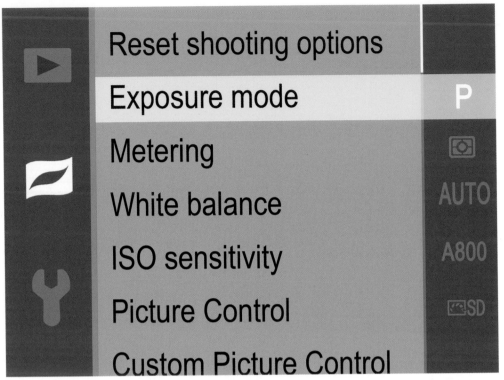

Figure 4.3
Choose settings for the motion snapshot.

4. **Frame the photo.** You can use the LCD to compose your image.

5. **Begin buffering.** Press the shutter release halfway to begin capturing the scene to the J1's memory buffer. Note that the *shutter release* is used, and not the red movie button located to the right of the shutter button. The screen will look something like Figure 4.4 (depending on the display view and settings you've selected) to indicate that buffering is underway. The movie "time remaining" indicator at the bottom right of the screen shows that about 1 second of video will be captured. Buffering will continue for a maximum of about 90 seconds, or until you press the shutter button down to take the picture.

6. **Capture.** Gently press the shutter release down the rest of the way to capture the sequence. An animated sequence of rotating boxes will appear on the screen for a few seconds, indicating your motion snapshot is being saved to the memory card. Note that audio is not recorded; a motion snapshot captures only a video representation of the scene.

7. **Review.** The still snapshot will be displayed for a few seconds to allow you to confirm that you've captured the motion snapshot.

Figure 4.4
When buffering
begins, an indi-
cator is dis-
played in the
upper-left
corner of the
monitor.

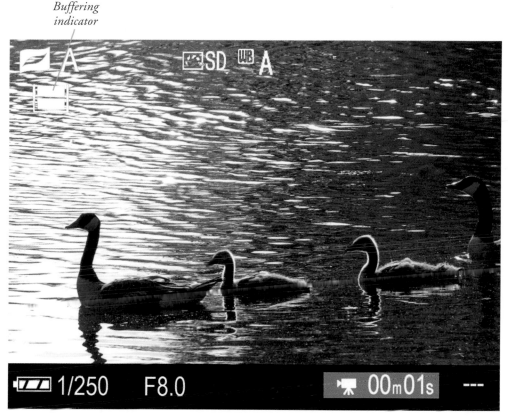

*Buffering
indicator*

Viewing and Reviewing Your Motion Snapshots

Once you've recorded one or more motion snapshots, you can view them as a slide show, as explained in Chapter 8, or see them individually by following these steps:

1. **Press Playback.** The most recently shot image will appear on the screen.

2. **Select motion snapshot to view.** Use the left/right directional buttons to navigate to the sequence you want to view. The Motion Snapshot icon will appear in the upper-left corner of the screen in any playback mode but Image Only.

3. **Press OK to view.** In Simple Details mode, you'll be prompted to press the OK button to view the snapshot.

4. **Watch your motion snapshot.** The snapshot and its audio theme will be played back over a period of about 2.5 seconds, and then the on-screen image will fade to the still photo version, and the theme music will continue for about 10 seconds total. Note that if you've rotated the camera and recorded the snapshot in vertical orientation, it will *not* be rotated on the screen (unlike still shots), even if you've set Rotate On in the Playback menu.

5. **Adjust playback volume.** While the clip is playing, you can adjust the volume by pressing the zoom bar up or down.

6. **Delete (optional).** You can trash the motion snapshot by pressing the Delete button twice. Or, you can cancel and exit by pressing the Playback button or tapping the shutter release.

Using Smart Photo Selector Mode

The buffering used in the Motion Snapshot mode serves as one of the tools deployed by your J1 for its magic Smart Photo Selector mode. In use, the camera takes 20 exposures at a rate of 30 frames per second (in effect, a 2/3-second movie) and stores the images in its buffer for a short period of time. It then examines the pictures, rejecting the blurriest, and those that otherwise don't make the cut (say, your human subject's eyes are closed), presenting you with the best shot and four additional candidates, which are all stored to the memory card. This is a fun feature, and easy to use. Just follow these steps:

1. **Shift to Smart Photo Selector mode.** Rotate the mode dial to the Smart Photo Selector position, shown earlier in Figure 4.1.

2. **Choose settings.** When in Smart Photo Selector mode, you can select from an array of adjustments, a different selection from the ones available in other modes. They include Image Quality, Image Size, Color Space, Noise Reduction, Vibration Reduction, and Built-in AF assist. I'll describe these in Chapter 8.

3. Note that you can't choose an exposure or metering mode, nor focus modes— except that the J1 will automatically switch to close-up focusing if it detects that your main subject is located in the macro range. The camera chooses a scene mode for you, as described in Chapter 2.

4. **Frame the photo.** Use the LCD to compose your image. For the "smarts" to work, your main subject should be in the center of the frame. The J1 will use this subject to gauge whether or not one of the buffered images is acceptable.

5. **Begin buffering.** Press the shutter release halfway to begin capturing the scene to the J1's memory buffer. The camera will adjust focus to accommodate subject movement closer or farther from the camera. AF area brackets in the frame show the area of focus. Buffering will continue for a maximum of about 90 seconds, or until you press the shutter button down to take the picture.

6. **Capture.** Gently press the shutter release down the rest of the way to capture the sequence of pictures. Animated rotating boxes will appear on the screen for a few seconds, indicating your photos are being saved to the memory card.

7. **Review.** The image the J1 decides is best is displayed on the LCD.

Viewing and Reviewing Your Smart Snapshots

Viewing your Smart Photo Selector mode images is a bit counter-intuitive, because the J1 stores them all to your memory card, but won't "allow" you to look at them all, except when you use the procedure I'll describe next. The process is simple, and easy to understand once you've tried it. Just follow these steps:

1. **Press Playback.** The most recently shot image will appear on the screen, with a series of borders that looks like a stack of pictures. The one chosen as best will be on top of the stack.

2. **Scroll through Smart Photos.** Use the left/right directional buttons to navigate to the "best shot" of the series you want to view. This is where things get a little interesting. The J1 will let you view *only* the best shot of the series in normal playback mode. For example, if you'd shot two Smart Photo sets on a blank memory card, the J1 would show that 10 pictures had been saved (five for each series), but might display only the fourth and seventh pictures, displaying them as 4/10 (four of ten) and 7/10 (seven of ten). The others are on your card, but are skipped over during normal playback, and you need to jump through a small hoop to see them.

3. **Choose the series to view.** When you see the "best" shot of the series you want to review, press the OK button. In Simple Details playback mode (press the DISP button to view), you'll be prompted to press the OK button to view the snapshot and its runners-up.

4. **Examine the images.** Use the left/right directional buttons to scroll through the four candidates. (See Figure 4.5.) If you see one you prefer to the best shot selected by the J1, press the OK button to upgrade its status.

5. **Delete (optional).** During best shot review, you can trash an individual image by pressing the Delete button. A screen appears with the options This Image (to remove the current image) and All Except Best Shot (to delete the runner-up candidates). Press OK to confirm, and then select Yes from the next screen that appears to go ahead with trashing the selected image(s). Or, you can cancel and exit by pressing the Playback button.

6. **Return to normal playback.** Press the Playback button to exit best shot review.

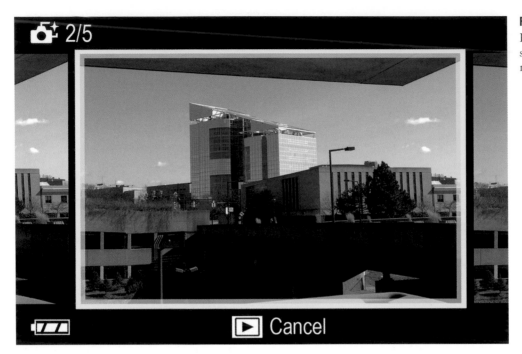

Figure 4.5
Review the best shot and runners-up.

Using Still Image Mode

Still Image mode is your all-purpose shooting mode used for most picture taking. Most of the rest of this book will deal with shooting in this mode. It features Automatic Scene Selection (in which the J1 chooses from among Portrait, Landscape, Night Portrait, Close-Up, and Auto scene modes), and the usual selection of semi-automatic and manual modes (Program, Shutter-priority, Aperture-priority, and Manual; commonly referred to as PSAM modes). I introduced you to the use of Still Image mode in Chapter 2. I'll be recapping what you learned there and provide some extra details in Chapters 5 and 6. To use Still Image mode in its most basic form, just follow these steps:

1. **Shift to Still Image mode.** Rotate the mode dial to the Still Image mode position, shown earlier in Figure 4.1.

2. **Select exposure mode.** Press the MENU button, choose the Shooting menu, and scroll to Exposure Mode, press OK, and select Scene Auto Selector, Programmed auto, Shutter-priority auto, Aperture-priority auto, or Manual.

3. **Choose settings.** When in Still Image mode, you can select from a full array of adjustments, which I'll explain later in this chapter, in Chapter 5 (which deals with understanding exposure), and Chapter 8 (which explains how to choose and use all the menu settings of the J1).

4. **Frame the photo.** You can use the LCD to compose your image.

5. **Focus.** Press the shutter release halfway to focus the image. If the J1 is successful at locking in focus, the focus area will be highlighted in green; otherwise, the focus area will glow red. You'll find more focus options in Chapter 6.

6. **Shoot.** Gently press the shutter release down the rest of the way to capture the picture. The image you've just taken will be displayed on the monitor for a few seconds.

Using Movie Mode

When the mode dial is set to Movie mode, the Nikon J1 captures full HD video with a 16:9 aspect ratio at 1080i/60 frames per second, 1080p/60fps, and 720p/60 frames per second (1920 × 1080 and 1280 × 720 pixels). It can also grab slow-motion movies at an 8:3 aspect ratio at 400fps, and play them back at 30fps to slow the image down to a crawl.

This section will introduce you to the basics of using each of these modes, and how to shoot stills while recording movies. I'll provide more detail on working with each option, including making movie settings, trimming movies, and movie sound options in the advanced movie-making discussion in Chapter 7.

Shooting Conventional HD Movies

Most of the time you'll want to record conventional HD movies for showing on your computer screen, HDTV, or other display, for editing, using Nikon's Short Movie Maker Software or other programs, including Adobe Premiere, Adobe Premiere Elements, or iMovie.

It's easy to get started shooting movies. Just follow these steps:

1. **Shift to Movie mode.** Rotate the mode dial to the Movie mode position, shown earlier in Figure 4.1.

2. **Select exposure mode.** Press the MENU button, choose the Shooting menu, and scroll to Exposure Mode, press OK and select Scene Auto Selector, Programmed auto, Shutter-priority auto, Aperture-priority auto, or Manual.

3. **Choose settings.** When in Movie mode, you can select from an array of other adjustments, including metering mode, white balance, ISO sensitivity, Picture Controls, and various movie options, including movie sound options, movie resolution, and fade-in/fade-out features.

4. **Frame the movie.** You can use the LCD to compose your image.

5. **Focus.** Press the shutter release halfway to focus the image. The subject in the center of the frame is used to establish focus, and face detection is not used. If the J1 is successful at locking in focus, the focus area will be highlighted in green; otherwise, the focus area will glow red. You'll find more focus modes and AF-area options in Chapter 8.

6. **Lock focus/exposure.** When using an exposure mode other than Scene Auto Selector, you can lock exposure and focus by pressing the AE-L/AF-L button (the multi selector up button).

7. **Shoot.** Gently press the red movie record button to begin shooting. The recording indicator will appear at the left of the frame; the time elapsed and the time still available will be displayed.

8. **End recording.** Press the movie record button a second time to halt recording. Movie making will also end automatically when the memory card is full, the maximum size of 4GB is reached, or the maximum time of 20 minutes is recorded.

Shooting Still Images in Movie Mode

When the Nikon J1 is set to Movie mode and you are not shooting slow-motion video, you can grab as many as 20 still images without interrupting your HD movie recording. However, the stills you capture will be 7.5MP in 1080i mode, 2MP in 1080p mode, and 1MP in 720p mode, all using the 16:9 aspect ratio. Just press the shutter release button while shooting, and the frame being captured at that moment will be stored as a still image.

Shooting Slow-Motion Movies

Slow-motion movies are silent clips recorded at the reduced aspect ratio of 8:3 at the amazing speed of 400 or 1200 frames per second. Because they are played back at 30fps, one second of 400fps slow-motion footage requires more than 13 seconds to play out on the screen, and one second of 1200fps footage takes 40 seconds, producing a pronounced slo-mo effect. You can use these movies to analyze your golf stroke, high diving technique, or for comic or dramatic effect in your more ambitious video productions. Of course, it's not easy to intercut 8:3 aspect ratio clips with 16:9 HD clips, so the editing techniques are going to take some work (and are beyond the scope of this book). The main roadblock is that at 400fps, the frame size is pared down to 640 × 240 pixels, and at 1200fps to a teensy 320 × 120 pixels. In either case, the maximum shooting length is five seconds, which plays back in 1 minute, 6 seconds from a clip shot at 400fps to 3 minutes, 20 seconds for a clip recorded at 1200fps.

It's easy to get started shooting slow-motion movies. Just follow these steps:

1. **Shift to Movie mode.** Rotate the mode dial to the Movie mode position, shown in Figure 4.1.

2. **Select Slow Motion mode.** Press the F button and use the multi selector directional buttons to choose Slow Motion. Press the OK button to confirm your choice.

3. **Select exposure mode.** Press the MENU button, choose the Shooting menu, and scroll to Exposure Mode, press OK and select Programmed auto, Shutter-priority auto, Aperture-priority auto, or Manual. Scene Auto Selector is not available.

4. **Choose settings.** When in Slow Motion movie mode, you can select from an array of other adjustments, including frame rate, white balance, ISO sensitivity, Picture Controls, and vibration reduction.

5. **Frame the movie.** You can use the LCD to compose your image. A wide mask showing the 8:3 slow-motion filming area appears on the screen.

6. **Shoot.** Gently press the red movie record button to begin shooting. The recording indicator will appear at the left of the frame; the time elapsed, and the time still available will be displayed. The camera focuses on the subject in the center of the screen, and face detection and still photo shooting are not available

7. **End recording.** Press the movie record button a second time to halt recording. Movie making will also end when the maximum time of about 5 seconds is reached, when the memory card is full, the maximum size of 4GB is reached, or, if you're using a slow memory card, the buffer fills before the existing recording is saved to the card.

Viewing Movies

You can view your movies in Playback mode. Just follow these steps:

1. **Start playback review.** Press the Playback button. You can review your movies when the camera is set to any shooting mode. You don't need to be using Movie mode to view them. When using full-frame playback (that is, when not in thumbnail or calendar view), movies are indicated by a movie camera icon in the upper-left corner. (See Figure 4.6.)

2. **Select a movie to review.** When the clip you want to watch is shown on the screen, press the OK button to start.

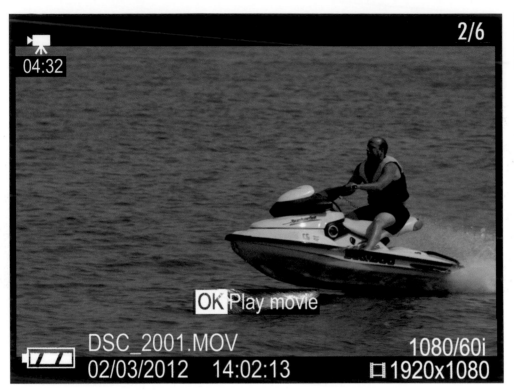

Figure 4.6
Select a movie
to view in
Playback mode.

3. **Pause movie.** Stop playback at any time by pressing the multi selector down button.

4. **Single frame advance/rewind.** When the movie is paused, pressing the right directional button advances one frame; the left directional button rewinds one frame. Or, you can rotate the multi selector dial clockwise or counter-clockwise.

5. **Resume play.** Press the OK button to resume playback of the movie.

6. **Fast forward/rewind.** Press the right directional button to advance, or the left directional button to rewind. A single press increases the speed from 1X to 2X. Keep pressing to accelerate playback to 5X, 10X, or 15X.

7. **Adjust volume.** The zoom bar can be pressed up or down to increase or decrease volume.

8. **Exit to Playback mode.** Press the up directional button to return to Playback mode to select a different still image or movie to resume.

9. **Return to shooting mode.** Tap the shutter release button halfway to return to shooting mode.

Understanding Exposure

When you bought your Nikon J1, you probably thought your days of worrying about getting the correct exposure were over. To paraphrase an old Kodak tagline dating back to the 19th Century—the goal is, "you press the button, and the camera does the rest." For the most part, that's a realistic objective. The J1 is one of the smartest cameras available when it comes to calculating the right exposure for most situations. You can generally choose Smart Photo Selector or switch to Still Image mode and let the Scene Auto Selector choose a scene mode for you, and shoot away. As you gain experience, you might want to try out Program (P), Shutter-priority (S), or Aperture-priority (A).

For example, when you shoot with the main light source behind the subject, you end up with *backlighting*, which can result in an overexposed background and/or an underexposed subject. The Nikon J1 recognizes backlit situations nicely, and can properly base exposure on the main subject, producing a decent photo. Features like Active D-Lighting (discussed in Chapter 8) can fine-tune exposure as you take photos, to preserve detail in the highlights and shadows.

But what if you're feeling creative and *want* to underexpose the subject, to produce a silhouette effect? Or, perhaps, you might want to elevate the J1's built-in flash unit to fill in the shadows on your subject. The more you know about how to use your J1, the more you'll run into situations where you want to creatively tweak the exposure to provide a different look than you'd get with a straight shot.

This chapter shows you the fundamentals of exposure, so you'll be better equipped to override the Nikon J1's default settings when you want to, or need to. After all, correct exposure is one of the foundations of good photography, along with accurate focus and sharpness, appropriate color balance, freedom from unwanted noise and excessive contrast, as well as pleasing composition.

The Nikon J1 gives you a great deal of control over all of these, although composition is entirely up to you. You must still frame the photograph to create an interesting arrangement of subject matter, but all the other parameters are basic functions of the camera. You can let your J1 set them for you automatically, you can fine-tune how the camera applies its automatic settings, or you can make them yourself, manually. The amount of control you have over exposure, sensitivity (ISO settings), color balance, focus, and image parameters like sharpness and contrast make the J1 a versatile tool for creating images.

In the next few pages I'm going to give you a grounding in one of those foundations, and explain the basics of exposure, either as an introduction or as a refresher course, depending on your current level of expertise. When you finish this chapter, you'll understand most of what you need to know to take well-exposed photographs creatively in a broad range of situations.

Getting a Handle on Exposure

In the most basic sense, exposure is all about light. Exposure can make or break your photo. Correct exposure brings out the detail in the areas you want to picture, providing the range of tones and colors you need to create the desired image. Poor exposure can cloak important details in shadow, or wash them out in glare-filled featureless expanses of white. However, getting the perfect exposure requires some intelligence—either that built into the camera or the smarts in your head—because digital sensors can't capture all the tones we are able to see. If the range of tones in an image is extensive, embracing both inky black shadows and bright highlights, we often must settle for an exposure that renders most of those tones—but not all—in a way that best suits the photo we want to produce.

For example, look at two exposures presented in Figure 5.1. For the image at left, the highlights (chiefly the clouds at upper left and the top-left edge of the skyscraper) are well-exposed, but everything else in the shot is seriously underexposed. The version on the right, taken an instant later with the tripod-mounted camera, shows detail in the shadow areas of the buildings, but the highlights are completely washed out. The camera's sensor simply can't capture detail in both dark areas and bright areas in a single shot.

The solution, in this particular case, was to resort to a technique called High Dynamic Range (HDR) photography, in which the two exposures from Figure 5.1 were combined in an image editor such as Photoshop, or a specialized HDR tool like Photomatix (about $100 from www.hdrsoft.com). The resulting shot is shown in Figure 5.2. If you want to learn how to shoot high dynamic range photos, I've got a whole section called "Bracketing and HDR Photography" in the Nuts and Bolts appendix at the end of the

book. For now, though, I'm going to concentrate on showing you how to get the best exposures possible without resorting to such tools, using only the features of your Nikon J1.

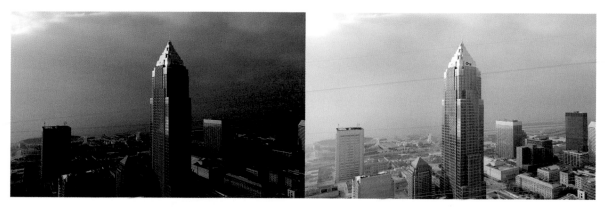

Figure 5.1 At left, the image is exposed for the highlights, losing shadow detail. At right, the exposure captures detail in the shadows, but the highlights are washed out.

Figure 5.2 Combining the two exposures produces the best compromise image.

To understand exposure, you need to understand the six aspects of light that combine to produce an image. Start with a light source—the sun, an interior lamp, or the glow from a campfire—and trace its path to your camera, through the lens, and finally to the sensor that captures the illumination. Here's a brief review of the things within our control that affect exposure, listed in "chronological" order (that is, as the light moves from the subject to the sensor):

■ **Light at its source.** Our eyes and our cameras—film or digital—are most sensitive to visible light. That light has several important aspects that are relevant to photography, such as color, and harshness (which is determined primarily by the apparent size of the light source as it illuminates a subject). But, in terms of exposure, the important attribute of a light source is its *intensity.* We may have direct control over intensity, which might be the case with an interior light that can be brightened or dimmed. Or, we might have only indirect control over intensity, as with sunlight, which can be made to appear dimmer by blocking some of the illumination.

■ **Light's duration.** We tend to think of most light sources as continuous. But, as you'll learn in Chapter 10, the duration of light can change quickly enough to modify the exposure, as when the main illumination in a photograph comes from an intermittent source, such as an electronic flash.

■ **Light reflected, transmitted, or emitted.** Once light is produced by its source, either continuously or in a brief burst, we are able to see and photograph objects by the light that is reflected from our subjects toward the camera lens; transmitted (say, from translucent objects that are lit from behind); or emitted (by a candle or television screen). When more or less light than before reaches the lens from the subject, we need to adjust the settings that control exposure. This part of the equation is under our control to the extent we can increase the amount of light falling on or passing through the subject (by adding extra light sources or using reflectors), or by pumping up the light that's emitted (by increasing the brightness of the glowing object).

■ **Light passed by the lens.** Not all the illumination that reaches the front of the lens makes it all the way through to the sensor. Filters placed on the front of the lens can remove some of the light before it enters. Inside the lens is an adjustable *diaphragm* that produces an opening called an *aperture* that dilates and contracts to control the amount of light that enters the lens. One way that you, or the J1's autoexposure system, can control exposure is by varying the size of the aperture. The relative size of the aperture is called the *f/stop.* (See Figure 5.3.)

■ **Light passing through the shutter.** Once light passes through the lens, the amount of time the sensor receives it is determined by the J1's electronic shutter, which can remain open for as long as 30 seconds (or even longer, but to 120 seconds if you use the ML-L3 infrared remote control to hold open the shutter) or as briefly as 1/16,000th second.

■ **Light captured by the sensor.** Not all the light falling onto the sensor is captured. If the number of photons reaching a particular photosite doesn't pass a set threshold, no information is recorded. Similarly, if too much light illuminates a pixel in the sensor, then the excess isn't recorded at all or, worse, spills over to contaminate adjacent pixels and cause a phenomenon called "blooming." We can modify the minimum and maximum number of pixels that contribute to image detail by adjusting the ISO setting. At higher ISOs, the incoming light is multiplied by the image processor, amplifying it to boost the effective sensitivity of the sensor.

Figure 5.3
This graphic (which isn't an actual photograph of the interior of a lens) represents the relative size of typical apertures. Top row (left to right): f/4, f/5.6, f/8; bottom row: f/11, f/16.

F/STOPS AND SHUTTER SPEEDS

If you're *really* new to more advanced cameras (and I realize that the Nikon J1 is very attractive as a step-up from point-and-shoot photography), you might need to know that the lens aperture, or f/stop, is a ratio, much like a fraction, which is why f/2 is larger than f/4, just as 1/2 is larger than 1/4. However, f/2 is actually *four times* as large as f/4. (If you remember your high school geometry, you'll know that to double the area of a circle, you multiply its diameter by the square root of two: 1.4.)

Lenses are usually marked with intermediate f/stops that represent a size that's twice as much/half as much as the previous aperture. So, a lens might be marked: f/2, f/2.8, f/4, f/5.6, f/8, f/11, f/16 with each larger number representing an aperture that admits half as much light as the one before, as shown in Figure 5.3.

Shutter speeds are actual fractions (of a second), but the numerator is omitted, so that 60, 125, 250, 500, 1,000, and so forth represent 1/60th, 1/125th, 1/250th, 1/500th, and 1/1,000th second. To avoid confusion, Nikon uses quotation marks to signify longer exposures: 2", 2"5, 4", and so forth representing 2.0, 2.5, and 4.0-second exposures, respectively.

These four factors—quantity of light, light passed by the lens, the amount of time the shutter is open, and the sensitivity of the sensor—all work proportionately and recipro-cally to produce an exposure. That is, if you double the amount of light, increase the size of the lens opening by one stop, make the shutter speed twice as long, or boost the ISO sensitivity setting 2X, in any of these cases you'll get twice as much exposure. Similarly, you can *increase* any one of these factors while *decreasing* one of the others by a similar amount to keep the same exposure.

Most commonly, exposure settings are made using the aperture and shutter speed, fol-lowed by adjusting the ISO sensitivity, if it's not possible to get the preferred exposure (that is, the one that uses the "best" f/stop or shutter speed for the depth-of-field or action stopping we want). Table 5.1 shows equivalent exposure settings using various shutter speeds and f/stops. Each pair provides exactly the same amount of exposure as any of the others in the table.

When the J1 is set for P mode, the metering system selects the correct exposure for you automatically, but you can change quickly to an equivalent exposure: a faster shutter speed coupled with a wider lens opening, or a slower shutter speed compensated for with a larger lens opening. Do that by pressing the zoom bar up or down until the desired equivalent exposure combination is displayed. You can use this feature, which Nikon calls *Flexible Program* more easily if you remember that you need to press the zoom bar down when you want to increase the size of the range of sharpness (the amount of depth-of-field) or use a slower/longer shutter speed; or press up when you want to reduce the amount of the sharpness range (the depth-of-field) or use a faster shutter speed to stop/freeze action. The need for more/less DOF and slower/faster shut-ter speed are the primary reasons you'd want to use Flexible Program. This program shift mode does not work when you're using the built-in flash. An asterisk (*) is dis-played next to the P on the LCD when this adjustment is in effect.

In Aperture-priority (A) and Shutter-priority (S) modes, explained later in this chapter, you can also change to an equivalent exposure, but only by either adjusting the aperture (in A mode; the camera chooses the shutter speed) or shutter speed (in S mode; the camera selects the aperture). I'll cover why you might want to use these exposure modes later in the chapter.

Table 5.1 Equivalent Exposures

Shutter speed	f/stop	Shutter speed	f/stop
1/60th second	f/16	1/500th second	f/5.6
1/125th second	f/11	1/1,000th second	f/4
1/250th second	f/8		

F/STOPS VERSUS STOPS

You'll hear the terms *stop* and *f/stop* sometimes used interchangeably. In photography parlance, *f/stop* always refers to the aperture or lens opening. However, because there is no current commonly used word for one exposure increment, the term *stop* is often applied to doubling/halving the size of the lens opening and to doubling/halving the exposure time. (In the past, EV served this purpose, but Exposure Value and its abbreviation have since been inextricably intertwined with its use in describing Exposure Compensation.) In this book, when I say "stop" by itself (no *f/*), I mean one whole unit of exposure, and am not necessarily referring to an actual f/stop or lens aperture. So, adjusting the exposure by "one stop" can mean both changing to the next shutter speed increment (say, from 1/125th second to 1/250th second) or the next aperture (such as f/4 to f/5.6). Similarly, 1/3 stop or 1/2 stop increments can mean either shutter speed or aperture changes, depending on the context. Be forewarned.

Choosing a Metering Method

The next few sections help you use the Nikon J1's controls to get perfect—or near-perfect—exposure every time. Everything you *must know* is right here. As you master your camera, if you want to learn more about how to adjust exposure for unusual situations, refer to the Nuts and Bolts section "How the J1 Calculates Exposure" in Appendix A at the end of this book.

The J1 has three different schemes for evaluating the light received by its exposure sensors: Matrix, Center-weighted, and Spot metering. You can select the mode you want to use when in Motion Snapshot, Still Image, or Movie modes (you can't choose a metering method in Smart Photo Selector mode at all). Press the MENU button, navigate to Metering, and choose one of the three options. (See Figure 5.4.) Here is what you need to know about each metering method:

Matrix Metering

For its various Matrix metering modes, the J1 examines many different areas of the frame. When Matrix metering is active, an icon appears in the bottom-left corner of the LCD. The J1 evaluates the differences between the zones, and compares them with a built-in database of several hundred thousand images to make an educated guess about what kind of picture you're taking. For example, if the top sections of a picture are much lighter than the bottom portions, the algorithm can assume that the scene is a landscape photo with lots of sky. An image that includes most of the lighter portions in the center area may be a portrait. A typical image suitable for Matrix metering is shown in Figure 5.5, with a representation of the icon in the upper-left corner.

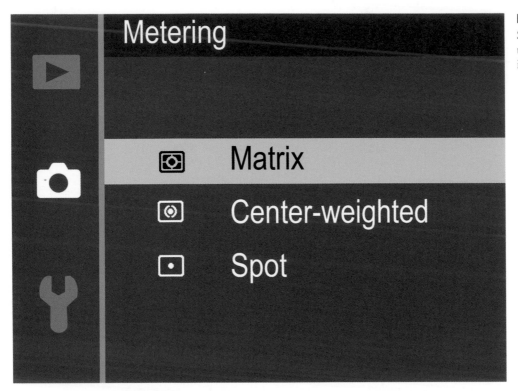

Figure 5.4
Select one of
the three meter-
ing modes.

Figure 5.5 Complex scenes lend themselves to the exposure interpretation provided by Matrix metering.

Matrix metering is best for most general subjects, because it is able to intelligently analyze a scene and make an excellent guess of what kind of subject you're shooting a great deal of the time. The camera can tell the difference between low-contrast and high-contrast subjects by looking at the range of differences in brightness across the scene. Because the J1 has a fairly good idea about what kind of subject matter you are shooting, it can underexpose slightly when appropriate to preserve highlight detail when image contrast is high. (It's often possible to pull detail out of shadows that are too dark using an image editor, but once highlights are converted to white pixels, they are gone forever.)

Center-Weighted Metering

In this mode, the exposure meter emphasizes a 4.5mm zone in the center of the frame to calculate exposure. About 75 percent of the exposure is based on that central area, and the remaining exposure is based on the rest of the frame. The theory, here, is that, for most pictures, the main subject will be located in the center. So, if the J1 reads the center portion and determines that the exposure for that region should be f/8 at 1/250th second, while the outer area, which is a bit darker, calls for f/4 at 1/125th second, the camera will give the center portion the most weight and arrive at a final exposure of f/5.6 at 1/250th second.

Center-weighting works best for portraits, architectural photos, backlit subjects with extra-bright backgrounds (such as snow or sand), and other pictures in which the most important subject is located in the middle of the frame, as in Figure 5.6. As the name suggests, the light reading is *weighted* towards the central portion, but information is also used from the rest of the frame. If your main subject is surrounded by very bright or very dark areas, the exposure might not be exactly right. However, this scheme works well in many situations if you don't want to use one of the other modes. This mode can be useful for close-ups of subjects like flowers, or for portraits.

Figure 5.6 Center-weighted metering calculates exposure based on the full frame, but gives 75 percent of the weight to a 4.5mm area in the middle of the image. Scenes with the main subject in the center, surrounded by areas that are significantly darker or lighter, are perfect for Center-weighted metering.

Spot Metering

Spot metering is especially favored by old-timers who used a hand-held light meter to measure exposure at various points (such as metering highlights and shadows separately), and digital photography veterans who want more precise metering. However, you can use Spot metering in any situation where you want to individually measure the light reflecting from light, midtone, or dark areas of your subject—or any combination of areas.

This mode confines the reading to a limited 2mm area in the viewfinder. The circle is centered on the *current focus point*. This is the only metering method you can use to tell the J1 exactly where to measure exposure. You'll find Spot metering useful when you want to base exposure on a small area in the frame. This mode is best for subjects where the background is significantly brighter or darker, as in Figure 5.7.

Figure 5.7
Spot metering calculates exposure based on a 2mm spot centered around the current focus point. It allowed measuring exposure from this performer's face.

Choosing an Exposure Method

You'll find four methods for choosing the appropriate shutter speed and aperture when using the semi-automatic/manual modes. (When using Scene Auto Selector mode, the exposure method is chosen for you by the camera.) You can choose among Program, Shutter-priority, Aperture-priority, or Manual from the Shooting menu when using any of the shooting modes except Smart Photo Selector, or when using the Electronic (Hi) shutter mode. (See Figure 5.8.) Your choice of which is best for a given shooting situation will depend on things like your need for lots of (or less) depth-of-field, a desire to freeze action or to allow motion blur, or how much noise you find acceptable in an image. Each of the J1's exposure methods emphasizes one aspect of image capture or another. This section introduces you to all four.

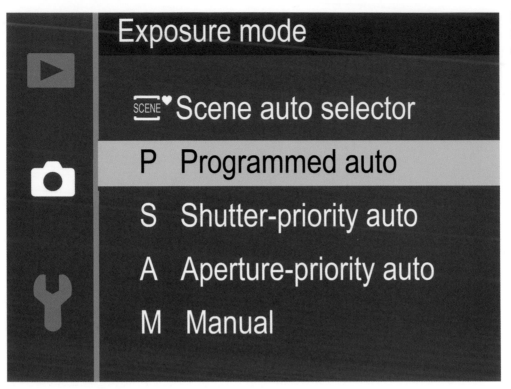

Figure 5.8
Select an expo-
sure method.

Program Mode

Program mode (P) uses the J1's built-in smarts to select the correct f/stop and shutter speed using a database of picture information that tells it which combination of shutter speed and aperture will work best for a particular photo. If the correct exposure cannot be achieved at the current ISO setting or ISO range, the Lo or Hi indicator, and a red focus bracket flash in the center of the frame. You can then boost or reduce the ISO to increase or decrease sensitivity.

The J1's recommended exposure can be overridden if you want. Use the EV (exposure value) setting feature (described next, because it also applies to S and A modes) to add or subtract exposure from the metered value. And, as I mentioned earlier in this chapter, in Program mode you can press the zoom bar up or down to change from the recommended setting to an equivalent setting (as shown earlier in Table 5.1) that produces the same exposure, but using a different combination of f/stop and shutter speed.

This is called "Flexible Program" by Nikon. As I noted, you can press the zoom bar down to reduce the size of the aperture (going from, say, f/4 to f/5.6), so that the J1 will automatically use a slower shutter speed (going from, say, 1/250th second to 1/125th second). Press the zoom bar up to use a larger f/stop, while automatically producing a shorter shutter speed that provides the same equivalent exposure as metered in P mode.

The asterisk appears next to the P in the LCD so you'll know you've overridden the J1's default program setting. Your adjustment remains in force until you press the zoom bar up or down until the * is no longer displayed, or you switch to another exposure mode, turn the camera off, or the J1 goes to sleep (enters standby mode).

MAKING EXPOSURE COMPENSATION CHANGES

Sometimes you'll want more or less exposure than indicated by the J1's metering system. Perhaps you want to underexpose to create a silhouette effect, or overexpose to produce a high key look. It's easy to use the J1's exposure compensation system to override the exposure recommendations, in Program, Shutter-priority, and Aperture-priority modes. (It's not available when using Scene Auto Selector or Manual exposure, nor when using the Electronic (Hi) shutter mode.)

Press the right directional button on the multi selector to produce the EV scale shown in Figure 5.9. Then press the zoom bar up to add exposure, and down to subtract exposure, in the range plus or minus 3EV, in 1/3 stop increments. The EV change you've made remains for the exposures that follow, until you manually zero it out. It is not reset when the camera is powered down.

Exposure compensation works best when used with Center-weighted or Spot metering modes.

Figure 5.9
Press the right directional button, then use the zoom bar to adjust exposure compensation.

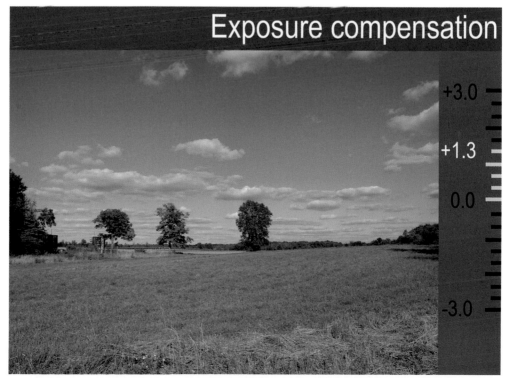

Shutter-Priority

Shutter-priority (S) is the inverse of Aperture-priority: you choose the shutter speed you'd like to use, and the camera's metering system selects the appropriate f/stop. Perhaps you're shooting action photos and you want to use a very fast shutter speed, such as 1/1000th second; in other cases, you might want to use a relatively slow shutter speed, such as 1/125th or 1/60th second to add some blur to a sports photo that would be mundane if the action were completely frozen. (See the ends of the hockey sticks in Figure 5.10.) Shutter-priority mode gives you some control over how much action-freezing capability your digital camera brings to bear in a particular situation.

You'll also encounter the same problem as with Aperture-priority when you select a shutter speed that's too long or too short for correct exposure under some conditions. I've shot outdoor soccer games on sunny Fall evenings and used Shutter-priority mode to lock in a 1/1,000th second shutter speed, and was unable to continue when the sun dipped behind some trees and there was no longer enough light to shoot at that speed, even with the lens wide open and the auto ISO boosted to the maximum amount I was willing to use.

Figure 5.10
Lock the shutter at a specific speed to introduce blur into an action shot.

Aperture-Priority

In A mode, you specify the lens opening used, and the J1 selects the shutter speed. Aperture-priority is especially good when you want to use a particular lens opening to achieve a desired effect. Perhaps you'd like to use the smallest f/stop possible to maximize depth-of-field in a close-up picture. Or, you might want to use a large f/stop to throw everything except your main subject out of focus, as in Figure 5.11.

Figure 5.11
Use Aperture-priority to "lock in" a large f/stop when you want to blur the background.

Maybe you'd just like to "lock in" a particular f/stop because it's the sharpest available aperture with that lens. Or, you might prefer to use, say, f/8 on a lens with a maximum aperture of f/3.5, because you want the best compromise between speed and sharpness.

Aperture-priority can even be used to specify a *range* of shutter speeds you want to use under varying lighting conditions, which seems almost contradictory. But think about it. You're shooting a soccer game outdoors with a telephoto lens and want a relatively high shutter speed, but you don't care if the speed changes a little should the sun duck behind a cloud. Set your J1 to A, and adjust the aperture until a shutter speed of, say, 1/1,000th second is selected at your current ISO setting. (In bright sunlight at ISO 400, that aperture is likely to be around f/11.) Then, go ahead and shoot, knowing that your J1 will maintain that f/11 aperture (for sufficient DOF as the soccer players move about the field), but will drop down to 1/750th or 1/500th second if necessary should the lighting change a little.

If you select f/8 in a dimly lit room, you might find yourself shooting with a very slow shutter speed that can cause blurring from subject movement or camera shake. Aperture-priority is best used by those with a bit of experience in choosing settings. Many seasoned photographers leave their J1 set on A all the time.

Manual Exposure

Part of being an experienced photographer comes from knowing when to rely on your J1's automation (with P mode), when to go semi-automatic (with S or A), and when to set exposure manually (using M). Some photographers actually prefer to set their exposure manually.

Manual exposure can come in handy in some situations. You might be taking a silhouette photo and find that none of the exposure modes or EV correction features give you exactly the effect you want. Set the exposure manually to use the exact shutter speed and f/stop you need.

Because, depending on your proclivities, you might not need to set exposure manually very often, you should still make sure you understand how it works. Fortunately, the J1 makes setting exposure manually very easy. Set Manual exposure in the Shooting menu, and then press the zoom bar up or down to set the shutter speed, and rotate the multi selector dial to adjust the aperture. Even though you're using Manual exposure mode, the J1's exposure meter is still operating; a scale on the right side of the LCD screen shows you how far your chosen setting diverges from the metered exposure. (See Figure 5.12.)

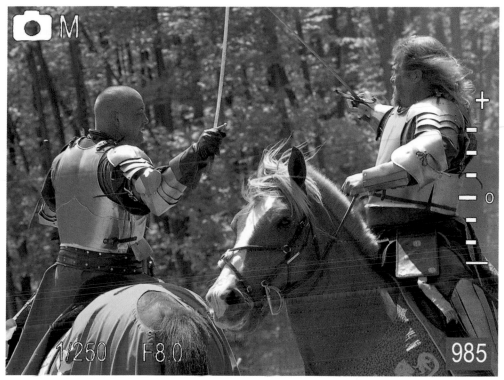

Adjusting Exposure with ISO Settings

Another way of adjusting exposures is by changing the ISO sensitivity setting. Sometimes photographers forget about this option, because the common practice is to set the ISO once for a particular shooting session, say, to the Auto 800 range to let the J1 select from a wide range of appropriate sensitivities. Or, you might choose a fixed setting of ISO 200 for bright sunlight outdoors, or ISO 800 when shooting indoors. ISOs higher than ISO 800 are sometimes seen as "bad" or "necessary evils." However, changing the ISO is a valid way of adjusting exposure settings, particularly with the Nikon J1, which produces good results at ISO settings that create grainy, unusable pictures with some other camera models.

Indeed, I find myself using ISO adjustment as a convenient alternate way of adding or subtracting EV when shooting in Manual mode, and as a quick way of choosing equivalent exposures when in Program or Shutter-priority or Aperture-priority modes. For example, I've selected a Manual exposure with both f/stop and shutter speed suitable for my image using, say, ISO 200. I can change the exposure in 1/3 stop increments by jumping to the Shooting menu and selecting ISO Sensitivity. The difference in image

quality/noise at ISO 200 is negligible if I dial in ISO 100 to reduce exposure a little, or change to ISO 400 to increase exposure. I keep my preferred f/stop and shutter speed, but still adjust the exposure.

Or, perhaps, I am using S mode and the metered exposure at ISO 200 is 1/500th second at f/11. If I decide on the spur of the moment I'd rather use 1/500th second at f/8, I can change the sensitivity to ISO 100. Of course, it's a good idea to monitor your ISO changes, so you don't end up at ISO 3200 outdoors when moving from an indoor location. An ISO indicator appears at the bottom of the LCD screen to remind you what sensitivity setting has been dialed in.

ISO settings can, of course, also be used to boost or reduce sensitivity in particular shooting situations. The J1 can use ISO settings from ISO 100 up to ISO 3200, plus Hi 1 (ISO 6400 equivalent). The camera can also adjust the ISO automatically as appropriate for various lighting conditions when you choose the A3200 Auto (ISO 100-3200), or A400 (ISO 100-400) options. When you choose one of these Auto ISO settings in the Shooting menu, the J1 adjusts the sensitivity dynamically to suit the subject matter, based on the minimum shutter speed limit you have prescribed. You should use Auto ISO cautiously if you don't want the J1 to use an ISO higher than you might otherwise have selected.

Dealing with Noise

Visual image noise is that random grainy effect that some like to use as a special effect, but which, most of the time, is objectionable because it robs your image of detail even as it adds that "interesting" texture. Noise is caused by two different phenomena: high ISO settings and long exposures. The potential for noise may be a special concern for digital photography veterans, because they know that the CX sensor, which is smaller relative to the larger DX and FX sensors found in Nikon's digital SLR cameras, are thought to produce excessive noise.

However, Nikon has taken several steps to keep the Nikon J1's noise at acceptable levels. The CX sensor was limited to a resolution of 10 megapixels, rather than some higher figure, such as 14 to 16 megapixels (and up) available with some other mirrorless models. At 10 megapixels, individual pixels are larger than those that would be required at higher resolutions, and thus more sensitive to light. Extra sensitivity means that the sensor signal doesn't have to be amplified as much to produce higher ISO settings, and the resulting noise is less. Nikon also limited the ISO range of the J1, establishing an upper ceiling of ISO 3200 (and ISO 6400 equivalent at the Hi 1 setting), where cameras with larger sensors often offer sensitivity settings of ISO 12800 or more. Finally, the individual photosites in the J1's sensor were designed to occupy as much of the sensor surface as possible, making them large enough to absorb light more efficiently.

High ISO noise commonly appears when you raise your camera's sensitivity setting above ISO 400. With the Nikon J1, noise may become fairly visible at ISO 1600, and is often quite noticeable at ISO 3200. At Hi 1 noise is usually quite bothersome. You can expect noise and increase in contrast in any pictures taken at these lofty ratings. High ISO noise appears as a result of the amplification needed to increase the sensitivity of the sensor. While higher ISOs do pull details out of dark areas, they also amplify non-signal information randomly, creating noise. You'll find a High ISO Noise Reduction choice in the Shooting menu, where you can turn it On or Off. Because noise reduction tends to soften the grainy look while robbing an image of detail, you may want to disable the feature if you're willing to accept a little noise in exchange for more details.

A similar noisy phenomenon occurs during long time exposures, which allow more photons to reach the sensor, increasing your ability to capture a picture under low light conditions. However, the longer exposures also increase the likelihood that some pixels will register random phantom photons, often because the longer an imager is "hot," the warmer it gets, and that heat can be mistaken for photons. There's also a special kind of noise that CMOS sensors like the one used in the J1 are potentially susceptible to. With a CCD, the entire signal is conveyed off the chip and funneled through a single amplifier and analog-to-digital conversion circuit. Any noise introduced there is, at least, consistent. CMOS imagers, on the other hand, contain millions of individual amplifiers and A/D converters, all working in unison. Because these circuits don't necessarily all process in precisely the same way all the time, they can introduce something called fixed-pattern noise into the image data.

You might want to apply the optional long exposure noise reduction that can be activated using Long Exp. NR in the Shooting menu, where the feature can be turned On or Off. This type of noise reduction involves the J1 taking a second, blank exposure, and comparing the random pixels in that image with the photograph you just took. Pixels that coincide in the two represent noise and can safely be suppressed. This noise reduction system, called dark frame subtraction, effectively doubles the amount of time required to take a picture, and is used only for exposures longer than one second. Noise reduction can reduce the amount of detail in your picture, as some image information may be removed along with the noise. So, you might want to use this feature with moderation.

You can also apply noise reduction to a lesser extent using Photoshop, and when converting RAW files to some other format, using your favorite RAW converter, or an industrial-strength product like Noise Ninja (www.picturecode.com) to wipe out noise after you've already taken the picture.

Fixing Exposures with Histograms

While you can often recover poorly exposed photos in your image editor, your best bet is to arrive at the correct exposure in the camera, minimizing the tweaks that you have to make in post-processing. However, you can't always judge exposure just by viewing the image on your J1's LCD after the shot is made. Nor can you get a 100 percent accurately exposed picture by using the J1's live viewing display. Ambient light may make the LCD difficult to see, and the brightness level you've set can affect the appearance of the playback image. Moreover the image you see on the internal EVF may not be 100 percent accurate.

Instead, you can use a histogram, which is a chart displayed on the J1's LCD that shows the number of tones being captured at each brightness level. You can use the information to provide correction for the next shot you take. The histogram is shown in the Detailed display during picture review, as shown in Figure 5.13. This screen provides a small histogram at the right side that displays the distribution of luminance or brightness.

The luminance histogram is a chart that includes a representation of up to 256 vertical lines on a horizontal axis that show the number of pixels in the image at each brightness

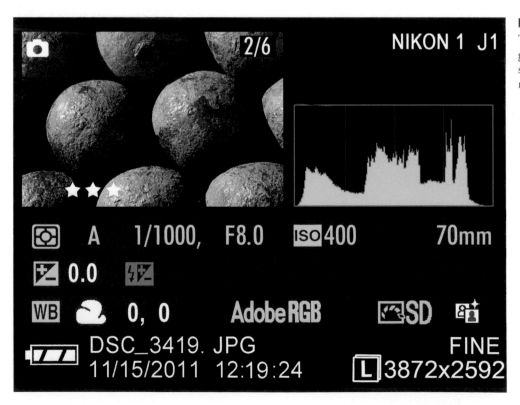

Figure 5.13
The J1's histogram screen shows luminance values.

level, from 0 (black) on the left side to 255 (white) on the right. (The three-inch LCD and internal EVF don't have enough pixels to show each and every one of the 256 lines, but, instead provide a representation of the shape of the curve formed.) The more pixels at a given level, the taller the bar at that position. If no bar appears at a particular position on the scale from left to right, there are no pixels at that particular brightness level.

As you can see, a typical histogram produces a mountain-like shape, with most of the pixels bunched in the middle tones, with fewer pixels at the dark and light ends of the scale. Ideally, though, there will be at least some pixels at either extreme, so that your image has both a true black and a true white representing some details. Learn to spot histograms that represent over- and underexposure, and add or subtract exposure using an EV modification to compensate.

For example, Figure 5.14 shows the histogram (in the inset) for an image that is badly underexposed. You can guess from the shape of the histogram that many of the dark tones to the left of the graph have been clipped off. There's plenty of room on the right side for additional pixels to reside without having them become overexposed. Or, a histogram might look like the insert in Figure 5.15, which is overexposed. In either case, you can increase or decrease the exposure (either by changing the f/stop or shutter speed in Manual mode or by adding or subtracting an EV value in A or S modes) to produce the corrected histogram shown inset in Figure 5.15, in which the tones "hug" the right side of the histogram to produce as many highlight details as possible. See "Making EV Changes," above for information on dialing in exposure compensation.

 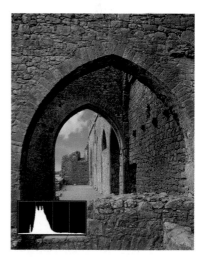

Figure 5.14 This histogram shows an underexposed image.

Figure 5.15 This histogram reveals that the image is overexposed.

Figure 5.16 A histogram for a properly exposed image should look like this.

The histogram can also be used to aid in fixing the contrast of an image, although gauging incorrect contrast is more difficult. For example, if the histogram shows all the tones bunched up in one place in the image, the photo will be low in contrast. If the tones are spread out more or less evenly, the image is probably high in contrast. In either case, your best bet may be to switch to RAW (if you're not already using that format) so you can adjust contrast in post-processing. However, you can also change to a Custom Picture Control with contrast set lower (-1 to -3) or higher (+1 to +3) as required. You'll find instructions for creating Picture Controls in Chapter 8.

Advanced Features

This chapter devotes a little extra space to some special features of the Nikon J1, such as autofocus, continuous shooting, high-speed photography, and long exposures. The focus here is on using these capabilities; you'll find a more in depth nuts and bolts discussion of how the J1 implements these features in Part V of this book.

Using Autofocus with the Nikon J1

Autofocus can sometimes be frustrating for the new digital photographer, especially those coming from the point-and-shoot world. That's because correct focus plays a greater role among your creative options with a mirrorless camera, even when photographing the same subjects. Most point-and-shoot digital cameras have sensors that are even tinier than the CX-sized sensor in the J1. Those smaller sensors require shorter focal lengths, which have, effectively, more depth-of-field.

The bottom line is that with the average point-and-shoot camera, *everything* is in focus from about one foot to infinity and at virtually every f/stop. Unless you're shooting close-up photos a few inches from the camera, the depth-of-field is prodigious, and autofocus is almost a non-factor. The J1, on the other hand, uses longer focal length lenses to achieve the same field of view with its larger sensor, so there is *less* depth-of-field. (That's true even though the J1's sensor is smaller than those found in Nikon's DX and FX cameras—size is relative.) The depth-of-field available with the Nikon J1 cameras, which is *more* than found in the company's DX and FX models, is still *less* than with point-and-shoot cameras. That makes the correct use of autofocus more critical.

If you want to know exactly how the Nikon 1 cameras' hybrid autofocus system works, check out the "Mastering the Mysteries of Autofocus" section in Appendix A. This chapter concentrates on choosing and using the J1's autofocus options.

To maintain the most creative control, you have to choose three attributes:

- **How much is in focus.** Generally, by choosing the f/stop used, you'll determine the *range* of sharpness/amount of depth-of-field. The larger the DOF, the "easier" it is for the autofocus system's locked-in focus point to be appropriate (even though, strictly speaking, there is only one actual plane of sharp focus). With less depth-of-field, the accuracy of the focus point becomes more critical, because even a small error will result in an out-of-focus shot.

- **What subject is in focus.** The portion of your subject that is zeroed in for autofocus is determined by the autofocus zone that is active, and which is chosen either by you or by the Nikon J1 (as described next). For example, when shooting portraits, it's actually okay for part of the subject—or even part of the subject's face—to be slightly out of focus as long as the eyes (or even just the *nearest* eye) appear sharp.

- **When focus is applied.** For static shots of objects that aren't moving, *when* focus is applied doesn't matter much. But when you're shooting sports, or birds in flight, or children, the subject may move within the viewfinder as you're framing the image. Whether that movement is across the frame or headed right towards you, timing the instant when autofocus is applied can be important.

Autofocus Simplifies Our Lives... Doesn't It?

Manual focus is tricky, requires judgment, and fast reflexes, even with the J1's enlarged-view manual focus mode. So, we're all better off now that autofocus has become almost universal, right? On the one hand, AF does save time and allows us to capture subjects (particularly fast-moving sports) that are difficult to image sharply using manual focusing (unless you have training and know certain techniques). On the other hand, learning to apply the Nikon J1's autofocus system most effectively requires a bit of study and some practice. Then, once you're comfortable with autofocus, you'll know when it's appropriate to use the manual focus option, too.

The important thing to remember is that focus isn't absolute. For example, some things that look in sharp focus at a given viewing size and distance might not be in focus at a larger size and/or closer distance. In addition, the goal of optimum focus isn't always to make things look sharp. Not all of an image will be or should be sharp. Controlling exactly what is sharp and what is not is part of your creative palette. Use of depth-of-field characteristics to throw part of an image out of focus while other parts are sharply focused is one of the most valuable tools available to a photographer. But selective focus works only when the desired areas of an image are in focus properly. For the digital photographer, correct focus can be one of the trickiest parts of the technical and creative process.

There are three things to keep in mind when using autofocus:

- **Autofocus mode.** This governs *when* during the framing and shooting process autofocus is achieved. Should the camera focus once when activated, or continue to monitor your subject and refocus should the subject move?

- **Autofocus point selection.** This aspect controls how the J1 selects which areas of the frame are used to evaluate focus. Point selection allows the camera (or you) to specify a subject and lock focus in on that subject. Should the camera look for faces, and focus on the zones that contain them?

- **Autofocus activation.** When should the autofocus process begin, and when should it be locked? This aspect is related to the autofocus mode, but uses controls that you can specify to activate and/or lock the autofocus process.

Autofocus Mode

Choosing the right autofocus mode is another key to focusing success. Autofocus isn't some mindless beast out there snapping your pictures in and out of focus with no feedback from you after you press that button. There are several settings you can modify that return at least a modicum of control to you.

Just press the MENU button when in Still Image mode or Movie mode, and navigate to Focus Mode in the Shooting menu. The screen shown in Figure 6.1 appears. Press the down directional button and select from AF-A, AF-S, AF-C, or MF (manual focus) when using Still Image mode, or AF-F, AF-S, or MF (manual focus) when using Movie mode. These options are available *only* when the exposure mode is set to P, S, A, or M. Autofocus mode cannot be specified if Scene Auto Selector is active for the exposure mode.

If you're using Smart Photo Selector, AF-A is used automatically; in Motion Shapshot mode, AF-S is used automatically, and neither can be changed.

The choice of autofocus mode determines *when* your J1 starts to autofocus, and what it does when focus is achieved. Automatic focus is not something that happens all the time when your camera is turned on. To save battery power, your J1 generally doesn't start to focus the lens until you partially depress the shutter release or press the AE-L/AF-L button (the up directional button). Here's a description of each of these modes:

AF-S (Single-Servo Autofocus)

In this mode, generally just called *AF-S* (available in both Still Image and Movie modes), focus is set once and remains at that setting until the button is fully depressed, taking the picture, or until you release the shutter button without taking a shot. For non-action photography, this setting is usually your best choice, as it minimizes out-of-focus pictures (at the expense of spontaneity).

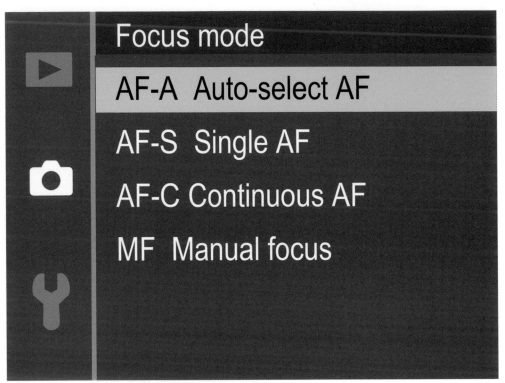

When sharp focus is achieved, the selected focus zone will flash green in the monitor. By keeping the shutter button depressed halfway, you'll find you can reframe the image while retaining the focus (and exposure) that's been set. You can also use the AE-L/AF-L button to lock focus. Because of the small delay while the camera zeroes in on correct focus, you might experience slightly more shutter lag. This mode uses less battery power. If the J1 is unable to focus correctly, the shutter release is locked and you can't take a picture.

AF-C (Continuous-Servo Autofocus)

This mode, also known as *AF-C*, is the mode to use for sports and other fast-moving subjects. In this mode, once the shutter release is partially depressed, the camera sets the focus but continues to monitor the subject, so that if it moves or you move, the lens will be refocused to suit. Focus and exposure aren't really locked until you press the shutter release down all the way to take the picture. You'll find that AF-C produces the least amount of shutter lag of any autofocus mode when set to release priority: press the button and the camera fires. It also uses the most battery power, because the autofocus system operates as long as the shutter release button is partially depressed. This mode works especially well with Subject Tracking autofocus zone selection. This mode is not available in Movie mode; use AF-F (described later) instead.

AF-A (Automatic Autofocus)

This setting, available only in Still Image mode, is actually a combination of the first two. When selected, the camera focuses using AF-S AF and locks in the focus setting. But, if the subject begins moving, it will switch automatically to AF-C and change the focus to keep the subject sharp. AF-A is a good choice when you're shooting a mixture of action pictures and less dynamic shots and want to use AF-S when possible. The camera will default to that mode, yet switch automatically to AF-C when it would be useful for subjects that might begin moving unexpectedly. However, as with AF-S, the shutter can be released only when the subject at the selected focus point is in focus.

AF-F (Full-Time Autofocus)

This setting, available only in Movie mode, replaces the AF-C and AF-A options. (Only AF-S, AF-F, or Manual focus can be selected in Movie mode.) When using AF-F, the camera focuses continuously, and images can be captured even if sharp focus is not quite locked in.

Manual Focus

When you've set the camera to manual focus, you can adjust the zone of sharpness visually using the viewfinder or LCD, as originally described in Chapter 2. To recap, just follow these steps:

1. **Activate focus guides.** Press the multi selector OK button to produce an enlarged view of the center of the frame, as shown in Figure 6.2. A focus scale and navigation window appear at the right of the screen. The outer box represents the entire frame, and the yellow box within it shows the relative portion of the frame currently being magnified.

2. **Zoom in or out.** You can increase/decrease the amount of magnification by pressing the zoom bar in the upper-right corner of the back panel up or down. The size of the yellow box changes to indicate the zoom magnification. Up to 10X magnification can be achieved.

3. **Position magnified area.** Although you can adjust the framing of the camera to relocate the magnified area, if you've mounted the J1 on a tripod, you might want to "lock down" the setup. In that case, you can press the multi selector directional buttons to move the yellow box around in the navigation window, and, thus, the magnified area.

4. **Focus.** Rotate the multi selector dial to focus the image. The focus indicator bar at the right of the screen will show the approximate distance.

5. **Confirm focus.** Press the OK button to lock in focus when you're satisfied.

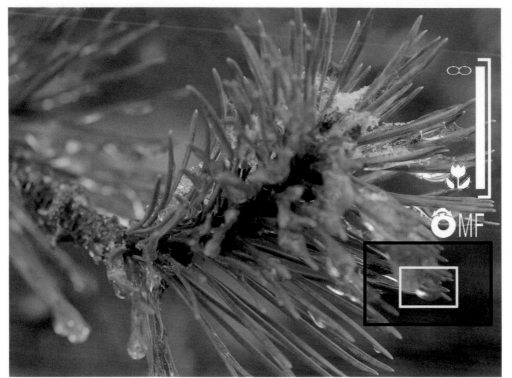

Figure 6.2
Manual focus is great for isolating subjects using selective focus.

Choosing an Autofocus Area Selection Mode

Autofocus area selection determines what part of the image will be focused on. The J1 has three different focus area selection modes. I'm going to describe each of the three modes, and explain how to use them. You can set any of the three point selection modes:

1. Press the MENU button and scroll down to AF-Area Mode in the Shooting menu.

2. Move the cursor to the right and the screen shown in Figure 6.3 appears.

3. Use the up/down directional keys to choose the AF-area mode you want.

4. Press the OK button to confirm.

5. Tap the shutter release button or press MENU to exit the menu system.

Here's how each of the three modes work:

Auto-Area AF

In this mode, autofocus point selection is out of your hands; the J1 performs the task for you and selects which of the zones to use with its own intelligence, and may choose one or several zones, depending on your subject. Thanks to the communication between

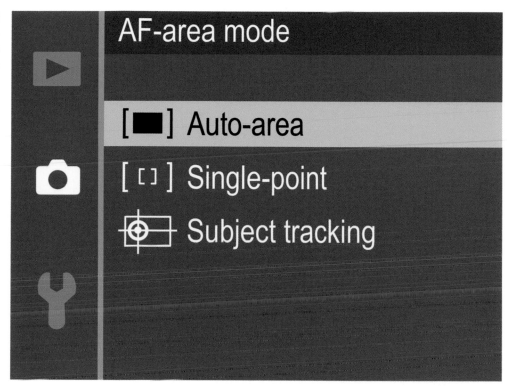

the Nikon 1 lenses and the camera, the J1 can even work with the supplied distance information to distinguish humans from their background, so a person standing at the side of the frame will be detected and used to evaluate focus, while the camera ignores the background area in the frame. In AF-S, AF-A, and AF-C modes, the active focus zones are highlighted in the viewfinder for about one second after focus is achieved. Zones are not used in manual focus mode, and thus not displayed. Figure 6.4 shows the approximate location of the focus zones used in this mode. In the figure, the green rectangles represent the zones selected by Auto-area AF. I've also included a "ghost" image that shows the location of the other zones; these semi-transparent zones don't appear on the LCD—I show them just for illustrative purposes.

Single-Point AF

In this mode, you always select the focus point manually. More zones are available than in Auto-area AF, because the zones overlap. To move the point to any of the 135 zones, just follow these steps:

1. **Access focus area selection.** While viewing your subject, press the OK button to activate the focus area selection display. Arrows around the highlighted focus frame indicate you can move the frame around the image.

Figure 6.4
The focus zone
you select can
be moved
around the
screen.

2. **Move active zone around the screen.** Press the up/down/left/right directional buttons to relocate the active zone. The approximate area is highlighted in yellow in Figure 6.5. (The yellow highlighting does not appear on the monitor.) The zones are arrayed 15 across horizontally and 9 vertically. Each zone overlaps the adjoining zone by about one-third, so each time you press the directional button, the zone will jump approximately two-thirds the width or height.

3. **Confirm choice.** Press the OK button to lock in the selected zone.

4. **Focus zone fixed.** Thereafter, the focus zone will be fixed at the zone you've selected, until you change it, switch to a different autofocus area mode, or turn the camera off.

Subject Tracking

As with Single-point AF, you can select the focus zone used by the J1 to autofocus. However, once you've locked in the initial zone, the camera will relocate the active zone around the screen to track the movement of your subject. Just follow these steps:

1. **Access focus area selection.** While viewing your subject, press the OK button to activate the focus area selection display.

2. **Move the active zone to your subject.** Press the up/down/left/right directional buttons to relocate the active zone on the subject you want to follow, as shown in Figure 6.6.

Figure 6.5
The focus zone you select can be moved around the screen within the area marked by the (imaginary) yellow lines.

Figure 6.6
The J1 can track moving subjects.

3. **Confirm choice.** Press the OK button to lock in the selected zone.

4. **Focus zone will track your subject.** Thereafter, the focus zone will move around the screen to track your subject, and when you press the shutter release halfway it will lock. The subject needs to remain in the area shown by the yellow highlighting in the figure (the highlighting does not appear on the monitor; it's just for illustrative purposes).

Subject tracking works only as long as the Nikon J1 is able to recognize it as the same object. Here are some situations in which the camera can be "fooled."

- **Lack of differentiation.** A solid green ball rolling across the surface of a green pool table may be difficult to track: the J1 uses color as one of the aspects that differentiate your subject from its surroundings. Any subject that is too similar to its background may be problematic, as well as those that are extra large or small, bright or dark.

- **Very rapid movement.** If your subject moves too quickly, the subject-tracking autofocus may lose it.

- **Leaving the frame.** If your subject moves out of the frame, the J1 will stop tracking it, and may not recognize it again if it returns.

- **Obscured by another subject.** If you're shooting football and the referee suddenly stops between you and that tight end you were tracking, when the ref moves on, the camera probably won't be able to find the subject again.

- **Sudden change in size or color.** If your subject is running toward the camera and "grows" from a small element in the frame to one that fills the frame, don't expect the Nikon J1 to be able to track it. A subject illuminated primarily by a red light that suddenly turns green may not be tracked, either. I've had this happen at concerts, when a performer bathed in a pure white light is unexpectedly highlighted by a red spot. The color change confuses the J1's tracking system.

Face-Priority AF

Although you don't select Face-priority AF in the AF-Area selection menu, it's a form of autofocus that's closely related to the subject-tracking option I just described. The difference is that the Nikon J1 searches for faces and locks in on them. Unfortunately, you can't select which face the camera will give priority to, except by re-framing the image. Just follow these steps to use Face priority AF:

1. **Activate Face-priority AF.** Visit the Shooting menu, and navigate to Face-priority AF, which is one entry down from the AF-Area Mode listing. Press the right directional button to view the selection screen and choose On.

2. **Once activated, Face-priority AF operates in any AF-area mode.** In Auto-area, Single-point, and Subject Tracking modes, the J1 will use Face-priority to choose the focus zone if one or more faces is detected facing the camera. Otherwise, each

of these AF-area modes operate in their normal way, and if faces leave the frame (or turn away from the camera), Face-priority is abandoned.

3. **Up to five faces are located.** The yellow boxes appear around each face, with a double box around the face located closest to the camera. (See Figure 6.7.) You can't select a different frame, except by recomposing your image.

4. **Lock in focus.** Press the shutter release halfway, and focus will lock in on the selected face. The focus zone highlighting turns green.

Figure 6.7
The closest face is selected automatically in Face-priority mode.

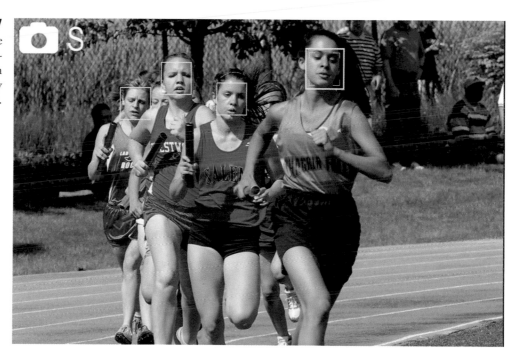

Continuous Shooting

The Nikon J1's continuous shooting modes remind me how far digital photography has brought us. The first accessory I purchased when I worked as a sports photographer some years ago was a motor drive for my film SLR. It enabled me to snap off a series of shots in rapid succession, which came in very handy when a fullback broke through the line and headed for the end zone. Even a seasoned action photographer can miss the decisive instant when a crucial block is made, or a baseball superstar's bat shatters and pieces of cork fly out. Continuous shooting simplifies taking a series of pictures, either to ensure that one has more or less the exact moment you want to capture or to capture a sequence that is interesting as a collection of successive images.

The J1's "motor drive" capabilities are, in many ways, much superior to what you get with a film camera. For one thing, a motor-driven film camera can eat up film at an

incredible pace, which is why many of them are used with cassettes that hold hundreds of feet of film stock. At three frames per second (typical of film cameras), a short burst of a few seconds can burn up as much as half of an ordinary 36 exposure roll of film. Digital cameras, in contrast, have reusable "film," so if you waste a few dozen shots on non-decisive moments, you can erase them and shoot more. In addition, the J1 has much higher frame rates. In Continuous mode, you can snap off up to 5 frames per second (see Figure 6.8), and in Electronic (Hi) shutter mode, machine gun 10, 30, or an amazing 60 frames per second at full resolution. Of course, there are some restrictions. The next sections tell you what you need to know to use continuous shooting effectively.

Continuous Mode: 5fps

To shoot continuously at a 5fps clip in Still Image mode, you need to follow these guidelines:

- **Set shooting defaults.** To get the maximum 5 fps, shooting defaults must be in force, with the exceptions noted below. In Still Image mode, press the MENU button, choose Reset Shooting Options from the Shooting menu, and choose Yes.

- **Select Continuous mode.** Press the F and choose Continuous shooting.

- **Choose Shutter-priority or Manual exposure mode.** Select either of these in the Shooting menu. These modes are required so you can ensure that a fast enough shutter speed is used. With Aperture-priority activated, the J1 may select a slower shutter speed, and that may reduce the maximum frame rate possible.

- **Set shutter speed to 1/250th second or faster.** A fast shutter speed is required to allow capturing images at 5 frames per second.

- **Fire away.** The actual number of images the J1's memory buffer can hold as you shoot in one burst may vary, depending on the format you choose for your images. The approximate number of images that can be captured using the current camera settings is displayed in the lower-right corner of the monitor when the shutter release is pressed halfway. Table 6.1 will give you a rough idea of the buffer's capacity when using full resolution.

To increase the numbers shown in Table 6.1, reduce the image-quality setting by switching to JPEG only (from JPEG+RAW), to a lower JPEG quality setting, such as JPEG Normal, or by reducing the J1's resolution from L to M or S. The reason the size of your bursts is limited is that continuous images are first shuttled into the J1's internal memory buffer, then doled out to the Secure Digital card as quickly as they can be written to the card. Technically, the J1 takes the RAW data received from the digital image processor and converts it to the output format you've selected—either JPG or NEF (RAW)—and deposits it in the buffer ready to store on the card.

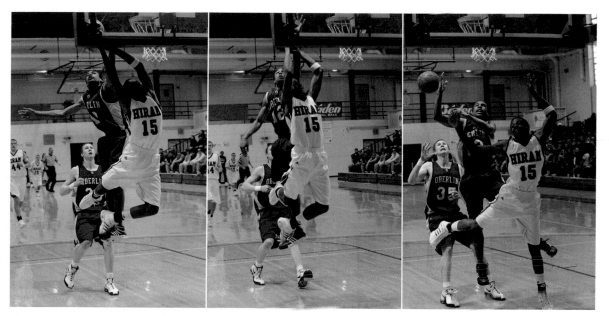

Figure 6.8 Continuous shooting allows you to capture an entire sequence of exciting moments as they unfold.

Table 6.1 Maximum Bursts in Continuous Mode

Image Quality	Buffer Capacity
NEF (RAW)	19
NEF (RAW)+JPEG FINE	19
JPEG FINE	28
JPEG Normal	38
JPEG Basic	53

This internal "smart" buffer can suck up photos much more quickly than the SD card and, indeed, some memory cards are significantly faster or slower than others. When the buffer fills, you can't take any more continuous shots until the J1 has written some of them to the card, making more room in the buffer. You should keep in mind that faster SD cards write images more quickly, freeing up buffer space faster. Today, SD cards are speed-rated using a "Class" figure, with Class 4 (4 megabits per second transfer speed) being the slowest units commonly available. Most SD cards on the market are at least Class 6 (6 megabits per second), with the most common "speedy" cards rated as Class 10 (at least 10 megabits per second). We're starting to see SDXC memory cards given a Class 10 designation, but with read/write speeds that actually top out at 20 megabits per second. (Theoretically, SDXC cards could eventually have speeds that are 10 to 20 times faster.)

Continuous Mode: 10, 30, or 60fps

To shoot continuously at these faster rates, you'll need to switch to the Nikon J1's Electronic (Hi) shutter setting. You don't need to have the camera set for Continuous shooting mode; bursts are the default (and only) action possible when using the Electronic (Hi) shutter setting. Just follow these steps:

1. **Switch to Electronic (Hi) shutter.** Although you can switch back and forth between Electronic and Electronic (Hi) shutters using the F button when in Still Image mode, if you want to change the frame rate, visit the Shutter Type entry in the Shooting menu.

2. **Choose Electronic (Hi).** Scroll down to the Electronic (Hi) setting, then press the right directional button to reach the screen where you can specify frame rate. (See Figure 6.9.)

3. **Fire away.** Keep in mind that as you shoot bursts, the exposure for all the frames is fixed at the exposure values specified for the first frame in a burst. If you're shooting under variable lighting conditions, such as in a gymnasium that has non-incandescent three-phase lighting that "cycles," you may see some variation in exposures.

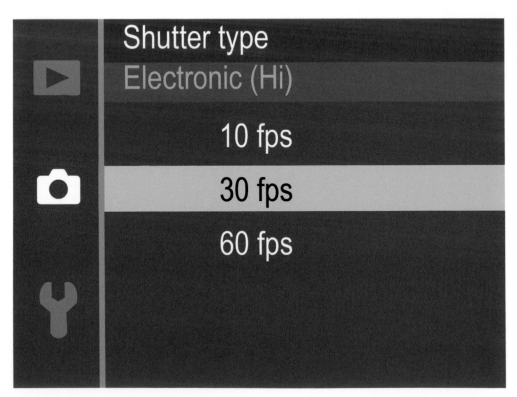

Figure 6.9
Select a frame rate for the electronic shutter.

A Tiny Slice of Time

Exposures that seem impossibly brief can reveal a world we didn't know existed. In the 1930s, Dr. Harold Edgerton, a professor of electrical engineering at MIT, pioneered high-speed photography using a repeating electronic flash unit he patented called the *stroboscope*. As the inventor of the electronic flash, he popularized its use to freeze objects in motion, and you've probably seen his photographs of bullets piercing balloons and drops of milk forming a coronet-shaped splash.

Electronic flash freezes action by virtue of its extremely short duration—as brief as 1/50,000th second or less. You can read more about using electronic flash to stop action in Chapter 10.

Of course, the J1 is fully capable of immobilizing all but the fastest movement using only its shutter speeds, which range all the way up to an astonishing 1/16,000th second. Indeed, you'll rarely have need for such a brief shutter speed in ordinary shooting. But if you wanted to use an aperture of f/2.8 at ISO 200 outdoors in bright sunlight, for some reason, a shutter speed of 1/8,000th second would more than do the job. You'd need a faster shutter speed only if you moved the ISO setting to a higher sensitivity (but why would you do that?). Under less than full sunlight, 1/8,000th second is more than fast enough for any conditions you're likely to encounter.

Most sports action can be frozen at 1/2,000th second or slower, and for many sports a slower shutter speed is actually preferable—for example, to allow the wheels of a racing automobile or motorcycle, or the rotors on a helicopter to blur realistically, as shown in Figure 6.10. At top, a 1/1,000th second shutter speed effectively stopped the rotors of the helicopter, making it look like a crash was impending. At bottom, I used a slower 1/250th second shutter speed to allow enough blur to make this a true action picture.

But if you want to do some exotic action-freezing photography without resorting to electronic flash, the J1's top shutter speeds are at your disposal.

Working with Short Exposures

You can have a lot of fun exploring the kinds of pictures you can take using very brief exposure times, whether you decide to take advantage of the action-stopping capabilities of your built-in flash or work with the Nikon J1's faster shutter speeds. Here are a few ideas to get you started:

■ **Take revealing images.** Fast shutter speeds can help you reveal the real subject behind the façade, by freezing constant motion to capture an enlightening moment in time. Legendary fashion/portrait photographer Philippe Halsman used leaping photos of famous people, such as the Duke and Duchess of Windsor, Richard Nixon, and Salvador Dali to illuminate their real selves. Halsman said, "*When you ask a person to jump, his attention is mostly directed toward the act of jumping and the mask falls so that the real person appears.*" Try some high-speed portraits of people

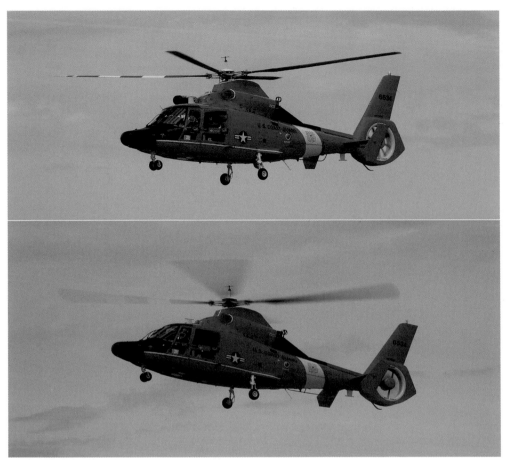

Figure 6.10
A little blur can be a good thing, as these shots of a helicopter at 1/1000th second (top) and 1/250th second (bottom) show.

you know in motion to see how they appear when concentrating on something other than the portrait.

- **Create unreal images.** High-speed photography can also produce photographs that show your subjects in ways that are quite unreal. A motocross cyclist leaping over a ramp, but with all motion stopped so that the rider and machine look as if they were frozen in mid-air, make for an unusual picture. When we're accustomed to seeing subjects in motion, seeing them stopped in time can verge on the surreal.

- **Capture unseen perspectives.** Some things are *never* seen in real life, except when viewed in a stop-action photograph. Edgerton's balloon bursts were only a starting point. Freeze a hummingbird in flight for a view of wings that never seem to stop. Or, capture the splashes as liquid falls into a bowl, as shown in Figure 6.11. No electronic flash was required for this image (and wouldn't have illuminated the water in the bowl as evenly). Instead, a clutch of high intensity lamps and an ISO setting of 1600 allowed the J1 to capture this image at 1/4,000th second.

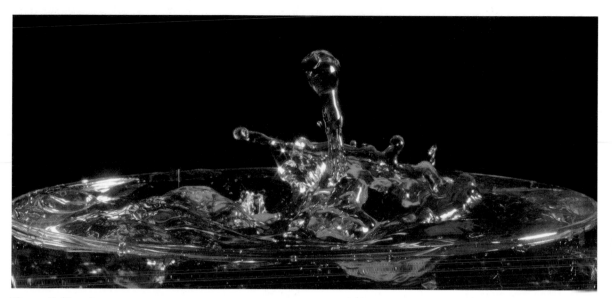

Figure 6.11 A large amount of artificial illumination and an ISO 1600 sensitivity setting allowed capturing this shot at 1/4,000th second without use of an electronic flash.

■ **Vanquish camera shake and gain new angles.** Here's an idea that's so obvious it isn't always explored to its fullest extent. A high enough shutter speed is even better at correcting for camera movement than the J1's built-in Vibration Reduction feature. It can free you from the tyranny of a tripod in light levels too low for even VR to counter camera shake, making it easier to capture new angles, or to shoot quickly while moving around, especially with longer lenses. I tend to use a monopod or tripod for almost everything when I'm not using vibration reduction, and I end up missing some shots because of a reluctance to adjust my camera support to get a higher, lower, or different angle. If you have enough light and can use an f/stop wide enough to permit a high shutter speed, you'll find a new freedom to choose your shots.

Long Exposures

Longer exposures are a doorway into another world, showing us how even familiar scenes can look much different when photographed over periods measured in seconds. At night, long exposures produce streaks of light from moving, illuminated subjects like automobiles or amusement park rides. Extra-long exposures of seemingly pitch-dark subjects can reveal interesting views using light levels barely bright enough to see by. At any time of day, including daytime (in which case you'll often need the help of neutral-density filters to make the long exposure practical), long exposures can cause moving objects to vanish entirely, because they don't remain stationary long enough to register in a photograph.

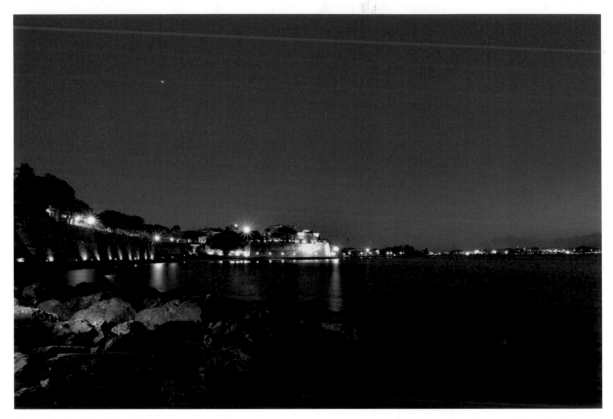

Figure 6.12 The ML-L3 remote control allows you to take longer exposures, such as this 60 second shot in San Juan, Puerto Rico.

The Nikon J1 allows you to take timed exposures of up to 30 seconds using the electronic shutter. You can take longer exposures with the "Bulb" setting in Manual exposure mode, or with the ML-L3 infrared remote control. This type of exposure is so-called because in the olden days the photographer squeezed and held an air bulb attached to a tube that provided the force necessary to keep the shutter open. Traditionally, a bulb exposure is one that lasts as long as the shutter release button is pressed; when you release the button, the exposure ends. (See Figure 6.12.)

Working with Long Exposures

Because the J1 produces such good images at longer exposures, and there are so many creative things you can do with long exposure techniques, you'll want to do some experimenting. Get yourself a tripod or another firm support and take some test shots with long exposure noise reduction both enabled and disabled (to see whether you prefer low noise or high detail) and get started.

Here are some things to try:

■ **Make people invisible.** One very cool thing about long exposures is that objects that move rapidly enough won't register at all in a photograph, while the subjects that remain stationary are portrayed in the normal way. That makes it easy to produce people-free landscape photos and architectural photos at night or, even, in full daylight if you use a neutral-density filter (or two) (or three) to allow an exposure of at least a few seconds. At ISO 100, f/16, and a pair of 8X (three-stop) neutral-density filters, you can use exposures of nearly two seconds; overcast days and/or even more neutral-density filtration would work even better if daylight people-vanishing is your goal. They'll have to be walking *very* briskly and across the field of view (rather than directly toward the camera) for this to work. At night, it's much easier to achieve this effect with the 20- to 30-second exposures that are possible, as you can see in Figure 6.13.

■ **Create streaks.** If you aren't shooting for total invisibility, long exposures with the camera on a tripod can produce some interesting streaky effects. Even a single 8X ND filter will let you shoot at f/16 and 1/12th second in daylight.

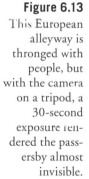

Figure 6.13
This European alleyway is thronged with people, but with the camera on a tripod, a 30-second exposure rendered the passersby almost invisible.

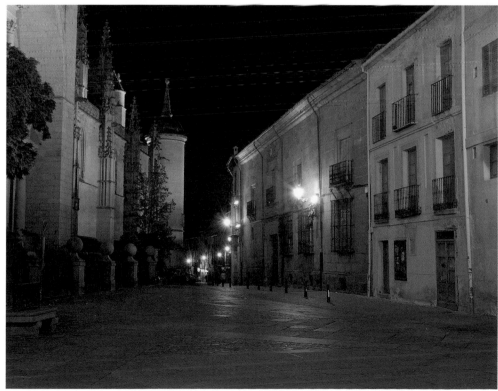

■ **Produce light trails.** At night, car headlights and taillights and other moving sources of illumination can generate interesting light trails, as shown in Figure 6.14. Your camera doesn't even need to be mounted on a tripod; hand-holding the J1 for longer exposures adds movement and patterns to your streaky trails. If you're shooting fireworks, a longer exposure may allow you to combine several bursts into one picture.

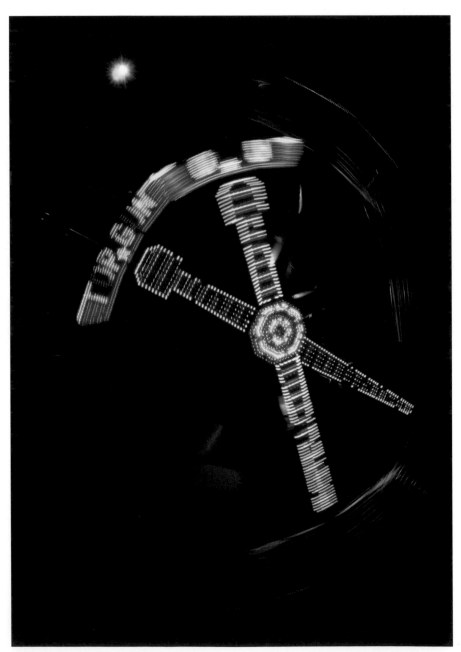

Figure 6.14
Long exposures can capture light trails from amusement park rides.

■ **Blur waterfalls, etc.** You'll find that waterfalls and other sources of moving liquid produce a special type of long-exposure blur, because the water merges into a fantasy-like veil that looks different at different exposure times, and with different waterfalls. Cascades with turbulent flow produce a rougher look at a given longer exposure than falls that flow smoothly. Although blurred waterfalls have become almost a cliché, there are still plenty of variations for a creative photographer to explore. (See Figure 6.15.)

■ **Show total darkness in new ways.** Even on the darkest, moonless nights, there is enough starlight or glow from distant illumination sources to see by, and, if you use a long exposure, there is enough light to take a picture, too.

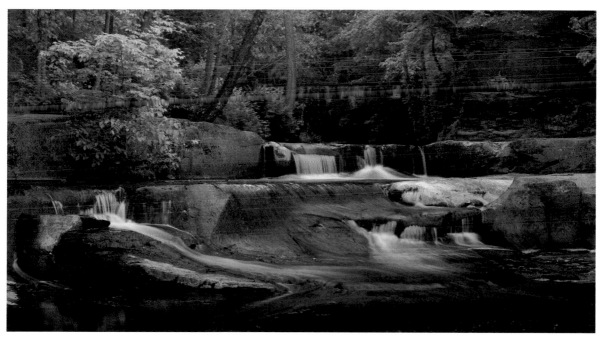

Figure 6.15 A three-second exposure blurred this cascade of flowing water.

Figure 7.2
Slow-motion movies are captured at reduced resolution with 8:3 proportions.

Viewing Movies

As I noted in Chapter 4, you can view your movies in Playback mode:

1. **Start Playback review.** Press the Playback button when the camera is set to any shooting mode. When using full-frame playback (that is, when not in thumbnail or calendar view), movies are indicated by a movie camera icon in the upper-left corner. (See Figure 7.3.)

2. **Select a movie to review.** When the clip you want to watch is shown on the screen, press the OK button to start.

3. **Pause movie.** Stop playback at any time by pressing the multi selector down button.

4. **Single frame advance/rewind.** When the movie is paused, pressing the right directional button advances one frame; the left directional button rewinds one frame. Or, rotate the multi selector dial clockwise or counterclockwise.

5. **Resume play.** Press the OK button to resume playback of the movie.

6. **Fast forward/rewind.** Press the right directional button to advance, or the left directional button to rewind. A single press increases the speed from 1X to 2X. Keep pressing to accelerate playback to 5X, 10X, or 15X.

Figure 7.3
Select a movie to view in Playback mode.

7. **Adjust volume.** The zoom bar can be pressed up or down to increase or decrease volume.

8. **Exit to Playback mode.** Press the up directional button to return to Playback mode to select a different still image or movie to resume.

9. **Return to shooting mode.** Tap the shutter release button halfway to return to shooting mode.

Fine-Tuning Movie Settings

Here's a summary of the various movie-related settings you can make:

■ **Movie options.** When the mode dial is set to Movie, you can press the MENU button, navigate to the Shooting menu's Movie Settings entry, and choose 1080/60i, 1080/30p, or 720/60p (Nikon's terminology), as discussed previously in this chapter.

■ **Fade in/Fade out.** This setting includes W Fade (white) and B Fade (black), as well as OFF. When you choose W or B, each scene will fade to white or black, respectively when you stop capturing. When you resume, the image will start in the faded position (either white or black) and fade into the full scene.

- **Movie sound options.** This Shooting menu entry has two adjustments to make: Microphone and Wind Noise Reduction. Choose to turn the microphone Off if you want to shoot silently (particularly if you are going to add music, voice-over, or other sound later in your movie editing software), or a sensitivity setting from Automatic, High, Medium, or Low. This is essentially a volume control for your internal microphones. Wind Noise Reduction can be switched On or Off, to reduce the effects of air rushing past your microphone.

- **Vibration reduction.** Although VR also applies to still photography, it's especially important when shooting movie clips, to minimize the shakiness of a hand-held camera. Unless you want your viewers to be seasick, or you've mounted the J1 on a tripod, you'll probably want to choose Normal, or Active (for difficult situations, as when shooting from a moving vehicle), rather than Off.

- **Flicker reduction.** When shooting under fluorescent or mercury-vapor lighting, the flickering produced can be especially visible for movie clips. Choose the frequency of your local power supply (generally 60Hz in the US) to minimize this flicker.

- **White balance.** Like exposure, metering mode, and several other settings, white balance applies to both still and movie shooting. However, if you're shooting in an environment where the color balance can change abruptly (such as a concert), you might want to avoid the Auto setting and choose a fixed WB value instead. That will reduce the chances of the J1 trying to adjust white balance in the middle of a shot or between shots. At a concert, for example, you'll probably *want* the vivid changing colors to be captured exactly as they occur, rather than let the camera try to compensate.

Editing Your Movies

In-camera editing is limited to trimming the beginning or end from a clip, and the clip must be at least two seconds long. For more advanced editing, you'll need an application capable of editing AVI movie clips. Short Movie Creator is included with your J1, and you can use that to create movies combined from still photos or Smart Photo Selector, along with Motion Snapshots, other movies, and music. Macs are furnished with the iLife suite that includes iMovie and iPhoto. PCs can be equipped with Windows Live Essentials and similar editing facilities. You can Google "AVI Editor" to locate any of the hundreds of other free video editors available. Or, you can use a commercial product like Corel Video Studio, Adobe Premiere Elements, or Pinnacle Studio. These will let you combine several clips into one movie, add titles, special effects, and transitions between scenes.

To do in-camera editing/trimming, follow these steps:

1. **Select movie clip.** Press the MENU button and choose Playback. Use the directional buttons of the multi selector to navigate to Edit Movie and select it. A screen like the one shown in Figure 7.4 appears.

2. **Highlight Choose a Start Point.** Press the right directional button to produce a screen showing a scrolling list of the available movie clips on your memory card. (See Figure 7.5.)

3. **Choose movie clip.** Use the directional buttons or rotate the multi selector to choose a clip and press OK to select it. The screen shown in Figure 7.6 appears. You must select a clip at least two seconds long.

4. **View the clip.** Press the OK button to begin playback. The down directional button will pause at any point in the clip. OK will resume playback. Pause when you reach the first frame you want to keep, and then press the down button to pause.

5. **Delete preceding frames.** Press the up directional button to delete all the frames that appear before the frame where you paused. A dialog, "Edit Movie?" appears. Choose Yes to confirm, or No to cancel. The J1 will store a copy of the movie on your memory card.

Figure 7.4
Choose to select start point or end point.

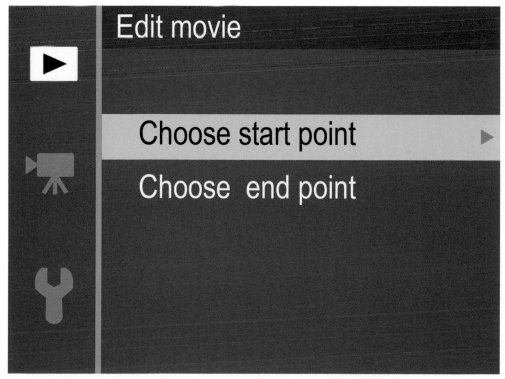

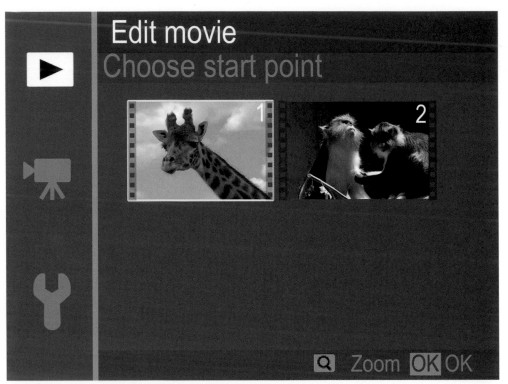

Figure 7.5
Select the movie to edit.

Figure 7.6
Play back movie and pause at the point where you want to trim.

6. **Trim from the end.** To trim video from the end of a clip, watch the movie until you reach the last frame you want to keep and then press the down button to pause. Then press the up button to trim. Confirm when the Edit Movie? dialog appears.

7. **Save movie.** You'll see a Saving Movie message and an icon as the J1 stores the trimmed clip to your memory card. Storage takes some time, and you don't want to interrupt it to avoid losing your saved clip. So, make sure your camera has a fully charged battery before you start to edit a clip.

Tips for Shooting Better Video

Once upon a time, the ability to shoot video with a digital still camera was one of those "Gee whiz" gimmicks camera makers seemed to include just to have a reason to get you to buy a new camera. That hasn't been true for a couple of years now, as the video quality of many digital still cameras has gotten quite good. The Nikon J1 is a stellar example. It's capable of HD quality video and is actually capable of outperforming typical modestly priced digital video camcorders, especially when you consider the range of lenses and other helpful accessories available for it.

Producing good quality video is more complicated than just buying good equipment. There are techniques that make for gripping storytelling and a visual language the average person is very used to, but also pretty unaware of. Producing high-quality videos can be a real challenge for amateur photographers. After all, by comparison we're used to watching the best productions that television, video, and motion pictures can offer. Whether it's fair or not, our efforts are compared to what we're used to seeing produced by experts. While this chapter can't make you into a pro videographer, it can help you improve your efforts.

There are a number of different things to consider when planning a video shoot, and when possible, a shooting script and storyboard can help you produce a higher quality video.

Keep Things Stable and on the Level

Camera shake's enough of a problem with still photography, but it becomes even more of a nuisance when you're shooting video. While the Nikon J1's image-stabilization feature can help minimize this, it can't work miracles. Placing your camera on a tripod will work much better than trying to hand-hold it while shooting. One bit of really good news is that compared to pro dSLRs the Nikon J1 can work very effectively on a lighter tripod.

Shooting Script

A shooting script is nothing more than a coordinated plan that covers both audio and video and provides order and structure for your video. A detailed script will cover what types of shots you're going after, what dialogue you're going to use, audio effects, transitions, and graphics.

Storyboards

A storyboard is a series of panels providing visuals of what each scene should look like. While the ones produced by Hollywood are generally of very high quality, there's nothing that says drawing skills are important for this step. Stick figures work just fine if that's the best you can do. The storyboard just helps you visualize locations, placement of actors/actresses, props and furniture, and also helps everyone involved get an idea of what you're trying to show. It also helps show how you want to frame or compose a shot. You can even shoot a series of still photos and transform them into a "storyboard" if you want, such as in Figure 7.7.

Storytelling in Video

Today's audience is used to fast-paced, short-scene storytelling. In order to produce interesting video for such viewers, it's important to view video storytelling as a kind of shorthand code for the more leisurely efforts print media offers. Audio and video should always be advancing the story. While it's okay to let the camera linger from time to time, it should only be for a compelling reason and only briefly.

It only takes a second or two for an establishing shot to impart the necessary information. For example, many of the scenes for a video documenting a model being photographed in a Rock and Roll music setting might be close-ups and talking heads, but an establishing shot showing the studio where the video was captured helps set the scene. (See Figure 7.8.)

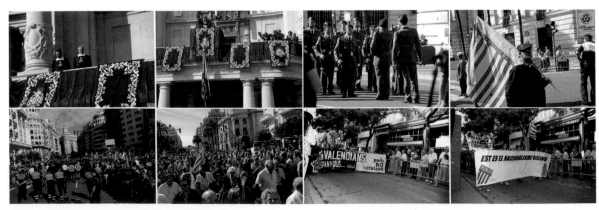

Figure 7.7 A storyboard is a series of simple sketches or photos to help visualize a segment of video.

Figure 7.8
An establishing shot from a distance sets the stage for closer views.

Provide variety too. Change camera angles and perspectives often and never leave a static scene on the screen for a long period of time. (You can record a static scene for a reasonably long period and then edit in other shots that cut away and back to the longer scene with close-ups that show each person talking.)

When editing, keep transitions basic! I can't stress this one enough. Watch a television program or movie. The action "jumps" from one scene or person to the next. Fancy transitions that involve exotic "wipes," dissolves, or cross fades take too long for the average viewer and make your video ponderous.

Composition

In movie shooting, several factors restrict your composition, and impose requirements you just don't always have in still photography (although other rules of good composition do apply). Here are some of the key differences to keep in mind when composing movie frames:

- **Horizontal compositions only.** Some subjects, such as basketball players and tall buildings, just lend themselves to vertical compositions. But movies are shown in horizontal format only. So if you're interviewing a local basketball star, you can end up with a worst-case situation like the one shown in Figure 7.9. If you want to show how tall your subject is, it's often impractical to move back far enough to show him full-length. You really can't capture a vertical composition. Tricks like getting down on the floor and shooting up at your subject can exaggerate the perspective, but aren't a perfect solution.

■ **Wasted space at the sides.** Moving in to frame the basketball player as outlined by the yellow box in Figure 7.9 means that you're still forced to leave a lot of empty space on either side. (Of course, you can fill that space with other people and/or interesting stuff, but that defeats your intent of concentrating on your main subject.) So when faced with some types of subjects in a horizontal frame, you can be creative, or move in *really* tight. For example, if I was willing to give up the "height" aspect of my composition, I could have framed the shot as shown by the green box in the figure, and wasted less of the image area at either side.

■ **Seamless (or seamed) transitions.** Unless you're telling a picture story with a photo essay, still pictures often stand alone. But with movies, each of your compositions must relate to the shot that preceded it, and the one that follows. It can be jarring to jump from a long shot to a tight close-up unless the director—you—is very creative. Another common error is the "jump cut" in which successive shots vary only slightly in camera angle, making it appear that the main subject has "jumped" from one place to another. (Although everyone from French New Wave director Jean-Luc Goddard to Guy Ritchie—Madonna's ex—have used jump cuts effectively in their films.) The rule of thumb is to vary the camera angle by at least

Figure 7.9
Movie shooting requires you to fit all your subjects into a horizontally oriented frame.

30 degrees between shots to make it appear to be seamless. Unless you prefer that your images flaunt convention and appear to be "seamy."

■ **The time dimension.** Unlike still photography, with motion pictures there's a lot more emphasis on using a series of images to build on each other to tell a story. Static shots where the camera is mounted on a tripod and everything is shot from the same distance are a recipe for dull videos. Watch a television program sometime and notice how often camera shots change distances and directions. Viewers are used to this variety and have come to expect it. Professional video productions are often done with multiple cameras shooting from different angles and positions. But many professional productions are shot with just one camera and careful planning, and you can do just fine with your Nikon J1.

Here's a look at the different types of commonly used compositional tools:

■ **Establishing shot.** Much like it sounds, this type of composition, as shown earlier in Figure 7.8, establishes the scene and tells the viewer where the action is taking place. Let's say you're shooting a video of your offspring's move to college; the establishing shot could be a wide shot of the campus with a sign welcoming you to the school in the foreground. Another example would be for a child's birthday party; the establishing shot could be the front of the house decorated with birthday signs and streamers or a shot of the dining room table decked out with party favors and a candle-covered birthday cake. Or, in Figure 7.8, I wanted to show the studio where the video was shot.

■ **Medium shot.** This shot is composed from about waist to head room (some space above the subject's head). It's useful for providing variety from a series of close-ups and also makes for a useful first look at a speaker. (See Figure 7.10.)

■ **Close-up.** The close-up, usually described as "from shirt pocket to head room," provides a good composition for someone talking directly to the camera. Although it's common to have your talking head centered in the shot, that's not a requirement. In Figure 7.11 the subject was offset to the right. This would allow other images, especially graphics or titles, to be superimposed in the frame in a "real" (professional) production. But the compositional technique can be used with Nikon J1 videos, too, even if special effects are not going to be added.

■ **Extreme close-up.** When I went through broadcast training back in the '70s, this shot was described as the "big talking face" shot and we were actively discouraged from employing it. Styles and tastes change over the years and now the big talking face is much more commonly used (maybe people are better looking these days?) and so this view may be appropriate. Just remember, the Nikon J1 is capable of shooting in high-definition video and you may be playing the video on a high-def TV; be careful that you use this composition on a face that can stand up to high definition. (See Figure 7.12.)

- **"Two" shot.** A two shot shows a pair of subjects in one frame. They can be side by side or one in the foreground and one in the background. This does not have to be a head to ground composition. Subjects can be standing or seated. A "three shot" is the same principle except that three people are in the frame. (See Figure 7.13.)

- **Over the shoulder shot.** Long a composition of interview programs, the "Over the shoulder shot" uses the rear of one person's head and shoulder to serve as a frame for the other person. This puts the viewer's perspective as that of the person facing away from the camera. (See Figure 7.14.)

Figure 7.10
A medium shot is used to bring the viewer into a scene without shocking them. It can be used to introduce a character and provide context via their surroundings.

Figure 7.11
A close up generally shows the full face with a little head room at the top and down to the shoulders at the bottom of the frame.

Figure 7.12
An extreme close-up is a very tight shot that cuts off everything above the top of the head and below the chin (or even closer!). Be careful using this shot since many of us look better from a distance!

Figure 7.13
A "two-shot" features two people in the frame. This version can be framed at various distances such as medium or close up.

Figure 7.14
An "over-the-shoulder" shot is a popular shot for interview programs. It helps make the viewers feel like they're the one asking the questions.

Lighting for Video

Much like in still photography, how you handle light pretty much can make or break your videography. Lighting for video can be more complicated than lighting for still photography, since both subject and camera movement is often part of the process.

Lighting for video presents several concerns. First off, you want enough illumination to create a useable video. Beyond that, you want to use light to help tell your story or increase drama. Let's take a better look at both.

Illumination

You can significantly improve the quality of your video by increasing the light falling in the scene. This is true indoors or out, by the way. While it may seem like sunlight is more than enough, it depends on how much contrast you're dealing with. If your subject is in shadow (which can help them from squinting) or wearing a ball cap, a video light can help make them look a lot better.

Lighting choices for amateur videographers are a lot better these days than they were a decade or two ago. An inexpensive incandescent video light, which will easily fit in a camera bag, can be found for $15 or $20. You can even get a good quality LED video light for less than $100. Work lights sold at many home improvement stores can also serve as video lights since you can set the camera's white balance to correct for any color casts. You'll need to mount these lights on a tripod or other support, or, perhaps, to a bracket that fastens to the tripod socket on the bottom of the camera.

Much of the challenge depends upon whether you're just trying to add some fill-light on your subject versus trying to boost the light on an entire scene. A small video light will do just fine for the former (you may have to mount it on a bracket that attaches to the tripod socket, as the J1 doesn't have a top panel shoe that accepts accessories). It won't handle the latter. Fortunately, the versatility of the Nikon J1 comes in quite handy here. Since the camera shoots video in Auto ISO mode, it can compensate for lower lighting levels and still produce a decent image. For best results though, better lighting is necessary.

Creative Lighting

While ramping up the light intensity will produce better technical quality in your video, it won't necessarily improve the artistic quality of it. Whether we're outdoors or indoors, we're used to seeing light come from above. Videographers need to consider how they position their lights to provide even illumination while up high enough to angle shadows down low and out of sight of the camera.

When considering lighting for video, there are several factors. One is the quality of the light. It can either be hard (direct) light or soft (diffused). Hard light is good for

showing detail, but can also be very harsh and unforgiving. "Softening" the light, but diffusing it somehow, can reduce the intensity of the light but make for a kinder, gentler light as well.

While mixing light sources isn't always a good idea, one approach is to combine window light with supplemental lighting. Position your subject with the window to one side and bring in either a supplemental light or a reflector to the other side for reasonably even lighting.

Lighting Styles

Some lighting styles are more heavily used than others. Some forms are used for special effects, while others are designed to be invisible. At its most basic, lighting just illuminates the scene, but when used properly it can also create drama. Let's look at some types of lighting styles:

- **Three-point lighting.** This is a basic lighting setup for one person. A main light illuminates the strong side of a person's face, while a fill-light lights up the other side. A third light is then positioned above and behind the subject to light the back of the head and shoulders. (See Figure 7.15.)

- **Flat lighting.** Use this type of lighting to provide illumination and nothing more. It calls for a variety of lights and diffusers set to raise the light level in a space enough for good video reproduction, but not to create a particular mood or emphasize a particular scene or individual. With flat lighting, you're trying to create even lighting levels throughout the video space and minimize any shadows. Generally, the lights are placed up high and angled downward (or possibly pointed straight up to bounce off of a white ceiling). (See Figure 7.16.)

- **"Ghoul lighting."** This is the style of lighting used for old horror movies. The idea is to position the light down low, pointed upwards. It's such an unnatural style of lighting that it makes its targets seem weird and unnatural.

- **Outdoor lighting.** While shooting outdoors may seem easier because the sun provides more light, it also presents its own problems. As a general rule of thumb, keep the sun behind you when you're shooting video outdoors, except when shooting faces (anything from a medium shot and closer) since the viewer won't want to see a squinting subject. When shooting another human this way, put the sun behind her and use a video light to balance light levels between the foreground and background. If the sun is simply too bright, position the subject in the shade and use the video light for your main illumination. Using reflectors (white board panels or aluminum foil covered cardboard panels are cheap options) can also help balance light effectively.

Figure 7.1
subject (4
Another li

Figure 7.1
be bounce
lighting a
direction.

WIND NOISE REDUCTION

Always use the wind screen with an external microphone to reduce the effect of noise produced by even light breezes blowing over the microphone. Both the camera and many mics include a low-cut filter to further reduce wind noise. However, these can also affect other sounds. You can disable the low-cut filters for the J1's internal microphones by choosing Off for Wind Noise Reduction in the Movie Sound Options menu when the mode dial is set to Movie mode.

Lens Craft

I'll cover the use of lenses with the Nikon J1 in more detail in Chapter 9, but a discussion of lens selection when shooting movies may be useful at this point. In the video world, not all lenses are created equal. The two most important considerations are depth-of-field, or the beneficial lack thereof, and zooming. I'll address each of these separately.

Depth-of-Field and Video

Have you wondered why professional videographers have gone nuts over still cameras that can also shoot video? The producers of Saturday Night Live could afford to have Alex Buono, their director of photography, use the niftiest, most expensive high-resolution video cameras to shoot the opening sequences of the program. Instead, Buono opted for a pair of digital SLR cameras. One thing that makes digital still cameras so attractive for video is that they have relatively large sensors, which provides improved low-light performance and results in the oddly attractive reduced depth-of-field, compared with most professional video cameras.

Figure 7.17 provides a comparison of the relative size of sensors. The typical size of a professional video camera sensor is shown at lower left. The Nikon 1 sensor used in the J1 is shown just northwest of it. You can see that it is much larger, especially when compared with the sensor found in the Nikon P7100 compact camera. Of course, the DX sensor shown at upper left, and a full-frame FX sensor (not shown) are even larger. But, compared with the sensors used in many pro video cameras and the even smaller sensors found in the typical computer camcorder, the Nikon 1's image-grabber is larger.

As you'll learn in Chapter 9, a larger sensor calls for the use of longer focal lengths to produce the same field of view, so, in effect, a larger sensor has reduced depth-of-field. And *that's* what makes cameras like the Nikon J1 or larger models like the Nikon D5100 attractive from a creative standpoint. Less depth-of-field means greater control over the range of what's in focus. Your J1, with its larger sensor, has a distinct advantage over consumer camcorders in this regard, and even does a slightly better job than professional video cameras.

Figure 7.17
Sensor size
comparison.

Zooming and Video

When shooting still photos, a zoom is a zoom is a zoom. The key considerations for a zoom lens used only for still photography are the maximum aperture available at each focal length ("How *fast* is this lens?"), the zoom range ("How far can I zoom in or out?"), and its sharpness at any given f/stop ("Do I lose sharpness when I shoot wide open?").

When shooting video, the priorities may change, and there are two additional parameters to consider. The first two I listed, lens speed and zoom range, have roughly the same importance in both still and video photography. Zoom range gains a bit of importance in videography, because you can usually move closer to shoot a still photograph, but when you're zooming during a shot, most of us don't have that option (or the funds to buy/rent a dolly to smoothly move the camera during capture). But, oddly enough, overall sharpness may have slightly less importance under certain conditions when shooting video. That's because the image changes in some way many times per second (30/60 times per second with the Nikon J1), so any given frame doesn't hang around long enough for our eyes to pick out every single detail. You want a sharp image, of course, but your standards don't need to be quite as high when shooting video.

Here are the remaining considerations, and the two new ones:

■ **Zoom lens maximum aperture.** The speed of the lens matters in several ways. A zoom with a relatively large maximum aperture lets you shoot in lower light levels, and a big f/stop allows you to minimize depth-of-field for selective focus. Keep in mind that the maximum aperture may change during zooming. The 10-30mm kit lens is an f/3.5 lens at the 10mm focal length, but provides only f/5.6 worth of light at 30mm.

■ Use the multi selector's left/right/up/down buttons to navigate among the menu entries to highlight your choice. Moving the highlighting to the left column lets you scroll up and down among the three top-level menus. From the top in Figure 8.1, they are Playback, Shooting, and Setup.

■ A highlighted top-level menu's icon will change from gray and white to yellow highlighting. Use the multi selector's right button to move into the column containing that menu's choices, and the up/down buttons to scroll among the entries. If more than one screen full of choices is available, a scroll bar appears at the far right of the screen, with a position slider showing the relative position of the currently highlighted entry.

■ To work with a highlighted menu entry, press the OK button in the center of the multi selector, or just press the right button on the multi selector. Any additional screens of choices will appear. You can move among them using the same multi selector movements.

■ You can confirm a selection by pressing the OK button or, frequently, by pressing the right button on the multi selector once again.

Figure 8.1
The multi selector's navigational buttons are used to move among the various menu entries.

- Pressing the multi selector left button usually backs you out of the current screen, and pressing the MENU button again usually does the same thing. You can exit the menu system at any time by tapping the shutter release button.

- The Nikon J1 "remembers" the top-level menu and specific menu entry you were using (but not any submenus) the last time the menu system was accessed, so pressing the MENU button brings you back to where you left off.

Playback Menu

The Playback menu has ten entries where you select options related to the display, review, editing, and printing of the photos you've taken. The choices you'll find include the following entries (the last three, Resize, Crop, and Edit Movie are not pictured in Figure 8.1, and don't appear until you scroll the listing to the bottom). You must have images on your memory card to select any of these:

- Delete
- Slide Show
- Rotate Tall
- DPOF Print Order
- Protect

- Rating
- D-Lighting
- Resize
- Crop
- Edit Movie

Delete

Choose this menu entry and you'll be given four choices: Delete Selected Images, Select Images By Date, Delete All Images, and Discard. (See Figure 8.2.) To delete only some pictures, choose Delete Selected Images and you'll see an image selection screen like the one shown in Figure 8.3. Then, follow these instructions:

1. **View images.** Use the multi selector left/right cursor keys or the dial to scroll among the available images. (See Figure 8.3.)

2. **See movies and still pictures.** Movie clips will have graphics representing sprocket holes displayed on either side of their thumbnails. Movie clips you have trimmed will have a scissors icon shown at the upper-left corner of the thumbnail.

3. **Mark images for deletion.** When you highlight an image or movie you think you might like to delete, press the up button to mark (with a trash can icon) or the down button to unmark.

4. **Zoom in to examine image.** Press and hold the zoom bar up to temporarily see the highlighted image in a larger size.

Figure 8.2
Choose which images to remove.

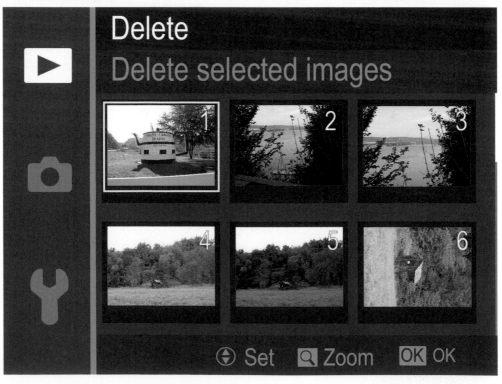

Figure 8.3
Delete specific selected images.

5. **Delete and confirm.** When you've finished marking images to delete, press OK. A final screen will appear asking you to confirm the removal of the image(s). Choose Yes to delete the image(s) or No to cancel deletion, and then press OK. If you selected Yes, then you'll return to the Playback menu; if you chose No, you'll be taken back to the selection screen to mark/unmark images.

6. **Exit.** To back out of the selection screen, press the MENU button or tap the shutter release button.

In the main Delete screen you can also choose Select Images by Date. Just follow these steps:

1. **See available dates.** The Select Images by Date screen will show you a thumbnail of the first movie/still captured on a particular date. (See Figure 8.4.)

2. **See images for that date.** While you can mark a date and all its images for deletion from this screen, if you like you can press the zoom bar down to view all the images taken on that date in a scrollable list.

3. **Zoom in to examine image.** From the screen that appears, press and hold the zoom bar up to temporarily see a highlighted image for that date in a larger size.

Figure 8.4
Remove only images taken on a certain date.

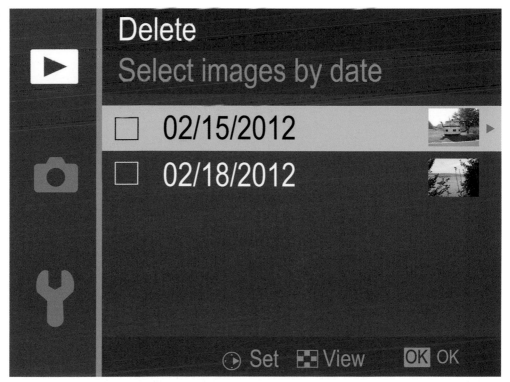

4. **Return to date selection screen.** When you're satisfied with deleting all the images for that date, press OK to mark them all for deletion. You'll be returned to the date selection screen with a check mark placed next to the thumbnail for that date. You can also press the zoom bar's down button to return to the screen without marking the images.

5. **Mark dates for deletion.** You can review other dates as described in Steps 2-4, or simply mark dates for deletion from this screen by pressing the right multi selector button. Dates scheduled for erasure are indicated with a checked box.

6. **Delete and confirm.** When you've finished marking dates to delete, press OK. A final screen will appear asking you to confirm the removal of the image(s). Choose Yes to delete the image(s) or No to cancel deletion, and then press OK. If you selected Yes, then you'll return to the Playback menu; if you chose No, you'll be taken back to the selection screen to mark/unmark images.

7. **Exit.** To back out of the selection screen, press the MENU button or tap the shutter release button.

Your final two choices from the main Delete screen are Delete All Images, which removes all the images from your memory card, and Discard. Discard removes all images you've marked with the Trash icon rating in the Rating Pictures menu.

Other Ways to Delete

There are ways to erase images other than from the Playback menu, all discussed elsewhere in this book. To recap, here are your options.

- **Format command.** The Format command, explained in the discussion of the Setup menu later in this chapter, is a much faster way of wiping a whole card than choosing Delete All Images. It's also a safer way of returning your memory card to a fresh, blank state, as it restores the file system to its original pristine state.

- **Delete button.** You can remove whatever image or movie preview is on the screen during playback by pressing the Delete button (with the trash can icon), and then confirming by pressing a second time.

- **Deleting Smart Photo Selector images.** When a Smart Photo is shown on the screen, pressing the Delete button twice removes the images chosen by the Smart Photo Selector. If you're viewing the Best Shot selection dialog, you are shown another screen that asks if you want to delete This Image, or All Except Best Shot. Use the multi selector buttons to choose, and press OK. Or press the playback button to Cancel.

Slide Show

The J1's Slide Show feature is a convenient way to review images one after another, without the need to manually switch between them.

To activate a slide show, just choose Start from this entry in the Playback menu. If you like, you can choose an interval for both still images and movies before commencing the show. During playback, you can press pause, skip back, skip ahead, adjust volume, and exit to playback or shooting mode. The next sections will show you how to set up and run your slide show.

Setting Up the Show

You can choose what type of images and/or movies will be displayed in your slide show, but, unfortunately, you can't pick and choose exactly which will be shown, except indirectly. Follow these steps to set up your show. First choose what images to view:

1. **Access slide show.** In the Playback menu, navigate to Slide Show and press the right navigational button. The screen shown in Figure 8.5 appears.

Figure 8.5
Choose which type of stills and movies to include in your slide show.

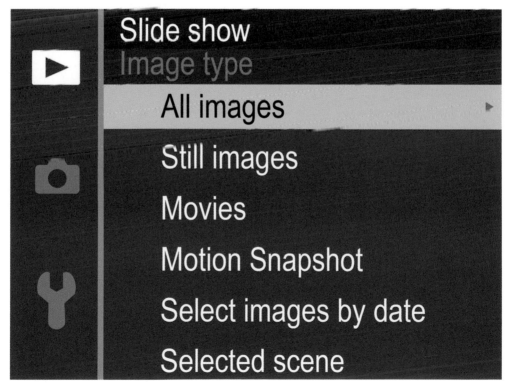

2. **Select from the eight image/movie types available.** If no images or movies are available of the type you specify, slide show setup will stop until you select an option that has available images. Only the first six are shown on the screen initially; you'll need to scroll down to see the last two, By Rating, and Face-priority. Your choices are:

 ■ **All Images.** All the movies and still images of any type on your memory card will be included.

 ■ **Still Images.** Only still photographs are included in the slide show.

 ■ **Movies.** Your slide show will display all movie clips.

 ■ **Motion Snapshot.** The slide show includes only the short movie part of your motion snapshots, and skips the photographs.

 ■ **Select Images by Date.** A calendar, like the one shown in Figure 8.6, appears. Use the multi selector buttons to highlight a date and press OK. Only the images taken on that date will be included in your slide show.

 ■ **Selected Scene.** Choose to display only the images that the Auto Scene Selector has selected to take using a particular scene classification. You can select from Auto, Portrait, Landscape, Night Portrait, and Close-ups. Say you've taken a lot of close-up pictures of flowers, or have many landscape-type photos on your memory card; this mode will search through your shots and include the ones the J1 classifies as that type of scene in your slide show. Its selection won't be perfect, but you'll be surprised at how accurate the assessment is.

 ■ **By Rating.** This is the closest you can come to hand-picking which photos to display in your slide show. Choosing By Rating displays a screen with five rows of stars, from five stars to one star, with a checkbox next to each. Highlight any row and press the right directional button to mark or unmark that rating. You can choose any combination of ratings you like: view only five star pictures, both five star and four star images, or, if you're feeling quirky, choose to see five star *and* one star images for a best shot/worst shot comparison. If you carefully rate your images during playback review you can effectively choose which ones will be included in a slide show. You might, for example, assign five stars to all the photos you want to include in a slide show, even if they aren't necessarily the best ones on the memory card.

 ■ **Face-priority.** If you hanker to view all your people shots in one sitting, this option will include only shots in which the J1 detected faces (if Face-priority was active during shooting).

3. **Advance to setup screen.** Once you've selected which images to include, you'll be taken to the setup screen shown in Figure 8.7. The next steps show you how to finish setting up your slide show.

Figure 8.6
You can select only images taken on a particular date.

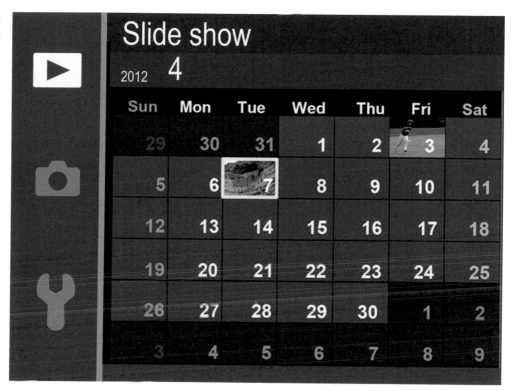

Figure 8.7
Specify the other parameters for your slide show.

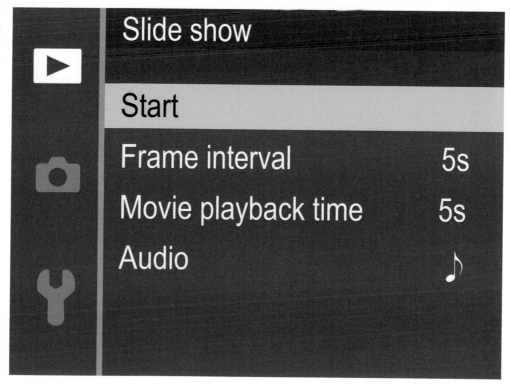

Figure 8.8 With Rotate Tall turned Off, vertical images appear large on the LCD, but you must turn the camera to view them upright. With Rotate Tall turned On, vertical images are shown in a smaller size, but oriented for viewing without turning the camera.

When Rotate Tall is turned On, the J1 rotates pictures taken in vertical orientation on the LCD screen so you don't have to turn the camera to view them comfortably. However, this orientation also means that the longest dimension of the image is shown using the shortest dimension of the LCD, so the picture is reduced in size, as you can see at right in Figure 8.8.

So, turn this feature On (as well as Auto Image Rotation in the Setup menu) if you'd rather not turn your camera to view vertical shots in their natural orientation, and don't mind the smaller image. Turn the feature Off if, as I do, you'd rather see a larger image and are willing to rotate the camera to do so.

DPOF Print Order

The Nikon J1 supports the DPOF (Digital Print Order Format) that is now almost universally used by digital cameras to specify which images on your memory card should be printed, and the number of prints desired of each image. This information is recorded on the memory card and can be interpreted by a compatible printer when the camera is linked to the printer using the USB cable, or when the memory card is inserted into a card reader slot on the printer itself. Photo labs are also equipped to read this data and make prints when you supply your memory card to them. You can create a Print Order using this menu entry, or select pictures for printing using the PictBridge menu that pops up when the J1 is connected to a printer.

When you choose this menu item, you're presented with a set of screens that looks very much like the Delete photos screens described earlier, only you're selecting pictures for printing rather than deleting them.

The button sequences are slightly different, however:

1. **Choose DPOF Print Order.** In the Playback menu, navigate to the DPOF Print Order selection and press the right directional button. You'll see a screen that allows you to select/set the images to be printed, or reset (which unselects any images currently selected).

2. **View images.** Use the multi selector left/right buttons or dial to move among the available images.

3. **Evaluate image.** When you highlight an image you want to print, press the zoom bar upwards to temporarily enlarge that image so you can evaluate it further. When you release the button, the selection screen returns.

4. **Set number of prints.** To mark an image for printing, press the multi selector up and down buttons to choose the number of prints you want, up to 99 per image. A printer icon and the number specified will appear overlaid on that image's thumbnail. (See Figure 8.9.)

5. **Reduce prints.** To unmark an image for printing, highlight and press the down button until the number of prints reaches zero. The printer icon will vanish.

6. **Confirm.** When you've finished marking images to print, press OK.

Figure 8.9
Select images
for printing.

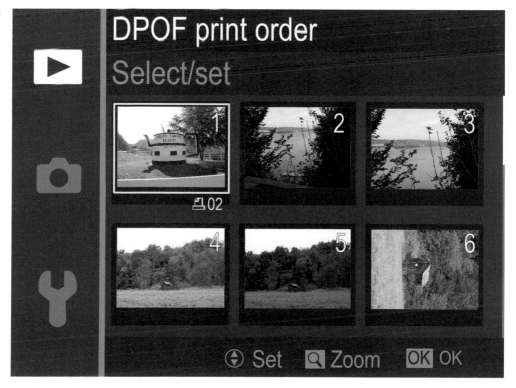

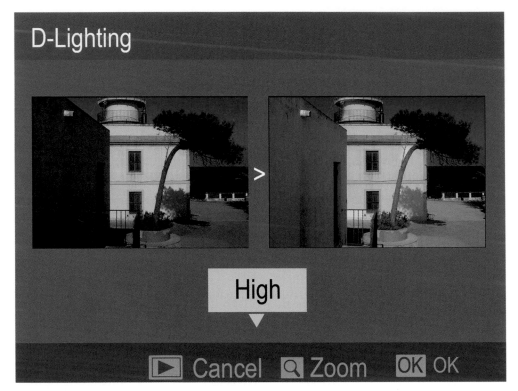

Figure 8.10
Choose the
degree of
D-Lighting to
apply.

3. **Select images.** The same image selection screen used previously in this chapter appears. Scroll among the images with the left/right directional buttons or dial and mark still images for reduction using the up button. The down button unmarks any previously specified image.

4. **Confirm.** Press OK when finished marking images. A screen with a message Create Resized Copy/Copies? appears. Choose Yes to confirm, or No to cancel.

It can be applied while viewing a single image in full-frame mode (just press the OK button while viewing a photo), or accessed from the Retouch menu (especially useful if you'd like to select and resize multiple images).

Crop

This option creates copies of still images in specific sizes based on the final size you select, chosen from among 3:2, 4:3, 1:1, and 16:9 aspect ratios (proportions). This is another way to create smaller and trimmed versions of a picture for e-mailing without the need to first transfer the image to your own computer. If you're traveling, create your smaller copy here or with the Resize feature described previously, insert the memory card in a card reader at an Internet café, your library's public computers, or some other computer, and e-mail the reduced-size version.

Just follow these steps:

1. **Select your photo.** Choose Trim from the Playback menu. You'll be shown the standard Nikon J1 image selection screen. Scroll among the photos using the multi selector left/right buttons and press OK when the image you want to trim is highlighted.

2. **Choose your aspect ratio.** Rotate the multi selector dial to change from 3:2, 4:3, 1:1, and 16:9 aspect ratios.

3. **Crop in on your photo.** Press the zoom bar up or down to crop in and out on your picture. The pixel dimensions of the cropped image at the selected proportions will be displayed in the upper-left corner (see Figure 8.11) as you zoom. The current framed size is outlined in yellow.

4. **Move cropped area within the image.** Use the multi selector left/right and up/down buttons to relocate the yellow cropping border within the frame.

5. **Save the cropped image.** Press OK to save a copy of the image using the current crop and size, or press the Playback button to exit without creating a copy. Table 8.1 shows the trim sizes available.

Figure 8.11
The Crop feature allows in-camera cropping.

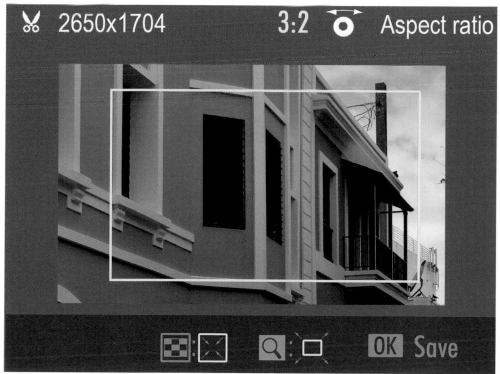

Table 8.1 Trim Sizes

Aspect Ratio	Sizes Available
3:2	3424 × 2280, 2560 × 1704, 1920 × 1280, 1280 × 856, 960 × 640, 640 × 424
4:3	3424 × 2568, 2650 × 1920, 1920 × 1440, 1280 × 960, 960 × 720, 640 × 480
1:1	2560 × 2560, 1920 × 1920, 1440 × 1440, 960 × 960, 720 × 720, 480 × 480
16:9	3424 × 1920, 2560 × 1440, 1920 × 1080, 1280 × 720, 960 × 536, 640 × 360

Edit Movie

You can edit movies as you view them, pausing (using the down directional button) and clipping off portions from the beginning and/or end of the movie to create an edited version. Movie editing can be done from this menu entry. Once you've located and selected a movie clip at least two seconds long in Playback mode, in-camera editing/ trimming has the following steps (a more complete description is in Chapter 7):

1. **View the clip.** Press the OK button to begin playback, using the down button to pause and OK to resume. When you reach the first frame you want to keep, press the down button to pause.

2. **Trim from beginning.** Press the up directional button to delete all the frames that appear before the frame where you paused. Choose Yes from the screen that appears next to save your trimmed movie. A dialog, "Edit Movie?" appears. Choose Yes to confirm, or No to cancel. The J1 will store a copy of the movie on your memory card.

3. **Trim from the end.** To trim video from the end of a clip, watch the movie until you reach the last frame you want to keep and then press the down button to pause. Then press the up button to trim. Choose Yes when the Edit Movie? dialog appears.

Shooting Menu

The Shooting menu differs slightly, depending on whether the mode dial is set for Still Image mode or Movie mode. There are 27 entries in the Still Image mode version, and 15 in the Movie mode version. The three flash entries are available only when you have the optional electronic flash mounted on the J1. The first seven entries in the Shooting menu when in Still Image mode are shown in Figure 8.12.

- Reset Shooting Options
- Exposure Mode
- Image Quality
- Image Size
- Continuous
- Frame Rate (High Speed Movie mode only)
- Movie Settings (Movie mode only)
- Metering
- White Balance
- ISO Sensitivity
- Picture Control
- Custom Picture Control
- Color Space

- Active D-Lighting
- Long Exposure NR
- High ISO Noise Reduction
- Fade in/Fade Out
- Movie Sound Options
- Interval Timer Shooting
- Vibration Reduction
- Focus Mode
- AF-area Mode
- Face-Priority AF
- Built-in AF assist
- Flash Compensation (When flash is raised)

Figure 8.12
The first page of the Shooting menu.

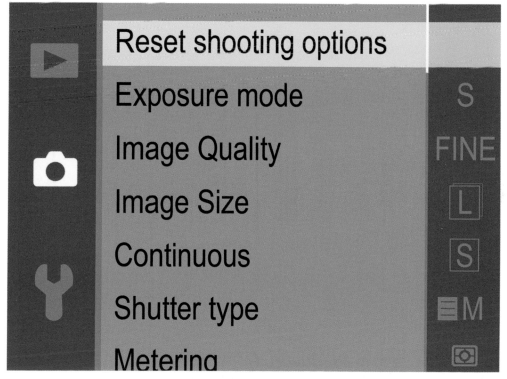

Reset Shooting Options

This entry returns the Shooting menu options to their default values, shown in Table 8.2.

Exposure Mode

Use this menu item to specify how the camera chooses shutter speed and aperture, as described in Chapters 2 and 5. Your choices are Scene Auto Selector, Programmed auto (P), Shutter-priority auto (S), Aperture-priority auto (A), and Manual. (See Figure 8.13.)

Table 8.2 Shooting Menu Defaults

Option	Default	Option	Default
Exposure mode	Scene auto selector	Vibration reduction	Active/On
Image quality	JPEG Normal	AF-area mode	Auto-area
Image size	3872x2592	Face-priority AF	On
Continuous	Single frame	Built-in AF assist	On
Electronic (Hi)	10fps	Flash mode	Fill flash
Frame rate	400fps	Flash control	TTL
Movie settings	1080/60i	Manual	Full
Metering	Matrix	Flash compensation	0.0
White balance	Auto		
ISO sensitivity	Auto (100-3200)	**Other Shooting Options**	
Picture Control	Standard	Focus Area	Center
Color space	sRGB	Flexible program	Off
Active D-Lighting	On	Autoexposure lock	Off
Long exposure NR	On	Focus lock	Off
Fade in/Fade Out	None	Self-timer	Off
Movie Sound options		Focus Mode	Varies with shooting mode
Microphone	Auto sensitivity (A)	Exposure Compensation	0.0
Wind noise reduction	On		
Interval timer shooting	00:01'00",001	Movie Mode	HD movie
		Theme	Beauty
		Picture Control	Not changed by reset

Figure 8.13
Select from
Scene Auto
Selector,
Shutter-priority
auto, Aperture-
priority auto,
and Manual
exposure
modes.

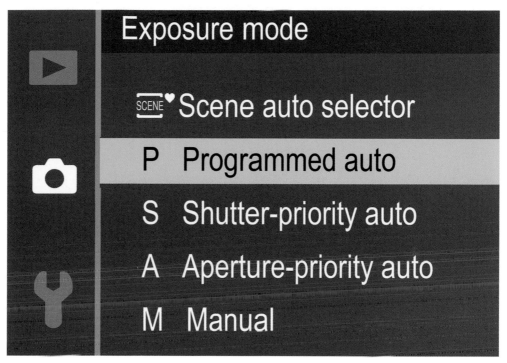

Image Quality

You can choose the image quality settings used by the J1 to store its still image files from this menu entry. You have five choices, NEF (RAW)+JPEG Fine, NEF (RAW), JPEG Fine, JPEG Normal, and JPEG Basic. The RAW/JPEG choices specify the file format used to store your image on your memory card. The JPEG options tell the J1 how much to compress the images. Here's the difference:

- **JPEG, RAW, or both.** You can elect to store only JPEG versions of the images you shoot, or you can save your photos as RAW files, which consume more than twice as much space on your memory card. Or, you can store both at once as you shoot. Many photographers elect to save *both* JPEG and a RAW, so they'll have a JPEG version that might be usable as-is, as well as the original "digital negative" RAW file in case they want to do some processing of the image later. You'll end up with two different versions of the same file: one with a .jpg extension, and one with the .nef extension that signifies a Nikon RAW file.

- **JPEG compression.** To reduce the size of your image files and allow more photos to be stored on a given memory card, the J1 uses JPEG compression to squeeze the non-RAW images down to a smaller size. This compacting reduces the image quality a little, so you're offered your choice of Fine (a 1:4 reduction), Normal (1:8 reduction), and Basic (1:16) compression. You can see an exaggerated version of the effects of JPEG compression in Figure 8.14.

Figure 8.14
At low levels of JPEG compression the image looks sharp even when you enlarge it enough to see the actual pixels (top); when using extreme JPEG compression (bottom), an image obviously loses quality.

To choose the combination you want, access the Shooting menu, scroll to Image Quality, and select it. A screen with the five choices available will appear. Scroll to highlight the setting you want, and either press OK or push the multi selector right button to confirm your selection.

In practice, you'll probably use the JPEG Fine, RAW+JPEG Fine selections most often. Why so many choices, then? There are some limited advantages to using the JPEG Normal and JPEG Basic settings, either at full resolution (Large) or when using the Medium and Small resolution settings. Settings that are less than max allow stretching the capacity of your memory card so you can shoehorn quite a few more pictures onto a single memory card. That can come in useful when on vacation and you're running out of storage, or when you're shooting non-critical work that doesn't require 16 mega-pixels of resolution (such as photos taken for real estate listings, web page display, photo ID cards, or similar applications). Some photographers like to record RAW+JPEG Normal so they'll have a moderate-quality JPEG file for review only and no intention of using for editing purposes, while retaining access to the original RAW file for serious editing.

For most work, using lower resolution and extra compression is false economy. You never know when you might actually need that extra bit of picture detail. Your best bet

is to have enough memory cards to handle all the shooting you want to do until you have the chance to transfer your photos to your computer or a personal storage device.

However, reduced image quality can sometimes be beneficial if you're shooting sequences of photos rapidly, as the J1 is able to hold more of them in its internal memory buffer before transferring to the memory card. Still, for most sports and other applications, you'd probably rather have better, sharper pictures than longer periods of continuous shooting. Do you really need 20 or 30 shots of a pass reception in a football game, or a dozen or two slightly different versions of your local basketball star driving in for a lay-up?

JPEG vs. RAW

You'll sometimes be told that RAW files are the "unprocessed" image information your camera produces, before it's been modified. That's nonsense. RAW files are no more unprocessed than your camera film is after it's been through the chemicals to produce a negative or transparency. A lot can happen in the developer that can affect the quality of a film image—positively and negatively—and, similarly, your digital image undergoes a significant amount of processing before it is saved as a RAW file. Nikon even applies a name (EXPEED 3) to the digital image processing (DIP) chip used to perform this magic.

A RAW file is more similar to a film camera's processed negative. It contains all the information, captured in 12-bit channels per color (and stored in a 16-bit space), with no sharpening and no application of any special filters or other settings you might have specified when you took the picture. Those settings are *stored* with the RAW file so they can be applied when the image is converted to a form compatible with your favorite image editor. However, using RAW conversion software such as Adobe Camera Raw or Nikon Capture NX, you can override those settings and apply settings of your own. You can select essentially the same changes there that you might have specified in your camera's picture-taking options.

RAW exists because sometimes we want to have access to all the information captured by the camera, before the camera's internal logic has processed it and converted the image to a standard file format. Even Compressed RAW doesn't save as much space as JPEG. What it does do is preserve all the information captured by your camera after it's been converted from analog to digital form.

So, why don't we always use RAW? Some photographers avoid using Nikon's RAW NEF files on the misguided conviction that they don't want to spend time in post-processing, forgetting that, if the camera settings you would have used for JPEG are correct, each RAW image's default attributes will use those settings and the RAW image will not need much manipulation. Post-processing in such cases is *optional*, and overwhelmingly helpful when an image needs to be fine-tuned.

Although some photographers do save *only* in RAW format, it's more common (and frequently more convenient) to use RAW plus one of the JPEG options, or, if you're confident about your settings, just shoot JPEG and eschew RAW altogether. In some situations, working with a RAW file can slow you down a little. RAW images take longer to store on the memory card, and must be converted from RAW to a format your image editor can handle, whether you elect to go with the default settings in force when the picture was taken, or make minor adjustments to the settings you specified in the camera.

As a result, those who depend on speedy access to images or who shoot large numbers of photos at once may prefer JPEG over RAW. Wedding photographers, for example, might expose several thousand photos during a bridal affair and offer hundreds to clients as electronic proofs for inclusion in an album. Wedding shooters take the time to make sure that their in-camera settings are correct, minimizing the need to post-process photos after the event. Given that their JPEGs are so good, there is little need to get bogged down shooting RAW. Sports photographers also avoid RAW files.

JPEG was invented as a more compact file format that can store most of the information in a digital image, but in a much smaller size. In my case, I shoot virtually everything at RAW+JPEG Fine. Most of the time, I'm not concerned about filling up my memory cards, as I usually have a minimum of five 32GB memory cards with me. If I know I may fill up all those cards, I have a tiny battery-operated personal storage device that can copy 8GB worth of images (a typical day's shooting) in about 15 minutes. Although it's a bit slower, I often copy shots to my Apple iPad because, thanks to its 3G connectivity, I can e-mail them immediately or post them on Facebook or Flickr, no matter where I happen to be.

I also use a netbook with an external 320GB hard drive, and, most recently, a tiny MacBook Air with an 11.6 inch screen (it's not much bigger than my iPad). As I mentioned earlier, when shooting sports I'll shift to JPEG FINE (with no RAW file) to squeeze a little extra speed out of my camera's continuous shooting mode, and to reduce the need to wade through eight-photo bursts taken in RAW format.

Image Size

The next menu command in the Shooting menu lets you select the resolution, or number of pixels captured as you shoot with your Nikon J1. Your choices range from Large (L—3872 × 2592 pixels, 10 megapixels), Medium (M—2896 × 1944 pixels, 5.6 megapixels), and Small (S—1936 × 1296 pixels, 2.5 megapixels). Your best choice is to shoot at full resolution (Large), with the other options useful if you need a lower resolution version for e-mailing or uploading to a website, such as Facebook, and would prefer not to resize the image in an image editor.

Continuous

This menu entry is available in Still Image mode. Your choices include:

- **Single frame.** In Single frame mode, the J1 takes one picture each time you press the shutter release button down all the way. You can take as many photographs in this mode as you have room for on your memory card.

- **Continuous.** This shooting mode can be set to produce bursts of up to 5 frames per second while the shutter release button is held down. You can take up to 100 pictures in a row in this mode if your memory card has sufficient storage space. (See Figure 8.15.)

- **Electronic (Hi) shutter.** The high-speed electronic shutter also provides speeds up to 1/16,000th second, and defaults to 10fps when shooting continuously. You can also choose 30fps or 60fps. Electronic (Hi) shutter is used for slow-motion movies at reduced resolutions, at 400fps (640 × 240 pixels) or 1200fps (320 × 120 pixels). You'll find more about continuous shooting in Chapter 6.

Figure 8.15
Single frame and continuous shutter modes are available.

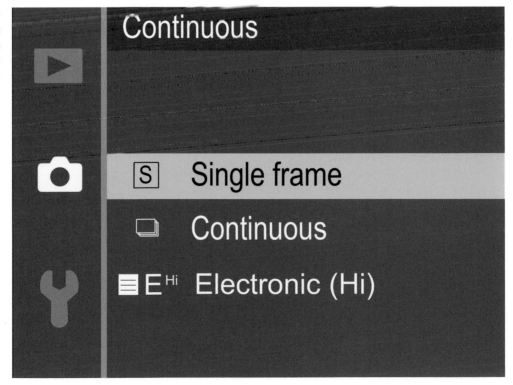

Metering

As you scroll down, Metering is at the top of the Shooting menu list (see Figure 8.16). Use this setting to choose Matrix, Center-weighted, or Spot metering, as described in Chapters 2 and 5. To recap:

- **Matrix metering.** The standard metering mode; the J1 attempts to intelligently classify your image and choose the best exposure based on readings from a broad span of the sensor area, matched against a database of thousands of patterns.

- **Center-weighted metering.** The J1 meters the entire scene, but gives the most emphasis to the central area of the frame, measuring about 4.5mm.

- **Spot metering.** Exposure is calculated from a smaller 3mm spot, about 2 percent of the image area, using the center focus area, except when working with Face-priority AF mode, which meters from a focus area spot closest to the center of the selected face.

Frame Rate

This option is available in the Shooting menu when you select Slow Motion as the Movie mode by pressing the F button when the mode dial is set to Movie. You can then choose 400fps or 1200fps as the slow-motion movie rate.

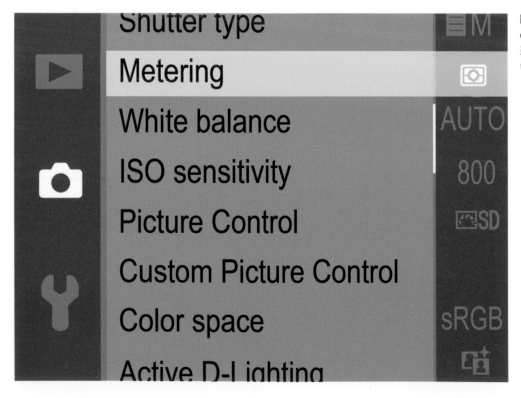

Figure 8.16
Choose metering mode from the menu.

As explained in Chapter 7, slow-motion movies are silent clips recorded at the reduced aspect ratio of 8:3 at 400 or 1200 frames per second. Played back at 30fps, one second of 400fps slow-motion footage requires more than 13 seconds to play out on the screen, and one second of 1200fps footage takes 40 seconds. At 400fps, the frame size is just 640 × 240 pixels, and at 1200fps a minuscule 320 × 120 pixels. In either case, the maximum shooting length is five seconds, which plays back in 1 minute, 6 seconds from a clip shot at 400fps to 3 minutes, 20 seconds for a clip recorded at 1200fps.

Movie Settings

This entry appears when the mode dial is set to Movie mode, and you've selected HD Movie rather than Slow Motion from the F button options. As described in Chapter 7, you have three choices here:

- **1080/60i.** This full HD, 16:9 aspect ratio format provides an interlaced video image at 60 fields per second. (See Appendix A for a description of interlaced/non-interlaced.) Use for scenes without a lot of action to get the sharpest image.

- **1080/30p.** This second full HD format saves storage space and is best for video that has action or motion sequences. You'll find more in Chapter 7 about how and why to choose between these two full HD formats.

- **720p/60 (1280 × 720 pixels).** This 16:9 format is called "standard HD" and for some types of scenes with fast movement can produce a sharper, smoother picture while taking even less storage space.

White Balance

This menu entry allows you to choose one of the white balance values from among Auto, Incandescent, Fluorescent illumination, Direct Sunlight, Flash, Cloudy, Shade, or a preset value taken at a measurement you make. Your white balance settings can have a significant impact on the color rendition of your images, as you can see in Figure 8.17.

When you select the White Balance entry on the Shooting menu, you'll see an array of choices, ranging from Auto to Shade, plus Preset. For all settings other than Preset, you can highlight the white balance option you want, then press the multi selector right button (or press OK) to view the fine-tuning screen shown in Figure 8.18 (and which uses the incandescent setting as an example). The screen shows a grid with two axes, a blue/amber axis extending left/right, and a green/magenta axis extending up and down the grid. By default, the grid's cursor is positioned in the middle, and a readout to the right of the grid shows the cursor's coordinates on the A-B axis (yes, I know the display has the end points reversed) and G-M axis at 0,0.

You can use the multi selector's up/down and right/left buttons to move the cursor to any coordinate in the grid, thereby biasing the white balance in the direction(s) you choose. The amber-blue axis makes the image warmer or colder (but not actually yellow

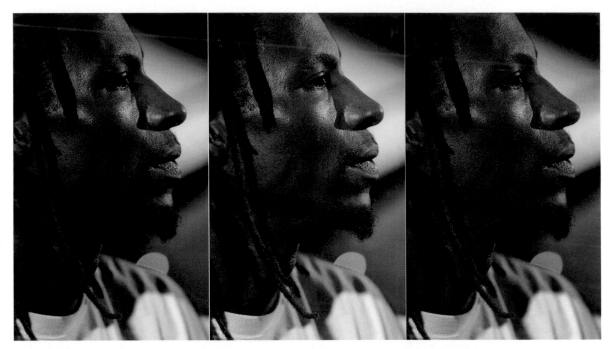

Figure 8.17 Adjusting color temperature can provide different results of the same subject at settings of 3,400K (left), 5,000K (middle), and 2,800K (right).

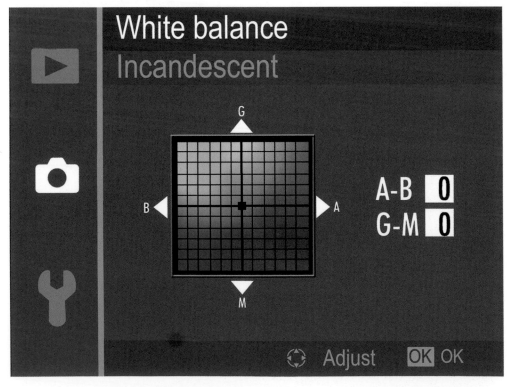

Figure 8.18
Specific white balance settings can be fine-tuned by changing their bias in the amber/blue, magenta/green directions—or along both axes simultaneously.

or blue). Similarly, the green-magenta axis preserves all the colors in the original image, but gives them a tinge biased toward green or magenta. When you've fine-tuned white balance, an asterisk appears next to the White balance setting in the Shooting menu and the detailed picture display in playback to remind you that this tweaking has taken place.

Using Preset Manual White Balance

If automatic white balance or one of the predefined settings available aren't suitable, you can set a custom white balance using the Preset Manual menu option. You can apply the white balance from a scene by shooting a new picture on the spot and using the resulting white balance. To perform direct measurement from your current scene using a reference object (preferably a neutral gray or white object), follow these steps:

1. **Position reference subject.** Place the neutral reference under the lighting you want to measure.

2. **Change to Preset white balance.** In the Shooting menu, select Preset Manual. A screen appears with the message *Measure a new value for preset manual white balance?* Highlight Yes and press the OK button.

3. **Capture white balance reference.** A message will appear asking you to photograph a white or gray object. After a few seconds, this message disappears, and the monitor will show the standard live view with a flashing PRE in the lower right corner of the screen. Take the photograph.

4. **Confirm successful capture of white balance.** If the camera successfully measured white balance, a message *White balance captured successfully* will appear. Otherwise, you'll see *Unable to measure present white balance. Please try again.*

5. **Use captured white balance.** You can immediately begin taking pictures using the captured white balance, until you hold down the WB button again and switch to one of the other white balance settings, such as Tungsten, or Fluorescent. The next time you switch to Pre, the white balance you just captured will be used again, unless you press the right directional button to activate a new capture.

ISO Sensitivity

This menu entry allows you to specify an exact ISO setting to use, or a *range* of ISO settings that the J1 will select from automatically, depending on the lighting conditions. Your choices are as follows:

■ **A3200 Auto (100-3200).** The J1 will choose an ISO setting from ISO 100 to ISO 3200. Under bright lighting conditions, you'll end up with a relatively low ISO setting and get your best results. However, the camera has the flexibility to go all the way up to ISO 3200 if the illumination is very dim. The drawback of this setting is that the J1 is free to choose a very high setting that will result in a lot of

noise. Use this option when your expected lighting conditions will vary widely, and you're willing to accept some visual noise if it means you'll get a picture you might miss otherwise.

- **A800 Auto (100-800).** With this setting, the J1 is limited to ISO 100 to 800. Use this option when you'll be shooting both indoors and outdoors, or in a mixture of bright and dim light conditions, and you're willing to risk a little visual noise.

- **A400 Auto (100-400).** This is the best setting to use when you want to avoid noise, as the camera will limit itself to the range from ISO 100 to 400. You may miss some pictures, or need to make some adjustments on your own (such as mounting the camera on a tripod in low light levels so slower shutter speeds can be used).

- **Specific values.** If you're shooting in relatively constant light levels, you can select an appropriate ISO setting and not be concerned that the J1 will select a drastically different ISO setting without warning. You can select individual settings including ISO 100, 200, 400, 800, 1600, and 3200, plus Hi 1, which is the equivalent of ISO 6400. You can expect to see significant noise in your images at ISO 3200, and at Hi 1, the visual grain may be objectionable. Use higher settings at your own risk.

The auto settings are potentially useful, although experienced photographers tend to shy away from any feature that allows the camera to change basic settings like ISO that have been carefully selected. Fortunately, you can set the range of ISO settings to use so the J1 will use this adjustment in a fairly intelligent way.

Picture Control

Nikon's Picture Control styles allow you to choose your own sharpness, contrast, color saturation, and hue settings and apply them to your images as they are taken. There are six predefined styles offered: Standard, Neutral, Vivid, Monochrome, Portrait, and Landscape. However, you can *edit* the settings of any of those styles so they better suit your taste. But that's only the beginning; the J1 also offers *nine* (count 'em) user-definable Picture Control styles, which you can edit to your heart's content and deploy at the press of a few buttons. Even better, you can *copy* these styles to a memory card, save them, edit them on your computer, and reload them into your camera at any time. So, effectively, you can have a lot more than nine custom Picture Control styles available: the nine in your camera, as well as a virtually unlimited library of user-defined styles that you have stored on memory cards. In Scene Auto Selector mode, the J1 will select a Picture Control for you.

Moreover, Nikon insists that these styles have been standardized to the extent that if you re-use a style created for one camera (say, your J1) and load it into a different compatible camera, you'll get substantially the same rendition. In a way, Picture Control styles are a bit like using a particular film. Do you want the look of Kodak Ektachrome or Fujifilm Velvia? Load the appropriate style created by you—or anyone else.

Using and managing Picture Control styles is accomplished using two different menu entries. This one, Picture Control, which allows you to choose an existing style and to edit the predefined styles that Nikon provides, and Custom Picture Control, discussed in the next section, which gives you the capability of creating and editing user-defined styles.

Choosing a Picture Control Style

To choose from one of the predefined styles (Standard, Neutral, Vivid, Portrait, Landscape, or Monochrome) or select a user-defined style (numbered C-1 to C-9, available only if you've created a custom style), follow these steps:

1. **Choose Picture Control.** This option is located in the Shooting menu. The screen shown in Figure 8.19 appears. Note that Picture Controls that have been modified from their standard settings have an asterisk next to their name.

2. **Select style.** Scroll down to the Picture Control you'd like to use.

3. **Activate Picture Control.** Press OK to activate the highlighted style. (Although you can usually select a menu item by pressing the multi selector right button; in this case, that button activates editing instead.)

4. **Exit menu.** Press the MENU button or tap the shutter release to exit the menu system.

Figure 8.19
You can choose from the pre-defined Picture Controls, or select a user-defined style.

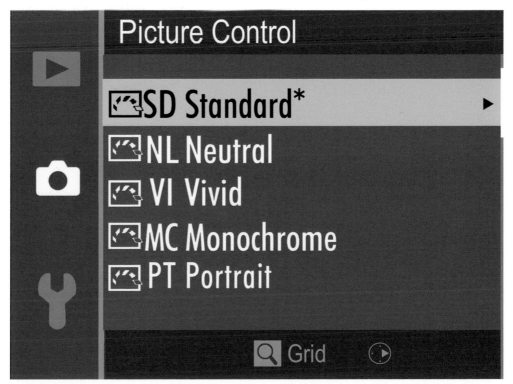

Editing a Picture Control Style

You can change the parameters of any of Nikon's predefined Picture Controls, or any of the nine user-defined styles you create. You are given the choice of using the quick adjust/fine-tune facility to modify a Picture Control with a few sliders, or to view the relationship of your Picture Controls on a grid. To make quick adjustments to any Picture Control except the Monochrome style, follow these steps:

1. **Access menu.** Choose Picture Control from the Shooting menu.

2. **Select style.** Scroll down to the Picture Control you'd like to edit.

3. **Access adjustment screen.** Press the multi selector right button to produce the adjustment screen shown in Figure 8.20.

4. **Make fast changes.** Use the Quick Adjust slider to exaggerate the attributes of any of the Picture Controls except Neutral and Monochrome.

5. **Change other attributes.** Scroll down to the Sharpening, Contrast, Brightness, Saturation, and Hue sliders with the multi selector up/down buttons, then use the left/right buttons to decrease or increase the effects. A line will appear under the original setting in the slider whenever you've made a change from the defaults. **Note:** You can't adjust contrast and brightness when Active D-Lighting (discussed later in this chapter) is active. Turn it off to make those Picture Control adjustments.

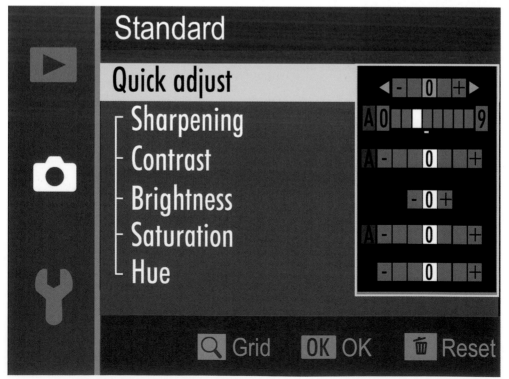

Figure 8.20
Sliders can be used to make quick adjustments to your Picture Control styles.

6. **Or use auto adjustments.** Instead of making changes with the slider's scale, you can move the cursor to the far left and choose A (for auto) instead when working with the Sharpening, Contrast, and Saturation sliders. The J1 will adjust these parameters automatically, depending on the type of scene it detects.

7. **To Reset Values.** Press the Delete button to reset the values to their defaults and confirm by choosing Yes in the screen that appears.

8. **View adjustment grid.** Press the zoom bar up to view an adjustment grid (discussed next).

9. **Confirm changes.** Press OK when you're finished making adjustments.

The changes Picture Controls make to your images are more subtle than you realize, because the values that are applied among the various Picture Controls aren't absolute. Adjustments you make to, say, the Standard or Vivid styles are relative to the base values of those styles themselves. For example, the Standard style is inherently less saturated than the Vivid style, so if you move the Saturation slider to two notches to the right you'll end up with a modified Standard style that is *still* less saturated than the Vivid style's default. You'll want to learn exactly what happens to your images when you adjust each individual Picture Control, and, moreover, use the right Picture Control as your base or "parent" style when creating Picture Controls of your own. If you wanted a very, very saturated Picture Control, you'd start with the Vivid style, then adjust that and save it as Super Vivid (or something along those lines). Figure 8.21 shows pairs of images that compare four of the most frequently adjusted attributes.

Editing the Monochrome style is similar to modifying the other styles, except that the parameters differ slightly. Sharpening, Contrast, and Brightness are available, but, instead of Saturation and Hue, you can choose a filter effect (Yellow, Orange, Red, Green, or none) and a toning effect (Black-and-white, plus seven levels of Sepia, Cyanotype, Red, Yellow, Green, Blue Green, Blue, Purple Blue, and Red Purple). (Keep in mind that once you've taken a JPEG photo using a Monochrome style, you can't convert the image back to full color.)

FILTERS VS. TONING

Although some of the color choices seem to overlap, you'll get very different looks when choosing between Filter Effects and Toning. Filter Effects add no color to the monochrome image. Instead, they reproduce the look of black-and-white film that has been shot through a color filter. That is, Yellow will make the sky darker and the clouds will stand out more, while Orange makes the sky even darker and sunsets more full of detail. The Red filter produces the darkest sky of all and darkens green objects, such as leaves. Human skin may appear lighter than normal. The Green filter has the opposite effect on

leaves, making them appear lighter in tone. Figure 8.22 shows the same scene shot with no filter, then Yellow, Green, and Red filters.

The Sepia, Blue, Green, and other toning effects, on the other hand, all add a color cast to your monochrome image. Use these when you want an old-time look or a special effect, without bothering to recolor your shots in an image editor. Several toning effects are shown in Figure 8.23.

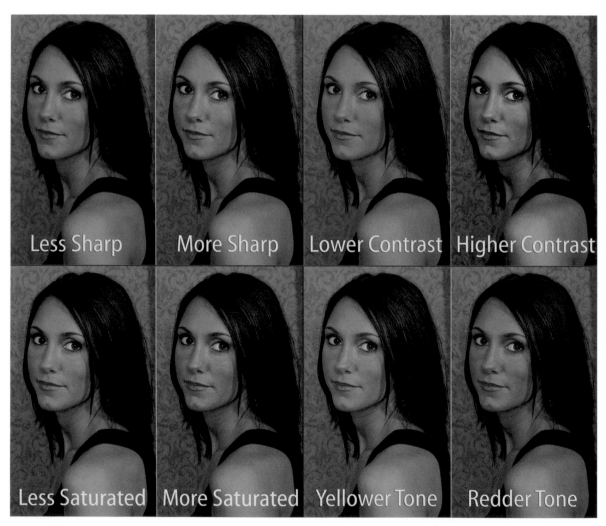

Figure 8.21 Picture Controls allow you to adjust attributes like sharpness (upper-left pair); contrast (upper-right pair); saturation (lower-left pair); and hue (lower-right pair).

Figure 8.22 No filter (upper left); yellow filter (upper right); green filter (lower left); and red filter (lower right).

Figure 8.23 Toning effects: Sepia (upper left); Purple Blue (upper right); Red Purple (lower left); and Green (lower right).

When you press the zoom bar up, a grid display, like the one shown in Figure 8.24, appears, showing the relative contrast and saturation of each of the predefined Picture Controls. If you've created your own custom Picture Controls, they will appear on this grid, too, represented by the numbers 1-9. Because the values for autocontrast and autosaturation may vary, the icons for any Picture Control that uses the Auto feature will be shown on the grid in green, with lines extending up and down from the icon to tip you off that the position within the coordinates may vary from the one shown.

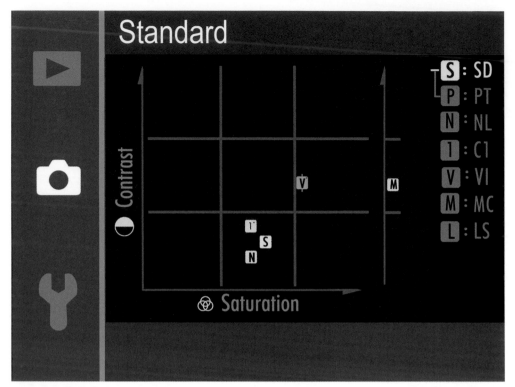

Figure 8.24
This grid shows the relationship of the Picture Controls being used.

Custom Picture Control

The Custom Picture Control menu entry can be used to create new styles, edit existing styles, rename or delete them, and store/retrieve them from the memory card. Here are the basic functions of this menu item, which can be found on the Shooting menu directly below the Picture Control entry:

- **Make a copy.** Choose Edit/Save, select from the list of available Picture Controls, and press OK to store that style in one of the user-defined slots C-1 to C-9.

- **Edit the copy.** In Save Edit, highlight the copy you saved and press the right directional button, and edit the parameters as described in the last section.

- **Save edited copy.** Press OK when finished editing, and then save the modified style in one of the user-defined slots C-1 to C-9.

- **Remove a style.** Select Delete, choose from the list of user-defined Picture Controls (you can't remove one of the default styles), press the multi selector right button, then highlight Yes in the screen that follows, and press OK to remove that Picture Control.

■ **Store/retrieve style on card.** Choose Load From/Save To card, then select Copy to Camera to locate a Picture Control on your Secure Digital card and copy it to the J1; Delete from Card to select a Picture Control on your memory card and remove it; or Copy to Card to duplicate a style currently in your camera onto the Secure Digital card. This last option allows you to create and save Picture Controls in excess of the nine that can be loaded into the camera at one time. Once you've copied a style to your memory card, you can modify the version in the camera, and, in effect, create a whole new Picture Control.

Color Space

The Nikon J1's Color Space option gives you two different color spaces (also called *color gamuts*), named Adobe RGB (because it was developed by Adobe Systems in 1998), and sRGB (supposedly because it is the *standard* RGB color space). These two color gamuts define a specific set of colors that can be applied to the images your J1 captures.

You're probably surprised that the Nikon J1 doesn't automatically capture *all* the colors we see. Unfortunately, that's impossible because of the limitations of the sensor and the filters used to capture the fundamental red, green, and blue colors, as well as that of the phosphors used to display those colors on your camera and computer monitors. Nor is it possible to *print* every color our eyes detect, because the inks or pigments used don't absorb and reflect colors perfectly.

On the other hand, the J1 does capture quite a few more colors than we need. With the J1's 12-bit capture, a RAW image contains a possible 68 *billion* different hues, which are condensed down to a mere 16.8 million possible colors when converted to a 24-bit (eight bits per channel) image. While 16.8 million colors may seem like a lot, it's a small subset of 68 billion captured, and an even smaller subset of all the possible colors we can see.

The set of colors, or gamut, that can be reproduced or captured by a given device (scanner, digital camera, monitor, printer, or some other piece of equipment) is represented as a color space that exists within the larger full range of colors. That full range is represented by the odd-shaped splotch of color shown in Figure 8.25, as defined by scientists at an international organization back in 1931. The colors possible with Adobe RGB are represented by the larger, black triangle in the figure, while the sRGB gamut is represented by the smaller white triangle.

Regardless of which triangle—or color space—is used by the J1, you end up with some combination of 16.8 million different colors that can be used in your photograph. (No one image will contain all 16.8 million! If each and every pixel in a J1's 16-megapixel image were a different color—which is extremely unlikely—you'd need only 16 million different colors.) But, as you can see from the figure, the colors available will be *different*.

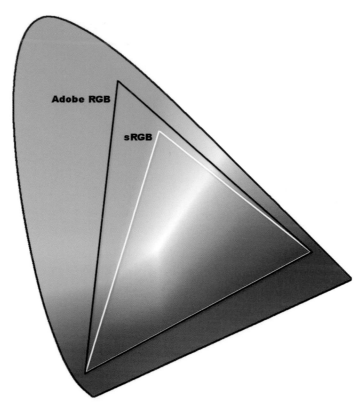

Figure 8.25
The outer figure shows all the colors we can see; the two inner outlines show the boundaries of Adobe RGB (black triangle) and sRGB (white triangle).

Adobe RGB is an expanded color space useful for commercial and professional printing, and it can reproduce a wider range of colors. It can also come in useful if an image is going to be extensively retouched, especially within an advanced image editor, like Adobe Photoshop, which has sophisticated color management capabilities that can be tailored to specific color spaces. As an advanced user, you don't need to automatically "upgrade" your J1 to Adobe RGB, because images tend to look less saturated on your monitor and, it is likely, significantly different from what you will get if you output the photo to your personal inkjet. (You can *profile* your monitor for the Adobe RGB color space to improve your on-screen rendition, as described below.)

While both Adobe RGB and sRGB can reproduce the exact same 16.8 million absolute colors, Adobe RGB spreads those colors over a larger portion of the visible spectrum, as you can see in the figure. Think of a box of crayons (the jumbo 16.8 million crayon variety). Some of the basic crayons from the original sRGB set have been removed and replaced with new hues not contained in the original box. Your "new" box contains colors that can't be reproduced by your computer monitor, but which work just fine with a commercial printing press. For example, Adobe RGB has more "crayons" available in the cyan-green portion of the box, compared to sRGB, which is unlikely to be an advantage unless your image's final destination are the cyan, magenta, yellow, and black inks of a printing press.

The other color space, sRGB, is recommended for images that will be output locally on the user's own printer, as this color space matches that of the typical inkjet printer fairly closely. You might prefer sRGB, which is the default for the Nikon J1 and most other cameras, as it is well suited for the range of colors that can be displayed on a computer screen and viewed over the Internet. If you plan to take your image file to a retailer's kiosk for printing, sRGB is your best choice, because those automated output devices are calibrated for the sRGB color space that consumers use.

BEST OF BOTH WORLDS

If you plan to use RAW+JPEG for most of your photos, go ahead and set sRGB as your color space. You'll end up with JPEGs suitable for output on your own printer, but you can still extract an Adobe RGB version from the RAW file at any time. It's like shooting two different color spaces at once—sRGB and Adobe RGB—and getting the best of both worlds.

Of course, choosing the right color space doesn't solve the problems that result from having each device in the image chain manipulating or producing a slightly different set of colors. To that end, you'll need to investigate the wonderful world of *color management*, which uses hardware and software tools to match or *calibrate* all your devices, as closely as possible so that what you see more closely resembles what you capture, what you see on your computer display, and what ends up on a printed hardcopy. Entire books have been devoted to color management, and most of what you need to know doesn't directly involve your Nikon J1, so I won't detail the nuts and bolts here.

To manage your color, you'll need, at the bare minimum, some sort of calibration system for your computer display, so that your monitor can be adjusted to show a standardized set of colors that is repeatable over time. (What you see on the screen can vary as the monitor ages, or even when the room light changes.) I use Pantone's Huey monitor color correction system for my computer's main 26-inch wide-screen LCD display, as well as for my matching 26-inch wide-screen secondary display that flanks it. The Huey checks room light levels every five minutes, and reminds me to recalibrate every week or two, using the small sensor device, which attaches temporarily to the front of the screen with tiny suction cups, and interprets test patches that the Huey software displays during calibration. The rest of the time, the Huey sensor sits in a stand, measuring the room illumination and adjusting my monitors for higher or lower ambient light levels.

The Huey (www.pantone.com) is an inexpensive (under $100) system that does a good job of calibrating a single monitor. You can upgrade it, as I did, for use with multiple monitors using a $40 software download. If you're serious about accurate color and

making prints, you'll want a more advanced system (up to $500) like the various Spyder products from Datacolor (www.datacolor.com), or Colormunki from X-Rite (www. colormunki.com).

Active D-Lighting

Scroll down the Shooting menu to Active D-Lighting, shown in Figure 8.26. It's a feature that improves the rendition of detail in highlights and shadows when you're photographing high contrast scenes. You'll find the "non-active" D-Lighting feature discussed under the Playback menu earlier in this chapter. Active D-Lighting applies its tonal improvements *while you are actually taking the photo.* That's good news and bad news. It means that, if you're taking photos in a contrasty environment, Active D-Lighting can automatically improve the apparent dynamic range of your image as you shoot, without additional effort on your part. However, you'll need to disable the feature once you leave the high contrast lighting behind, and the process does take some time. There are many situations in which the selective application of D-Lighting using the Playback menu is a better choice. You wouldn't want to use Active D-Lighting for continuous shooting of sports subjects, for example.

You can turn the Active D-Lighting feature on or off in the Shooting menu. Note that when this feature is activated, brightness and contrast Picture Control settings cannot be changed. Figure 8.27 shows an example of Active D-Lighting applied. For best results, use your J1's Matrix metering mode, so the Active D-Lighting feature can work with a full range of exposure information from multiple points in the image. Active D-Lighting works its magic by subtly *underexposing* your image so that details in the highlights (which would normally be overexposed and become featureless white pixels) are not lost. At the same time, it adjusts the values of pixels located in midtone and shadow areas so they don't become too dark because of the underexposure. Highlight tones will be preserved, while shadows will eventually be allowed to go dark more readily. Bright beach or snow scenes, especially those with few shadows (think high noon, when the shadows are smaller) can benefit from using Active D-Lighting.

It's important to *always* keep in mind that Active D-Lighting not only adjusts the contrast automatically of your image (that's why you can't adjust the brightness/contrast of a Picture Control when Active D-Lighting is turned on), it modifies exposure for both existing light and flash as well, as I've noted. Exposure for both is reduced from about 1/3 stop to as much as 1 full stop less.

Tip

In Manual exposure mode, Active D-Lighting does not adjust the exposure of your image; it simply shifts the center (zero) point of the analog exposure indicator in the viewfinder/LCD.

Figure 8.26
The next screen
of the Shooting
menu.

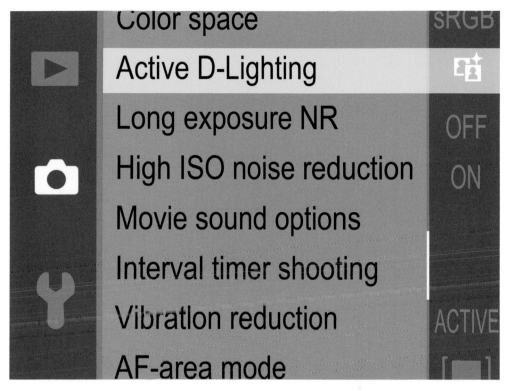

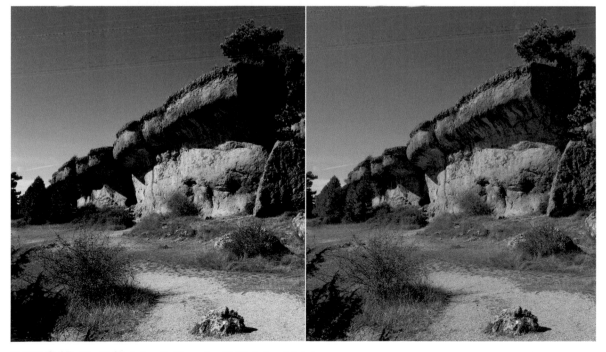

Figure 8.27 No D-Lighting (left); active D-Lighting (right).

Long Exp. NR

Visual noise is that awful graininess caused by long exposures and high ISO settings, and which shows up as multicolored specks in images. This setting helps you manage the kind of noise caused by lengthy exposure times. In some ways, noise is like the excessive grain found in some high-speed photographic films. However, while photographic grain is sometimes used as a special effect, it's rarely desirable in a digital photograph. There are easier ways to add texture to your photos.

Some noise is created when you're using shutter speeds longer than eight seconds to create a longer exposure. Extended exposure times allow more photons to reach the sensor, but increase the likelihood that some photosites will react randomly even though not struck by a particle of light. Moreover, as the sensor remains switched on for the longer exposure, it heats, and this heat can be mistakenly recorded as if it were a barrage of photons. This menu setting can be used to activate the J1's long exposure noise-canceling operation performed by the EXPEED 3 digital signal processor.

- **Off.** This default setting disables long exposure noise reduction. Use it when you want the maximum amount of detail present in your photograph, even though higher noise levels will result. This setting also eliminates the extra time needed to take a picture caused by the noise reduction process. If you plan to use only lower ISO settings (thereby reducing the noise caused by ISO amplification), the noise levels produced by longer exposures may be acceptable. For example, you might be shooting a waterfall at ISO 100 with the camera mounted on a tripod, using a neutral-density filter and a long exposure to cause the water to blur. (Try exposures of 2 to 16 seconds, depending on the intensity of the light and how much blur you want.) To maximize detail in the non-moving portions of your photos for the exposures that are eight seconds or longer, you can switch off long exposure noise reduction.

- **On.** When exposures are one second or longer, the Nikon J1 takes a second, blank exposure to compare that to the first image. (While the second image is taken, the warning Job nr appears on the LCD.) Noise (pixels that are bright in a frame that *should* be completely black) in the "dark frame" image is subtracted from your original picture, and only the noise-corrected image is saved to your memory card. Because the noise-reduction process effectively doubles the time required to take a picture, you won't want to use this setting when you're rushed. Some noise can be removed later on, using tools like the noise reduction features built into Adobe Photoshop or Nikon Capture NX.

High ISO Noise Reduction

Noise can also be caused by higher ISO sensitivity settings, and the Nikon J1 offers settings up to ISO 3200 (and thence up to the equivalent of ISO 6400 with the Hi 1 setting). Even so, High ISO Noise Reduction, which can be set with this menu option, may be a good option in many cases. You can choose Off when you want to preserve detail at the cost of some noise graininess. Or you can select On, which is applied when ISO sensitivity has been set to ISO 800 or higher.

The effects of high ISO noise are something like listening to a CD in your car, and then rolling down all the windows. You're adding sonic noise to the audio signal, and while increasing the CD player's volume may help a bit, you're still contending with an unfavorable signal to noise ratio that probably mutes tones (especially higher treble notes) that you really want to hear.

The same thing happens when the analog image signal is amplified: You're increasing the image information in the signal, but boosting the background fuzziness at the same time. Tune in a very faint or distant AM radio station on your car stereo. Then turn up the volume. After a certain point, turning up the volume further no longer helps you hear better. There's a similar point of diminishing returns for digital sensor ISO increases and signal amplification as well.

As the captured information is amplified to produce higher ISO sensitivities, some random noise in the signal is amplified along with the photon information. Increasing the ISO setting of your camera raises the threshold of sensitivity so that fewer and fewer photons are needed to register as an exposed pixel. Yet, that also increases the chances of one of those phantom photons being counted among the real-life light particles, too.

Fortunately, the Nikon J1's CMOS sensor and its EXPEED 3 digital processing chip are optimized to produce the low noise levels, so ratings as high as ISO 1600 to ISO 3200 can be used routinely (although there will be some noise, of course), and even ISO 3200 can generate good results. Some kinds of subjects may not require this kind of noise cancellation, particularly with images that have a texture of their own that tends to hide or mask the noise.

Fade In/Fade Out

This movie-only setting has three options: W Fade (white) and B Fade (black), as well as OFF. When you choose W or B, each scene will fade to white or black, respectively when you stop capturing. When you resume, the image will start in the faded position (either white or black) and fade into the full scene. Choose Off and no fade in/fade out will take place.

Movie Sound Options

This entry has two adjustments to make: Microphone and Wind Noise Reduction.

- **Microphone.** This setting controls the J1's built-in microphones. Choose to turn the microphone Off if you want to shoot silently (particularly if you are going to add music, voice-over, or other sound later in your movie-editing software). Or, select a sensitivity setting from Automatic, High, Medium, or Low. This is essentially a volume control for your internal microphones.

- **Wind Noise Reduction.** This feature can be switched On or Off, to reduce the effects of air rushing past your microphone.

Interval Timer Shooting

When the J1 is set to Single frame rather than one of the continuous modes, the Nikon J1's built-in time-lapse photography feature allows you to take pictures for up to 999 intervals in bursts of as many as nine shots, with a delay of up to 23 hours and 59 minutes between shots/bursts, and an initial start-up time of as long as 23 hours and 59 minutes from the time you activate the feature. That means that if you want to photograph a rosebud opening and would like to photograph the flower once every two minutes over the next 16 hours, you can do that easily. If you like, you can delay the first photo taken by a couple hours so you don't have to stand there by the J1 waiting for the right moment.

Or, you might want to photograph a particular scene every hour for 24 hours to capture, say, a landscape from sunrise to sunset to the following day's sunrise again. The J1 can do that, too. The Interval Timer Shooting screen is shown in Figure 8.28. The screen shows the current settings, and has an option to Start the shooting. At the very bottom is the setting Interval/Number of Shots. Highlight that and press the right directional button to move to a second screen where you can set the parameters for your time-lapse shooting.

To set up interval timer shooting, just follow these steps.

Before you start:

1. **Set your clock.** The J1 uses its internal World Time clock to activate, so make sure the time has been set accurately in the Setup menu before you begin.

2. **Secure camera.** Mount the camera on a tripod or other secure support.

3. **Fully charge the battery.** Although the camera more or less goes to sleep between intervals, some power is drawn, and long sequences with bursts of shots can drain power even when you're not using the interval timer feature.

4. **Protect your camera.** Make sure the camera is shielded from the elements, accidents, and theft.

Figure 8.28
The Interval
Timer Shooting
main screen.

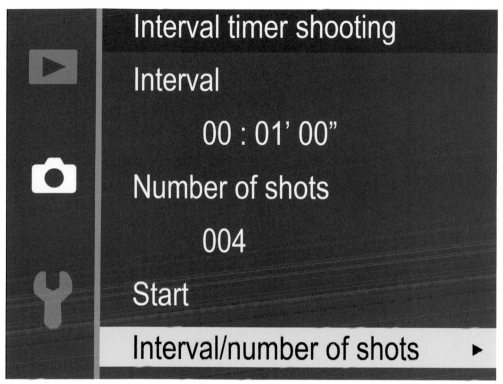

When you're ready to go, set up the J1 for interval shooting:

1. **Select timer.** Choose Interval Timer Shooting from the Shooting menu; advance to the Interval/Number of Shots screen.

2. **Set the interval between exposures.** You can use the left/right buttons to move among hours, minutes, and seconds, and use the up/down buttons to choose an interval from one second to 24 hours. Press the right button when finished to move down to the number of intervals/shots per interval sub-screen.

 Tip

The interval cannot be shorter than the shutter speed; for example, you can not set one second as the interval if the images will be taken at two seconds or longer.

1. **Set number of total shots.** Highlight the number of shots and select up to 999 intervals.

2. **Confirm.** Press OK to confirm your settings.

3. **Start.** When all the parameters have been entered, you'll be returned to the Main Interval Timer Shooting screen. Highlight the Start option and press OK.

PAUSE OR CANCEL INTERVAL SHOOTING

Press the MENU button between intervals (but not when images are still being recorded to the memory card), and the interval shooting will be automatically canceled. A message appears on the LCD to confirm.

Vibration Reduction

Certain lenses have built-in anti-shake qualities called *vibration reduction*, which counter the blurring effects of camera movement by shifting lens elements simultaneously to compensate. VR is a "smart" feature, in that it recognizes when the camera is being panned (moved continuously in one direction, generally to follow the motion of a subject), and adjusts *only* for the motion that is not part of the panning action. For example, if you're panning horizontally to follow a running athlete, VR will reduce the effects of virtual shake, while ignoring the side-to-side motion.

VR lenses may offer two types of vibration reduction, *normal* and *active,* and this menu item allows you to choose between them, or switch VR off entirely. Select Normal for most subjects; use Active, if available with your particular lens, under extra-challenging conditions, such as shooting when walking or riding in a vehicle. Turn VR Off when the camera is mounted on a tripod or other support and is not needed. Disabling vibration saves power and keeps the camera from hunting for vibration to counter.

Focus Mode

Use this menu entry to select from AF-A, AF-S, AF-C, AF-F, and Manual focus, as described in Chapter 6. To recap:

- **AF-S (Single-servo autofocus)**. Available in both Still Image and Movie modes, this mode sets focus once and locks it until the button is fully depressed, taking the picture, or until you release the shutter button without taking a shot. When sharp focus is achieved, the selected focus zone will flash green in the monitor. By keeping the shutter button depressed halfway, you'll find you can reframe the image while retaining the focus (and exposure) that's been set. You can also use the AE-L/AF-L button to lock focus. If the J1 is unable to focus correctly, the shutter release is locked and you can't take a picture.

- **AF-C (Continuous-servo autofocus).** This is the mode to use for sports and other fast-moving subjects. Once the shutter release is partially depressed, the camera sets the focus but continues to monitor the subject, so that if it moves or you move, the lens will be refocused to suit. Focus and exposure aren't really locked until you press the shutter release down all the way to take the picture. This mode is not available in Movie mode; use AF-F (described later), instead.

■ **AF-A (Automatic autofocus).** Available only in Still Image mode, this setting is a combination of AF-S and AF-C. The camera focuses using AF-S and locks in the focus setting, but if the subject begins moving, it will switch automatically to AF-C and change the focus to keep the subject sharp. However, as with AF-S, the shutter can be released only when the subject at the selected focus point is in focus.

■ **AF-F (Full-time autofocus).** Available only in Movie mode, it replaces the AF-C and AF-A options. When using AF-F, the camera focus continuously, and images can be captured even if sharp focus is not quite locked in.

■ **Manual focus.** When you've set the camera to manual focus, you can adjust the zone of sharpness visually using the LCD. How to use manual focus is described in Chapter 6.

AF-Area Mode

The J1 has three different focus area selection modes, which can be selected with this menu entry (Figure 8.29). I explained how to choose an AF-area mode fully in Chapter 6, but here's a quick recap:

■ **Auto-area AF.** The J1 always selects the autofocus zone, depending on your subject. In AF-S, AF-A, and AF-C modes, the active focus zones are highlighted in the display for about one second after focus is achieved. Zones are not used or displayed in Manual focus mode.

■ **Single-point AF.** You always select the focus zone manually from 135 different areas, using the up/down/left right directional buttons to relocate the active zone. The zones are arrayed 15 across horizontally and 9 vertically. Each zone overlaps the adjoining zone by about one-third, so each time you press the directional button, the zone will jump approximately two-thirds the width or height.

■ **Subject tracking.** As with Single-point AF, you can select the focus zone used by the J1 to autofocus. However, once you've locked in the initial zone, the camera will relocate the active zone around the screen to track the movement of your subject. While viewing your subject, the OK button activates focus area selection. Use the directional buttons to move the zone around where you want, then press OK to lock it in. The focus zone will move around the screen to track your subject, and when you press the shutter release halfway it will lock.

Face-Priority AF

This separate Shooting menu entry is used to enable/disable the AF-area mode known as Face-priority, which can be used in conjunction with any of the other three AF-area modes. In Face-priority mode, the Nikon J1 searches for up to five faces and locks in on one of them. Unfortunately, you can't select which face the camera will give priority

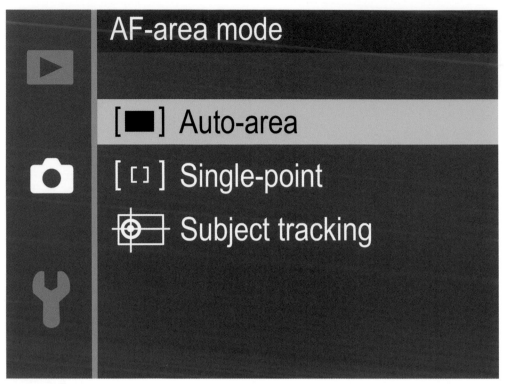

Figure 8.29
Select an auto-
focus-area
mode.

to, except by re-framing the image. You'll find complete instructions for using Face-priority in Chapter 6. This menu entry has two options On and Off.

Built-in AF Assist

Choose On to activate the AF-assist illuminator lamp on the front of the camera, as described in Chapter 2. The lamp will illuminate as required to help the autofocus system operate in Still Image, Smart Photo Selector or Motion Snapshot modes when using AF-S. It also will light up as required when AF-A is activated and operating in AF-S mode, using Auto-area AF mode or when Single-point AF is used and the center focus area is selected.

Flash Compensation

If you find your flash exposures are too bright or too dim, you can adjust flash exposure compensation here, selecting up to one full stop more exposure or three stops less exposure, in one-third stop increments. An indicator appears at the lower-right corner of the LCD in shooting mode when you've dialed in flash compensation. Flash compensation is "sticky" and doesn't reset when the J1 is turned off. You'll need to revisit this menu item and zero out flash compensation (change it to +/-0).

Setup Menu

The Setup menu provides options for changing the way your camera operates. You won't change these very often; except for a few settings, like Format Memory Card, these are generally of the "set it, forget it" type—until you're ready to make a specific change. (See Figure 8.30.)

- Reset Setup Options
- Format Memory Card
- Slot Empty Release Lock
- Welcome Screen
- Display Brightness
- Grid Display
- Sound Settings
- Auto Power Off
- Remote on Duration
- Assign AE/AF-L button

- Shutter Button AE Lock
- Video Mode
- HDMI Device Control
- Flicker Reduction
- Reset File Numbering
- Time Zone and Date
- Language
- Auto Image Rotation
- Firmware Version

Figure 8.30
The first page of the Setup menu.

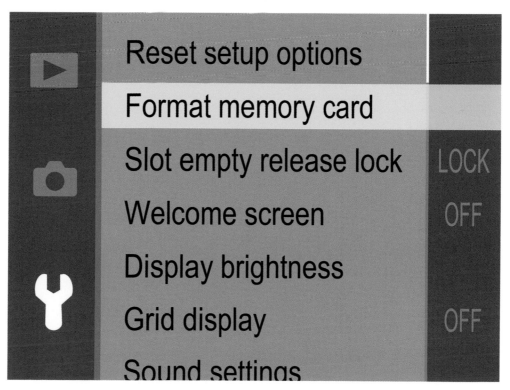

Reset setup options

Format memory card

Slot empty release lock LOCK

Welcome screen OFF

Display brightness

Grid display OFF

Sound settings

Reset Setup Options

This setting returns all the Setup menu options to their factory default value, except for Video mode, Flicker Reduction, Time Zone and Date, and Language (which can only be changed manually). The default values are shown in Table 8.3.

Table 8.3 Setup Menu Defaults			
Option	**Default**	**Option**	**Default**
Slot empty release lock	Locked	Remote on duration	5 minutes
Welcome screen	Off	Assign AE/AF-L button	AE-AF lock
Monitor Brightness	0	Shutter button AE lock	Off
Grid display	Off	HDMI device control	Off
Sound settings		Time zone and date	Not changed by reset
Autofocus/self-timer	On	Daylight saving time	Off
Shutter	On	Auto image rotation	On
Auto power off	30 seconds		

Format Memory Card

I recommend using this menu entry to reformat your memory card after each shoot. While you can move files from the memory card to your computer, leaving behind a blank card, or delete files using the Playback menu's Delete feature, both of those options can leave behind stray files (such as those that have been marked as Protected). Format removes those files completely and beyond retrieval (unless you use a special utility program as described in Chapter 13) and establishes a spanking new fresh file system on the card, including a spanking-new DCIM (Digital Camera Images) folder, which will contain subfolders for each model camera that the card happens to be used in. (That's why you can remove a card from your J1, use it in another model camera, and find that the images from each type of camera reside in folders of their own within the main DCIM folder.) Reformatting resets all the file allocation table (FAT) pointers (which tell the camera and your computer's operating system where all the images reside) efficiently pointing where they are supposed to on a blank card.

Select this menu entry, select Yes from the screen that appears. Press OK to begin the format process.

Slot Empty Release Lock

This entry gives you the ability to snap off "pictures" without a memory card installed—or, alternatively, to lock the camera shutter release if no card is present. It is sometimes informally called Play mode, because you can experiment with your camera's features or even hand your J1 to a friend to let them fool around, without any danger of pictures actually being taken.

Back in our film days, we'd sometimes finish a roll, rewind the film back into its cassette surreptitiously, and then hand the camera to a child to take a few pictures—without actually wasting any film. It's hard to waste digital film, but "shoot without card" mode is still appreciated by some, especially camera vendors who want to be able to demo a camera at a store or trade show, but don't want to have to equip each and every demonstrator model with a memory card. Choose Enable Release to activate "play" mode or Release Locked to disable it. A red warning indicator appears on the LCD in shooting mode. The pictures you actually "take" are displayed on the LCD during playback with the legend "Demo mode" superimposed on the screen, and they are, of course, not saved.

Welcome Screen

You can select On or Off to show/hide the "Nikon 1" welcome screen that appears when the camera is powered up. If you don't need a reminder of what camera you're using, you can turn this off.

Monitor Brightness

This menu option allows you to adjust the relative brightness of the LCD display (which Nikon calls the "monitor"). When you access the menu item, a Monitor Brightness screen appears showing the current settings (+3 to –3) and the option of choosing which of the two you want to adjust. A screen like the one shown in Figure 8.31 appears.

You should be able to see all 10 swatches from black to white. If the two end swatches blend together, the brightness has been set too low. If the two whitest swatches on the right end of the strip blend together, the brightness is too high. Brighter settings use more battery power, but can allow you to view an image on the back-panel LCD outdoors in bright sunlight. Use the multi selector up/down buttons or rotate the dial to make the adjustment. When you have the brightness you want, press OK to lock it in and return to the menu. You can cancel and exit the menu system by tapping the shutter release button.

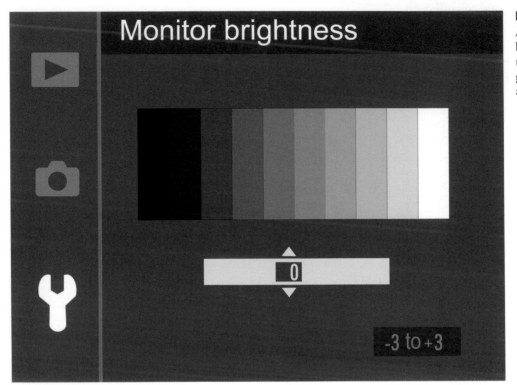

Figure 8.31
Adjust the LCD brightness so that all the grayscale strips are visible.

Grid Display

Your On/Off choices in this menu item enable or disable display of the J1's grid overlay, which can be handy for lining up vertical and horizontal components of your image as you shoot. (See Figure 8.32.) While it's not a "rule of thirds" grid layout, it may still help you in planning your compositions.

Sound Settings

This entry allows separate enabling/disabling of the J1's sound beeper for two operational components. Highlight the sound feature you want to adjust and press the right directional button to mark/unmark the checkbox next to that feature. Press the OK button to confirm and go back to the menu, or tap the shutter release button to cancel:

- **Autofocus/self-timer.** A beep is emitted when the camera finishes focusing, and during the self-timer countdown. If you prefer totally silent operation (say, at a religious ceremony or some other event where you want to be discrete), deactivate this sound.

Figure 8.32
The grid display can help you align elements in your composition.

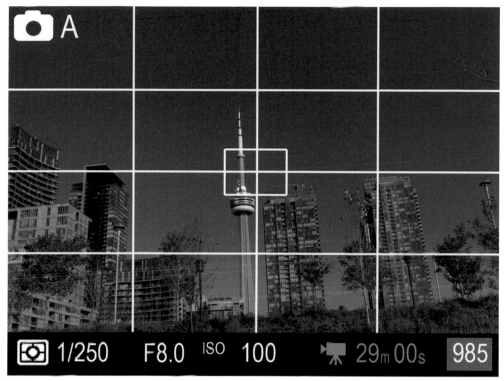

- **Shutter.** The silence of the electronic shutter can be great in some circumstances, but if you're not concerned about noise, it can be helpful to have a clicking sound as confirmation when taking a picture. You can choose either sound mode as you prefer.

Auto Power Off

Your Nikon J1 will eventually power down the LCD and EVF displays to save battery power if you perform no operations for a specified period of time. When the displays have turned off, use any control, including a quick tap on the shutter release, to bring them back to life. You can select delays of 15 or 30 seconds, and 1, 5, or 10 minutes.

Remote on Duration

When you use the ML-L3 infrared remote control, the J1 will remain vigilant and look for a signal for a specific period of time. This uses up battery power. So, you can select active remote durations of 1, 5, 10, or 15 minutes. If the specified time expires and you haven't used the remote control, you'll need to reselect the remote control mode to activate it again.

As explained earlier, to activate the remote control, press the self-timer/remote button on the multi selector (the left button), and choose either 2s Delayed Remote or Quick Response remote.

Assign AE/AF-L Button

This button (the multi selector up directional button) can be programmed by you to provide two different autoexposure/autofocus locking behaviors:

- **AE/AF Lock.** With this default setting, the J1 locks both focus and exposure while the AE-L/AF-L button is pressed. In most shooting situations, when not using Auto-area autofocus (in which the camera, not you, selects what subject to focus on), this is the best compromise. You can select your focus area in the other two modes (Single Point and Subject Tracking), press the shutter release halfway to achieve both exposure and focus, and then press and hold the up button to lock them at those settings. An indicator appears at the bottom of the EVF/LCD.

 While focus and exposure are locked, you can then reframe your picture as desired, without either value changing. If you take a picture *or* remove your finger from the shutter release button, while the AE-L/AF-L button is pressed, the settings remain locked, so you can take several photographs in a row at the same focus and exposure setting.

 You'll find the AE-L/AF-L lock button handy when you're shooting subjects that aren't entirely within one of the focus zones. Frame the image and lock focus/ exposure for your subject, then re-frame for the final composition you want with both locked using the button.

- **AE Lock only.** Lock only the exposure while the AE-L/AF-L button is pressed. This option is helpful when you don't want the exposure to change (say, bright or dark, but unimportant objects are wandering in and out of the frame), but want to allow focus to adjust as required.

- **AF Lock only.** Focus is locked in while the AE-L/AF-L button is held down. In this mode, focus is locked, and you can reframe your image if necessary, but exposure will be adjusted until you take the picture.

Shutter Button AE Lock

When switched On (the default), exposure is locked when the shutter release button is pressed halfway. If you select Off, then you'll need to press the AE/AF lock button instead (with AE/AF Lock or AE Lock only active, as described above) to lock exposure. When shutter button AE Lock is deactivated, pressing the shutter release halfway locks *only* the focus, and *only* when you're using AF-S focus mode. The Off mode is most useful when you'd like to use the shutter release to lock focus (say, to fix focus on a particular subject), while allowing the exposure to change as required.

HDMI Device Control

This option (see Figure 8.33) controls the Nikon J1's High-Definition Multimedia Interface (HDMI) video connection, used to play back your camera's images on HDTV or HD monitors using a type A cable, which Nikon does not provide to you, but which is readily available from third parties. Before you link up you'll want to choose the HDMI resolution to be used, from 480p (640 × 480 progressive scan); 576p (720 × 576 progressive scan); 720p (1280 × 720 progressive scan); or 1080i (1920 × 1080 interlaced scan).

You can also choose to turn Device Control on or off. When On is chosen and the camera is connected to a television that supports the HDMI-CEC protocol, when both are turned on you'll see PLAY and SLIDE SHOW messages on the television. You can then use the television's compatible remote control instead of the multi selector and OK buttons to review images and play slide shows. Choose Off, and this capability is disabled.

Figure 8.33
HDMI device control is listed on the next page of the Setup menu.

Flicker Reduction

This option (see Figure 8.34) reduces flicker and banding, which can occur when shooting stills or movies under fluorescent and mercury vapor illumination, because the cycling of these light sources interacts with the frame rate of the camera's video system. In the United States, you'd choose the 60Hz frequency; in locations where 50Hz current is the norm, select that option instead.

Figure 8.34
Adjust Flicker reduction.

Reset File Numbering

The J1's file system increments the numbers included in the file names of still photographs or movies by one with each successive capture, up to a maximum of 9999 (as with DSC_9999). Moreover, each image is deposited into a folder on your memory card which can hold up to 999 images. Folders are assigned a name like 100NC1J1. When 999 images are in the current folder, a new folder with a number one larger (for example 101NC1VI up to 999NC1VI) will be created.

Everything works swimmingly until the J1 runs out of numbers. When you finally get to a folder numbered 999NC1J1, and that folder contains 999 images, the J1 has no place to "put" the next image, as it can't create a higher numbered folder (it doesn't

"wrap around" to 100NC1J1, in other words). The same thing happens if that 999NC1J1 folder has an image numbered DSC_9999. The shutter release locks up and you can't take any more pictures until you visit this menu entry, and in the Reset File Numbering screen select Yes. Then, you'll need to insert a new memory card or reformat the current card to continue with the new numbering scheme.

Of course, you can always reset the numbering before the system "tops out." The best reason for doing that would be to insure that your camera doesn't lock up at an inopportune moment, by resetting a few hundred (or thousand) images before the forced rollover happens.

Time Zone and Date

Use this menu entry to adjust the J1's internal clock. Your options include:

- **Time Zone.** A small map will pop up on the setting screen and you can choose your local time zone. I sometimes forget to change the time zone when I travel (especially when going to Europe), so my pictures are all time-stamped incorrectly. I like to use the time stamp to recall exactly when a photo was taken, so keeping this setting correct is important.

- **Date and Time.** Use this setting to enter the exact year, month, day, hour, minute, and second, using a 24-hour clock.

- **Date Format.** Choose from Y/M/D (year/month/day), M/D/Y (month/day/year), or D/M/Y (day/month/year) formats.

- **Daylight Saving Time.** Use this to turn daylight saving time On or Off. Because the date on which DST goes into effect each year has been changed from time to time, if you turn this feature on you may need to monitor your camera to make sure DST has been implemented correctly.

Language

Choose from 25 languages for menu display, choosing from Czech, Danish, German, English, Spanish, Greek, French, Indonesian, Italian, Dutch, Norwegian, Polish, Portuguese, Russian, Romanian, Finnish, Swedish, Turkish, Ukrainian, Arabic, Simplified Chinese, Traditional Chinese, Japanese, Korean, or Thai.

Auto Image Rotation

Turning this setting On tells the Nikon J1 to include camera orientation information in the still image file (but not in movies or motion snapshots). The orientation can be read by many software applications, including Adobe Photoshop, Nikon ViewNX, and Capture NX, as well as the Rotate Tall setting in the Playback menu. Turn this feature Off, and none of the software applications or Playback's Rotate Tall will be able to

determine the correct orientation for the image. Nikon notes that only the first image's orientation is used when shooting continuous bursts; subsequent photos will be assigned the same orientation, even if you rotate the camera during the sequence (which is something I have been known to do myself when shooting sports like basketball).

Firmware Version

You can see the current firmware release in use in the menu listing. You can learn how to update firmware in Chapter 13.

9

Working with Lenses

The Nikon 1 cameras were the first interchangeable lens mainstream models introduced by Nikon with an all-new lens mount since 1959. While the latest Nikon digital SLRs can use most of the millions of lenses available for the original F-mount, the Nikon J1 provides full functionality only with lenses designed especially for it. Although Nikon offers an F-mount adapter (which wasn't available for testing when this book was written), and you can bet third-party accessory manufacturers will come up with their own adapters to allow use of Nikon, Canon, Sony, and other lenses, you're better off with optics created specifically for the CX format. Right now, the number of lenses available is not large, but will be growing in the months and years to come.

The right choice of lenses can give you a wider view, bring distant subjects closer, let you focus closer, shoot under lower light conditions, or provide a more detailed, sharper image for critical work. Other than the sensor itself, the lens you choose for your mirrorless camera is the most important component in determining image quality and perspective of your images. This chapter explains how to select the best lenses for the kinds of photography you want to do.

Your Lens Selections

Currently, it's impossible to purchase any Nikon 1 series camera without a lens. (See Figure 9.1.) The Nikon J1 is available in various combinations of the following four lenses, which make up the initial offerings that debuted with the cameras themselves. Being the Nikon fanatic I am, I purchased all four along with my camera, even though there is some overlap in focal lengths and purpose. (I also bought the Nikon V1, and every accessory available for the Nikon 1 line.) The next section is a rundown of the four optics that were available at the time I wrote this book.

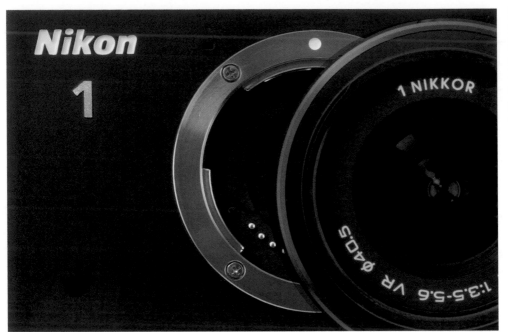

Figure 9.1
Interchangeable lenses are what elevate the Nikon 1 line above basic point-and-shoot cameras.

1 NIKKOR VR 10-30mm f/3.5-5.6

The kit lens is a must-have, partially because it comes with the camera and there is no easy way to *not* own one of these. (I own two, because I bought both the J1 and V1 models.) Fortunately, it's a handy lens to have, with a combination of compact size, built-in vibration reduction, and a useful, if limited, zoom range. (See Figure 9.2.)

- **Aperture.** The maximum aperture of f/3.5 at the widest 10mm focal length is fast enough for indoor shooting, particularly when you factor in this lens's vibration reduction, which should allow most people to hand-hold the camera at 1/30th second or even slower with no problem. However, at the modest telephoto end of its range, it has a maximum aperture of f/5.6, which is quite slow. You'll want to reduce the aperture one stop for best sharpness, giving you an effective f/8 lens to work with. The smallest aperture available is f/16, which is quite adequate for shooting even under bright lighting conditions, because the J1 has those fast shutter speeds (up to 1/16,000th second with the electronic shutter) to call upon.

- **Zoom range.** This is only a 3X zoom, and its 10-30mm range is good for moderate wide-angle scenes up to short telephoto shots. At 30mm, it's ideal for head and shoulders portraits. But if you want to go longer, say, for sports photography, you'll need to pair this lens with the Nikon 1 30-110mm optic, discussed next.

- **Size.** In use, this lens measures just 2.3 × 1.7 inches, and retracts (manually, by pressing a button on the lens and rotating the barrel) to become even smaller. It's a featherweight 4.1 ounces. This is my walk-around lens, used when I'm toting the J1 around with no special plans to take pictures. I want a compact camera without a lot of weight, and this lens fills the bill nicely. (See Figure 9.3.)

- **Focus distance.** It focuses down to about eight inches, even at 30mm, making it a good choice for simple close-up and macro photography. You can capture great images of flowers and larger insects and other critters. Close focusing adds to its versatility. Because this lens uses internal focusing (the lens elements shift inside the lens barrel as it focuses), it doesn't gain in length when focusing extra close. That means the lens is less likely to cast shadows on your subject when zoomed up close and personal.

- **Other features.** While you need to remember to retract the lens barrel manually, the J1 helpfully reminds you to extend it again when the camera is next powered up. It uses the same 40.5mm screw-on filter size compatible with two of the other three Nikon 1 lenses. These filters are readily available and inexpensive, so you won't have to buy multiple filters unless you own the 10-100mm zoom.

Figure 9.2 The 10-30mm kit lens is a must-have, because there is no way to buy a Nikon J1 without it.

Figure 9.3 The 10-30mm lens and Nikon J1 make a compact package.

Here's a breakdown of the features/benefits you have to look forward to.

- **Aperture.** This is the slowest 10mm lens in the Nikon 1 line. At the widest zoom setting, it has a maximum aperture of f/4.5, which makes it a bit slow for available light shooting, even if the built-in VR does make hand-holding the J1 at slower shutter speeds feasible. At the long end, this lens has an f/5.6 maximum aperture at 100mm, which is actually quite reasonable for the amount of image magnification you get. I suspect that producing a 10X zoom with, say, a constant f/4.5 f/stop throughout the zoom range would have made this lens even more expensive, much larger, or, possibly optically impossible. I don't design these things; I just evaluate them. It has an f/16 minimum aperture, which is useful, and expected given the limitations of design for a lens of this type.

- **Zoom range.** The 10X zoom range is great, particularly for shooting movie clips with a continuous zoom shot. This lens covers all the bases, so you don't really need another lens, unless you want something a bit faster for low-light shooting. Because of the overlap, you wouldn't want to buy this lens and the 30-110mm zoom, unless you're a Nikon completist like me. Once you have the 10-100mm zoom, you can use it all the time as a humongous walk-about lens, or alternate between this lens and the 10-30mm kit lens when you want something that takes less of a toll on your neck or shoulders. This range is suitable for everything from moderate wide angle all the way out to super-telephoto shots.

- **Size.** This is a *large* lens, probably larger and heftier than many of the lenses you might own for your digital SLR, if you have one. It measures 3.0 × 3.7 inches (3.5 × 5.5 inches with the lens hood attached) and weighs 18.2 ounces. To put that in perspective, this zoom is heavier than the J1 camera (which tips the scales at 13.5 ounces), and bulkier, too (the camera measures 3.0 × 4.4 × 1.7 inches). (See Figure 9.8.) On the plus side, this road-hugging weight makes the J1 with lens attached fairly stable when the camera is held with the left hand supporting the lens (and left thumb on the zoom button). Be cautious when holding the camera out at arm's length to frame using the LCD monitor. That stance avoids making the lens/camera front-heavy. The built-in VR reduces camera shake.

- **Focus distance.** This one focuses down to 12 inches at the 10mm zoom setting, and 2.8 feet at the 100mm zoom setting. You can use it for some close-up photography, particularly subjects that are best captured from a decent distance away.

- **Other features.** The three-speed power zoom is great for shooting movies, and convenient for changing the focal length when shooting still images, too. This lens automatically retracts when the camera is powered down (you can disable this feature to speed access). Unlike the other three lenses, it uses 72mm filters. I already have a complete set of 77mm filters for my other Nikon lenses, so I purchased a 72mm to 77mm step-up ring and can use any of those filters with this lens.

Figure 9.8
With the
10-100mm
zoom mounted,
the Nikon J1
camera is no
longer petite
and light in
weight.

Using Other Lenses

The Nikon FT-1 adapter, which allows using F-mount Nikon lenses on Nikon 1 cameras was not available when I wrote this book, although it was just being released in Japan. Here's what I do know:

■ **Easy adaptation.** Creating an adapter so the Nikon 1 cameras can use F-mount lenses was relatively easy. The Nikon 1's lens mount was based, in part, on the design of the original F mount used by virtually all Nikon interchangeable lens cameras since 1959. The exceptions are lenses produced for the Nikonos line of underwater cameras, and Nikon's ill-fated Pronea film cameras, developed for Kodak's Advanced Photo System, which lives on today only in the APS-C term applied to the most common digital SLR sensor size. (The C stands for "Classic," a film format measuring 25.1mm × 16.7mm.) Because the body thickness of the Nikon 1 is so shallow, adding the adapter still allows focusing the F-mount lens to infinity.

■ **Wide range of Nikon lenses can be used.** Virtually any lens that can be used with a Nikon digital SLR will work to a certain extent with the Nikon 1 cameras. The adapter includes the corresponding electrical contacts, so autofocus (with AF-S lenses only), autoexposure, and vibration reduction features continue to operate (assuming the F-mount lens has those features). Older AF lenses (those without the AF-S designation in their names) must be manually focused.

■ **Not cheap.** The introductory price of the FT-1 adapter in Japanese yen corresponds to roughly $250-$300 in US dollars at the current exchange rate. That's a lot to pay for an adapter to use with a $650 camera like the J1—unless you already own

several F-mount lenses for your "other" digital camera. Then the adapter becomes a bargain.

■ **Adapted lenses offer new versatility.** If you already own the Nikon 50mm f/1.8 or f/1.4 lenses, the adapter gives you the equivalent of a 135mm f/1.8 or f/1.4 telephoto lens, thanks to the CX sensor's "crop factor." An inexpensive Nikon 55-200mm f/4-5.6G ED IF AF-S DX VR lens becomes the equivalent of a 148-540mm super zoom *with vibration reduction* for less than $200.

■ **Third-party vendors.** Theoretically, lenses from third parties, such as Tamron, Tokina, and Sigma should work well on the Nikon J1 and V1 *if you purchase one with a built-in autofocus motor.* These vendors are adding AF-S style lenses to their line-ups gradually. If you already own one and get the FT-1 adapter, by all means try it out on your Nikon 1 camera. But before buying a lens specifically so you can use it with your J1, I'd urge you to check with the vendor or try the lens out in a camera store before making a purchase.

CROP FACTOR?

I've deliberately omitted a discussion of "crop factors" in this chapter, because any Nikon 1 camera owner who *doesn't* plan to use non-Nikon 1 lenses, through an adapter, or who wants to compare effective focal lengths among cameras with different sensor sizes, has no need to bother with or learn about the crop factor. For those who do have a need to know, I've included a discussion in Appendix A.

What Lenses Can Do for You

Though your choice of lenses for your Nikon J1 is currently limited, each of them still provides lots of flexibility and plenty of opportunities for shooting great photos. This section will reveal some of the things lenses can do for you.

■ **Wider perspective.** When your back is up against a wall and you *can't* take a step backwards to take in more subject matter, you'll be thankful for that 10mm setting on your zoom lens. Figure 9.9 was taken using a 10mm focal length from the banks of the Rio Tormes in Salamanca, Spain, showing the "distant" vista of the old city, which really wasn't as far away as it appears in the figure.

■ **Bring objects closer.** A long lens brings subjects closer to you, offers better control over depth-of-field, and avoids the perspective distortion that wide-angle lenses provide. They compress the apparent distance between objects in your frame. For Figure 9.10, I stepped a few feet to one side, and photographed this same scene with the 10-100mm zoom set to a 50mm focal length, providing a medium-telephoto look. Then, I zoomed in to 100mm for the ultra-telephoto shot shown in Figure 9.11.

Figure 9.9
A wide-angle lens provided this view of Salamanca, Spain.

Figure 9.10
This photo, taken from roughly the same distance shows the view using a short telephoto lens.

Figure 9.11
The 100mm zoom position captured this close-up view of Salamanca's Old Cathedral and New Cathedral (which are combined in a single edifice).

- **Bring your camera closer.** The close focusing capabilities of Nikon 1 lenses (which can focus as close as eight inches) let you grab macro images. At longer focal lengths, you can still maintain a bit of distance from your subject (say, to avoid spooking a skittish creature).

- **Look sharp.** Nikon lenses are prized for their sharpness and overall image quality. While your run-of-the-mill lens available for other cameras is likely to be plenty sharp for most applications, the very best optics are even better over their entire field of view (which means no fuzzy corners), are sharper at a wider range of focal lengths (in the case of zooms), and have better correction for various types of distortion.

- **More speed.** Your 10-100mm f/4.5-5.6 zoom might have the perfect focal length and sharpness for sports photography, but the maximum aperture won't cut it shooting in dark surroundings. You need a faster lens, such as the 10mm f/2.8 pancake optic for wide-angle subjects.

- **Special features.** Some lenses offer special features, such as the power zoom built into the 10-100mm f/3.5-5.6 lens. I expect Nikon will offer other lenses with special features in the future, particularly macro lenses, faster fixed focal-length lenses, and, maybe a fisheye.

Categories of Lens Focal Lengths

Lenses can be easily categorized by their focal lengths. Different focal lengths have different attributes and can do different things. Here's a description of what each zoom range can do for you.

Using Wide-Angle and Wide-Zoom Lenses

To use wide-angle prime lenses like the 10mm f/2.8 and zooms that include a wide field of view in their focal length range, such as the 10-30mm and 10-100mm Nikon 1 optics, you need to understand how wide-angle perspectives affect your photography. Here's what you need to know.

- **More depth-of-field.** Practically speaking, wide-angle lenses offer more depth-of-field at a particular subject distance and aperture. (But see the sidebar below for an important note.) You'll find that helpful when you want to maximize sharpness of a large zone, but not very useful when you'd rather isolate your subject using selective focus (telephoto lenses are better for that).

- **Stepping back.** Wide-angle lenses have the effect of making it seem that you are standing farther from your subject than you really are. They're helpful when you don't want to back up, or can't because there are impediments in your way.

■ **Wider field of view.** While making your subject seem farther away, as implied above, a wide-angle lens also provides a larger field of view, including more of the subject in your photos.

■ **More foreground.** As background objects retreat, more of the foreground is brought into view by a wide-angle lens. That gives you extra emphasis on the area that's closest to the camera. Photograph your home with a normal lens/normal zoom setting, and the front yard probably looks fairly conventional in your photo (that's why they're called "normal" lenses). Switch to a wider lens and you'll discover that your lawn now makes up much more of the photo. So, wide-angle lenses are great when you want to emphasize that lake in the foreground, but problematic when your intended subject is located farther in the distance.

■ **Super-sized subjects.** The tendency of a wide-angle lens to emphasize objects in the foreground, while de-emphasizing objects in the background can lead to a kind of size distortion that may be more objectionable for some types of subjects than others. Shoot a bed of flowers up close with a wide angle, and you might like the distorted effect of the larger blossoms nearer the lens. Take a photo of a family member with the same lens from the same distance, and you're likely to get some complaints about that gigantic nose in the foreground.

■ **Perspective distortion.** When you tilt the camera so the plane of the sensor is no longer perpendicular to the vertical plane of your subject, some parts of the subject are now closer to the sensor than they were before, while other parts are farther away. So, buildings, flagpoles, or NBA players appear to be falling backwards, as you can see in Figure 9.12. While this kind of apparent distortion (it's not caused by a defect in the lens) can happen with any lens, it's most apparent when a wide angle is used.

■ **Steady cam.** You'll find that you can hand-hold a wide-angle lens at slower shutter speeds, without need for vibration reduction, than you can with a telephoto lens. The reduced magnification of the wide-lens or wide-zoom setting doesn't emphasize camera shake like a telephoto lens does. That's why lack of VR in the 10mm f/2.8 lens isn't much of a handicap, and why its availability in the 10-30mm and 10-100mm lenses is a bonus.

■ **Interesting angles.** Many of the factors already listed combine to produce more interesting angles when shooting with wide-angle lenses. Raising or lowering a telephoto lens a few feet probably will have little effect on the appearance of the distant subjects you're shooting. The same change in elevation can produce a dramatic effect for the much-closer subjects typically captured with a wide-angle lens or wide-zoom setting.

Figure 9.12
Tilting the camera back produces this "falling back" look in architectural photos.

DOF IN DEPTH

The DOF advantage of wide-angle lenses is diminished when you enlarge your picture; believe it or not, a wide-angle image enlarged and cropped to provide the same subject size as a telephoto shot would have the *same* depth-of-field. Try it: take a wide-angle photo of a friend from a fair distance, and then zoom in to duplicate the picture in a telephoto image. Then, enlarge the wide shot so your friend is the same size in both. The wide photo will have the same depth-of-field (and will have much less detail, too).

Avoiding Potential Wide-Angle Problems

Wide-angle lenses have a few quirks that you'll want to keep in mind when shooting so you can avoid falling into some common traps. Here's a checklist of tips for avoiding common problems:

- **Symptom: converging lines.** Unless you want to use wildly diverging lines as a creative effect, it's a good idea to keep horizontal and vertical lines in landscapes, architecture, and other subjects carefully aligned with the sides, top, and bottom of the frame. That will help you avoid undesired perspective distortion. Sometimes it helps to shoot from a slightly elevated position so you don't have to tilt the camera up or down.

- **Symptom: color fringes around objects.** Lenses are often plagued with fringes of color around backlit objects, produced by *chromatic aberration*, which comes in two forms: *longitudinal/axial*, in which all the colors of light don't focus in the same plane; and *lateral/transverse*, in which the colors are shifted to one side. Axial chromatic aberration can be reduced by stopping down the lens, but transverse CA cannot. Both can be reduced by using lenses with low diffraction index glass (or ED elements, in Nikon nomenclature) and by incorporating elements that cancel the chromatic aberration of other glass in the lens. For example, a strong positive lens made of low dispersion crown glass (made of a soda-lime-silica composite) may be mated with a weaker negative lens made of high-dispersion flint glass, which contains lead.

- **Symptom: lines that bow outward.** Some wide-angle lenses cause straight lines to bow outwards, with the strongest effect at the edges. This is called barrel distortion. You can also minimize this effect simply by framing your photo with some extra space all around, so the edges where the defect is most obvious can be cropped out of the picture. Some image editors, such as Photoshop and Photoshop Elements have a lens distortion correction feature.

- **Symptom: light and dark areas when using polarizing filter.** If you know that polarizers work best when the camera is pointed 90 degrees away from the sun and have the least effect when the camera is oriented 180 degrees from the sun, you know only half the story. With lenses having a focal length of 10mm, the angle of view is extensive enough to cause visible problems.

Using Telephoto Focal Lengths

Telephoto focal lengths also can have a dramatic effect on your photography. Here are the most important things you need to know. In the next section, I'll concentrate on telephoto considerations that can be problematic—and how to avoid those problems.

- **Selective focus.** Long lenses have reduced depth-of-field within the frame, allowing you to use selective focus to isolate your subject. You can open the lens up wide to create shallow depth-of-field, or close it down a bit to allow more to be in focus. The flip side of the coin is that when you *want* to make a range of objects sharp, you'll need to use a smaller f/stop to get the depth-of-field you need. Like fire, the depth-of-field of a telephoto lens can be friend or foe. Figure 9.13 shows a photo of a statue, photographed at 100mm at f/5.6 to de-emphasize the distracting background.

- **Getting closer.** Telephoto lenses bring you closer to wildlife, sports action, and candid subjects. No one wants to get a reputation as a surreptitious or "sneaky" photographer (except for paparazzi), but when applied to candids in an open and honest way, a long lens can help you capture memorable moments while retaining enough distance to stay out of the way of events as they transpire.

Figure 9.13
A wide f/stop helped isolate the statue from its background.

■ **Reduced foreground/increased compression.** Telephoto lenses have the opposite effect of wide angles: they reduce the importance of things in the foreground by squeezing everything together. This compression even makes distant objects appear to be closer to subjects in the foreground and middle ranges. You can use this effect as a creative tool to squeeze subjects together.

■ **Accentuates camera shakiness.** Telephoto focal lengths hit you with a double-whammy in terms of camera/photographer shake. Lenses like the 10-100mm Nikon 1 zoom are bulky and more difficult to hold steady unless you cradle the lens in your left hand. Telephotos also magnify any camera shake. It's no wonder that vibration reduction is a must in longer lenses like the 10-100mm and 30-110mm zooms.

■ **Interesting angles require creativity.** Telephoto lenses require more imagination in selecting interesting angles, because the "angle" you do get on your subjects is so narrow. Moving from side to side or a bit higher or lower can make a dramatic difference in a wide-angle shot, but raising or lowering a telephoto lens a few feet probably will have little effect on the appearance of the distant subjects you're shooting.

Avoiding Telephoto Lens Problems

Many of the "problems" that telephoto lenses pose are really just challenges and not that difficult to overcome. Here is a list of the seven most common picture maladies and suggested solutions.

■ **Symptom: flat faces in portraits.** Head-and-shoulders portraits of humans tend to be more flattering when a focal length of 25mm to 40mm is used. Longer focal lengths compress the distance between features like noses and ears, making the face look wider and flat. A wide-angle 10mm focal length might make noses look huge and ears tiny when you fill the frame with a face. So stick with 25mm to 40mm focal lengths, going longer only when you're forced to shoot from a greater distance, and wider only when shooting three-quarters/full-length portraits, or group shots.

■ **Symptom: blur due to camera shake.** Take advantage of your lens's built-in VR, and, if necessary, use a higher shutter speed (boosting ISO as required). Or, mount your camera on a tripod, monopod, or brace it with some other support. Of those three solutions, only the first will reduce blur caused by *subject* motion; a VR lens or tripod won't help you freeze a racecar in mid-lap.

■ **Symptom: color fringes.** Chromatic aberration is the most pernicious optical problem found in telephoto lenses. There are others, including spherical aberration, astigmatism, coma, curvature of field, and similarly scary-sounding phenomena. The best solution for any of these is to use a better lens that offers the proper degree

of correction, or stop down the lens to minimize the problem. But that's not always possible. Your second-best choice may be to correct the fringing in your favorite RAW conversion tool or image editor. Photoshop's Lens Correction filter (found in the Distort menu) offers sliders that minimize both red/cyan and blue/yellow fringing.

■ **Symptom: low contrast from haze or fog.** When you're photographing distant objects, a long lens shoots through a lot more atmosphere, which generally is muddied up with extra haze and fog. That dirt or moisture in the atmosphere can reduce contrast and mute colors. Some feel that a skylight or UV filter can help, but this practice is mostly a holdover from the film days. Digital sensors are not sensitive enough to UV light for a UV filter to have much effect. So you should be prepared to boost contrast and color saturation in your Picture Controls menu or image editor if necessary.

■ **Symptom: low contrast from flare.** Your 30-110mm and 10-100mm lenses are furnished with lens hoods for a good reason: to reduce flare from bright light sources at the periphery of the picture area, or completely outside it. Because telephoto lenses often create images that are lower in contrast in the first place, you'll want to be especially careful to use a lens hood to prevent further effects on your image (or shade the front of the lens with your hand).

10

Making Light Work for You

Successful photographers and artists have an intimate understanding of the importance of light in shaping an image. Rembrandt was a master of using light to create moods and reveal the character of his subjects. Artist Thomas Kinkade's official tagline is "Painter of Light." The late Dean Collins, co-founder of Finelight Studios, revolutionized how a whole generation of photographers learned and used lighting. Photo guru Ed Pierce conducts seminars called "Captivated by the Light," that reveal his secrets for portrait lighting. It's impossible to underestimate how the use of light adds to—and how misuse can detract from—your photographs.

All forms of visual art use light to shape the finished product. Sculptors don't have control over the light used to illuminate their finished work, so they must create shapes using planes and curved surfaces so that the form envisioned by the artist comes to life from a variety of viewing and lighting angles. Painters, in contrast, have absolute control over both shape and light in their work, as well as the viewing angle, so they can use both the contours of their two-dimensional subjects and the qualities of the "light" they use to illuminate those subjects to evoke the image they want to produce.

Photography is a third form of art. The photographer may have little or no control over the subject (other than posing human subjects) but can often adjust both viewing angle *and* the nature of the light source to create a particular compelling image. The direction and intensity of the light sources create the shapes and textures that we see. The distribution and proportions determine the contrast and tonal values: whether the image is stark or high key, or muted and low in contrast. The colors of the light (because even "white" light has a color balance that the sensor can detect), and how much of those colors the subject reflects or absorbs, paint the hues visible in the image.

As a Nikon J1 photographer, you must learn to be a painter and sculptor of light if you want to move from *taking* a picture to *making* a photograph. This chapter provides an

- **Exposure calculation—Pro: continuous lighting.** Your J1 has no problem calculating exposure for continuous lighting, because it remains constant and can be measured right off the imaging sensor. The amount of light available just before the exposure will, in almost all cases, be the same amount of light present when the shutter is released. The J1's Spot metering mode can be used to measure and compare the proportions of light in the highlights and shadows, so you can make an adjustment (such as using more or less fill light) if necessary. You can even use a hand-held light meter to measure the light yourself.

- **Exposure calculation—Con: electronic flash.** Electronic flash illumination doesn't exist until the flash fires, and so can't be measured prior to taking the photo. Instead, the light must be evaluated by metering the intensity of a pre-flash triggered an instant before the main flash, as it is reflected back to the camera and through the lens. If you have a do-it-yourself bent, there are hand-held flash meters, too, including models that measure both flash and continuous light and can provide meter readings you can transfer to the camera in Manual exposure mode.

- **Evenness of illumination—Pro/con: continuous lighting.** Of continuous light sources, daylight, in particular, provides illumination that tends to fill an image completely, lighting up the foreground, background, and your subject almost equally. Shadows do come into play, of course, so you might need to use reflectors or fill-in light sources to even out the illumination further, but barring objects that block large sections of your image from daylight, the light is spread fairly evenly. Indoors, however, continuous lighting is commonly less evenly distributed. The average living room, for example, has hot spots and dark corners. But on the plus side, you can *see* this uneven illumination and compensate with additional lamps.

- **Evenness of illumination—Con: electronic flash.** Electronic flash units, like continuous light sources such as lamps that don't have the advantage of being located 93 million miles from the subject, suffer from the effects of their proximity. The *inverse square law*, first applied to both gravity and light by Sir Isaac Newton, dictates that as a light source's distance increases from the subject, the amount of light reaching the subject falls off proportionately to the square of the distance. In plain English, that means that a flash or lamp that's eight feet away from a subject provides only one-quarter as much illumination as a source that's four feet away (rather than half as much). (See Figure 10.3.) This translates into relatively shallow "depth-of-light."

- **Action stopping—Con: continuous lighting.** Action stopping with continuous light sources is completely dependent on the shutter speed you've dialed in on the camera. And the speeds available are dependent on the amount of light available and your ISO sensitivity setting. Outdoors in daylight, there will probably be enough sunlight to let you shoot at 1/2,000th second and f/6.3 with a non-grainy sensitivity setting of ISO 400. (See Figure 10.4.) That's a fairly useful combination

Figure 10.3
A light source that is twice as far away provides only one-quarter as much illumination.

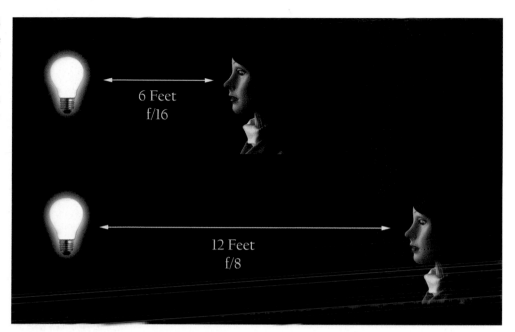

Figure 10.4
A fast shutter speed can freeze almost any action.

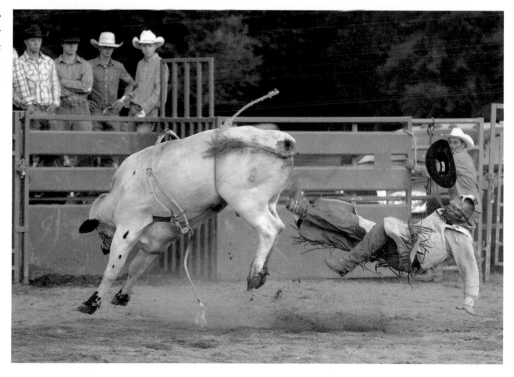

of settings if you're not using a super-telephoto like the Nikon 1 10-100mm f/3.5-4.5 zoom with a small maximum aperture. But inside, the reduced illumination quickly has you pushing your J1 to its limits. For example, if you're shooting indoor sports, there probably won't be enough available light to allow you to use a 1/2,000th second shutter speed (although I routinely shoot indoor basketball with my J1 at ISO 1600 and 1/500th second at f/4). In many typical indoor sports situations, you may find yourself limited to 1/500th second or slower.

- **Action stopping—Pro: electronic flash.** When it comes to the ability to freeze moving objects in their tracks, the advantage goes to electronic flash. The brief duration of electronic flash (1/4000th second when the flash is fired at full power) serves as a very high "shutter speed" when the flash is the main or only source of illumination for the photo. Your J1's shutter speed may be set for 1/60th second during a flash exposure, but if the flash illumination predominates, the *effective* exposure time will be the 1/1,000th second or less duration of the flash, because the flash unit reduces the amount of light released by cutting short the duration of the flash. The only fly in the ointment is that, if the ambient light is strong enough, it may produce a secondary, "ghost" exposure, as I'll explain later in this chapter.

- **Cost—Pro: continuous lighting.** Incandescent or fluorescent lamps are generally very inexpensive. I've used everything from desktop high-intensity lamps to reflector flood lights for continuous illumination at very little cost. There are lamps made especially for photographic purposes, too. Maintenance is economical, too: many incandescent or fluorescents use bulbs that cost only a few dollars.

- **Flexibility—Con: continuous lighting.** Because incandescent and fluorescent lamps are not as bright as electronic flash, the slower shutter speeds required (see Action stopping, above) mean that once you've ventured beyond the anti-shake capabilities of your lens's vibration reduction feature, you may have to use a tripod more often, especially when shooting portraits. The incandescent variety of continuous lighting gets hot, especially in the studio, and the side effects range from discomfort (for your human models) to disintegration (if you happen to be shooting perishable foods like ice cream). The heat also makes it more difficult to add filtration to incandescent sources.

- **Flexibility—Pro: electronic flash.** Electronic flash's action-freezing power allows you to work without a tripod, adding flexibility and speed when choosing angles and positions. Flash units can be easily filtered, and, because the filtration is placed over the light source rather than the lens, you don't need to use high-quality filter material. For example, Roscoe or Lee lighting gels, which may be too flimsy to use in front of the lens, can be mounted or taped in front of your built-in flash with ease.

Continuous Lighting Basics

While continuous lighting and its effects are generally much easier to visualize and use than electronic flash, there are some factors you need to take into account, particularly the color temperature of the light. (Color temperature concerns aren't exclusive to continuous light sources, of course, but the variations tend to be more extreme and less predictable than those of electronic flash, which output relatively consistent daylight-like illumination.)

Color temperature, in practical terms, is how "bluish" or how "reddish" the light appears to be to the digital camera's sensor. Indoor illumination is quite warm, comparatively, and appears reddish to the sensor. Daylight, in contrast, seems much bluer to the sensor. Our eyes (our brains, actually) are quite adaptable to these variations, so white objects don't appear to have an orange tinge when viewed indoors, nor do they seem excessively blue outdoors in full daylight. Yet, these color temperature variations are real and the sensor is not fooled. To capture the most accurate colors, we need to take the color temperature into account in setting the color balance (or *white balance*) of the J1 —either automatically using the camera's smarts or manually using our own knowledge and experience.

Daylight

Daylight is produced by the sun, and so is moonlight (which is just reflected sunlight). Daylight is present, of course, even when you can't see the sun. When sunlight is direct, it can be bright and harsh. If daylight is diffused by clouds, softened by bouncing off objects such as walls or your photo reflectors, or filtered by shade, it can be much dimmer and less contrasty.

Daylight's color temperature can vary quite widely. It is highest in temperature (most blue) at noon when the sun is directly overhead, because the light is traveling through a minimum amount of the filtering layer we call the atmosphere. The color temperature at high noon may be 6,000K. At other times of day, the sun is lower in the sky and the particles in the air provide a filtering effect that warms the illumination to about 5,500K for most of the day. Starting an hour before dusk and for an hour after sunrise, the warm appearance of the sunlight is even visible to our eyes when the color temperature may dip to 5,000-4,500K, as shown in Figure 10.5.

Because you'll be taking so many photos in daylight, you'll want to learn how to use or compensate for the brightness and contrast of sunlight, as well as how to deal with its color balance.

Figure 10.5 At dawn and dusk, the color temperature of daylight may dip as low as 4,500K.

Incandescent/Tungsten Light

The term incandescent or tungsten illumination is usually applied to the direct descendents of Thomas Edison's original electric lamp. Such lights consist of a glass bulb that contains a vacuum, or is filled with a halogen gas, and contains a tungsten filament that is heated by an electrical current, producing photons and heat. Tungsten-halogen lamps are a variation on the basic light bulb, using a more rugged (and longer-lasting) filament that can be heated to a higher temperature, housed in a thicker glass or quartz envelope, and filled with iodine or bromine ("halogen") gases. The higher temperature allows tungsten-halogen (or quartz-halogen/quartz-iodine, depending on their construction) lamps to burn "hotter" and whiter. Although popular for automobile headlamps today, they've also been used for photographic illumination.

Of course, old-style tungsten lamps are on the way out, to be replaced either by compact fluorescent lights (CFL) or newer, more energy efficient (and expensive) tungsten lights. Despite government regulations, tungsten lamps can't be phased out completely, because CFLs don't work in all fixtures and for all applications, such as dimmers (even if you purchase special "dimmable" CFLs), electronic timer or "dusk-to-dawn" light controllers, some illuminated wall switches, or with motion sensors. Only certain types of CFLs (cold cathode models) operate outside in cold weather; they emit IR signals

that can confuse the remote control of your TV, air-conditioner, etc., and the typical CFL has a Color Rendering Index of 80, compared to the virtually perfect 100 rating of incandescent lights.

The other qualities of this type of lighting, such as contrast, are dependent on the distance of the lamp from the subject, type of reflectors used, and other factors that I'll explain later in this chapter.

Fluorescent Light/Other Light Sources

Fluorescent light has some advantages in terms of illumination, but some disadvantages from a photographic standpoint. This type of lamp generates light through an electro-chemical reaction that emits most of its energy as visible light, rather than heat, which is why the bulbs don't get as hot. The type of light produced varies depending on the phosphor coatings and type of gas in the tube. So, the illumination fluorescent bulbs produce can vary widely in its characteristics.

That's not great news for photographers. Different types of lamps have different "color temperatures" that can't be precisely measured in degrees Kelvin, because the light isn't produced by heating. Worse, fluorescent lamps have a discontinuous spectrum of light that can have some colors missing entirely. A particular type of tube can lack certain shades of red or other colors (see Figure 10.6), which is why fluorescent lamps and other alternative technologies such as sodium-vapor illumination can produce ghastly looking human skin tones. Their spectra can lack the reddish tones we associate with healthy skin and emphasize the blues and greens popular in horror movies.

Also gaining in popularity are LED light sources, particularly for movies, in the form of compact units that clip onto the camera and provide a continuous beam of light to fill in shadows indoors or out, and/or to provide the main illumination when shooting video inside. As the Nikon J1 doesn't have an industry standard accessory shoe, if you want to use an LED light source, you'll need to attach a flash bracket to the tripod socket.

Electronic Flash Basics

Until you delve into the situation deeply enough, it might appear that serious photographers have a love/hate relationship with electronic flash. You'll often hear that flash photography is less natural looking, and that the built-in flash in most cameras should never be used as the primary source of illumination because it provides a harsh, garish look. Indeed, the most advanced "pro" cameras like the Nikon D2xs and D3 don't have a built-in flash at all. Available ("continuous") lighting is praised, and built-in flash photography seems to be roundly denounced.

- **Rear-curtain sync (S and M modes only).** With this setting (not shown in Figure 10.7), which can be used with Shutter-priority or Manual exposure modes, the J1 fires the flash at the *end* of the exposure. The flash is fired and the sensor stops capturing the image. If the subject is moving and ambient light levels are high enough, the movement will cause a secondary "ghost" exposure that appears behind the flash exposure (trailing it). You'll find more on "ghost" exposures next.

Figure 10.9
I deliberately used flash and slow sync to separate this Roman sphinx sculpture (limned in bluish light from the flash) from the background illuminated by warmer incandescents.

■ **Rear-curtain sync with slow sync (P and A modes only).** With this setting, which can be used with Program and Aperture-priority modes only, the sensor begins capturing the image, and does so for the duration of the exposure. At the end of the exposure, the flash is fired. If the subject is moving and ambient light levels are high enough, the movement will cause a secondary "ghost" exposure that appears behind the flash exposure (trailing it). You'll find more on "ghost" exposures next. In Program and Aperture-priority modes, the J1 will combine rear-curtain sync with slow shutter speeds to balance ambient light with flash illumination. (It's best to use a tripod to avoid blur at these slow shutter speeds.)

Ghost Images

The concept behind front- and rear-curtain sync can easily confuse even veteran photographers, especially since cameras with only an electronic shutter, like the Nikon J1, don't have shutter "curtains" at all. The difference between the two types of syncs—firing the flash at the beginning of the exposure or at the end of the exposure, might not seem like much, but whether you use first-curtain sync (the default setting) or rear-curtain sync (an optional setting) can make a significant difference to your photograph *if the ambient light in your scene also contributes to the image.* That can be a serious problem when using the electronic shutter, which syncs at speeds no faster than 1/60th second. Such a slow shutter speed allows sufficient ambient light that a second exposure is entirely possible.

At slower shutter speeds, or with very bright ambient light levels, there is a significant difference, particularly if your subject is moving, or the camera isn't steady. In any of those situations, the ambient light will register as a second image accompanying the flash exposure, and if there is movement (camera or subject), that additional image will not be in the same place as the flash exposure. It will show as a ghost image and, if the movement is significant enough, as a blurred ghost image trailing in front of or behind your subject in the direction of the movement.

As I mentioned earlier, when you're using first-curtain sync, the flash goes off the instant the shutter opens, producing an image of the subject on the sensor. Then, the shutter remains open for an additional period (which can be from 30 seconds to 1/60th second). If your subject is moving, say, towards the right side of the frame, the ghost image produced by the ambient light will produce a blur on the right side of the original subject image, making it look as if your sharp (flash-produced) image is chasing the ghost. (See Figure 10.10, top.) For those of us who grew up with lightning-fast superheroes who always left a ghost trail *behind them*, that looks unnatural (see Figure 10.10, bottom).

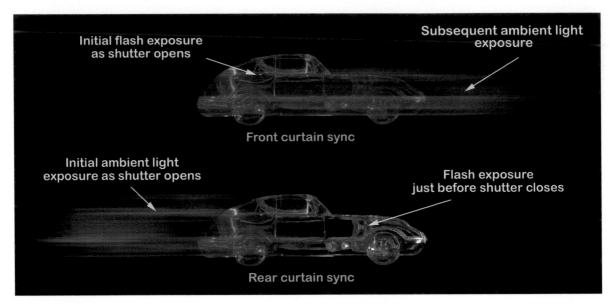

Figure 10.10 Front-curtain sync produces an image that trails in front of the flash exposure (top), while rear-curtain sync creates a more "natural looking" trail behind the flash image (bottom).

So, Nikon provides rear (second) curtain sync to remedy the situation. In that mode, the shutter opens, as before. The shutter remains open for its designated duration, and the ghost image is captured by the sensor. If your subject moves from the left side of the frame to the right side, the ghost will move from left to right, too. *Then*, about 1.5 milliseconds before the sensor ceases capturing the image, the flash is triggered, producing a nice, sharp flash image *ahead* of the ghost image. Voilà! We have monsieur *le Flash* outrunning his own trailing image.

EVERY WHICH WAY, INCLUDING UP

Note that, although I describe the ghost effect in terms of subject matter that is moving left to right in a horizontally oriented composition, it can occur in any orientation, and with the subject moving in *any* direction. (Try photographing a falling rock, if you can, and you'll see the same effect.) Nor are the ghost images affected by the fact that modern shutters travel vertically rather than horizontally. Secondary images are caused between the time the first curtain fully opens, and the second curtain begins to close. The direction of travel of the shutter curtains, or the direction of your subject, does not matter.

Sync Speed Problems Avoided

Using a shutter speed faster than 1/60th second with the electronic shutter could potentially create problems. Because only part of the sensor is exposed/sensitized at one time, you'd end up with only a partial exposure, seen as a narrow band. Fortunately, Nikon has taken care of this problem for us. When you're using the electronic shutter, speeds faster than 1/60th second are locked out when the flash is mounted and turned on. Not all shutter speeds slower than the sync speed setting are available with particular exposure modes. The usable shutter speeds in each mode are shown in Table 10.2.

Table 10.2 Available Shutter Speeds when Using Flash	
Exposure mode	Shutter speeds available
Scene Auto Selector	1/60–1 second
Shutter-Priority Auto	1/60–30 seconds
Manual	1/60–30 seconds, Bulb
Programmed Auto	1/60 second
Aperture-Priority Auto	1/60 second

Using Flash Exposure Compensation

You can manually add or subtract exposure to the flash exposure calculated by the J1. Just choose Flash Compensation from the Shooting menu, and select up to +1 more exposure (in one-third stop increments) or –3 stops (in one-third stop increments). The smaller range of plus exposure steps means it's more difficult to boost exposure for flash pictures that are too dark than it is to reduce exposure for overly bright images. That makes sense from a technological standpoint (it's easy to cut the flash burst short) and logical standpoint (as the flash is a bit underpowered to begin with). Flash compensation will be displayed at the bottom of the LCD screen, and is "sticky." Turning the camera or flash off does not cancel flash compensation. You must return to the menu and zero it out manually when you no longer need the adjustment.

Part IV

Enhancing Your Experience

What do you do after the shutter clicks and your image has been captured in electrons for posterity? This part of the book will help you get more from your Nikon J1 as you download and edit the pictures you've taken, and take the steps necessary to keep your camera humming like the finely (non-oiled) machine that it really is.

Chapter 11 discusses some accessories and add-ons that work well with your Nikon J1, Wi-Fi cards, and smartphone/tablet applications. Chapter 12 details some of your options for downloading and editing your photographs. I'll provide quick introductions to the software bundled with your camera, and describe some of the other applications available to convert RAW files and fine-tune images. The chapter is not a software how-to—this book is virtually 100 percent devoted to photographic shooting techniques. (I want to help you *avoid* having to patch up your pictures in Photoshop where possible, by capturing them correctly in the camera.) Chapter 13 tells you everything you need to know about upgrading your camera's firmware, protecting your LCD and memory card data, and, when necessary, cleaning your sensor manually.

11

Accessories and Add-Ons

Unless you only take pictures, and then immediately print them directly to a PictBridge-compatible printer, somewhere along the line you're going to need to make use of the broad array of software available for the Nikon J1. The picture-fixing options in the Retouch menu let you make only modest modifications to your carefully crafted photos. If your needs involve more than fixing red-eye, cropping and trimming, and maybe adjusting tonal values with D-Lighting, you're definitely going to want to use a utility or editor of some sort to perfect your images. After you've captured some great images and have them safely stored on your Nikon J1's memory card, you'll need to transfer them from your camera and memory card to your computer, where they can be organized, fine-tuned in an image editor, and prepared for web display, printing, or some other final destination.

Wi-Fi

These days, Wi-Fi capabilities work with your J1 in interesting new ways. Wireless capabilities allow you to upload photos directly from your J1 to your computer at home or in your studio, or, through a hotspot at your hotel or coffee shop back to your home computer or to a photo sharing service like Facebook or Flickr. A special Wi-Fi-enabled memory card that you slip in the SD slot of your camera performs the magic. GPS capabilities—built right into some of those Wi-Fi cards—allow you to mark your photographs with location information, so you don't have to guess where a picture was taken.

Both capabilities are very cool. Wi-Fi uploads can provide instant backup of important shots and sharing. And, as noted in the previous section, geotagging is most important as a way to associate the geographical location where the photographer was when a picture was taken, with the actual photograph itself. It can be done with the location-mapping capabilities of the Wi-Fi card, or through add-on devices that third parties make available for your J1.

A relatively affordable solution is offered by Eye-Fi (www.eye.fi). The Eye-Fi card (see Figure 11.1) is an SDHC memory card with a wireless transmitter built in. You insert it in your camera just as with any ordinary card, and then specify which networks to use. You can add as many as 32 different networks. The next time your camera is on within range of a specified network, your photos and videos can be uploaded to your computer and/or to your favorite sharing site. During setup, you can customize where you want your images uploaded. The Eye-Fi card will only send them to the computer and to the sharing site you choose. Upload to any of 25 popular sharing websites, including Flickr, Facebook, Picasa, Kodak Gallery, MobileMe, Costco, Adorama, Smugmug, YouTube, Shutterfly, or Walmart. Online Sharing is included as a lifetime, unlimited service with all X2 cards.

When uploading to online sites, you can specify not just where your images are sent, but how they are organized, by specifying preset album names, tags, descriptions, and

Figure 11.1
The Eye-Fi card is an SD card with built-in Wi-Fi features.

even privacy preferences on certain sharing sites. Some Eye-Fi cards also include the aforementioned geotagging service, which help you view uploaded photos on a map, and sort them by location. Eye-Fi's geotagging uses Wi-Fi Positioning System (WPS) technology. Using built-in Wi-Fi, the Eye-Fi card senses surrounding Wi-Fi networks as you take pictures. When photos are uploaded, the Eye-Fi service then adds the geotags to your photos. You don't need to have the password or a subscription for the Wi-Fi networks the card accesses; it can grab the location information directly without the need to "log in." You don't need to set up or control the Eye-Fi card from your camera. Software on your computer manages all the parameters. (See Figure 11.2.)

Figure 11.2
Functions of the
Eye-Fi card can
be controlled
from your
computer.

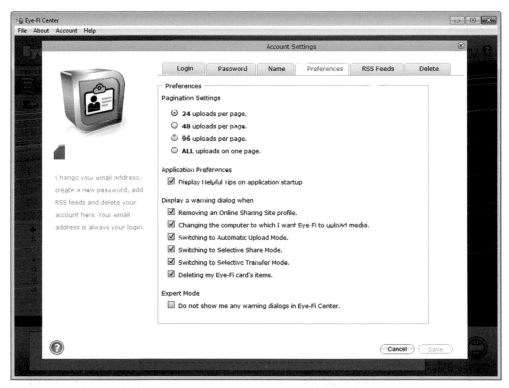

You'll want to turn off Eye-Fi when traveling on an airplane (just as you disable your cell phone, tablet, or laptop's wireless capabilities when required to do so) by removing the card or keeping your J1 powered down. In addition, use of Wi-Fi cards may be restricted or banned outside the United States, because the telecommunications laws differ in other countries.

If you frequently travel outside the range of your home (or business) Wi-Fi network, an optional service called Hotspot Access is available, allowing you to connect to any AT&T Wi-Fi hotspot in the USA. In addition, you can use your own Wi-Fi accounts from commercial network providers, your city, even organizations you belong to such as your university.

The card has another interesting feature called Endless Memory. When pictures have been safely uploaded to an external site, the card can be set to automatically erase the oldest images to free up space for new pictures. You choose the threshold where the card starts zapping your old pictures to make room.

Eye-Fi currently offers four models, including the basic Eye-Fi Home (about $50), which can be used to transmit your photos from the dSLR to a computer on your home network (or any other network you set up somewhere, say, at a family reunion). Eye-Fi Share and Eye-Fi Share Video (about $60 and $80, respectively) are basically exactly the same (Share Video is 4GB instead of 2GB in capacity), but include software to allow you to upload your images from your camera through your computer network directly to websites and digital printing services already mentioned. The most sophisticated option is Eye-Fi Explore, a 4GB SDHC card that adds geographic location labels to your photo (so you'll know where you took it), and frees you from your own computer network by allowing uploads from more than 10,000 Wi-Fi hotspots around the USA. Very cool, and the ultimate in picture backup. (See Figure 11.3.)

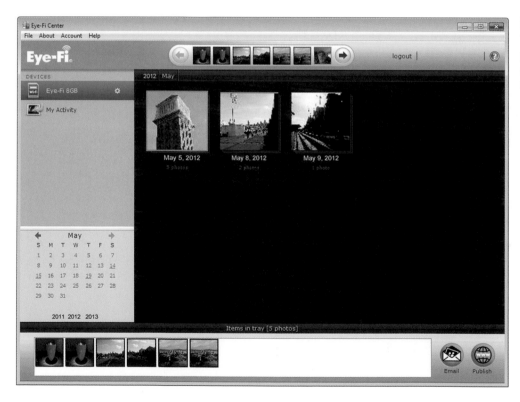

Figure 11.3
Upload your pictures to your computer or many websites.

Tablets, Smart Phones, and the Nikon J1

Although tablets and smart phones are still in their infancies, in the future, your iPhone, iPad/tablet computer, iPod Touch/MP3 player, smart phone, or Google Android portable device will be one of the most important accessories you can have for your Nikon 1 (or other) digital camera. We're only now seeing the beginnings of the trend. The relevant platforms are these:

- **Old-style smart phones.** I include in this category all smart phones that are *not* iPhones or phones based on Google's Android operating system. You can buy lots of interesting apps for these phones, although not many applications specifically for photography. This type of phone should be on its way out, too, with iPhone and Android smart phones dominating, simply because it's easier to write applications for the iPhone's iOS and Android than to create them for multiple "old" smart phone platforms.

- **Android smart phones.** There are already more Android-based smart phones on the market than for all other types, including iOS. Although Apple had a head start, the number of Android applications is rapidly catching up.

- **iPhones.** It might sound strange to say that the skyrocketing sales of iPhones has been held in check, but it's true. The real or imagined shortcomings of AT&T's data network—which only got worse as more users grabbed iPhones—have kept many from switching to the iOS platform. The difficulties may even have contributed to the rapid growth of Android-based phones, which have been offered by Verizon and other suppliers seen as having "better" communications networks. Even so, iOS leads in a number of applications, especially for photography apps. When my first camera-oriented app was developed, it appeared for the iOS platform first. With Verizon entering the iOS picture, it's possible that iPhone sales *will* genuinely skyrocket. Or, Android may have picked up enough steam to blunt any dramatic increase in iPhone sales.

- **iPod Touch.** Basically, the latest iPod Touch is an iPhone that can't make phone calls. (Although there are some hacks around that limitation.) Virtually all of the apps that run on the iPhone under iOS also run on the iPod Touch. You need a Wi-Fi connection to access features that use network capabilities, but, these days, Wi-Fi hot spots aren't that difficult to find. Tethering and Mi-Fi (which allow another device to serve as a hot spot for non-connected gadgets like the Touch), and *automobiles* that include built-in Wi-Fi (!) make connectivity almost universal. In my travels through Europe in the last year, I found free Wi-Fi connections in the smallest towns. (Indeed, the only time I was asked to pay for it was when staying in an upscale hotel.) So, for many who are tied to a non-iPhone cell phone, the iPod Touch is a viable alternative.

■ **Tablet computers.** I've been welded to my iPad (shown alongside my iPhone in Figure 11.4) since I bought it the first day they became available. I use them to access e-mail, useful apps, and as a portable portfolio. Today, there are alternative tablet computers running Android. I recently picked up an Amazon Kindle Fire, which also does e-mail and a limited number of apps, and which has a Gallery feature (see Figure 11.5) that transforms it into a compact portfolio almost as useful for that purpose as an iPad. (However, only 6 of the Kindle Fire's 8GB of storage are available to the user, so you'll have to limit the size of your portfolio.)

I use the Kindle Fire and both an iPhone and iPad. (If I'm traveling overseas where my iPhone can't be used, I usually take along the iPod Touch instead.) The iPhone/Touch slips in a pocket and can be used anywhere. I don't even have to think about taking it with me, because I always have one or the other. I have to remember to tote along the iPad or Kindle Fire, and, I do, to an extent you'd probably find surprising. (When venturing to the movies, I fold them into their cases after the movie finally starts and use them as a tray for my popcorn bucket.) Tablet computers can do everything a pocket-sized device can do, and are easier to read/view/type on. When I am out shooting, I prefer to have all my apps in a smaller device that I can slip in the camera bag, but if there's room, the iPad goes along instead. Because my iPad (unlike the Kindle Fire) has 3G connectivity, I don't need a Wi-Fi connection to use it almost anywhere. I do have a Wi-Fi hot spot built into my iPhone that I can use to connect the Kindle Fire to the net if I need to.

Figure 11.4
The iPad, iPod, and other devices open a whole world of useful apps to the photographer.

Figure 11.5
The Kindle Fire is a smaller, more affordable alternative to the iPad.

What Else Can You Do with Them?

Many of these devices can serve as a backup for your Nikon J1's memory cards. I've got Apple's camera connection kit, and can offload my pictures to my iPad's 64GB of memory, then upload them to Flickr or Facebook, or send to anyone through e-mail. My iPad also makes a perfect portable portfolio, too. I have hundreds of photos stored on mine, arranged into albums (see Figure 11.4, earlier) ready for instant display, either individually, or in slide shows. I have the same photo library on my iPhone and iPod Touch, and more than a few pictures available for showing on my Kindle Fire.

But the real potential for using these devices comes from specialized apps written specifically to serve photographic needs. Here are some of the kinds of apps you can expect in the future. (I'm working on more than a few of them myself.)

■ **Camera guides.** Even the rotten manual that came with your camera is too large to carry around in your camera bag all day. I'm converting many of my own camera-specific guides to app form, while adding interactive elements, including hyperlinks and videos. You can already put a PDF version of your camera manual on your portable device and read it, if you like. In the future, you should be able to read any of the more useful third-party guides anywhere, anytime.

■ **Lens selector.** Wonder what's the best lens to use in a specific situation? Enter information about your scene, and your app will advise you.

■ **Exposure estimator.** Choose a situation and the estimated exposure will be provided. Useful as a reality check and in difficult situations, such as fireworks, where the camera's meters may falter.

■ **Shutter speed advisor.** The correct shutter speed for a scene varies depending on whether you want to freeze action, or add a little blur to express motion. Other variables include whether the subject is crossing the frame, moving diagonally, or headed toward you. The photographer also needs to consider the focal length of the

lens, and the presence/absence of image stabilization features, tripod, monopod, etc. This app will allow you to tap in all the factors and receive advice about what shutter speed to use.

- **Hyperfocal length calculator.** In any given situation, set the focus point at the distance specified for your lens's current focal length setting, and everything from half that distance to infinity will be in focus. But the right setting differs at various focal lengths. This app tells you, and is a great tool for grab shots.

- **Accessory selector.** Confused about what flash, remote control, battery grip, lens hood, filter, or other accessory to use with your camera or lens? This selector lists the key gadgets, which ones fit which cameras, and explains how to use them.

- **Before and after.** Images showing before/after versions of dozens of situations with and without corrective/in-camera special effects, such as D-Lighting, applied.

- **Fill light.** Pesky shadows on faces from overhead lighting indoors? This turns your iPod/iPhone or (best of all) iPad into a bright, diffuse fill light panel. Choose from white fill light, or *colors* for special effects. Makes good illumination for viewing your camera's buttons and dials in dark locations, too.

- **Level.** Set your device on top of your camera and use it to level the camera, with or without a tripod.

- **Gray card.** Turn your i-device into an 18-percent gray card for metering and color balance.

- **Super links.** If you don't find your answer in the Toolkit, you can link to websites, including mine (at http://www.dslrguides.com/blog), with more information.

- **How It's Made.** A collection of inspiring photos, with details on how they were taken in camera—or manipulated in Photoshop (if that's your thing).

- **Quickie guides.** Small apps that lead you, step-by-step, through everything you need to photograph lots of different types of scenes. Typical subjects would be sports, landscape photography, macro work, portraits, concerts/performances, flowers, wildlife, and nature.

As you can see, the potential for apps is virtually unlimited. You can expect your smart phone, tablet computer, or other device to be a mainstay in your camera bag within a very short time.

Useful Software for the Nikon J1

Unless you only take pictures, and then immediately print them directly to a PictBridge-compatible printer, somewhere along the line you're going to need to make use of the broad array of software available for the Nikon J1. If your needs involve more than the in-camera fixes available for red-eye, cropping and trimming, and maybe adjusting tonal values with D-Lighting, you're definitely going to want to use a utility or editor of some sort to perfect your images. After you've captured some great images and have them safely stored on your Nikon J1's memory card, you'll need to transfer them from your camera and memory card to your computer, where they can be organized, fine-tuned in an image editor, and prepared for web display, printing, or some other final destination.

Fortunately, there are lots of software utilities and applications to help you do all these things. This chapter will introduce you to a few of them. Please note that this is *not* a "how-to-do-it" software chapter. I'm going to use every available page to offer advice on how to get the most from your J1. There's no space to explain how to use all the features of Nikon Capture NX 2, nor how to tweak RAW file settings in Adobe Camera Raw. Entire books have been written about both products. This chapter is intended solely to help you get your bearings among the large number of utilities and applications available, to help you better understand what each does, and how you might want to use them. At the very end of the chapter, however, I'm going to make an exception and provide some simple instructions for using Adobe Camera Raw, to help those who have been using Nikon's software exclusively get a feel for what you can do with the Adobe product.

The basic functions found in most of the programs discussed in this chapter include image transfer and management, camera control, and image editing. You'll find that many of the programs overlap several of these capabilities, so it's not always possible to categorize the discussions that follow by function. In fact, I'm going to start off by describing a few of the offerings available from Nikon.

Nikon's Applications and Utilities

If nothing else, Nikon has made sorting through the software for its digital cameras an interesting pursuit. Through the years, we've had various incarnations of programs with names like PictureProject, Nikon View, and Nikon Capture. Some have been compatible with digital SLRs, the new Nikon mirrorless camera, and amateur Coolpix product lines. Many of them have been furnished on disc with the cameras. Others, most notoriously Nikon Capture NX 2, have been an extra-cost option.

Nikon provides you with just two programs on the disc packaged with the Nikon J1: Nikon ViewNX 2 (a simple viewing/conversion program), and Short Movie Creator (which assembles Motion Snapshots and music of your choice into a brief video compilation). You can find other Nikon software for free on their website, including Nikon Transfer (a tool for moving files from your camera to your computer), and software that you must pay for, like Nikon Capture NX 2.

The next few sections provide some descriptions of the Nikon software you'll want to use with your J1.

Nikon ViewNX 2

This latest incarnation of Nikon's basic file viewer is better than ever, making it easy to browse through images, convert RAW files to JPEG or TIFF, and make corrections to white balance and exposure, either on individual files or on batches of files. It now includes Nikon Transfer and a movie-editing tool, and works in tandem with Nikon Capture NX 2, as you can open files inspected in ViewNX in one of the other programs—or within a third-party application you "register."

First and foremost, Nikon ViewNX is a great file viewer. There are three modes for looking at images: a thumbnail grid mode for checking out small previews of your images; an image viewer mode (see Figure 12.1) that shows a group of thumbnails along with an enlarged version of a selected image; and full screen mode, which allows you to examine an image in maximum detail.

If you like to shoot RAW+JPEG, you can review image pairs as if they were a single image (rather than view the RAW and JPEG versions separately), and work with whichever version you need. Should you want to organize your images, there are 10 labels available to classify images by criteria such as images printed, images copied, or images

Figure 12.1
Nikon ViewNX
is a great basic
file viewing
utility.

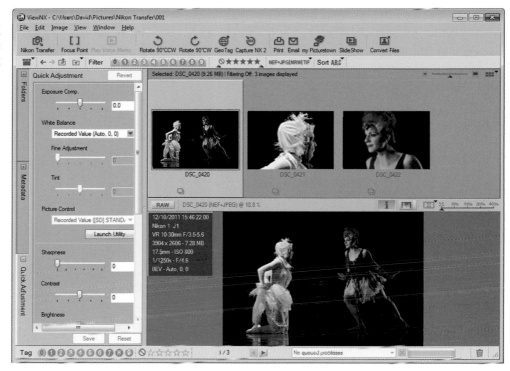

scnt as e-mail, and you can mark your best shots for easier retrieval with a rating system of one to five stars. ViewNX also allows you to edit embedded XMP/IPTC information in fields such as Creator, Origin, Image Title, and suitable keywords. The utility can be downloaded from the support/download pages of the Nikon website at www.niko-nusa.com.

Short Movie Creator

The other program bundled with the J1 is Nikon's Short Movie Creator. The most interesting application of this program is enhancing your Motion Snapshots (explained in Chapter 4), while making these 2.5 second clips a bit easier to view by combining them—plus music you select—into a compilation. You can choose from four themes or styles: Ultra Plain, Classic Vanilla, Pump it Up, or Scrapbook, search your hard drive for .wav or .mp4 music files, put your clips in any order you like, and then save your short movies to your hard drive.

You can select image and movie files to compile from within ViewNX 2's browser window, and then launch Short Movie Creator directly from ViewNX 2. You're not limited to your Motion Snapshots. You can combine JPEG, TIFF, RAW still images, and assemble your short movies from Windows video format (AVI) or QuickTime (MOV) files (except for "Motion JPEGs" created with Nikon Coolpix cameras).

Drag and drop image and movie files, change their order, and append up to 20 different music files to use as background tunes. When you're finished, you can save the short movie as a new file that can be viewed on your computer or even saved to a memory card to play back on the Nikon J1. (See Figure 12.2.)

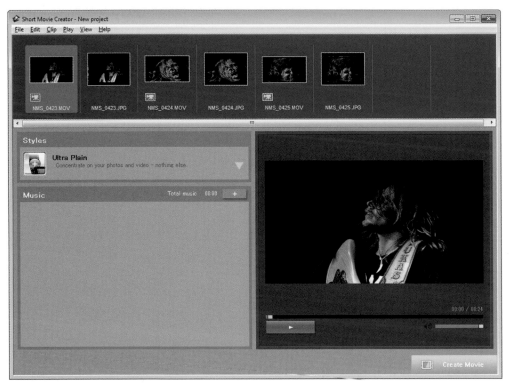

Figure 12.2
Short Movie Creator assembles your clips into a new video.

Nikon Transfer

It seems like everyone offers some sort of image transfer system that automatically recognizes when a memory card is inserted in a reader, or a digital camera like the Nikon J1 is attached to a computer using a USB cable. The most popular operating systems, from Mac OS X to Windows XP, Vista, and Windows 7 have their own built-in transfer programs, and Adobe Photoshop Elements includes one in its suite of utilities.

Nikon Transfer, now included with Nikon ViewNX 2, is particularly well-suited for J1 owners, because it integrates easily with other Nikon software products, including ViewNX and Nikon Capture NX 2. You can download photos to your computer, and then continue to work on them in the Nikon application (or third-party utility) of your choice.

When a memory card is inserted into a card reader, or when the J1 is connected to your computer through a USB cable, Nikon Transfer recognizes the device, searches it for thumbnails, and provides a display like the one shown in Figure 12.3. You can preview the images and mark the ones you want to transfer with checks to create a Transfer Queue.

Figure 12.3
After Nikon Transfer displays thumbnails of the images on your memory card or camera, mark the ones you want to transfer.

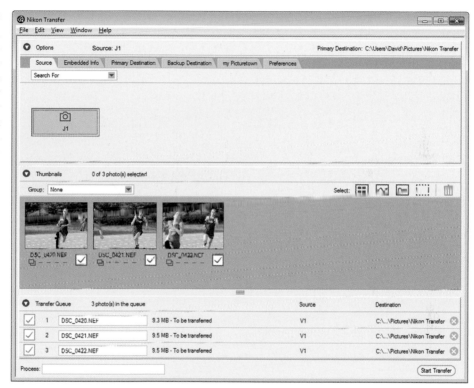

Then, click on the Primary Destination tab (see Figure 12.4) and choose a location for the photos that will be transferred. Nikon Transfer can create a new folder for each transfer based on a naming convention you set up (click the Edit button next to the box at top center in the figure), or copy to a folder named after the current folder in the J1's memory card. You can keep the current filename as the files are transferred, or assign a new name with a prefix you designate, such as Spain07_ . The program will add a number from 001 to 999 to the filename prefix you specify.

One neat feature is the ability to name a Backup Destination location, so that all transferred pictures can also be copied to a second folder, which can be located on a different hard disk drive or other media. You can embed information such as copyright data, star ratings, and labels in the images as they are transferred. When the file transfer is complete, Nikon Transfer can launch an application of your choice, set with a few clicks in the Preferences tab (see Figure 12.5). Nikon Transfer has a tab that gives you the

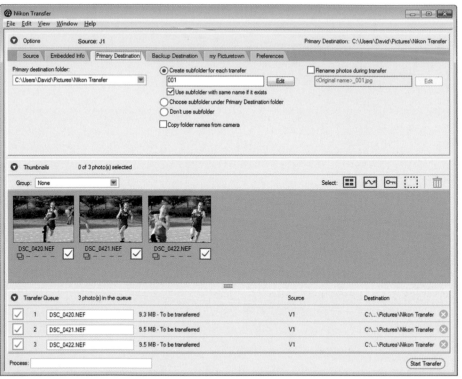

Figure 12.4
Copy files to a destination you specify using an optional file-name template you can define.

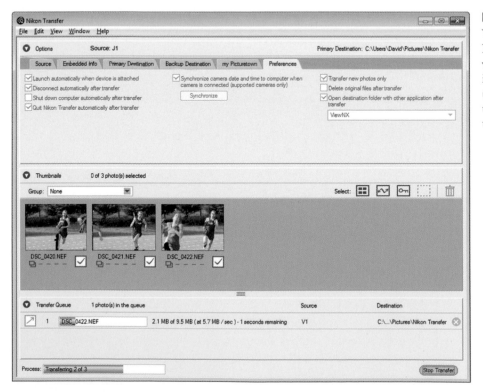

Figure 12.5
You can tell Nikon Transfer what to do after images are transferred in the Preferences tab.

opportunity to sign up for My PictureTown, an online picture sharing service. It allows you to share files (including those made with the Motion Snapshot feature) and integrates full HD video and still images made with Nikon 1 cameras like the J1.

Nikon Capture NX 2

Capture NX 2 is a pretty hefty chunk of software for the typical entry-level Nikon owner, but you, as a J1 buyer, should be up to it. However, this program is challenging to master (and is somewhat expensive at about $150), but if you're ambitious and willing to plant your pitons for a steep climb up the learning curve, the program is indeed a powerful image-editing utility. It's designed specifically to process Nikon's NEF-format RAW files (although this edition has added the ability to manipulate JPEG and TIFF images as well). It includes an image browser (with labeling, sorting, and editing) that can be used to make many adjustments directly through the thumbnails. It also has advanced color management tools, impressive noise reduction capabilities, and batch processing features that allow you to apply sets of changes to collections of images. All the tools are arranged in dockable/expandable/collapsible palettes (see Figure 12.6) that tell you everything you need to know about an image, and provide the capabilities to push every pixel in interesting ways.

Photographers tend to love Capture NX or hate it, particularly in the NX 2 version that was current when I wrote this book, and it's easy to separate the fans from the furious. Those who are enamored of the program have invested a great deal of time in learning

Figure 12.6
Capture NX 2's tools are arranged in dockable palettes.

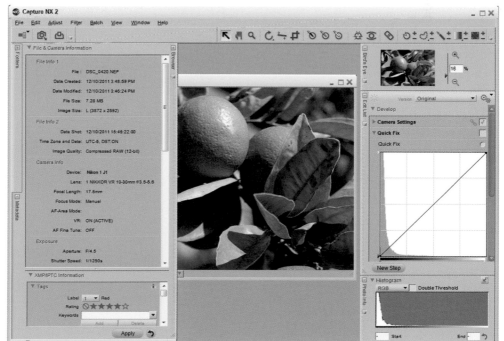

its quirky paradigm and now appreciate just how powerful Capture NX is. The detractors are usually those who are comfortable with another program, such as Photoshop or even Capture 4, this program's predecessor, and are upset that even the simplest functions can be confoundingly difficult for a new user to figure out. Capture NX's murky Help system isn't a lot of help; there's room for a huge book (or two) to explain how to use this program.

For example, instead of masks, Capture NX 2 uses Nik Software's U Point technology, which applies Control Points to select and isolate parts of an image for manipulation. There are Color Control Points, with up to nine different sliders for each selected area. (See Figure 12.7.) There are also Black and White Control points for setting dynamic range, Neutral Control Points for correcting color casts, and a Red-Eye Reduction Control Point that removes crimson glows from pupils.

The workflow revolves around an Edit List, which contains a list of enhancements, including Camera Adjustments, RAW Adjustments, Light & Color Adjustments, Detail Adjustments, and Lens Adjustments, which can each be controlled separately. You can add steps of your own, cancel adjustments individually, and store steps in the Edit List as Settings that can be applied to individual images or batches.

There are also Color Aberration Controls, D-Lighting, Image Dust Off, Vignette Control, Fisheye-to-Rectilinear Image Transformation ("de-fishing"), and a Distortion Control to reduce pincushion and barrel distortion.

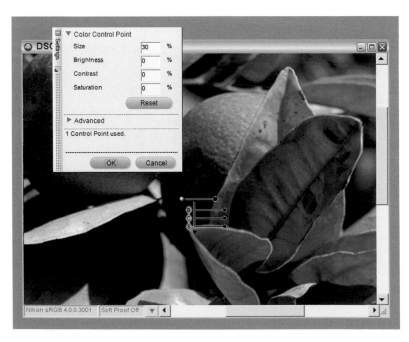

Figure 12.7
Control Points are used to make common adjustments.

Photoshop/Photoshop Elements

Photoshop is the high-end choice for image editing, and Photoshop Elements is a great alternative for those who need some of the features of Photoshop, but can do without the most sophisticated capabilities, including editing CMYK files. Both editors use the latest version of Adobe's Camera Raw plug-in (you'll need Camera Raw 6.6 or later versions to process files from any Nikon 1 camera), which makes it easy to adjust things like image resolution, white balance, exposure, shadows, brightness, sharpness, luminance, and noise reduction. One plus with the Adobe products is that they are available in identical versions for both Windows and Macs.

The latest version of Photoshop includes a built-in RAW plug-in that is compatible with the proprietary formats of a growing number of digital cameras, both new and old, and which can perform a limited number of manipulations on JPEG and TIFF files, too. This plug-in also works with Photoshop Elements, but with fewer features. Here's how easy it is to manipulate a RAW file using the Adobe converter:

1. Transfer the RAW images from your camera to your computer's hard drive.

2. In Photoshop, choose Open from the File menu, or use Organizer or Bridge (depending on the version you have installed).

3. Select a RAW image file. The Adobe Camera Raw plug-in will pop up, showing a preview of the image, like the one shown in Figure 12.8.

Figure 12.8
The basic ACR dialog box looks like this when processing a single image.

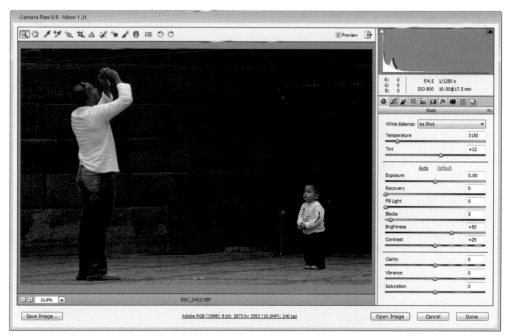

4. If you like, use one of the tools found in the toolbar at the top left of the dialog box. From left to right, they are:

 ■ **Zoom.** Operates just like the Zoom tool in Photoshop.

 ■ **Hand.** Use like the Hand tool in Photoshop.

 ■ **White Balance.** Click an area in the image that should be neutral gray or white to set the white balance quickly.

 ■ **Color Sampler.** Use to determine the RGB values of areas you click with this eyedropper.

 ■ **Crop.** Pre-crops the image so that only the portion you specify is imported into Photoshop. This option saves time when you want to work on a section of a large image, and you don't need the entire file.

 ■ **Straighten.** Drag in the preview image to define what should be a horizontal or vertical line, and ACR will realign the image to straighten it.

 ■ **Retouch.** Used to heal or clone areas you define.

 ■ **Red-Eye Removal.** Quickly zap red pupils in your human subjects.

 ■ **ACR Preferences.** Produces a dialog box of Adobe Camera Raw preferences.

 ■ **Rotate Counterclockwise.** Rotates counterclockwise in 90-degree increments with a click.

 ■ **Rotate Clockwise.** Rotates clockwise in 90-degree increments with a click.

5. Using the Basic tab, you can have ACR show you red and blue highlights in the preview that indicate shadow areas that are clipped (too dark to show detail) and light areas that are blown out (too bright). Click the triangles in the upper-left corner of the histogram display (shadow clipping) and upper-right corner (highlight clipping) to toggle these indicators on or off.

6. Also in the Basic tab you can choose white balance, either from the drop-down list or by setting a color temperature and green/magenta color bias (tint) using the sliders.

7. Other sliders are available to control exposure, recovery, fill light, blacks, brightness, contrast, vibrance, and saturation. A checkbox can be marked to convert the image to grayscale.

8. Make other adjustments (described in more detail below).

9. ACR makes automatic adjustments for you. You can click Default and make the changes for yourself, or click the Auto link (located just above the Exposure slider) to reapply the automatic adjustments after you've made your own modifications.

10. If you've marked more than one image to be opened, the additional images appear in a "filmstrip" at the left side of the screen. You can click on each thumbnail in the filmstrip in turn and apply different settings to each.

11. Click Open Image/Open Image(s) into Photoshop using the settings you've made.

The Basic tab is displayed by default when the ACR dialog box opens, and it includes most of the sliders and controls you'll need to fine-tune your image as you import it into Photoshop. These include:

- **White Balance.** Leave it As Shot or change to a value such as Daylight, Cloudy, Shade, Tungsten, Fluorescent, or Flash. If you like, you can set a custom white balance using the Temperature and Tint sliders.

- **Exposure.** This slider adjusts the overall brightness and darkness of the image.

- **Recovery.** Restores detail in the red, green, and blue color channels.

- **Fill Light.** Reconstructs detail in shadows.

- **Blacks.** Increases the number of tones represented as black in the final image, emphasizing tones in the shadow areas of the image.

- **Brightness.** This slider adjusts the brightness and darkness of an image.

- **Contrast.** Manipulates the contrast of the midtones of your image.

- **Clarity.** Use this slider to apply a hybrid type of contrast enhancement to boost midtone contrast.

- **Vibrance.** Prevents over-saturation when enriching the colors of an image.

- **Saturation.** Manipulates the richness of all colors equally, from zero saturation (gray/black, no color) at the −100 setting to double the usual saturation at the +100 setting.

Additional controls are available on the Tone Curve, Detail, HSL/Grayscale, Split Toning, Lens Corrections, Camera Calibration, and Presets tabs, shown in Figure 12.9. The Tone Curve tab can change the tonal values of your image. The Detail tab lets you adjust sharpness, luminance smoothing, and apply color noise reduction. The HSL/Grayscale tab offers controls for adjusting hue, saturation, and lightness and converting an image to black-and-white. Split Toning helps you colorize an image with sepia or cyanotype (blue) shades. The Lens Corrections tab has sliders to adjust for chromatic aberrations and vignetting. The Camera Calibration tab provides a way for calibrating the color corrections made in the Camera Raw plug-in. The Presets tab (not shown) is used to load settings you've stored for reuse.

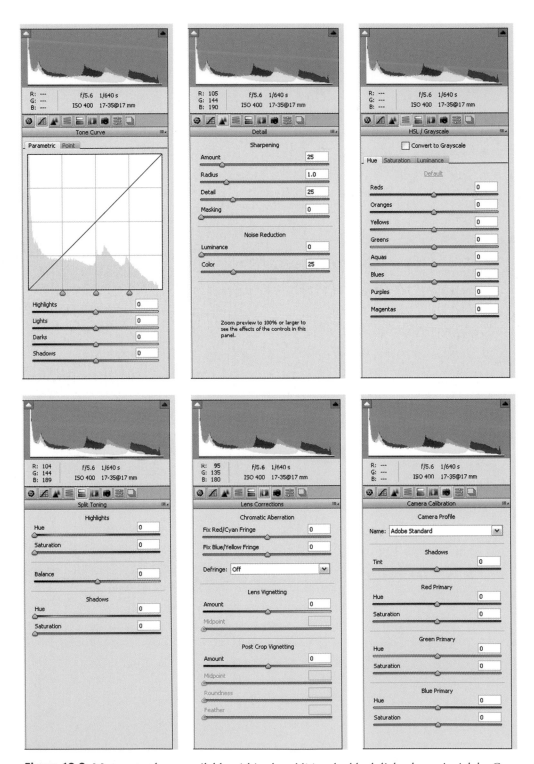

Figure 12.9 More controls are available within the additional tabbed dialog boxes in Adobe Camera Raw.

13

Nikon J1: Troubleshooting and Prevention

One of the nice things about modern electronic cameras like the Nikon J1 is that they have fewer mechanical moving parts to fail, so they are less likely to "wear out." No film transport mechanism, no wind lever or motor drive, no complicated mechanical linkages from camera to lens to physically stop down the lens aperture. Instead, tiny, reliable motors are built into each lens (and you lose the use of only that lens should something fail), and the Nikon 1 series lacks one of the few major moving parts in its dSLR counterparts—the moving mirror. Even the shutter of this camera functions without moving, because it's electronic.

You don't need to worry about sensor cleaning—the J1 has a glass filter located well in front of the sensor (unlike it's cousin, the Nikon V1, which has no such protection and must use both a sensor cleaning mechanism and human cleaning instead). With the J1, any dust that settles on the filter is always out of focus, and it can be easily brushed off without worrying about damaging a filter secured directly to the sensor itself.

The only other things on the camera that move are switches, dials, buttons, and the door that slides open to allow you to remove and insert the battery and Secure Digital card. There's not a lot that can go wrong mechanically with your Nikon J1.

On the other hand, one of the chief drawbacks of modern electronic cameras is that they are modern *electronic* cameras. Your J1 is fully dependent on two different batteries. Without them, the camera can't be used. There are numerous other electrical and

electronic connections in the camera (many connected to those mechanical switches and dials), and components like the color LCD that can potentially fail or suffer damage. The camera also relies on its "operating system," or *firmware*, which can be plagued by bugs that cause unexpected behavior. Luckily, electronic components are generally more reliable and trouble-free, especially when compared to their mechanical counterparts from the pre-electronic film camera days. (Film cameras of the last 10 to 20 years have had almost as many electronic features as digital cameras, but, believe it or not, there were whole generations of film cameras that had *no* electronics or batteries.)

Digital cameras have problems unique to their breed, too; the most troublesome being the need to clean the sensor of dust and grime periodically. This chapter will show you how to diagnose problems, fix some common ills, and, importantly, learn how to avoid some of them in the future.

Battery Powered

I've grown to live with the need for batteries even though I shot for years using all-mechanical Nikon cameras that had no batteries (or even a built-in light meter!). The need for electrical power is the price we pay for modern conveniences like autofocus, autoexposure, LCD image display, backlit menus, and, of course, digital images.

One of the batteries you rely on is the EN-EL20 battery. It's rechargeable, can last for as long as 230 shots, and is user-replaceable if you have a spare. The second power cell in your camera is a so-called *clock battery,* which is also rechargeable, but is tucked away within the innards of the camera and can't be replaced by the user. The clock battery retains the settings of the camera when it's powered down, and, even, when the main battery is removed for charging. If you remove the EN-EL20 for long periods, the clock battery may discharge, but it will be quickly rejuvenated when you replace the main battery. (It's recharged by juice supplied by the EN-EL20.) Although you can't replace this battery yourself, you can expect it to last for the useful life of the camera.

So, your main concern will be to provide a continuous, reliable source of power for your J1. As I noted in Chapter 1, you should always have a spare battery or two so you won't need to stop shooting when your internal battery dies. I recommend buying Nikon-brand batteries: saving $20 or so for an after-market battery may save you a few dollars, but can cost you much more than that if the battery malfunctions and damages your camera.

There are several techniques you can use to stretch the longevity of your J1's battery. To get the most from each charge, consider these steps:

- **Power Off Delay.** In the Setup menu, choose the minimum value, 15 seconds, if you're willing to restart the camera at frequent intervals. As a practical matter, a value of 1 minute might be more convenient and practical. After the specified time, the display will go blank and the green power LED on top of the camera will begin

flashing to indicate the camera will soon go to sleep, until the J1 finally powers down completely. Touch the shutter release to bring the camera back to full power.

■ **Reduce LCD brightness.** In the Setup menu's Display Brightness option, select the lowest of the seven brightness settings that work for you under most conditions.

■ **Reduce flash use.** No flash at all or fill flash use less power than a full blast.

■ **Cancel VR.** Turn off vibration reduction if your lens has that feature and you feel you don't need it.

■ **Use a card reader.** When transferring pictures from your J1 to your computer, use a card reader instead of the USB cable. Linking your camera to your computer and transferring images using the cable takes longer and uses a lot more power.

■ **Set minimum Remote On Duration.** Don't let the J1 wait too long for the ML-L3's signal by setting the lowest value in the Setup menu. Of course, unless you use the remote a lot, you won't save all that much power with this option.

KEEPING TRACK OF YOUR BATTERIES AND MEMORY CARDS

Here's a trick I use to keep track of which batteries are fresh/discharged, and which memory cards are blank/exposed. I cut up some small slips of paper and fold them in half, forming a tiny "booklet." Then I write EXPOSED in red on the "inside" pages of the booklet and UNEXPOSED in green on the outside pages. Folded one way, the slips read EXPOSED; folded the other way, the slips read UNEXPOSED. I slip them inside the plastic battery cover, which you should *always* use when the batteries are not in the camera (to avoid shorting out the contacts), folded so the appropriate "state" of the batteries is visible. The same slips are used in the translucent plastic cases I use for my memory cards. (See Figure 13.1.) For my purposes, EXPOSED means the same as DISCHARGED, and UNEXPOSED is the equivalent of CHARGED. The color coding is an additional clue as to which batteries/memory cards are good to go, or not ready for use.

Figure 13.1
Mark your batteries—or memory cards—so you'll know which are ready for use.

Upgrading Your Firmware

The camera relies on its "operating system," or *firmware*, which should be updated in a reasonable fashion as new releases become available. The firmware in your Nikon J1 handles everything from menu display (including fonts, colors, and the actual entries themselves), what languages are available, and even support for specific devices and features, such as the lenses. Upgrading the firmware to a new version makes it possible to add or fine-tune features while fixing some of the bugs that sneak in.

Firmware upgrades are used most frequently to fix bugs in the software, and much less frequently to add or enhance features. The exact changes made to the firmware are generally spelled out in the firmware release announcement. You can examine the remedies provided and decide if a given firmware patch is important to you. If not, you can usually safely wait a while before going through the bother of upgrading your firmware—at least long enough for the early adopters (such as those who haunt the Digital Photography Review forums at www.dpreview.com) to report whether the bug fixes have introduced new bugs of their own. Each new firmware release incorporates the changes from previous releases, so if you skip a minor upgrade you should have no problems.

WHEN TO UPGRADE YOUR FIRMWARE

I *always* recommend waiting at least two weeks after a firmware upgrade is announced before changing the software in your camera. This is often in direct contradiction to the online Nikon "gurus" who breathlessly announce each new firmware release on their web pages, usually with links to where you can download the latest software. *Don't do it!* Yet. Nikon has, in the past, introduced firmware upgrades that were buggy and added problems of their own. If you own a camera affected by a new round of firmware upgrades, I urge you to wait and let a few million over-eager fellow users "beta test" this upgrade for you. Within a few weeks, any problems (although I don't expect there will be any) will surface and you'll know whether the update is safe. Your camera is working fine right now, so why take the chance?

How It Works

If you're computer savvy, you might wonder how your Nikon J1 is able to overwrite its own operating system—that is, how can the existing firmware be used to load the new version on top of itself? It's a little like lifting yourself by reaching down and pulling up on your bootstraps.

Not ironically, that's almost exactly what happens: At your command (when you start the upgrade process), the J1 shifts into a special mode in which it is no longer operating from its firmware but, rather, from a small piece of software called a *bootstrap loader*, a

separate, protected software program that functions only at startup or when upgrading firmware. The loader's function is to look for firmware to launch or, when directed, to copy new firmware from a memory card to the internal memory space where the old firmware is located. Once the new firmware has replaced the old, you can "reboot" the camera using the new operating system.

Why Three Firmware Modules?

Your Nikon J1's firmware is divided into three parts; many earlier Nikon models had the firmware in just two sections. Why chop the firmware up in the first place? And what is that third module for, anyway?

Previous Nikon cameras had an A and B firmware listing, located in the Firmware Version entry in the Setup menu. There's a good reason why the firmware was previously divided in twain. Each of the two modules was "in charge" of particular parts of the camera's operating system. So, when a bug was found, or a new feature added, it was possible, in many cases, to offer only an upgrade for either Firmware A or Firmware B, depending on which module was affected. Although mistakes in upgrading firmware are rare, you cut the opportunities for user errors in half when only one of the modules needs to be replaced.

But there's a more important reason for having at least two firmware modules. If your camera had just one, and you had the misfortune to munge that firmware during an ill-fated upgrade, it's very likely your camera would be magically transformed into a digital doorstop. Part of the firmware is needed simply to install (or re-install firmware) in the first place. With all Nikon cameras, Firmware A and Firmware B each has the capability of locating and installing replacement firmware. So, if A is ruined, you can use the routines in B to re-install a new copy of A. And vice versa. We can all agree that this is a wise move on Nikon's part.

So, what is the L firmware module? It controls operation of the lenses. When you visit the Firmware Version entry in the Setup menu, you'll see a display something like the one shown in Figure 13.2.

The information in the display will change depending on what equipment you have attached to the J1. That's because the lower entry, the L module, doesn't report information about the camera itself. Instead, the camera reads the firmware information stored in a solid state module in each lens, and reports that instead. If you switch lenses, the L firmware status will change to reflect the firmware installed in that particular lens. As I write this, the firmware for the 10mm f/2.8 lens is 1.00; for the 10-30mm and 30-100mm lenses, 1.02; and for the 10-100mm lens, 1.01. Those values will display when each of those lenses are mounted on the J1.

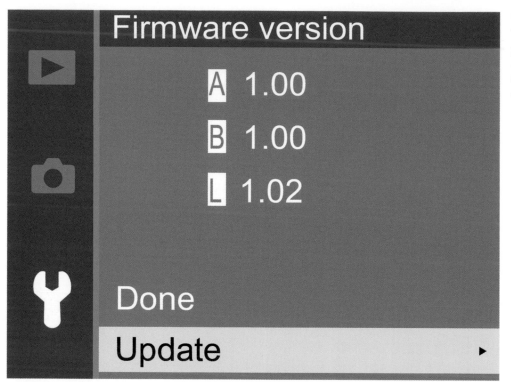

Figure 13.2
The status of your firmware modules is shown in the Setup menu.

WARNING

Use a fully charged EN-EL20 battery to ensure that you'll have enough power to operate the camera for the entire upgrade. Moreover, you should not turn off the camera while your old firmware is being overwritten. Don't open the memory card door or do anything else that might disrupt operation of the J1 while the firmware is being installed.

Getting Ready

The first thing to do is determine whether you need the current firmware update. First, confirm the version number of your Nikon J1's current firmware:

1. Turn on the J1.

2. Press the MENU button and select Firmware Version from the Setup menu. The camera's firmware version will be displayed, as shown earlier in Figure 13.2.

3. Write down the Version number for Parts A, B, and L.

4. Turn off the J1.

Next, go to the Nikon support site, locate, and download the firmware update. In the USA, the place to go is http://support.nikonusa.com/, which will offer a list of choices, including one for current firmware downloads available for Nikon Products. Navigate to the listings for your camera, lens, or electronic flash.

If the version is later than the one you noted in your camera, click the firmware link in either the Windows or Macintosh columns (depending on your computer) to download the file. It will have a name like F-XXXX-V####W.exe" (Windows) or F-XXXX-V####W.dng" (Macintosh), where "XXXX" is the device name and "####" the firmware version. Extract the file to a folder on your computer by double-clicking on it, or using the unzipping or unstuffing software of your choice.

Updating from a Card Reader

To update from a card reader, use a reader connected to your computer with a USB cable. Then, follow these steps:

1. Insert a formatted memory card into the card reader. If you have been using Nikon transfer or the "autoplay" features of your operating system to transfer images from your memory card to the computer, the automated transfer dialog box may appear. Close it.

2. The memory card will appear on your Macintosh desktop, or in the Computer/My Computer folders under Windows 7/Windows Vista/Windows XP.

3. Drag one firmware file to the memory card. Remember to copy the firmware to the *root* (top) directory of the memory card. The J1 will be unable to find it if you place it in a folder.

Updating with a USB Connection

You can also copy the firmware to the J1's memory card using a USB connection. Just follow these steps:

1. With the camera turned off, insert the formatted memory card. Then, turn the camera back on.

2. Press the MENU button and navigate to the Setup menu.

3. Turn the J1 off and connect it to your computer using the UC-E6 USB cable.

4. Turn the camera back on. If you have been using Nikon transfer or the "autoplay" features of your operating system to transfer images from your memory card to the computer, the automated transfer dialog box may appear. Close it.

5. The camera will appear on the Macintosh desktop, or in the Computer/My Computer folders under Windows 7/Windows Vista/Windows XP.

6. Drag one firmware file to the memory card. Remember to copy the firmware to the *root* (top) directory of the memory card. The J1 will be unable to find it if you place it in a folder.

7. Disconnect the camera from the computer.

Starting the Update

To perform the actual update, follow these steps:

1. With the memory card containing the firmware update software in the camera, and the lens or flash unit to be updated mounted (if you're not simply updating the camera itself), turn the camera on.

2. Press the MENU button and select Firmware Version in the Setup menu.

3. Select Update and press the multi selector button to the right.

4. When the Firmware Update screen appears, highlight Yes and press OK to begin the update. (See Figure 13.3.)

5. The actual process may take a few minutes (from two to five). Be sure not to turn off the camera or perform any other operations while it is underway.

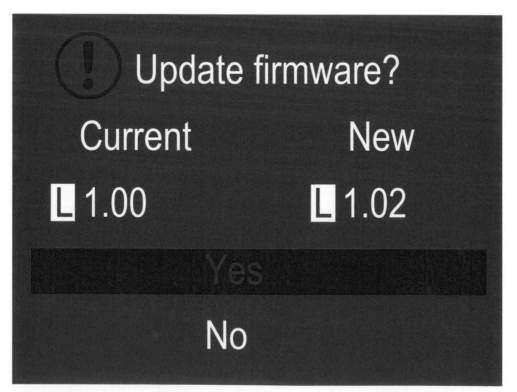

Figure 13.3
Don't turn the camera off while updating is underway.

6. When the update is completed, the warning message will no longer be displayed on the screen. You can turn off the camera when the message disappears.

7. Remove the memory card.

8. Turn the J1 back on to load the updated firmware.

9. Press the MENU button and select Firmware Version in the Setup menu to view the current firmware number. If it matches the update, you've successfully upgraded that portion of the firmware.

10. Reformat the memory card.

11. If there are additional parts to your firmware upgrade, then repeat all the steps for the additional firmware software.

12. Reformat the memory card to return it to a "clean" condition.

Protecting Your LCD

The massive three-inch color LCD on the back of your Nikon J1 almost seems like a target for banging, scratching, and other abuse. The LCD itself is quite rugged, and a few errant knocks are unlikely to shatter the protective cover over the LCD, and scratches won't easily mar its tempered glass surface. However, if you want to be on the safe side, there are a number of protective products you can purchase to keep your LCD safe—and, in some cases, make it a little easier to view. Here's a quick overview of your options.

■ **Plastic overlays.** The simplest solution (although not always the cheapest) is to apply a plastic overlay sheet or "skin" cut to fit your LCD. These adhere either by static electricity or through a light adhesive coating that's even less clingy than stick-it notes. You can cut down overlays made for PDAs (although these can be pricey at up to $19.95 for a set of several sheets), or purchase overlays sold specifically for digital cameras. Vendors such as Hoodman (www.hoodmanusa.com) offer overlays of this type. These products will do a good job of shielding your J1's LCD screen from scratches and minor impacts, but will not offer much protection from a good whack.

■ **Acrylic shields.** These scratch-resistant acrylic panels, laser cut to fit your camera perfectly, are my choice as the best protection solution, and what I use on my own J1. At about $6 each, they also happen to be the least expensive option as well. I get mine from a company called 'da Products (www.daproducts.com). They attach using strips of sticky adhesive that hold the panel flush and tight, but which allow the acrylic to be pried off and the adhesive removed easily if you want to remove or replace the shield. They don't attenuate your view of the LCD and are non-reflective enough for use under a variety of lighting conditions. I also like the glass covers from GGS, available from a variety of sources, and shown in Figure 13.4.

Figure 13.4
A tough glass
shield can pro-
tect your LCD
from scratches.

■ **Magnifiers.** If you look hard enough, you should be able to find an LCD magni-
fier that fits over the monitor panel and provides a 2X magnification. These often
strap on clumsily, and serve better as a way to get an enlarged view of the LCD than
as protection. Hoodman and other suppliers offer these specialized devices.

Troubleshooting Memory Cards

Sometimes good memory cards go bad. Sometimes good photographers can treat their
memory cards badly. It's possible that a memory card that works fine in one camera
won't be recognized when inserted into another. In the worst case, you can have a card
full of important photos and find that the card seems to be corrupted and you can't
access any of them. Don't panic! If these scenarios sound horrific to you, there are lots
of things you can do to prevent them from happening, and a variety of remedies avail-
able if they do occur. You'll want to take some time—before disaster strikes—to con-
sider your options.

All Your Eggs in One Basket?

The debate about whether it's better to use one large memory card or several smaller
ones has been going on since even before there were memory cards. I can remember
when computer users wondered whether it was smarter to install a pair of 200MB (not

gigabyte) hard drives in their computer, or if they should go for one of those new-fangled 500MB models. By the same token, a few years ago the user groups were full of proponents who insisted that you ought to use 128MB memory cards rather than the huge 512MB versions. Today, most of the arguments involve 16GB cards versus 32GB cards, and I expect that as prices for larger capacity cards continue to drop, they'll find their way into the debate as well.

Why all the fuss? Are 16GB memory cards more likely to fail than 8B cards? Are you risking all your photos if you trust your images to a larger card? Isn't it better to use several smaller cards, so that if one fails you lose only half as many photos? Or, isn't it wiser to put all your photos onto one larger card, because the more cards you use, the better your odds of misplacing or damaging one and losing at least some pictures?

In the end, the "eggs in one basket" argument boils down to statistics, and how you happen to use your J1. The rationales can go both ways. If you have multiple smaller cards, you do increase your chances of something happening to one of them, so, arguably, you might be boosting the odds of losing some pictures. If all your images are important, the fact that you've lost 100 rather than 200 pictures isn't very comforting.

After all, the myth assumes that a damaged card will always be full before it becomes corrupted. Fortunately, memory cards don't magically wait until they are full before they fail. In a typical shooting session, it doesn't matter whether you've shot 3.5GB worth of pictures on a 4GB card or 3.5GB worth of pictures on a 16GB card. If either card fails, you've lost the same number of images. Your risk increases *only* when you start shooting additional photos on the larger card. In the real world, most of us who use larger memory cards don't fill them up very often. We just like having the extra capacity there when we need it.

The myth also says that by using several smaller cards, you're spreading the risk around so that only some pictures will be lost in case of a failure. What is more important to you, your photographs or the members of your family? When going on vacation, do you insist on splitting your kin up and driving several smaller cars?

If you shoot photojournalist-type pictures, you probably change memory cards when they're less than completely full in order to avoid the need to do so at a crucial moment. (When I shoot sports, my cards rarely reach 80 to 90 percent of capacity before I change them.) Using multiple smaller cards means you have to change them that more often, which can be a real pain when you're taking a lot of photos. As an example, if you use 1GB memory cards with a Nikon J1 and shoot RAW+JPEG FINE, you may get only a few dozen pictures on the card. That's not even twice the capacity of a 36-exposure roll of film (remember those?). In my book, I prefer keeping all my eggs in one basket, and then making very sure that nothing happens to that basket.

Preventive Measures

Here are some options for preventing loss of valuable images:

- **Interleaving.** One option is to *interleave* your shots. Say you don't shoot weddings, but you do go on vacation from time to time. Take 50 or so pictures on one card, or whatever number of images might fill about 25 percent of its capacity. Then, replace it with a different card and shoot about 25 percent of that card's available space. Repeat these steps with diligence (you'd have to be determined to go through this inconvenience), and, if you use four or more memory cards, you'll find your pictures from each location scattered among the different memory cards. If you lose or damage one, you'll still have *some* pictures from all the various stops on your trip on the other cards. That's more work than I like to do (I usually tote around a portable hard disk and copy the files to the drive as I go), but it's an option.

- **Transmit your images.** Another option is to transmit your images, as they are shot, over a network to your laptop, assuming a network and a laptop are available. A company called Eye-Fi (www.eye.fi) markets a clever Secure Digital card with wireless capabilities built-in (covered more in Chapter 11), which can be used to transmit your photos from the J1 to a computer on your home network (or any other network you set up somewhere, say, at a family reunion). They include software to allow you to upload your images from your camera through your computer network directly to websites such as Flickr, Facebook, Shutterfly, Nikon's own My Picturetown, and digital printing services that include Walmart Digital Photo Center. Very cool, and the ultimate in picture backup.

- **External backup.** You can purchase external hard disk gadgets called Personal Storage Devices (see Figure 13.5), which can copy files from your memory cards automatically. More expensive models have color LCD screens so you can review your images. I tend to prefer using a netbook, like the one shown in Figure 13.6, or my MacBook Air. I can store images on the netbook or MacBook's internal hard disk, and make an extra backup copy to an external drive as well. Plus, I can access the Internet from Wi-Fi hotspots, all using a very compact device. Lately, I've been backing up many images on my iPad, which has 64GB of storage—enough for short trips.

What Can Go Wrong?

There are lots of things that can go wrong with your memory card, but the ones that aren't caused by human stupidity are statistically very rare. Yes, a memory card's internal bit bin or controller can suddenly fail due to a manufacturing error or some inexplicable event caused by old age. However, if your card works for the first week or two that you own it, it should work forever. There's really not a lot that can wear out.

Figure 13.5
Small battery-operated personal storage devices can back up your images.

Figure 13.6
A small netbook, with or without an external hard drive, is another backup option.

The typical memory card is rated for a Mean Time Between Failures of 1,000,000 hours of use. That's constant use 24/7 for more than 100 years! According to the manufacturers, they are good for 10,000 insertions in your camera, and should be able to retain their data (and that's without an external power source) for something on the order of 11 years. Of course, with the millions of cards in use, there are bound to be a few lemons here or there.

Given the reliability of solid-state memory compared to magnetic memory, though, it's more likely that your problems will stem from something that you do. Secure Digital cards are small and easy to misplace if you're not careful. For that reason, it's a good idea to keep them in their original cases or a "card safe" offered by Gepe (www.gepe.com), Pelican (www.pelican.com), and others. Always placing your memory

card in a case can provide protection from the second-most common mishap that befalls memory cards: the common household laundry. If you slip a card in a pocket, rather than a case or your camera bag often enough, sooner or later it's going to end up in the washing machine and probably the clothes dryer, too. There are plenty of reports of relieved digital camera owners who've laundered their memory cards and found they still worked fine, but it's not uncommon for such mistreatment to do some damage.

Memory cards can also be stomped on, accidentally bent, dropped into the ocean, chewed by pets, and otherwise rendered unusable in myriad ways. It's also possible to force a Secure Digital card into your J1's Secure Digital card slot incorrectly if you're diligent enough, doing little damage to the card itself, but possibly damaging the connectors in the camera, eliminating its ability to read or write to any memory card.

Or, if the card is formatted in your computer with a memory card reader, your J1 may fail to recognize it. Occasionally, I've found that a memory card used in one camera would fail if used in a different camera (until I reformatted it in Windows, and then again in the camera). Every once in awhile, a card goes completely bad and—seemingly—can't be salvaged.

Another way to lose images is to do commonplace things with your card at an inopportune time. If you remove the card from the J1 while the camera is writing images to the card, you'll lose any photos in the buffer and may damage the file structure of the card, making it difficult or impossible to retrieve the other pictures you've taken. The same thing can happen if you remove the memory card from your computer's card reader while the computer is writing to the card (say, to erase files you've already moved to your computer). You can avoid this by *not* using your computer to erase files on a memory card but, instead, always reformatting the card in your J1 before you use it again.

What Can You Do?

Pay attention: If you're having problems, the *first* thing you should do is *stop* using that memory card. Don't take any more pictures. Don't do anything with the card until you've figured out what's wrong. Your second line of defense (your first line is to be sufficiently careful with your cards that you avoid problems in the first place) is to *do no harm* that hasn't already been done. Read the rest of this section and then, if necessary, decide on a course of action (such as using a data recovery service or software described later) before you risk damaging the data on your card further.

Now that you've calmed down, the first thing to check is whether you've actually inserted a card in the camera. If you've set the camera so that shooting without a card has been turned on, it's entirely possible (although not particularly plausible) that you've been snapping away with no memory card to store the pictures to, which can lead to massive disappointment later on. Of course, the no card warning appears on the LCD when the camera is powered up, and the demo message is superimposed on the review

THE ULTIMATE IRONY

I recently purchased an 8GB Kingston memory card that was furnished with some nifty OnTrack data recovery software. The first thing I did was format the card to make sure it was okay. Then I hunted around for the free software, only to discover it was pre-loaded onto the memory card. I was supposed to copy the software to my computer before using the memory card for the first time.

Fortunately, I had the OnTrack software that would reverse my dumb move, so I could retrieve the software. No, wait. I *didn't* have the software I needed to recover the software I erased. I'd reformatted it to oblivion. Chalk this one up as either the ultimate irony or Stupid Photographer Trick #523.

image after every shot (assuming you've enabled the J1 to take photos when a card is not inserted), but maybe you're inattentive or aren't using picture review. You can avoid all this by locking the camera when no card is installed, as described in Chapter 8.

Things get more exciting when the card itself is put in jeopardy. If you lose a card, there's not a lot you can do other than take a picture of a similar card and print up some Have You Seen This Lost Flash Memory? flyers to post on utility poles all around town.

If all you care about is reusing the card, and have resigned yourself to losing the pictures, try reformatting the card in your camera. You may find that reformatting removes the corrupted data and restores your card to health. Sometimes I've had success reformatting a card in my computer using a memory card reader (this is normally a no-no because your operating system doesn't understand the needs of your J1), and *then* reformatting again in the camera.

If your memory card is not behaving properly, and you *do* want to recover your images, things get a little more complicated. If your pictures are very valuable, either to you or to others (for example, a wedding), you can always turn to professional data recovery firms. Be prepared to pay hundreds of dollars to get your pictures back, but these pros often do an amazing job. You wouldn't want them working on your memory card on behalf of the police if you'd tried to erase some incriminating pictures. There are many firms of this type, and I've never used them myself, so I can't offer a recommendation. Use a Google search to turn up a ton of them.

A more reasonable approach is to try special data recovery software you can install on your computer and use to attempt to resurrect your "lost" images yourself. They may not actually be gone completely. Perhaps your card's "table of contents" is jumbled, or only a few pictures are damaged in such a way that your camera and computer can't read some or any of the pictures on the card. Some of the available software was written specifically to reconstruct lost pictures, while other utilities are more general purpose applications that can be used with any media, including floppy disks and hard disk

drives. They have names like OnTrack, Photo Rescue 2, Digital Image Recovery, MediaRecover, Image Recall, and the aptly named Recover My Photos. You'll find a comprehensive list and links, as well as some picture recovery tips at www.ultimateslr. com/memory-card-recovery.php. I like the RescuePRO software that SanDisk supplies (see Figure 13.7), especially since it came on a mini-CD that I was totally unable to erase by mistake.

DIMINISHING RETURNS

Usually, once you've recovered any images on a memory card, reformatted it, and returned it to service, it will function reliably for the rest of its useful life. However, if you find a particular card going bad more than once, you'll almost certainly want to stop using it forever. See if you can get it replaced by the manufacturer if you can, but, in the case of Secure Digital card failures, the third time is never the charm.

Figure 13.7
SanDisk supplies RescuePRO recovery software with some of its memory cards.

Part V

Reference

This last Part of the book includes an appendix that outlines some of the nuts and bolts techie stuff that didn't appear in the main body of the text, a glossary that will help you master some of the terms you'll encounter when shooting digital photos, and an index that makes it easy to find specific facts in the book.

A

Some Nuts and Bolts

In creating the entry level Nikon J1 version of its new line of Nikon 1 cameras, the company created a very special niche for potential buyers of their mirrorless ILC (interchangeable lens camera) models. On the one hand, the J1 is a step up from the point-and-shoot cameras that many avid—but non-hobbyist—photographers have enthusiastically embraced. But on the other hand, the J1 also appeals to those who are more serious about photography—whether they intended to become photo buffs or not.

In order to meet the needs of both audiences, I've extracted some of the more techie discussions that would ordinarily go in the mainstream text and lodged them here. Much of the information in this appendix is good to know, but not absolutely essential when you're starting out using the Nikon J1 camera. So, you can absorb the must-know information presented in the 13 chapters of this book, and, after you've mastered the requisites, you can come here to learn more. The nuts and bolts presented here will help you master all the richer capabilities and techniques possible with your Nikon 1 camera, which is, despite its simplicity, a very sophisticated piece of machinery. Consider the main body of the text as your undergraduate curriculum, and you can come here to earn your graduate degree. Here are the "courses" available to you in this Nuts and Bolts Part:

- **How the Nikon J1 Calculates Exposure.** (Reference material for Chapter 5.)
- **Bracketing and High Dynamic Range Photography.** (Reference material for Chapter 5.)
- **Mastering the Mysteries of Autofocus.** (Reference material for Chapter 6.)
- **Focus Stacking.** (Reference material for Chapter 6.)

- **Choosing Interlaced or Progressive Scan Movie formats.** (Reference material for Chapter 7.)
- **Dealing with the crop factor.** (Reference material for Chapter 9.)

How the Nikon J1 Calculates Exposure

In Chapter 5, I gave you all the basic information you needed to get proper exposure with your Nikon J1. This next section goes into more detail about how your Nikon J1 uses its measurement of light to calculate exposure. It's useful information that can come in handy when you need to figure out exactly why some kinds of subjects make your pictures come out too dark or too light.

Your J1 calculates exposure by measuring the light that passes through the lens and reaches the sensor, based on the assumption that each area being measured reflects about the same amount of light as a neutral gray card that reflects a "middle" gray of about 12- to 18-percent reflectance. (The photographic "gray cards" you buy at a camera store have an 18-percent gray tone; your camera is calibrated to interpret a somewhat darker 12-percent gray; I'll explain more about this later.) That "average" 12- to 18-percent gray assumption is necessary, because different subjects reflect different amounts of light. In a photo containing, say, a white cat and a dark gray cat, the white cat might reflect five times as much light as the gray cat. An exposure based on the white cat will cause the gray cat to appear to be black, while an exposure based only on the gray cat will make the white cat washed out.

This is more easily understood if you look at some photos of subjects that are dark (they reflect little light), those that have predominantly middle tones, and subjects that are highly reflective. The next few figures show some images of actual cats (actually, the *same* cat rendered in black, gray, and white varieties through the magic of Photoshop), with each of the three strips exposed using a different cat for reference.

Correctly Exposed

The three pictures shown in Figure A.1 represent how the black, gray, and white cats would appear if the exposure were calculated by measuring the light reflecting from the middle, gray cat, which, for the sake of illustration, we'll assume reflects approximately 12 to 18 percent of the light that strikes it. The exposure meter sees an object that it thinks is a middle gray, calculates an exposure based on that, and the feline in the center of the strip is rendered at its proper tonal value. Best of all, because the resulting exposure is correct, the black cat at left and white cat at right are rendered properly as well.

When you're shooting pictures with your J1, and the meter happens to base its exposure on a subject that averages that "ideal" middle gray, then you'll end up with similar (accurate) results. The camera's exposure algorithms are concocted to ensure this kind

Figure A.1
When exposure is calculated based on the middle-gray cat in the center, the black and white cats are rendered accurately, too.

of result as often as possible, barring any unusual subjects (that is, those that are backlit, or have uneven illumination). The J1 has three different metering modes (described next), plus Scene modes, each of which is equipped to handle certain types of unusual subjects, as I'll outline.

Overexposed

The strip of three images in Figure A.2 shows what would happen if the exposure were calculated based on metering the leftmost, black cat. The light meter sees less light reflecting from the black cat than it would see from a gray middle-tone subject, and so figures, "Aha! I need to add exposure to brighten this subject up to a middle gray!" That lightens the black cat, so it now appears to be gray.

But now the cat in the middle that was *originally* middle gray is overexposed and becomes light gray. And the white cat at right is now seriously overexposed, and loses detail in the highlights, which have become a featureless white.

Figure A.2
When exposure is calculated based on the black cat at the left, the black cat looks gray, the gray cat appears to be a light gray, and the white cat is seriously overexposed.

Underexposed

The third possibility in this simplified scenario is that the light meter might measure the illumination bouncing off the white cat, and try to render that feline as a middle gray. A lot of light is reflected by the white kitty, so the exposure is *reduced*, bringing that cat closer to a middle gray tone. The cats that were originally gray and black are now rendered too dark. Clearly, measuring the gray cat—or a substitute that reflects about the same amount of light, is the only way to ensure that the exposure is precisely correct. (See Figure A.3.)

Figure A.3
When exposure is calculated based on the white cat on the right, the other two cats are underexposed.

As you can see, the ideal way to measure exposure is to meter from a subject that reflects 12 to 18 percent of the light that reaches it. If you want the most precise exposure calculations, if you don't have a gray cat handy, the solution is to use a stand-in, such as the evenly illuminated gray card I mentioned earlier. But, because the standard Kodak gray card reflects 18 percent of the light that reaches it and, as I said, your camera is calibrated for a somewhat darker 12-percent tone, you would need to add about one-half stop *more* exposure than the value metered from the card.

Another substitute for a gray card is the palm of a human hand (the backside of the hand is too variable). But a human palm, regardless of ethnic group, is even brighter than a standard gray card, so instead of one-half stop more exposure, you need to add one additional stop. That is, if your meter reading is 1/500th of a second at f/11, use 1/500th second at f/8 or 1/250th second at f/11 instead. (Both exposures are equivalent.)

If you actually wanted to use a gray card, place it in your frame near your main subject, facing the camera, and with the exact same even illumination falling on it that is falling on your subject. Then, use the Spot metering function (described in the next section) to calculate exposure. Of course, in most situations, it's not necessary to do this. Your camera's light meter will do a good job of calculating the right exposure, especially if you use the exposure tips in the next section. But, I felt that explaining exactly what is going on during exposure calculation would help you understand how your J1's metering system works.

To meter properly you'll want to choose both the *metering method* (how light is evaluated) and *exposure method* (how the appropriate shutter speeds and apertures are chosen). I'll describe both in the following sidebar.

Bracketing and High Dynamic Range Photography

At the beginning of Chapter 5, I showed you a photo of a skyscraper captured using a technique called high dynamic range photography. The process requires *bracketing,* which is a method for shooting several consecutive exposures using different settings, as a way of improving the odds that one will be exactly right. Alternatively, bracketing can be used to create a series of photos with slightly different exposures in anticipation

MODES, MODES, AND MORE MODES

Call them modes or methods, the Nikon J1 seems to have a lot of different sets of options that are described using similar terms. Here's how to sort them out:

- **Metering method.** These modes determine the *parts of the image* within the frame that are examined in order to calculate exposure. The J1 may look at many different points within the image, segregating them by zone (Matrix metering), examine the same number of points, but give greater weight to those located in the middle of the frame (Center-weighted metering), or evaluate only a limited number of points in a limited area (Spot metering).

- **Exposure method.** These modes determine *which* settings are used to expose the image. The J1 may adjust the shutter speed, the aperture, or both, depending on the method you choose.

WHY THE GRAY CARD CONFUSION?

Why are so many photographers under the impression that cameras and meters are calibrated to the 18-percent "standard," rather than the true value, which may be 12 to 14 percent, depending on the vendor? You'll find this misinformation in an alarming number of places. I've seen the 18-percent "myth" taught in camera classes; I've found it in books, and even been given this wrong information from the technical staff of camera vendors. (They should know better—the same vendors' engineers who design and calibrate the cameras have the right figure.)

The most common explanation is that during a revision of Kodak's instructions for its gray cards in the 1970s, the advice to open up an extra half stop was omitted, and a whole generation of shooters grew up thinking that a measurement off a gray card could be used as-is. The proviso returned to the instructions by 1987, it's said, but by then it was too late. Next to me is a (c)2006 version of the instructions for KODAK Gray Cards, Publication R-27Q, and the current directions read (with a bit of paraphrasing from me in italics):

- For subjects of normal reflectance increase the indicated exposure by 1/2 stop.

- For light subjects use the indicated exposure; for very light subjects, decrease the exposure by 1/2 stop. (*That is, you're measuring a cat that's lighter than middle gray.*)

- If the subject is dark to very dark, increase the indicated exposure by 1 to 1-1/2 stops. (*You're shooting a black cat.*)

that one of the exposures will be "better" from a creative standpoint. For example, bracketing can supply you with a normal exposure of a backlit subject, one that's "underexposed," producing a silhouette effect, and a third that's "overexposed" to create still another look.

The Nikon J1, unlike many other cameras, does not have automatic bracketing, but that's not a deal-breaker. Before digital cameras took over the universe, it was common to bracket exposures *manually,* as you can do with the J1, shooting, say, a series of three photos at 1/125th second, but varying the f/stop from f/8 to f/11 to f/16. In practice, smaller than whole-stop increments were used for greater precision, and lenses with apertures that were set manually commonly had half-stop detents on their aperture rings, or could easily be set to a mid-way position between whole f/stops. It was just as common to keep the same aperture and vary the shutter speed, although in the days before electronic shutters, film cameras often had only whole increment shutter speeds available.

Today, cameras like the J1 can bracket exposures much more precisely in 1/3 stop increments, although you must make the adjustments yourself, either using EV changes in P, S, or A modes or by working in Manual exposure mode and setting the exposures yourself. As I mentioned, the J1 does not have automatic exposure bracketing. Although manual exposure bracketing takes time, the results can be worth it. Bracketing is especially useful when shooting *high dynamic range* (HDR) photos.

Bracketing and Merge to HDR

While my goal in this book is to show you how to take great photos *in the camera* rather than how to fix your errors in Photoshop, the Merge to HDR Pro (high dynamic range) feature in Adobe Photoshop and Photoshop Elements is too cool to ignore. The ability to have a bracketed set of exposures that are identical except for exposure is key to getting good results with this feature, which allows you to produce images with a full, rich dynamic range that includes a level of detail in the highlights and shadows that is almost impossible to achieve with digital cameras. In contrasty lighting situations, even the Nikon J1 has a tendency to blow out highlights when you expose solely for the shadows or midtones.

Suppose you wanted to photograph a dimly lit room that had a bright window showing an outdoors scene. Proper exposure for the room might be on the order of 1/60th second at f/2.8 at ISO 200, while the outdoors scene probably would require f/11 at 1/400th second. That's almost a 7 EV step difference (approximately 7 f/stops) and well beyond the dynamic range of any digital camera, including the Nikon J1.

When you're using Merge to HDR Pro, you'd take two to three pictures, one for the shadows, one for the highlights, and perhaps one for the midtones. (You could also take more than three pictures, but for this example, I'm going to assume you're working with just three.) Then, you'd use the Merge to HDR command to combine all of the images

into one HDR image that integrates the well-exposed sections of each version. You can use the Nikon J1's bracketing feature to produce those images.

The images should be as identical as possible, except for exposure. So, it's a good idea to mount the J1 on a tripod, use a remote release like the ML-L3 infrared remote, and take all the exposures one after another. Just follow these steps:

1. **Set up the camera.** Mount the J1 on a tripod.

2. **Activate the remote control.** In Still Image mode, press the left multi selector button and choose either 2 Second Remote or Quick Release Remote. (See Figure A.4.)

3. **Choose Manual exposure mode.** In Still Image mode, press the MENU button, navigate to Exposure Mode, and choose Manual Exposure.

4. **Choose RAW exposures.** In the Shooting menu, navigate to Image Quality and select NEF (RAW). You'll need RAW files to give you the 16-bit high dynamic range images that the Merge to HDR feature processes best.

5. **Set the exposure.** Using the exposure scale at the bottom of the monitor, set the exposure so the image is one stop underexposed. The scale will be biased towards the left.

6. **Set for manual focus.** Press the down directional button on the multi selector and choose MF.

Figure A.4
Choose Remote
Control mode.

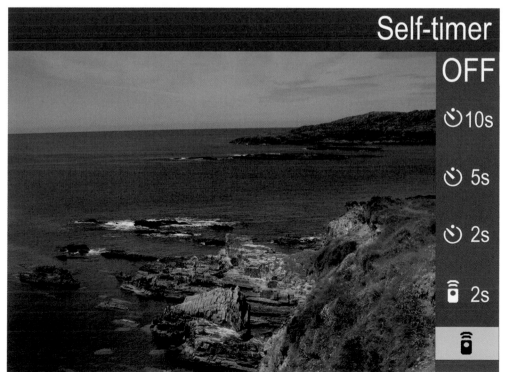

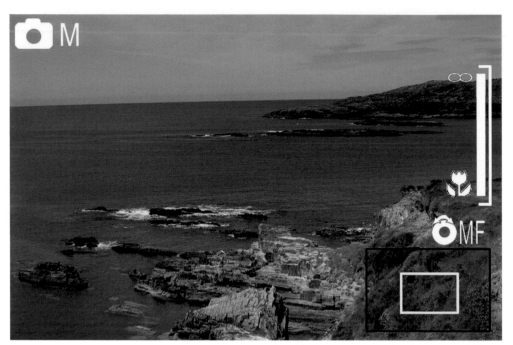

7. **Focus the scene.** Press the OK button to produce the manual focus screen, and press the zoom bar up or down to focus. (See Figure A.5.)

8. **Take the first shot.** Press the button on the ML-L3 remote and take the first exposure.

9. **Adjust shutter speed one stop.** Press the zoom bar up to adjust the shutter speed to one stop faster.

10. **Take the second shot.** Press the button on the ML-L3 remote and take the second exposure.

11. **Adjust shutter speed one more stop.** Press the zoom bar up to adjust the shutter speed to one stop faster.

12. **Take the third shot.** Press the button on the ML-L3 remote and take the final exposure. Continue with the Merge to HDR Pro steps listed next.

The next steps show you how to combine the separate exposures into one merged high dynamic range image. The sample images in Figure A.6 show the results you can get from a three-shot bracketed sequence.

1. **Copy your images to your computer.** If you use an application to transfer the files to your computer, make sure it does not make any adjustments to brightness, contrast, or exposure. You want the real raw information for Merge to HDR Pro to work with. If you do everything correctly, you'll end up with at least three photos like the ones shown in Figures A.6.

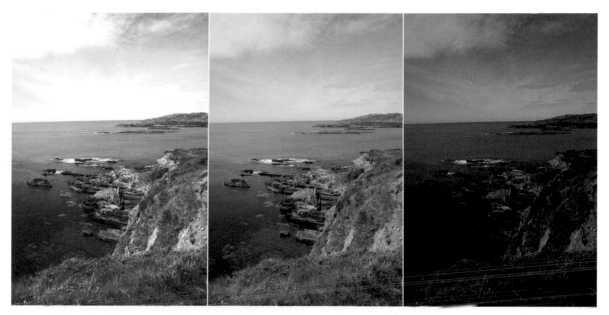

Figure A.6 Make three exposures for the highlights, midtones, and shadow areas.

2. **Activate Merge to HDR Pro.** Choose File > Automate > Merge to HDR Pro.

3. **Select the photos to be merged.** See Figure A.7, where I have specified the three 16-bit NEF files. You'll note a checkbox that can be used to automatically align the images if they were not taken with the J1 mounted on a rock-steady support. This will adjust for any slight movement of the camera that might have occurred when you changed exposure settings.

Figure A.7
Use the Merge to HDR Pro command in Photoshop or Photoshop Elements to combine the two images.

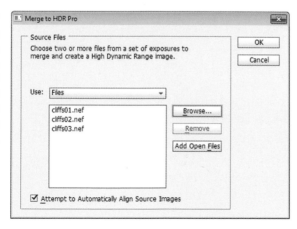

4. **Click OK.** The merger begins.

5. **Save.** Once HDR merge has done its thing, you must save in PSD, PFM, TIFF, or EXR formats to retain the 16-bit file's floating-point data, in case you want to work with the HDR image later. Otherwise, you can convert to a normal 24-bit file and save in any compatible format.

If you do everything correctly, you'll end up with a photo like the one shown in Figure A.8, which has the properly exposed foreground of the first shot, and the well-exposed rocks of the second and third images. Note that, ideally, nothing should move between shots. In the example pictures, the ocean waves are moving, but the exposures were made so close together that, after the merger, you can't really tell.

What if you don't have the opportunity, inclination, or skills to create several images at different exposures, as described? If you shoot in RAW format, you can still use Merge to HDR, working with a *single* original image file. What you do is import the image into Photoshop several times, using Adobe Camera Raw to create multiple copies of the file at different exposure levels.

For example, you'd create one copy that's too dark, so the shadows lose detail, but the highlights are preserved. Create another copy with the shadows intact and allow the highlights to wash out. Then, you can use Merge to HDR to combine the two and end up with a finished image that has the extended dynamic range you're looking for. (This concludes the image-editing portion of the chapter. We now return you to our alternate sponsor: photography.)

Mastering the Mysteries of Autofocus

In Chapter 6, I showed you how to use the Nikon J1's autofocus controls. This Nuts and Bolts section tells you a bit more about how autofocus works. Indeed, one of the most useful and powerful features of modern digital cameras is their ability to lock in sharp focus faster than the blink of an eye. Sometimes. Although autofocus has been with us for more than 20 years, it continues to be problematic. That's been especially true with mirrorless cameras prior to the introduction of the Nikon 1 series, because they generally used a slower form of autofocus, called *contrast detection,* rather than *phase detection.* (Don't worry, I'll explain both later in this appendix.) The Nikon J1 uses a hybrid system that combines the best features of both, giving you faster and more precise autofocus systems. This section will explain the mysteries of autofocus, and how to get sharp, well-focused images without fail.

Why is achieving good focus such a challenge? One key problem is that the camera doesn't really know, for certain, what subject you want to *be* in sharp focus. It may select an object and lock in focus with lightning speed—even though the subject is not the one that's the center of interest of your photograph. Or, the camera may lock focus too soon, or too late.

Figure A.8
You'll end up with an extended dynamic range photo like this one.

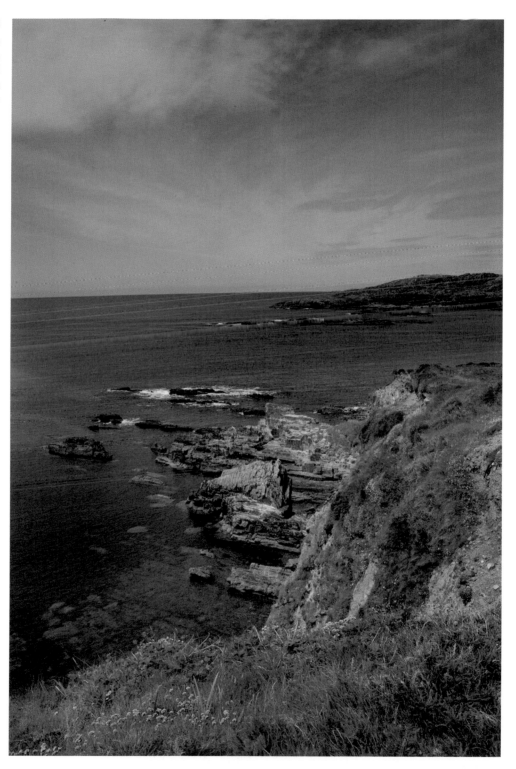

How Focus Works

Although Nikon added autofocus capabilities in the 1980s, back in the day of film cameras, prior to that focusing was always done manually. Honest. Even though the optical viewfinders were big and bright, special focusing screens, magnifiers, and other gadgets were often used to help the photographer achieve correct focus. Imagine what it must have been like to focus manually under demanding, fast-moving conditions such as sports photography.

Focusing was problematic because our eyes and brains have poor memory for correct focus, which is why your eye doctor must shift back and forth between sets of lenses and ask "Does that look sharper—or was it sharper before?" in determining your correct prescription. Similarly, manual focusing involves jogging the focus ring back and forth as you go from almost in focus, to sharp focus, to almost focused again. The little clockwise and counterclockwise arcs decrease in size until you've zeroed in on the point of correct focus. What you're looking for is the image with the most contrast between the edges of elements in the image.

The camera also looks for these contrast differences among pixels to determine relative sharpness. There are two ways that sharp focus is determined, and the Nikon J1 is able to use both in its *hybrid* focus system. One is *contrast detection,* used by all point-and-shoot cameras and most mirrorless models, and employed by the J1 in dim lighting conditions. The second method is called *phase detection,* a much faster system that the J1 uses in higher light levels (in other words, for everyday shooting).

Contrast Detection

This method is the easiest to understand, because it's the way we focus when using our naked eyes or focus binoculars, or sharpen an image when focusing manually while evaluating a scene with any kind of viewing system in a digital or film camera. It's a slower mode, suitable for static subjects, and used by the J1 in reduced light levels. Contrast detection operates by visually or electronically examining the contrast between the edges of objects in an image, as you can see in Figure A.9. At top in the figure, the transitions between the edges found in the image are soft and blurred because of the low contrast between them. The focus system looks only for contrast between edges, and those edges can run in any direction.

At the bottom of Figure A.9, the image has been brought into sharp focus, and the edges have much more contrast; the transitions are sharp and clear. Although this example is a bit exaggerated so you can see the results on the printed page, it's easy to understand that when maximum contrast in a subject is achieved, it can be deemed to be in sharp focus. Achieving focus with contrast detection is generally slow, compared to phase detection (discussed next).

Figure A.9
Focus in contrast detection mode evaluates the increase in contrast in the edges of subjects, starting with a blurry image (top) and producing a sharp, contrasty image (bottom).

However, the J1 still does a good job with contrast detection. Like the human eye, the system evaluates the degree of focus, but, can remember the progression from blurry to sharp perfectly, so that autofocus can lock in much more quickly and, with an image that has sufficient contrast, more precisely.

Phase Detection

In phase detection mode, the Nikon J1 uses a different type of focusing system. Instead of evaluating the overall contrast of an image, the camera looks at certain autofocus zones within the frame and splits each zone into two halves. The two parts of each zone are compared, much like (actually, *exactly* like) a two-window rangefinder used in surveying, weaponry—and non-SLR cameras like the venerable Leica M film models. The relative positions between the two images change as focus is moved in or out, until sharp focus is achieved when the images are "in phase," or lined up.

You can visualize how phase detection autofocus works if you look at Figures A.10 and A.11. However, the action of your camera's actual autofocus sensors don't look *anything* like this; I'm providing a greatly simplified view just for illustration. The Nikon J1 actually has special autofocus sensors built right into the imaging sensor. These pixels are used only for autofocus, and not for image capture.

In Figure A.10, a typical focus sensor is looking at a series of parallel vertical lines in a weathered piece of wood. The lines are broken into two halves by the camera's rangefinder algorithm, and you can see that they don't line up exactly; the image is slightly out of focus.

Figure A.10 When an image is out of focus, the split lines don't align precisely.

Figure A.11 Using phase detection, the J1 is able to align the features of the image and achieve sharp focus quickly.

Fortunately, the rangefinder approach of phase detection tells the J1 exactly how out of focus the image is, and in which direction (focus is too near, or too far) thanks to the amount and direction of the displacement of the split image. The camera can quickly and precisely snap the image into sharp focus and line up the vertical lines, as shown in Figure A.11. Of course, this scenario is ideal. When the same sensor is asked to measure focus for, in the worst case, subjects such as the sky (which may have neither vertical nor horizontal lines), focus can slow down drastically, or even become impossible.

Phase detection, using 73 zones in the sensor image as autofocus zones is the normal mode used by the J1 when light levels are sufficient. If you're familiar with how phase detection works with a digital SLR camera, you can see that the Nikon J1's system is a bit different; dSLRs use a separate AF sensor located in the floor of the mirror box, and evaluate image information reflected downwards by the camera's partially silvered mirror. The J1 has no mirror, of course, so its phase detection system works with the same pixels used to capture the image. The system allows many more focus zones: 73, compared with the 39 zones available with a camera like the Nikon D7000 digital SLR.

Unfortunately, while the J1's focus system finds it easy to measure degrees of apparent focus at each of the focus points, it doesn't really know with any certainty *which* object should be in sharpest focus. Is it the closest object? The subject in the center? Something

lurking *behind* the closest subject? A person standing over at the side of the picture? Many of the techniques for using autofocus effectively involve telling the Nikon J1 exactly what it should be focusing on, by choosing a focus zone or by allowing the camera to choose a focus zone for you. I'll address that topic shortly.

As the camera collects focus information from the sensors, it then evaluates it to determine whether the desired sharp focus has been achieved. The calculations may include whether the subject is moving, and whether the camera needs to "predict" where the subject will be when the shutter release button is fully depressed and the picture is taken. The speed with which the camera is able to evaluate focus and then move the lens elements into the proper position to achieve the sharpest focus determines how fast the autofocus mechanism is. Although your J1 will almost always focus more quickly than a human, there are types of shooting situations where that's not fast enough. For example, if you're having problems shooting sports because the J1's autofocus system manically follows each moving subject, a better choice might be to switch Autofocus modes or shift into Manual and prefocus on a spot where you anticipate the action will be, such as a goal line or soccer net.

Adding Circles of Confusion

But there are other factors in play, as well. You know that increased depth-of-field brings more of your subject into focus. But more depth-of-field also makes autofocusing (or manual focusing) more difficult in contrast detection mode because the contrast is lower between objects at different distances. So, autofocus with a 100mm focal length may be easier than at a 10mm focal length because the longer lens has less apparent depth-of-field. By the same token, a lens with a maximum aperture of f/3.5 at its widest zoom setting will be easier to autofocus (or manually focus) than one with an f/5.6 maximum aperture, because the f/5.6 lens has more depth-of-field *and* a dimmer view.

To make things even more complicated, many subjects aren't polite enough to remain still. They move around in the frame, so that even if the J1 is sharply focused on your main subject, it may change position and require refocusing. An intervening subject may pop into the frame and pass between you and the subject you meant to photograph. You (or the J1) have to decide whether to lock focus on this new subject, or remain focused on the original subject. Finally, there are some kinds of subjects that are difficult to bring into sharp focus because they lack enough contrast to allow the J1's AF system (or our eyes) to lock in. Blank walls, a clear blue sky, or other subject matter may make focusing difficult.

If you find all these focus factors confusing, you're on the right track. Focus is, in fact, measured using something called a *circle of confusion*. An ideal image consists of zillions of tiny little points, which, like all points, theoretically have no height or width. There is perfect contrast between the point and its surroundings. You can think of each point as a pinpoint of light in a darkened room. When a given point is out of focus, its edges decrease in contrast and it changes from a perfect point to a tiny disc with blurry

When a pin-point of light (left) goes out of focus, its blurry edges form a circle of confusion (center and right).

edges (remember, blur is the lack of contrast between boundaries in an image). (See Figure A.12.)

If this blurry disc—the circle of confusion—is small enough, our eye still perceives it as a point. It's only when the disc grows large enough that we can see it as a blur rather than a sharp point that a given point is viewed as out of focus. You can see, then, that enlarging an image, either by displaying it larger on your computer monitor or by making a large print, also enlarges the size of each circle of confusion. Moving closer to the image does the same thing. So, parts of an image that may look perfectly sharp in a 5 × 7-inch print viewed at arm's length, might appear blurry when blown up to 11 × 14 and examined at the same distance. Take a few steps back, however, and it may look sharp again.

To a lesser extent, the viewer also affects the apparent size of these circles of confusion. Some people see details better at a given distance and may perceive smaller circles of confusion than someone standing next to them. For the most part, however, such differences are small. Truly blurry images will look blurry to just about everyone under the same conditions.

Technically, there is just one plane within your picture area, parallel to the back of the camera (or sensor, in the case of a digital camera), that is in sharp focus. That's the plane in which the points of the image are rendered as precise points. At every other plane in front of or behind the focus plane, the points show up as discs that range from slightly blurry to extremely blurry (see Figure A.13). In practice, the discs in many of these planes will still be so small that we see them as points, and that's where we get depth-of-field. Depth-of-field is just the range of planes that include discs that we perceive as points rather than blurred splotches. The size of this range increases as the aperture is reduced in size and is allocated roughly one-third in front of the plane of sharpest focus, and two-thirds behind it. The range of sharp focus is always greater behind your subject than in front of it.

Figure A.13
Only the blossoms in the foreground are in focus—the area behind them appears blurry because the depth-of-field is limited.

Focus Stacking

In Chapter 6, you learned how to use the Nikon J1's focusing features. Now I'd like to introduce you to a technique called *focus stacking,* which is useful if you are doing macro (close-up) photography of flowers, or other small objects at short distances. In such cases, the depth-of-field often will be extremely narrow, even with a camera with a relatively small sensor like the Nikon J1. In some cases, it will be so narrow that it will be impossible to keep the entire subject in focus in one photograph. Although having part of the image out of focus can be a pleasing effect for a portrait of a person, it is likely to be a hindrance when you are trying to make an accurate photographic record of a flower, or small piece of precision equipment. One solution to this problem is focus stacking, a procedure that can be considered like HDR translated for the world of focus—taking multiple shots with different settings, and, using software as explained below, combining the best parts from each image in order to make a whole that is better than the sum of the parts. Focus stacking requires a non-moving object, so some subjects, such as flowers, are best photographed in a breezeless environment, such as indoors.

For example, see Figures A.14 through A.16, in which I took photographs of three colorful crayons using the J1's standard 10-30mm kit lens, which can focus down to about eight inches even at the 30mm telephoto setting. As you can see from these images, the depth-of-field was extremely narrow, and only a small part of the subject was in focus for each shot.

Now look at Figure A.17, in which the entire subject is in reasonably sharp focus. This image is a composite, made up of the three shots above, as well as 10 others, each one focused on the same scene, but at very gradually increasing distances from the camera's lens. All 13 images were then combined in Adobe Photoshop CS5 using the focus stacking procedure.

Figures A.14 A.15 A.16 These three shots were all focused on different distances within the same scene. No single shot could bring the entire subject into sharp focus.

Figure A.17
Three partially out-of-focus shots have been merged, along with ten others, through a focus stacking procedure in Adobe Photoshop CS5, to produce a single image with the entire subject in focus.

Here are the steps you can take to combine shots for the purpose of achieving sharp focus in this sort of situation:

1. **Set the camera firmly on a solid tripod.** A tripod or other equally firm support is absolutely essential for this procedure.

2. **Set the Nikon J1 for remote control.** Press the left directional button on the multi selector and choose either of the two remote control settings. (See Figure A.18.)

3. **Set the camera to manual focus mode.** Use the procedure described in the previous section to activate manual focus.

4. **Set the exposure, ISO, and white balance manually.** Use test shots if necessary to determine the best values. This step in the Shooting menu will help prevent visible variations from arising among the multiple shots that you'll be taking. You don't want the J1 to change the ISO setting or white balance between shots.

5. **Set the quality of the images to NEF (RAW) + JPEG FINE.** Use the Shooting menu to make this adjustment. Having both formats will give you flexibility when combining the images.

Figure A.10
Using the ML-L3 infrared remote control can help you take successive exposures without shaking the camera.

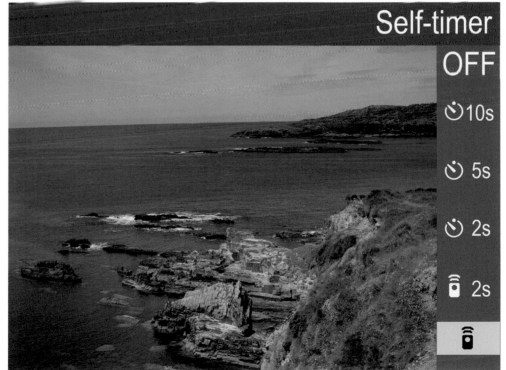

6. **Turn off image stabilization.** Navigate to Vibration Reduction in the Shooting menu. You don't need it when the camera is securely mounted on a tripod, and disabling VR will keep the J1 from making any sort of image adjustment between exposures.

7. **Focus manually on the very closest point of the subject to the lens.** Press the OK button and rotate the multi selector dial to change the focus.

8. **Trip the shutter.** Use the ML-L3 infrared remote.

9. **Carefully refocus.** Repeat Steps 7 and 8, but gently rotate the multi selector dial to focus on a point slightly farther away from the lens each time.

10. **Continue shooting.** Take photographs in this way until you have covered the entire subject with in-focus shots.

The next step is to process the images you've taken in Photoshop. Transfer the images to your computer, and then follow these steps:

1. In Photoshop, select File > Scripts > Load Files into Stack. In the dialog box that then appears, navigate on your computer to find the files for the photographs you have taken, and highlight them all.

2. At the bottom of the next dialog box that appears, check the box that says, "Attempt to Automatically Align Source Images," then click OK. The images will load; it may take several minutes for the program to load the images and attempt to arrange them into layers that are aligned based on their content.

3. Once the program has finished processing the images, go to the Layers panel and select all of the layers. You can do this by clicking on the top layer and then Shift-clicking on the bottom one.

4. While the layers are all selected, in Photoshop go to Edit > Auto-Blend Layers. In the dialog box that appears, select the two options, Stack Images and Seamless Tones and Colors, then click OK. The program will process the images, possibly for a considerable length of time.

5. If the procedure worked well, the result will be a single image made up of numerous layers that have been processed to produce a sharply focused rendering of your subject. If it did not work well, you may have to take additional images the next time, focusing very carefully on small slices of the subject as you move progressively farther away from the lens.

Although this procedure can work very well in Photoshop, you also may want to try it with programs that were developed more specifically for focus stacking and related procedures, such as Helicon Focus (www.heliconsoft.com), PhotoAcute (www.photo-acute.com), or CombineZM (www.hadleyweb.pwp.blueyonder.co.uk).

Understanding Interlacing and Progressive Scan

You learned how to use the Nikon J1's movie-making capabilities in Chapter 7. However, I didn't go into a lot of detail about the difference between the *i* and the *p* designations when choosing between interlaced and progressive scan formats. We'll do that here.

As you know, the Nikon J1 is aimed at both point-and-shooters who are upgrading their equipment and goals, and more advanced photographers who want to shoot stills and video with a more compact camera without making too many compromises feature-wise. That's why the J1 offers the resolution and frame rate options it has. This next section is aimed at more advanced movie-makers who want to understand some of the nuts and bolts behind their choices. To understand which resolution and frame rate you might want to use, it's necessary to understand the difference between interlaced and progressive scans. I'll make the explanation as painless as possible. Those of you who just want to shoot movies can opt to choose 720p/60 in the Movie Settings section of the Shooting menu.

Video images as you see them on your TV or monitor consist of a series of lines which are displayed, or *scanned*, at a fixed rate. When captured by your Nikon J1, the images are also grabbed, using what is called a *rolling shutter,* which simply means that the image is grabbed one line at a time at the same fixed rate that will be used during play-back. (There is a more expensive option, not used in the J1, called a *global shutter* that captures all the lines at one time.)

Line-by-line scanning during capture and playback can be done in one of two ways. With *interlaced scanning*, odd-numbered lines (lines 1, 3, 5, 7… and so forth) are captured with one pass, and then the even-numbered lines (2, 4, 6, 8…and so forth) are grabbed. With the 1080/60i format, roughly 60 pairs of odd/even line scans, or 60 *fields* are captured each second. (The actual number is 59.94 fields per second.) Interlaced scanning was developed for and works best with analog display systems such as older television sets. It was originally created as a way to reduce the amount of bandwidth required to transmit television pictures over the air. Modern LCD, LED, and plasma-based HDTV displays must de-interlace a 1080i image to display it. (See Figure A.19.)

Newer displays work better with a second method, called *progressive scanning* or *sequential scanning.* Instead of two interlaced fields, the entire image is scanned as consecutive lines (lines 1,2,3,4…and so forth). This happens at a rate of 30 frames per second (not fields), or, more precisely, 29.97 frames per second. (All these numbers apply to the NTSC television system used in the United States, Canada, Japan, and some other countries; other places use systems like PAL, where the nominal scanning figures are 50/25 rather than 60/30.)

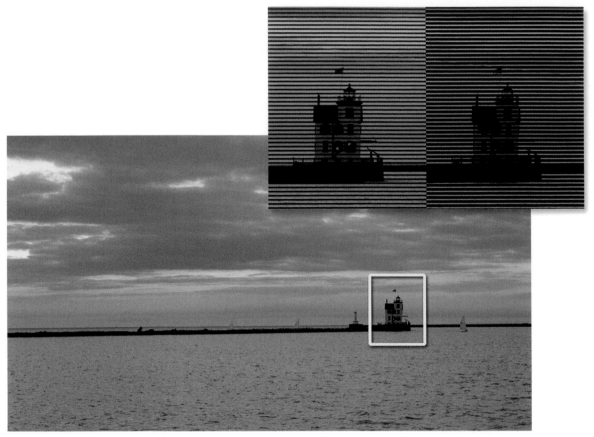

Figure A.19 The inset shows how lines of the image alternate between odd and even in an interlaced video capture.

One problem with interlaced scanning appears when capturing video of moving subjects. Half of the image (one set of interlaced lines) will change to keep up with the movement of the subject while the other interlaced half retains the "old" image as it waits to be refreshed. Flicker or *interline twitter* results. That makes your progressive scan options 1080p/30 or 720p/60 a better choice for action photography.

DIFFERENT FLICKER

The Nikon J1's Flicker Reduction option, found in the Setup menu, does not affect interline twitter; it's used to reduce flicker and banding that can occur when shooting under fluorescent or mercury-vapor lighting, which "cycles" imperceptibly. Choose 60Hz in most cases to correspond with the frequency of your local power system. An alternate setting of 50hz (cycles per second) is available if that's used in your area.

Which to Choose?

If you're shooting a relatively static image, choose 1080p/30 for the best combination of resolution and image quality. Use 1080i/60 only if you know you'll be mixing your video with existing 1080i/60 footage, or if you happen to be shooting for NBC, CBS, or The CW. (Ha!) For action shooting, choose 720p/60 to get the smoothest looking image, one that's more film-like (since the *true* "filmy" look of 720p/24 isn't available with the Nikon J1). Fox, ABC, and ESPN use 720p, for example.

You don't lose as much resolution as you might think in switching to 720p. With 1080i, each of the interlaced fields is actually 1920 × 540 pixels (about one million total pixels), with each field refreshed 30 times per second. In contrast, 720p captures 1280 × 720 pixels, but refreshes 60 times per second and also captures very close to one million pixels. In effect, 720p has more vertical resolution, giving almost exactly the same pixels captured per "frame," but twice as many frames per second. With moving images, that makes all the difference. Both 1080i/60 and 1080p/30 deliver roughly the same number of "pixels per second" as 720p/60. (Technoids call this *temporal resolution*.)

Sensor Sensibilities

In Chapter 9, I showed you how to use the lenses available for your Nikon J1 camera. But one thing I didn't explain fully (because most of you never need to worry about it), is the so-called *crop factor*. Even if you never heard the term previously, it certainly came to your attention when the Nikon 1 line of cameras was introduced. That's because your Nikon J1 has a "crop" factor of 2.7, which is considerably larger than that of any other interchangeable lens camera currently being produced. So, you may be wondering, is that a good thing or a bad thing? And what's a crop factor, anyway? But rather than being a distinct plus or minus, the so-called crop factor, or *lens multiplier factor* has both good effects and bad effects, and is simply something that (perhaps) needs to be understood, and allowed for.

Both crop factor and lens multiplier factor are misleading and inaccurate terms used to describe the same phenomenon: the fact that cameras like the J1 (and most other affordable interchangeable lens cameras) provide a field of view that's smaller and narrower than that produced by the top-end "full frame" cameras, when fitted with exactly the same lens. Of course, swapping lenses with another camera system is possible only if you happen to have an adapter for your J1 that allows you to mount lenses produced for non-CX format cameras, or you want to compare the perspective of your Nikon 1 lenses with those of other models. If you use only Nikon 1 lenses, and don't care to make comparisons, you can safely ignore the whole crop factor business, because the bottom line is this: *When you look at the LCD monitor, what you see is what you're going to get.* Everything else is just numbers.

Those who do care about crop factors can read on. Figure A.20 quite clearly shows the phenomenon at work. The outer rectangle, marked 1X, shows the field of view you might expect with a 28mm lens mounted on one of Nikon's "full-frame" FX-format cameras, like the Nikon D3s. The area marked 1.5X shows the field of view you'd get with that 28mm lens installed on a DX-format model like the Nikon D7000. The inner area, marked 2.7X shows the equivalent field of view with that lens (or with your 10-30mm kit lens zoomed in to roughly its maximum focal length). It's easy to see from the illustration that the 1X rendition provides a wider, more expansive wide-angle view, while the inner field of view, in comparison, gives a healthy telephoto effect, because it's *cropped*. Because of this cropping, a 28mm focal length on an FX camera gives a wide-angle view, whereas the same focal length on the J1 offers a telephoto image.

The extreme cropping effect is produced because the sensors of CX cameras like the Nikon J1 are smaller than the sensors of the D3s or D7000. In the case of a "full-frame" FX camera, the sensor is the size of the standard 35mm film frame: 24mm × 36mm. Your J1's sensor does *not* measure 24mm × 36mm; instead, it specs out at 8.8 × 13.2mm. The FX sensor is 2.7X times the size of the CX sensor in each direction, producing the 2.7X crop factor.

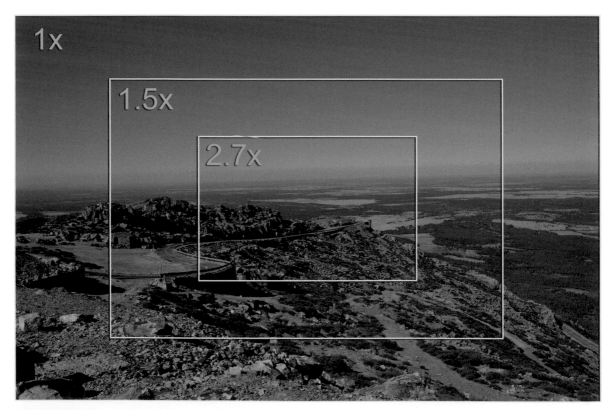

Figure A.20 Nikon offers interchangeable lens cameras with full-frame (1X) crops, as well as 1.5X and 2.7X.

This translation is generally useful only if you're accustomed to using full-frame cameras (often of the film variety) and want to know how a familiar lens will perform on a digital camera. I strongly prefer *crop factor* over *lens multiplier*, because nothing is being multiplied; your 10-30mm lens doesn't "become" a 27-81mm lens—the depth-of-field and lens aperture remain the same. Only the field of view is cropped. But *crop factor* isn't much better, as it implies that the 24 × 36mm frame is "full" and anything else is "less." I get e-mails all the time from photographers who point out that they own full-frame cameras with 36mm × 48mm sensors (like the Mamiya 645ZD or Hasselblad H3D-39 medium format digitals). By their reckoning, the "half-size" sensors found in cameras like the Nikon D700 and D3/D3x are "cropped."

If you're accustomed to using full-frame film cameras, you might find it helpful to use the crop factor "multiplier" to translate a lens's real focal length into the full-frame equivalent, even though, as I said, nothing is actually being multiplied. Throughout most of this book, I've been using actual focal lengths and not equivalents, except when referring to specific wide-angle or telephoto focal length ranges and their fields of view.

Crop or Not?

There's a lot of debate over the "advantages" and "disadvantages" of using a camera like the Nikon 1 series, with 2.7X cropped sensors. The two most important arguments go like these:

- **Dense pixels=more noise.** In order to pack 10 megapixels into the J1's small sensor, each pixel must be much smaller than those found in DX or FX cameras of the same resolution, and will have less light-gathering capabilities. Larger pixels capture light more efficiently, reducing the need to amplify the signal when boosting ISO sensitivity, and, therefore, producing less noise. In an absolute sense, this is true, and cameras like the D3s and D7000 *do* have sensational high-ISO performance. However, the J1's sensor is improved over earlier cameras, so you'll find it performs very well at higher ISOs. You needn't hesitate to use ISO 1600 with the Nikon J1: just don't expect the same low-noise results at ISO 3200 as D7000 owners get from their cameras.

- **Lack of wide-angle perspective.** Of course, the 2.7X "crop" factor applies to wide-angle lenses, too, so your J1 needs specially designed extra-wide lenses to provide a wide field of view. To date, the widest lenses available in CX format all have a minimum focal length of 10mm, which, after the 2.7X crop factor is applied, offers the same field of view as a moderate wide angle on an FX model. Ultrawide focal lengths are currently not available for the Nikon 1 cameras.

B

Glossary

Here are some terms you might encounter while reading this book or working with your Nikon J1.

additive primary colors The red, green, and blue hues that are used alone or in combinations to create all other colors that you capture with a digital camera, view on a computer monitor, or work with in an image-editing program, such as Photoshop.

ambient lighting Diffuse, non-directional lighting that doesn't appear to come from a specific source but, rather, bounces off walls, ceilings, and other objects in the scene when a picture is taken.

analog/digital converter The EXPEED 3 electronics built into the Nikon J1 that convert the analog information captured by the camera's sensor into digital bits that can be stored as an image bitmap.

angle of view The area of a scene that a lens can capture, determined by the focal length of the lens. Lenses with a shorter focal length have a wider angle of view than lenses with a longer focal length.

anti-alias A process that smoothes the look of rough edges in images (called *jaggies* or *staircasing*) by adding partially transparent pixels along the boundaries of diagonal lines that are merged into a smoother line by our eyes. *See also* jaggies.

Aperture-priority A camera setting, labeled A on the mode dial, that allows you to specify the lens opening or f/stop that you want to use, with the camera selecting the required shutter speed automatically based on its light-meter reading. This setting is represented by the abbreviation A in the Nikon J1's Exposure mode entry in the Shooting menu. *See also* Shutter-priority.

artifact A type of noise in an image, or an unintentional image component produced in error by a digital camera during processing, usually caused by the JPEG compression process in digital cameras.

aspect ratio The proportions of an image as printed, displayed on a monitor, or captured by a digital camera.

autofocus A camera setting that allows the Nikon J1 to choose the correct focus distance for you, based on the contrast of an image (the image will be at maximum contrast when in sharp focus).

backlighting A lighting effect produced when the main light source is located behind the subject. Backlighting can be used to create a silhouette effect, or to illuminate translucent objects. *See also* front lighting and side lighting.

barrel distortion A lens defect that causes straight lines at the top or side edges of an image to bow outward into a barrel shape. *See also* pincushion distortion.

blooming An image distortion caused when a photosite in an image sensor has absorbed all the photons it can handle so that additional photons reaching that pixel overflow to affect surrounding pixels, producing unwanted brightness and overexposure around the edges of objects.

blur To soften an image or part of an image by throwing it out of focus, or by allowing it to become soft due to subject or camera motion. Blur can also be applied in an image-editing program.

bokeh A term derived from the Japanese word for blur, which describes the aesthetic qualities of the out-of-focus parts of an image. Some lenses produce "good" bokeh and others offer "bad" bokeh. Some lenses produce uniformly illuminated out-of-focus discs. Others produce a disc that has a bright edge and a dark center, producing a "doughnut" effect, which is the worst from a bokeh standpoint. Lenses that generate a bright center that fades to a darker edge are favored, because their bokeh allows the circle of confusion to blend more smoothly with the surroundings. The bokeh characteristics of a lens are most important when you're using selective focus (say, when shooting a portrait) to de-emphasize the background, or when shallow depth-of-field is a given because you're working with a macro lens, a long telephoto, or a wide-open aperture. *See also* circle of confusion.

bounce lighting Light bounced off a reflector, including ceiling and walls, to provide a soft, natural-looking light.

bracketing Taking a series of photographs of the same subject at different settings, including exposure and white balance, to help ensure that one setting will be the correct one.

buffer The digital camera's internal memory where an image is stored immediately after it is taken until it can be written to the camera's non-volatile (semi-permanent) memory or a memory card.

bulb The shutter remains open while the shutter release button is held down. This setting is available when the camera is set to Manual mode.

burst mode Known as continuous shooting mode, burst shooting is the digital camera's equivalent of the film camera's motor drive, used to take multiple shots within a short period of time, with each image stored in a memory buffer temporarily before writing it to the media.

calibration A process used to correct for the differences in the output of a printer or monitor when compared to the original image. Once you've calibrated your scanner, monitor, and/or your image editor, the images you see on the screen more closely represent what you'll get from your printer, even though calibration is never perfect.

Camera Raw A plug-in included with Photoshop and Photoshop Elements that can manipulate the unprocessed images captured by digital cameras. The latest versions of this module can also work with JPEG and TIFF images.

camera shake Movement of the camera, aggravated by slower shutter speeds, which produces a blurred image. You can minimize camera shake by using the J1's image-stabilization feature.

Center-weighted metering A light-measuring method that emphasizes the area in the middle of the frame when calculating the correct exposure for an image. *See also* Matrix metering and Spot metering.

chromatic aberration An image defect, often seen as green or purple fringing around the edges of an object, caused by a lens failing to focus all colors of a light source at the same point. *See also* fringing.

circle of confusion A term applied to the fuzzy discs produced when a point of light is out of focus. The circle of confusion is not a fixed size. The viewing distance and amount of enlargement of the image determine whether we see a particular spot on the image as a point or as a disc. *See also* bokeh.

close-up lens A lens add-on accessory that allows you to take pictures at a distance that is less than the closest-focusing distance of the lens alone.

color correction Changing the relative amounts of color in an image to produce a desired effect, typically a more accurate representation of those colors. Color correction can fix faulty color balance in the original image, or compensate for the deficiencies of the inks used to reproduce the image.

compression Reducing the size of a file by encoding using fewer bits of information to represent the original. Some compression schemes, such as JPEG, operate by discarding some image information, while others, such as RAW, preserve all the detail in the original, discarding only redundant data.

contrast The range between the lightest and darkest tones in an image. A high-contrast image is one in which the shades fall at the extremes of the range between white and black. In a low-contrast image, the tones are closer together.

depth-of-field A distance range in a photograph in which all included portions of an image are at least acceptably sharp.

diaphragm An adjustable component, similar to the iris in the human eye, that can open and close to provide specific-sized lens openings, or f/stops, and thus control the amount of light reaching the sensor or film.

diffuse lighting Soft, low-contrast lighting.

digital processing chip A solid-state device found in digital cameras, such as the EXPEED 3 chip in the Nikon J1, that's in charge of applying the image algorithms to the raw picture data prior to storage on the memory card.

diopter A value used to represent the magnification power of a lens, calculated as the reciprocal of a lens's focal length (in meters). Diopters are most often used to represent the optical correction used in a viewfinder to adjust for limitations of the photographer's eyesight, and to describe the magnification of a close-up lens attachment.

exchangeable image file format (Exif) Developed to standardize the exchange of image data between hardware devices and software. A variation on JPEG, Exif is used by most digital cameras, and includes information such as the date and time a photo was taken, the camera settings, resolution, amount of compression, and other data.

Exif *See* exchangeable image file format (Exif).

exposure The amount of light allowed to reach the film or sensor, determined by the intensity of the light, the amount admitted by the iris of the lens, the length of time determined by the shutter speed, and the ISO sensitivity setting for the sensor.

exposure values (EV) EV settings are a way of adding or decreasing exposure without the need to reference f/stops or shutter speeds. For example, if you tell your camera to add +1EV, it will provide twice as much exposure by using a larger f/stop, slower shutter speed, or both.

fill lighting In photography, lighting is used to illuminate shadows. Reflectors or additional incandescent lighting or electronic flash can be used to brighten shadows. One common technique for outdoors is to use the camera's flash as a fill.

filter In photography, a device that fits over the lens, changing the light in some way. In image editing, a feature that changes the pixels in an image to produce blurring, sharpening, and other special effects. Photoshop includes several interesting filter effects, including Lens Blur and Photo Filters.

focal length The distance between the film and the optical center of the lens when the lens is focused on infinity, usually measured in millimeters.

format To erase a memory card and prepare it to accept files.

fringing A chromatic aberration that produces fringes of color around the edges of subjects, caused by a lens's inability to focus the various wavelengths of light onto the same spot. Purple fringing is especially troublesome with backlit images.

front lighting Illumination that comes from the direction of the camera. *See also* backlighting and side lighting.

f/stop The relative size of the lens aperture, which helps determine both exposure and depth-of-field. The larger the f/stop number, the smaller the f/stop itself.

gray card A piece of cardboard or other material with a standardized 18-percent reflectance. Gray cards can be used as a reference for determining correct exposure or for setting white balance.

HDMI (High Definition Multimedia Interface) An interface for transmitting audio and video information between a source, such as a digital camera or television tuner, to an output device, such as a high-definition television (HDTV) monitor.

high contrast A wide range of density in a print, negative, or other image.

highlights The brightest parts of an image containing detail.

histogram A kind of chart showing the relationship of tones in an image using a series of 256 vertical bars, one for each brightness level. A histogram chart, such as the one the Nikon J1 can display, typically looks like a curve with one or more slopes and peaks, depending on how many highlight, midtone, and shadow tones are present in the image.

hyperfocal distance A point of focus where everything from half that distance to infinity appears to be acceptably sharp. For example, if your lens has a hyperfocal distance of four feet, everything from two feet to infinity would be sharp. The hyperfocal distance varies by the lens and the aperture in use. If you know you'll be making a grab shot without warning, sometimes it is useful to turn off your camera's automatic focus, and set the lens to infinity, or, better yet, the hyperfocal distance. Then, you can snap off a quick picture without having to wait for the lag that occurs with most digital cameras as their autofocus locks in.

image rotation A feature that senses whether a picture was taken in horizontal or vertical orientation. That information is embedded in the picture file so that the camera and compatible software applications can automatically display the image in the correct orientation.

image stabilization A technology that compensates for camera shake, usually by adjusting the position of the camera sensor (with some vendors) or, in the case of the Nikon J1 cameras, lens elements that shift in response to movements of the camera.

incident light Light measured as it falls on a surface, as opposed to light reflected from that surface.

International Organization for Standardization (ISO) A governing body that provides standards used to represent film speed, or the equivalent sensitivity of a digital camera's sensor. Digital camera sensitivity is expressed in ISO settings.

interpolation A technique digital cameras, scanners, and image editors use to create new pixels required whenever you resize or change the resolution of an image based on the values of surrounding pixels. Devices such as scanners and digital cameras can use interpolation to create pixels in addition to those actually captured, thereby increasing the apparent resolution or color information in an image.

ISO *See* International Organization for Standardization (ISO).

jaggies Staircasing effect of lines, most easily seen at large magnifications, that are not perfectly horizontal or vertical, caused by pixels that are too large to represent the line accurately. *See also* anti-alias.

JPEG Short for Joint Photographic Experts Group. A file "lossy" format that supports 24-bit color and reduces file sizes by selectively discarding image data. Digital cameras generally use JPEG compression to pack more images onto memory cards. You can select how much compression is used (and, therefore, how much information is thrown away) by selecting from among the Standard, Fine, Super Fine, or other quality settings offered by your camera. *See also* RAW.

Kelvin (K) A unit of measure based on the absolute temperature scale in which absolute zero is zero; it's used to describe the color of continuous-spectrum light sources and applied when setting white balance. For example, daylight has a color temperature of about 5,500K, and a tungsten lamp has a temperature of about 3,400K.

lag time The interval between when the shutter is pressed and when the picture is actually taken. During that span, the camera may be automatically focusing and calculating exposure. With digital cameras like the Nikon J1, lag time is generally very short.

latitude The range of camera exposure that produces acceptable images with a particular digital sensor or film.

lens flare A feature of conventional photography that is both a bane and a creative outlet. It is an effect produced by the reflection of light internally among elements of an optical lens. Bright light sources within or just outside the field of view cause lens flare. Flare can be reduced by the use of coatings on the lens elements or with the use of lens hoods. Photographers sometimes use the effect as a creative technique, and Photoshop includes a filter that lets you add lens flare at your whim.

lighting ratio The proportional relationship between the amount of light falling on the subject from the main light and other lights, expressed in a ratio, such as 3:1.

lossy compression An image-compression scheme, such as JPEG, that creates smaller files by discarding image information, which can affect image quality.

Matrix metering One system of exposure calculation used by the Nikon J1 that looks at many different segments of an image to determine the brightest and darkest portions. *See also* Center-weighted metering and Spot metering.

maximum burst The number of frames that can be exposed at the current settings until the buffer fills.

midtones Parts of an image with tones of an intermediate value, usually in the 25 to 75 percent brightness range. Many image-editing features allow you to manipulate midtones independently from the highlights and shadows.

neutral color A color in which red, green, and blue are present in equal amounts, producing a gray.

neutral-density filter A gray camera filter that reduces the amount of light entering the camera without affecting the colors.

noise In an image, pixels with randomly distributed color values. Noise in digital photographs tends to be the product of low-light conditions and long exposures, particularly when you've set your camera to an ISO rating higher than about ISO 800.

noise reduction A technology used to cut down on the amount of random information in a digital picture, usually caused by long exposures at increased sensitivity ratings. In the Nikon J1, noise reduction is automatically applied for long exposures. Noise reduction can be switched off if you'd rather not use it.

overexposure A condition in which too much light reaches the film or sensor, producing a dense negative or a very bright/light print, slide, or digital image.

pincushion distortion A type of lens distortion in which lines at the top and side edges of an image are bent inward, producing an effect that looks like a pincushion. *See also* barrel distortion.

RAW An image file format, such as the NEF format in the Nikon J1, which includes all the unprocessed information captured by the camera after conversion to digital form. RAW files are very large compared to JPEG files and must be processed by a special program such as Nikon ViewNX or Adobe's Camera Raw filter after being downloaded from the camera.

saturation The purity of color; the amount by which a pure color is diluted with white or gray.

selective focus Choosing a lens opening that produces a shallow depth-of-field. Usually this is used to isolate a subject in portraits, close-ups, and other types of images, by causing most other elements in the scene to be blurred.

self-timer A mechanism that delays the opening of the shutter for some seconds after the release has been operated.

sensitivity A measure of the degree of response of a film or sensor to light, measured using the ISO setting.

shadow The darkest part of an image, represented on a digital image by pixels with low numeric values.

sharpening Increasing the apparent sharpness of an image by boosting the contrast between adjacent pixels that form an edge, whether done in the camera or in image-editing software.

shutter In a conventional film camera, the shutter is a mechanism consisting of blades, a curtain, a plate, or some other movable cover that controls the time during which light reaches the film. The Nikon J1 has an electronic shutter which performs the functions of physical blades, allowing much faster shutter speeds (up to 1/16,000th second).

Shutter-priority An exposure mode, represented by the letter S in the Exposure entry in the Nikon 1's Shooting menu, in which you set the shutter speed and the camera determines the appropriate f/stop. *See also* Aperture-priority.

side lighting Applying illumination from the left or right sides of the camera. *See also* backlighting and front lighting.

slow sync An electronic flash synchronizing method that uses a slow shutter speed so that ambient light is recorded by the camera in addition to the electronic flash illumination. This allows the background to receive more exposure for a more realistic effect.

specular highlight Bright spots in an image caused by reflection of light sources, often from shiny surfaces.

Spot metering An exposure measuring system that concentrates on a small area in the image. *See also* Center-weighted metering and Matrix metering.

time exposure A picture taken by leaving the shutter open for a long period, usually more than one second. The camera is generally locked down with a tripod to prevent blur during the long exposure. The shutter remains open until the button is pressed a second time. Requires the ML-L3 remote control on this camera.

tungsten light Light from ordinary room lamps and ceiling fixtures, as opposed to fluorescent illumination.

underexposure A condition in which too little light reaches the film or sensor, producing a thin negative, a dark slide, a muddy looking print, or a dark digital image.

white balance The adjustment of a digital camera to the color temperature of the light source. Interior illumination is relatively red; outdoor light is relatively blue. Digital cameras like the Nikon J1 set correct white balance automatically or let you do it through menus. Image editors can often do some color correction of images that were exposed using the wrong white balance setting, especially when working with RAW files that contain the information originally captured by the camera before white balance was applied.

Index

COURSE TECHNOLOGY
CENGAGE Learning™
Professional • Technical • Reference

Like the Book?

Let us know on Facebook or Twitter!

facebook.com/courseptr

twitter.com/courseptr

INSPIRED

A Bible Companion for Teens

MARK HART

Authored by Mark Hart

Cover design by David Calavitta
Interior design by Ryan McQuade

Copy editing by Elizabeth Bayardi

Published by Life Teen, Inc. 2222 S. Dobson Rd. Suite 601 Mesa, AZ 85202
LifeTeen.com

TABLE OF CONTENTS

Making Scripture a Daily Prayer

Appendix

INTRODUCTION

There it sits: big, intimidating, and one might even say "*old*." But calling the Bible old is actually a little short-sighted. While the writings are old, it would probably be more accurate to call it *ancient* since the word "old" usually has a negative connotation associated with it. When we say the Bible is ancient, however, it can mean many things. Ancient as in "it comes from a different time or place," yes, but also as in it has survived countless centuries and assaults against it.

Written in more languages, read by more people, with more copies published and sold than any other written work in the history of the world, the Holy Bible stands alone. Kings and rulers have tried to outlaw it, wars have been waged over it, and millions of lives have been lost but also found because of it. God's divine revelation: inspired, recorded, entrusted, and gifted to us. And although the Bible is often judged by its cover and let's be honest, the covers of many Bibles are pretty un-inspiring, no other book will ever compare. Seventy-three books, inspired by God and recorded over a span of about 1,700 years by more than 40 separate authors, the Bible is one of our greatest family heirlooms.

Consider a starry sky, a sunset on the ocean, or a baby's laughter. Assuredly, the creator is seen throughout His gorgeous creations, but God's revelation is not limited to nature. God declares His love and providence in a myriad of ways and just as freely as He reveals Himself to us through created things, so He does through His inspired Word. God's plan for our salvation is played out age-after-age, from the dawn of history. But the danger for modern believers is when we fail to see

history as just that: *His story*. Even more dangerous is when we don't understand that our stories are found in and wrapped up in God's.

As Pope Francis reminded us, "So this love story began, a story that has gone on for so long, and is not yet ended. We, the women and men of the Church, we are in the middle of a love story: each of us is a link in this chain of love. And if we do not understand this, we have understood nothing of what the Church is." [1]

Consider this: Jesus Christ could have chosen to teach us in a variety of ways. He could have stuck with only long sermons using such big words that even the greatest minds, like St. Thomas Aquinas, would have appeared as nothing more than gurgling babies in comparison. The fact that the second person of the Trinity chose to employ story-telling (parables) as His primary teaching tool tells us a great deal. Everyone loves a good story and our story is part of the greatest story ever told.

There's a reason the Bible has been translated into every conceivable language on Earth (even "Klingon" for you Star Trek fans). There's a reason that when Johannes Gutenberg — a Catholic — invented the printing press, his first print job was the Bible. There's a reason we paint our favorite verses on walls or scribble them in greeting cards. After thousands of years not even Hallmark can do better than "Love is patient. Love is kind," which is probably why they quote it so often. And although the works of Shakespeare and Austen and Hemingway are beautiful, and their characters are beloved, these authors were only masters of the

written word — but Jesus is the living Word incarnate who came down from heaven. While inspired by life and love, these authors were not inspired in the same way as the authors of the Bible — not by the purest love of the Holy Spirit.

The Bible is prayer, the very breath and life of God. It is the Word of God, not mere words "about" God. That distinction necessitates our attention and demands reverence. That distinction should comfort you in your affliction and "afflict" you when you get too comfortable. The journey to God is about joy not happiness. Happiness is fleeting but joy — of a life in Christ and life in heaven — is eternal. We come to know that life in Christ through the sacraments and quite literally through the Scriptures, for only in knowing Christ do we come to know what it means to truly live.

WHY SCRIPTURE?

GETTING TO KNOW GOD

There are a lot of ways you can get to know someone: you can hear about them from someone else, you can check out their Snapchat or Instagram, or you can watch how they interact with other people. If they're famous, you might even watch a YouTube interview or read a blog about their life. None of these methods, though, are nearly as effective as actually sitting with the person, one-on-one, and asking them meaningful questions like:

Where did you grow up?
What was your childhood like?
What are you most afraid of?
What brings you the most joy?
Why do you do what you do?
How does it make you feel when...?
Who is your personal hero?
What roles do God and faith play in your life?

Questions like these help you get past shallow topics and allow you to really get to know a person; they reveal a person's true identity. While you can use these questions to get to know other people, they are also a great starting point for getting to know yourself.

Where does your identity come from? Where do your beliefs come from? What (or who) do you base your decisions on? These are all important questions to reflect on and they should all lead you back to one fundamental truth: You are not your own creator. You are the main character in your story, but you are not the author of your life.

God is the author of your life.

That's right, God is the author and you are a character in *His story*, not the other way around. Reality reveals (and the Bible affirms) that God created you through your parents. He loves you and wants you here. And if you really want to know yourself, the best and fastest way to do that is to get to know the one who created you.

The Bible is a great way to get to know God, the author of your story. By reading about His interactions with people who came before us, you not only learn about how God thinks and moves, but how others have responded to Him in both right and wrong ways.

When you read Scripture, you will see that while customs and traditions change, people don't really change all that much. You will realize that you have more in common with Biblical characters than you would have originally thought. We aren't just reading about people from thousands of years ago. No, when we read the Bible it's as though we're reading about ourselves. God doesn't change, so knowing what did and did not please Him then is a great way of knowing what does and does not please Him now.

In this Bible companion you are going to be introduced (or reintroduced) to God's Word in a variety of ways. You'll learn how to navigate the Scriptures, locating the chapter, verse, and specific stories. You'll be given an overview of different kinds of writings and styles, what to look for, and honestly, what you probably want to "avoid" as you begin reading. You'll be given practical examples, tools, and important insights so you can start to successfully pray the Bible on your own. Additionally, you'll be directed to dozens of passages and stories, some of which you might know well and others you might not recognize at all. Some

are heroic and some are heartbreaking, but they're all thoroughly human. If you look hard enough, you might find a little bit of yourself in each story. At the very least, you'll be reintroduced to a God who is madly in love with you.

It's important to remember that while God might not love everything you do, He loves you and is cheering you on to your own sainthood. This companion will act as a small step in that direction. Some of the verses you'll find cited will convict you, some will challenge you, and many will affirm you. In the pages that follow, the Holy Spirit will meet you where you're at and inspire you to look deeper, further, and higher.

The characters and stories from Sacred Scripture all have something worth imitating and learning, so stop and learn from them. What you'll soon realize is that living as a Christian is not so much about "finding yourself," as it is about finding and unleashing Christ's presence and power within you. The more you recognize God's presence — in you, your family, your school, the Church, the world — the better you'll be able to share His love with all those you come in contact with.

The secret to a joyful life and a hope-filled future isn't about figuring out tomorrow, it's about listening to God today. God, the author of life, has something to say to you through the brothers and sisters who came before you. If you want to know God better, take a deep breath and turn the page.

It's story time.

OUR TYPICAL CATHOLIC
EXPERIENCE OF SCRIPTURE

The opening music has ended (hopefully on the correct note). The priest has recited the opening prayer. We have punched ourselves in the chest while uttering the Latin phrase *"mea culpa."* A kind-looking, elderly woman in a flower-print dress walks up to the ambo (the podium that holds the book of readings) and adjusts the microphone, sending an awful sound and nerve-wracking shockwaves down every Mass-goers' spine.

"A Reading from Second Kings," she proclaims in a monotone voice, eliciting neither excitement nor familiarity from 99 percent of the souls in the pews. She continues with a passage such as this:

"But every nation still made gods of its own, and put them in the shrines of the high places which the Samaritans had made, every nation in the cities in which they dwelt; the men of Babylon made Suc'coth-be'noth, the men of Cuth made Nergal, the men of Hamath made Ashi'ma, and the Av'vites made Nibhaz and Tartak; and the Sephar'vites burned their children in the fire to Adram'melech and Anam'melech, the gods of Sepharva'im. They also feared the Lord, and appointed from among themselves all sorts of people as priests of the high places, who sacrificed for them in the shrines of the high places."

At this point, even Biblical scholars have a headache. If you were able to track the reading for even the first 15 seconds, you probably began wondering, *"Is it God's*

plan to torture me? Why am I hearing this? What could this possibly have to do with my life?!?"

Then the kind lady utters, "The Word of the Lord" to the congregation. We respond, "Thanks be to God" in a tone that sounds more like gratitude for the painful reading coming to an end than a prayer.

It was usually at this point — after the first reading (from the Old Testament) and before the song (which is a psalm, also from the Bible) — that I would completely zone out. I believed God and the Church had nothing for me and could not be more disassociated from my reality, so I stopped listening.

The truth is that I'm not the only person who has ever felt this way and if you've ever shared this feeling, you're not alone. It doesn't make you horrible, it makes you human.

But, here's the thing: A reading or passage from the Old Testament (or anywhere in Scripture, for that matter) may not appear to have any point or purpose or anything to do with your life, but there is always something you can take away from it.

God's Word is timeless truth and nothing in Scripture is there by "accident." The Bible was inspired by the Holy Spirit, so the writing is intentional and purposeful. That being said, since we are reading about ancient cultures in foreign lands, many of the facts and details — in order to be properly understood — require context.

This is where people go wrong.

Often times people focus only on the *content*, the who, what, when, and where of a story. The problem with this being the sole focus, however, is that it fails to take into consideration the original authors' intended meaning and audience, as well as their cultural perspective and idiomatic expressions. We, as Catholics, are blessed to have sacred tradition, which helps us "read out" the intended meaning of a passage (a term called *exegesis*) rather than "read into" a passage with our own cultural biases. Put more simply, the Catholic perspective offers us *context* — which gives us information (content), but also shows us how all of the content (the who, what, when, and where) is woven together (context) into the picture of salvation history. Context gives us a bigger perspective; it speaks to the "why."

At first hearing, then passage from 2 Kings could not be more confusing as it mentions gods and lands we are not familiar with in the 21st century. However, if we know or learn a little Biblical history and the time period it is set in, we realize this story offers us timeless truth. Interestingly enough, this passage comes from a period in which the northern kingdom of Israel had been overrun by the king of Assyria. Israel's king at the time was a despicable and cowardly man who turned his back on the one, true God. As a result, the king of Assyria (who believed in many gods) overthrew Israel, enslaved many, killed many more, and settled in Samaria (Israel's capital) with many Assyrians who brought their worship of false gods with them. In this reading, we hear of some of the horrid practices that took place — Assyrians worshipping their false gods

and murdering their innocent children, burning them alive as part of their idol worship.

Can you imagine a culture or society that does not protect the innocent lives of children? Can you imagine what terrible things happen when people stop worshipping the one, true God and begin worshipping false gods or, worse yet, themselves? Of course you can. Even in the 21st century, we see what happens when people turn their backs on God, truth, and the dignity of human life. This is just one example of verses that may seem "outdated" or purposeless to us upon first hearing but that, after further examination, prove to be timeless in their wisdom.

Still, it takes time to learn the backstory, history, and context. You may be thinking, *That's great, but what does the Bible have to say to me about everything I have going on in my life today?*

Let's take a step back and try an exercise.

First, take a deep breath and clear your mind of all distractions.

Next, make the Sign of the Cross. Invite the Holy Spirit, the author of Scripture, to be with you and open your eyes, mind, and heart to what He wants to speak to you, this day.

Pray, "Come Holy Spirit" several times. Then pray through the verses that follow until you find one that "speaks" to your heart. Once you find one, read and pray through it several times.

GOD "VERSES" US

"Let no one despise your youth, but set the believers an example in speech and conduct, in love, in faith, in purity." – 1 Timothy 4:12

"Not every one who says to me, 'Lord, Lord,' shall enter the kingdom of heaven, but he who does the will of my Father who is in heaven." – Matthew 7:21

"If the world hates you, know that it has hated me before it hated you. If you were of the world, the world would love its own; but because you are not of the world, but I chose you out of the world, therefore the world hates you." – John 15:18-19

"Truly, I say to you, whoever does not receive the kingdom of God like a child shall not enter it." – Mark 10:15

"No temptation has overtaken you that is not common to man. God is faithful, and he will not let you be tempted beyond your strength, but with the temptation will also provide the way of escape, that you may be able to endure it." – 1 Corinthians 10:13

"You shall love the Lord your God with all your heart, and with all your soul, and with all your mind, and with all your strength." – Mark 12:30

"Finally, be strong in the Lord and in the strength of his might." – Ephesians 6:10

"Take heed to yourselves; if your brother sins, rebuke him, and if he repents, forgive him." – Luke 17:3

"My lips will shout for joy, when I sing praises to thee; my soul also, which thou hast rescued." – Psalm 71:23

"Then our mouth was filled with laughter and our tongue with shouts of joy; then they said among the nations, 'The Lord has done great things for them.'"
– Psalm 126:2

"Count it all joy, my brethren, when you meet various trials." – James 1:2

"Whoever hates reproof walks in the steps of the sinner, but he that fears the Lord will repent in his heart."
– Sirach 21:6

"Without having seen him you love him; though you do not now see him you believe in him and rejoice with unutterable and exalted joy." – 1 Peter 1:8

"O God, from my youth thou hast taught me, and I still proclaim thy wondrous deeds." – Psalm 71:17

Now, ask yourself these questions:

- Why did this verse jump out at me today?

- Did any of the other verses also stand out to me?

- How is it that something written thousands of years ago can still speak to me, today?

- What difference does it make that these words come from God and not just a human author?

- What is God trying to tell me today about Himself, His love, or my life through this verse?

Now, read through the verse again and try to commit it to memory. You can go back to it daily or weekly, too. You'll probably find that, in time, other verses will begin to jump out and speak to you as well. Timeless truth has a funny way of never becoming outdated.

IS THE BIBLE RELIABLE READING?

The hotel room was pitch black. The air conditioner was on full blast. I was surrounded by pillows and hibernating in a cocoon-like fashion. I was perfectly comfortable so, of course, it was at that moment that I had to pee.

I began to navigate the foreign surroundings in the dark, making my way to the bathroom when, "WHAM!" I discovered a large dresser in my path. I yelped and fell back onto the bed. I'm not certain but it's quite likely that the word "shin" is Latin for "to find furniture in the dark."

It was at that moment, writhing in pain and wishing for death, that I recalled the famous passage from the Book of Psalms:

"Thy word is a lamp to my feet and a light to my path."
– Psalm 119:105

If only I had taken advantage of the light, I could have avoided so much pain.

But, the passage is teaching us more than that by reminding us that if more people sought the Word of God (Jesus Christ) in His Word (the Bible), they wouldn't be trapped in darkness (sin), blindly stumbling through life.

The Scriptures are meant to be a light. They are designed to not only guide us through darkness but also to beckon others to safety. They reveal God's plan, speak truth, and challenge us to change. God's Word, while timeless, offers timely wisdom for any circumstance or challenge we face. Basically, the Father loved us so

much that He gave us His Word (the compass) and His Church (the guide), refusing to orphan His children in a wilderness of sin and immorality.

Still, there are countless people who argue that the Bible is "unreliable" or "outdated." Many people — some of whom are well read and quite intellectual — do everything they can to debunk the validity of Scripture, thinking that if they can exploit seeming "inconsistencies" or supposed "errors," they can somehow do away with Christianity and God. That's the first mistake.

When Theology is "Out of Order"

Saying, "The Bible has some things I don't agree with, so the Church must be wrong and God, therefore, is 'unloving' or 'not real' (or whatever else)" is completely backward. Faith doesn't begin with the Bible. You don't use the Bible to prove God's existence — that's like using the music of Nikki Minaj or One Direction to "prove" God hates me.

No, we begin with God. Once a soul believes in God, there's a decision to make regarding whether or not Jesus is God. Then, one must determine whether or not Christ instituted a Church. After that, one must understand that the Bible came out of a living Church (not vice versa).

The early Church — the first generation of eyewitness believers — was a Church of oral tradition that slowly gave us written tradition. That's one reason St. Paul is so quick to remind us to follow the Church (1 Timothy

3:15, 1 Corinthians 11:2, 2 Thessalonians 2:15). The Church didn't "come out of" the Bible, the Bible came out of Christ's Church.

Words Matter

We proclaim, as did the early Christians, that the Bible is the Word of God, not merely words "about" God. By the inspiration of the Holy Spirit, these words were written down to communicate the truth of the events that had occurred and were occurring.

Saint Luke, by his own admission, was not an eyewitness (although Matthew and John were) but received the truth of the events from eyewitnesses and ministers (Luke 1:2). He was so taken by the inexplicable reality of what he heard and saw, that he just had to write it down in an orderly way and share it (Luke 1:3). The truth was too good not to share (Luke 1:4). So, the question isn't, "Why did they feel the need to share this with all they encountered?" The real question is, "Why don't more people today have a passion to share it?"

"Modern" Snobs

The next mistake is when modern minds get snobbish, saying the Bible is "too outdated" or "not applicable" in our current culture. The notion that "old ideas" are not as solid as new ideas is not only senseless, it's dangerously prideful. In fact, old ideas are often far better because they've held up over time.

If you claimed to know better than a group of people in the modern age, you'd sound like a snob. Someone

claiming to "know better'" than a group of people from the past really isn't any different. Yes, you have the internet, but they knew how to build pyramids without cranes, harvest crops without tractors, heal people without prescriptions, and chart stars without telescopes. Newer isn't always better and that idea applies to the Bible as well.

Angels are not Fairies

Some people try to dismiss the Bible because they say it's just fairy tales and myths. Not only are they denying the eyewitness accounts of countless souls who saw loaves multiplied, the dead raised, and the sea parted, they are also confusing different types of storytelling. Allegory was a popular form of storytelling, for instance. When the writers of Scripture, led and inspired by the Holy Spirit, used allegories as moral parables, they communicated truth, even if the truth was not literal.

The Church doesn't teach that God created everything in six, 24-hour periods. However, she does teach that everything was created by God with purpose. While the stories of creation may not be "scientifically accurate" as some scholarly types like to point out, it's important to note that Genesis was not written as a scientific account. The author(s) of Genesis sought to explain why God created, not "how." Saying Genesis scientifically proves God doesn't exist is like saying my love letter to my wife doesn't prove I exist or the phone book doesn't prove gravity is real; that was never their intended purpose!

Now, that's not to say that everything in the Bible is allegorical, far from it. Jesus healed the blind man, literally. He multiplied the loaves, literally. You can take additional symbolic or sacramental meaning out of the miracle, but it only enhances the physical, literal truth of the action. It's not an "either/or" but a "both/and" kind of miracle.

Finding Yourself in Scripture

Given all of this, some still wonder why we even need the Bible anymore. I mean, if we have our common sense, a conscience, and the Church, isn't the Bible — with all of its ancient, cultural references and accepted "ways of life" — kind of unnecessary?

If anything, we need the Bible more now than ever before. For instance, what if the God you think you know isn't the actual God, at all? Many people today follow a concept of Jesus that is not historically accurate — a pleasant, politically correct, "be nice to everyone" Jesus who is anything but Biblical. Many people ascribe traits to God that are not even remotely consistent with the God of Scripture.

In the Bible, you encounter the God of the universe and see how He moves, thinks, and speaks. You're not simply reading about characters from long ago, you're reading about your very self. The Bible isn't merely speaking to you; it's speaking about you. You are Adam and Eve, standing before God in all of your sin. You are Moses, worrying about your reputation. You are David, putting your wants before God's. You are Esther, deciding whether or not to endanger

yourself in order to protect others. You are Peter, being called to lead even though you're far from perfect. You are the woman at the well, being told you have worth regardless of your past.

This is what the Bible offers you: an invitation to know God more deeply. The Bible helps you know God beyond just your head and engage Him in your heart. Scripture deepens your prayer, enlivens your worship, and makes the sacraments come to life in a whole new way.

WHY DO IT? THE GOAL OF READING THE BIBLE

What is the goal of reading the Bible, in general? There are far easier "self-help" books you can access and more readily understand, so why do you go to church or pray or take a few minutes to open up a book that is thousands of years old?

Well, since we're on the subject — and since the goal of this book is to help you begin to read and "get more" out of the Bible — let's let Scripture answer the question for us.

Turn to **1 Peter 1:9**.

What does it say is the "goal" of our faith?

The reason we "do" any and all of these faith-y, church-y things is the same: salvation. The reason we read the Bible, the reason we pray, the reason we go to Mass, the reason for every confession, rosary, act of service, and sacrament is the same — salvation. Notice, though, that the verse says, "the salvation of souls."

It's plural.

The goal of faith — and of reading the Bible — is not just for your salvation, but for the salvation of all. We have a responsibility to not only share a "what" (God's truth), but a "who" (God, Himself, in Jesus Christ). This is the reason we read the Bible, not merely to grow in knowledge of how God works or thinks or all He promises, but to grow in love for Him. Through Scripture,

we learn how to die to ourselves (2 Corinthians 5:15) and let Christ shine in and through us (Galatians 2:20). So that's the goal of reading the Bible, that all might know Christ and experience salvation from sin and death — that all can come to know God and live with Him for eternity.

Now that you understand the overarching goal, you're going to need to desire to actually read the Bible. You'll need to know where to start as well as what books and sections to wait on until you develop some background and skills.

Let's begin at the beginning and get a feel for the Bible, as a whole, and how to navigate it before we start talking about which books to dive into and which (for now) to "avoid."

HOW IS THE BIBLE ORGANIZED?

NAVIGATING THE BIBLE

The Bible is the most unique and unparalleled book in existence. Truthfully, though, it is not one book but many. The very word "bible" comes from the Latin word *biblia*, which means "collection of books" (think of the term "bibli-ography").

The Catholic Bible is comprised of 73 books and contains many different types of writing, including history, poetry, music, personal letters, visions, prophecies, advice, letters to communities of people, memoirs, allegories, and more.

THE BOOKS OF THE BIBLE
AND THEIR ABBREVIATIONS

The 73 Books of the Bible are broken into 46 Old Testament books that trace salvation history from creation until just before the birth of Christ. The 27 New Testament books begin with the four Gospels, which tell us of Christ's life, death, and Resurrection, and are followed by stories of the growth, challenges, persecutions, and successes of the early Church and the first Christian communities. The New Testament closes with the Book of Revelation, giving us insight into both the past and the future.

All of the books also have abbreviations to make it easier to cite them in books like this one or other works. The 73 Biblical books and their most common abbreviations are as follows:

Old Testament

Genesis – Gen

Exodus – Ex

Leviticus – Lev

Numbers – Num

Deuteronomy – Deut

Joshua – Josh

Judges – Judg

Ruth – Ruth

1 Samuel – 1 Sam

2 Samuel – 2 Sam

1 Kings – 1 Kings

2 Kings – 2 Kings

1 Chronicles – 1 Chr

2 Chronicles – 2 Chr

Ezra – Ezra

Nehemiah – Neh

Tobit - Tob

Judith – Jdt

Esther – Esth

1 Maccabees – 1 Macc

2 Maccabees – 2 Macc

Job – Job

Psalms – Ps(s) Hosea – Hos
Proverbs – Prov Joel – Joel
Ecclesiastes – Eccl Amos – Am
Song of Songs – Song Obadiah – Ob
Wisdom – Wis Jonah – Jon
Sirach – Sir Micah – Mic
Isaiah – Isa Nahum – Nah
Jeremiah – Jer Habakkuk – Hab
Lamentations – Lam Zephaniah – Zeph
Baruch – Bar Haggai – Hag
Ezekiel – Ezek Zechariah – Zech
Daniel – Dan Malachi – Mal

New Testament

Matthew – Mt 1 Timothy – 1 Tim
Mark – Mk 2 Timothy – 2 Tim
Luke – Lk Titus – Titus
John – Jn Philemon – Philem
Acts of the Apostles – Acts Hebrews – Heb
Romans – Rom James – Jas
1 Corinthians – 1 Cor 1 Peter – 1 Pet
2 Corinthians – 2 Cor 2 Peter – 2 Pet
Galatians – Gal 1 John – 1 Jn
Ephesians – Eph 2 John – 2 Jn
Philippians – Phil 3 John – 3 Jn
Colossians – Col Jude – Jude
1 Thessalonians – 1 Thess Revelation – Rev
2 Thessalonians – 2 Thess

How to Look Up a Bible Verse Using its Citation

It's possible you've never actually looked up a Bible verse before, but it's actually really easy. You may have seen the famous citation "John 3:16," for instance, on a poster in the end zone of a football field. You may have even seen "Jn 3:16." So, we know the "Jn" stands for the Gospel of John. The first number (before the colon) always references the chapter of the aforementioned book. You'll find the chapter numbers at the top of your Bible's pages and at the beginning of individual sections on each page. The second number (after the colon) stands for the verse. These are the smaller numbers you find within the text, separating thoughts and sentences.

So, when you see John 3:16, you'll turn to the New Testament (use the list on the previous page until you learn your way around the Old and New Testaments). Then you'll flip to chapter three (look at the top of the pages) and once in chapter three, look for the number "16" embedded within the text. There you'll find quite possibly the most famous verse in all of Sacred Scripture:

"For God so loved the world that he gave his only Son, that whoever believes in him should not perish but have eternal life." – John 3:16

NAVIGATING THE DIFFERENT TYPES OF BOOKS

Let's say you look up **Jn 3:16** and it seems to make sense. It's talking about Jesus, the cross, and God's plan to save us. It's read just as it was intended. It's clear. It's concise.

What if the next verse was **Prov 3:5-6** or **Rev 21:4-5**?

Go ahead and look them both up.

Now, do we understand them in the same way? All three verses teach us something about God, but they are different types of writing. In the Gospel of John, we have tales and details about Jesus' life and ministry. In Proverbs, we have what is called a "wisdom book," a book which, quite obviously, offers us wisdom. In Revelation, we have an "other" book that some list as prophetic, others apocalyptic, and still others, in a category all its own.

If you had to break the Bible down into only three "types" of books, they would be: history, wisdom, and prophecy. In other words, you can look at the past (historical), the present (wisdom), and the future (prophetic); or to put it more simply, where we've been, where we are, and where we're going.

The point being, we cannot fall into the trap of reading all of the books of the Bible in the same way. Some are meant to be read factually. Others are meant to be read allegorically or, even, metaphorically. Some are meant to communicate symbolism and others literalism.

Some people get annoyed with the first 11 chapters of Genesis because they aren't "scientific enough." They're looking for an exact "how" regarding the creation of the universe. The problem is that the author(s) of Genesis wasn't nearly as concerned about the "how" of creation as the "why." Looking for scientific facts while reading Genesis is like looking for a mathematic equation in a love letter — it's not the point of that type of writing.

Say you're writing a persuasive paper for your English class. The strategy you employ and points you make to support your thesis will look very different in this type of paper than they would in a compare/contrast paper, for instance. You, as the author, utilize different styles and strategies to make different points at different times to different audiences, all the while trying to convey truth. That is what the different types of writings in the Bible do, too.

In an effort to make the varying styles of the 73 books a little more understandable, I've broken them down into seven categories:

The Law
- Genesis
- Exodus
- Leviticus
- Numbers
- Deuteronomy

Historical (some Bibles list the last five as Narratives/ Novellas in their "own" section)
- Joshua
- Judges

- Ruth
- 1 Samuel
- 2 Samuel
- 1 Kings
- 2 Kings
- 1 Chronicles
- 2 Chronicles
- Ezra
- Nehemiah
- Tobit
- Judith
- Esther
- 1 Maccabees
- 2 Maccabees

Wisdom
- Job
- Psalms
- Proverbs
- Ecclesiastes
- Song of Songs
- Wisdom
- Sirach

The Prophets
- Isaiah
- Jeremiah
- Lamentations
- Baruch
- Ezekiel
- Daniel
- Hosea
- Joel
- Amos

- Obadiah
- Jonah
- Micah
- Nahum
- Habakkuk
- Zephaniah
- Haggai
- Zechariah
- Malachi

The Gospels
- Matthew
- Mark
- Luke
- John
- Acts of the Apostles (technically not a Gospel but a "sequel" to Luke's Gospel — it deserves a prominence all its own apart from the other New Testament letters and books)

The Epistles
- Romans
- 1 Corinthians
- 2 Corinthians
- Galatians
- Ephesians
- Philippians
- Colossians
- 1 Thessalonians
- 2 Thessalonians
- 1 Timothy
- 2 Timothy
- Titus
- Philemon

The (Other) New Testament Letters
- Hebrews
- James
- 1 Peter
- 2 Peter
- 1 John
- 2 John
- 3 John
- Jude
- Revelation (although people classify Revelation many different ways)

Hopefully this list will make it a little easier to spot consistencies and idiosyncrasies when reading different types of writing. Before you open a Biblical book, take a few minutes to look at the overview in this resource or read the introduction that (hopefully) precedes it in your own Bible. Remember, too, that the Catholic Church — given its long tradition and history — is invaluable at helping you navigate and read Scripture through its proper contextual lens.

Some stories are strictly historical, others completely symbolic. You'll come across many, however, that capture both senses and styles beautifully (divinely, I'd say). Take, for instance, the story of the man born blind in John chapter nine. This story is historically true — Jesus did, in fact, heal a blind man. This story is also very symbolic in that Jesus healed a man born blind (meaning original sin) and through the water of God (spit) and the ceremonial washing (in the pool of Siloam), the man was "reborn" in water (baptism) and light. This is a story not only of the historical and symbolic, but also of the prophetic and sacramental.

Taking time to read the introduction, as well as any footnotes your Bible might offer, is a great way to gain proper context and get even more out of your Bible.

PRAYING WITH SCRIPTURE

HOW TO START READING THE BIBLE

I meet tens of thousands of people a year at different events. Most of them are Catholic Christians who want to start reading the Bible but don't know where to start. So, if you've ever wanted to go deeper into God's Word but haven't known how to approach it, let me suggest a few tips (and allow you to learn from my mistakes).

Like anything else, if you want to build something — in this case, your knowledge and love for the Scriptures — you don't just grab a hammer and some nails and start pounding. There are things you can do to be more successful and ensure you don't jump in and then quit out of frustration or confusion.

We'll attack it on three levels: the tools, the blueprint, and the construction. By the end, you'll have ten steps to help you build your bodily temple into a Biblical fortress, able to resist anything the devil throws at you.

The Tools

Let's start with three things you should do before you start reading.

1. Pick a time, but not just any time. Commit to a daily time that you'll open God's Word but be sure it's an intelligent time. If you're really tired, for example, reading the Bible once you're in bed probably isn't the best idea. Pick a time when you're totally awake so you can give your full attention to the passage. Commit to ten minutes a day and work up to 20 minutes from there.

2. Pick a Bible you can understand. Get yourself a good, Catholic Bible so you'll have all 73 books. If you don't have one right now, it's OK. Don't let that stop you from reading. In reality, the best translation today is the one you already have.

It's important that your Bible is comfortable to read, light enough to take with you, durable enough to really use, and inexpensive enough that you don't feel bad writing or marking in it. I highly recommend the Life Teen Catholic Teen Bible for everyday use. It's durable and the additional 128 pages of content offer you even more of the practical insights you've found in this book. If you're looking for the "best" Catholic translation of the Bible, the Revised Standard Version Catholic Edition (RSVCE) is great as it is cross-referenced with the *Catechism of the Catholic Church*. You might also want to have a copy of the New American Bible (NAB), which is the translation the Life Teen Bible uses and is also the translation we hear at Mass. Regardless of which translation you choose, remember, your Bible is like a telescope — it's not meant to be looked at but, rather, looked through.

3. Have other books that help you understand *the BOOK.* There are some great resources out there designed to help you better understand the Bible, like those available through lifeteen.com and from other fine, Catholic publishers. It's also great to have the *Catechism of the Catholic Church* handy so you can use it as you read.

The Blueprint

Next, we'll cover three things you can do as you read.

1. Pray, and then pray some more. Before you open God's Word, ask the author of that Word — the Holy Spirit — to be present in a bold and fierce way. Quiet yourself, spend some time in silence, and hold the Bible in your hands as you pray. Ask God, through the power of His Spirit, to open your eyes, mind, and heart to His truth and thank Him for the gift of His Word. It doesn't have to be a long prayer but don't rush it — this is the most important step in your Bible study.

2. Have a plan. If you were planning on reading the Bible cover to cover, don't. The Bible isn't a novel; it wasn't designed to be read from Genesis straight through to Revelation. You must first learn the story of salvation history. You can access free video overviews and downloadable guides at biblegeek.com that will help you learn this story. Additionally, "The Great Adventure" Bible timeline series is a great resource for groups. There is a middle school version (Encounter), a teen version (T3), and a version for adults (TGA), all available at evangelization.com.

After you get the "big picture" of the Bible, you can focus on smaller portraits. I'd pick one book you are going to start with and make it your focus for a while. If you are starting from scratch, I'd suggest the Gospel of Mark. Mark's Gospel is the shortest and easiest to understand as you already know the main characters and plotline, as well as its personal significance and relevance to your faith walk. The Gospels are the hinge-pin to the entire

Bible — they're a great place to start and get into a reading "rhythm."

3. Get the background. If you do start in a Gospel, take time to learn about the author: Who was he? Who was he writing to? What are the basic themes of his Gospel account? Ask yourself what makes that specific account different than the other three. Similarly, don't just jump into a letter of St. Paul without knowing what is going on in the city to which he is writing. If you are reading a story from a prophet, know what was going on in his world at the time.

"Where do I learn these things?" you might ask. Read the introduction to the Gospel on the pages preceding it. Use one of your additional books or resources to help you. When you know what is going on with the author and the audience, the words will jump out at you in a much different way and give you far greater insight.

The Construction

Finally, let's hit four things you should remember while reading the Bible and beyond.

1. Less is more. Don't just open the Gospel and read until you get tired or "for 15 minutes" because that's what you committed to doing. Most Bibles break down the chapters into subchapters. If you begin with the Gospel of Mark, for instance, you shouldn't just start with verse 1 and continue through verse 45 (the end of the chapter). Instead, read verses 1-8 and spend 15 minutes meditating on them. Take verses 9-11 and reflect on them. The 45 verses of the first chapter should

be broken down into about ten different studies alone. Studying Scripture is not like driving across country — it's not about how much distance you cover in a set amount of time, so roll the windows down, take everything in, and enjoy the ride.

2. Periods are there for a reason. The period at the end of a sentence is almost as much a gift as the words that precede it. Each little "dot" is an invitation to take a breath and reflect on what you just read. At each period, take a moment to envision the story that's unfolding. If you are reading about the baptism of Jesus (Mk 1:9-11), don't just say, "Hey cool, Jesus is getting baptized." Go deeper and insert yourself into the story. For instance, at Christ's baptism, where are you? Are you on the shore, on the mountain overlooking the scene, or in the water right next to Him? Is it hot out? Does the water smell bad? Is it noisy or peaceful? Let the story come alive.

3. Journal. As you read, write down any verses that confuse you or questions that arise. Don't allow yourself to get hung up on "tough verses." Scribble down the verse number with a question mark in a journal and keep moving. Later on, you can search the footnotes and other books or ask someone knowledgeable for more help. The journal isn't just for questions, though. You should also use it to write out reflections the verses stir within you. Write down images God gives you in your imagination and record key verses that stand out to you. God will reveal a great deal about who you are when you let Him.

4. Put the book down. Don't become a bookworm, who never takes their eyes off of the page. The Bible is the living Word (Jn 1:1-5, Heb 4:12). It lives and breathes well

beyond the page that contains it. Share what you learn. Write out passages and hang them up in your room or locker. Send verses to your friends or put them on the fridge for your family to see. Just like the Eucharist, the Word should be taken, blessed, broken (down), and shared. The greatest gift you can give someone is to live a life that mirrors the Gospels, reflecting God in all you do. The second greatest gift is to invite others to peer into that mirror.

In Conclusion

OK, so that's a substantial start. Although there are several ways to begin reading Scripture, these are what I've found over the years to be the best, most realistic steps. Get the tools, pull together your blueprints, and start building your love for God's Word.

And don't just think that you have to "study" every time you open the Bible. It's great if you set aside 30-45 minutes every day to study, but that doesn't mean you can't flip through other books like the Psalms, Proverbs, Sirach, Wisdom, Ecclesiastes, or St. Paul's letters — you'll be blessed by all of them.

THINGS TO KEY INTO WHEN READING

Many people are too intimidated to read or study the Bible. Let's face it: The Bible can be a very intimidating book. It's big and heavy. It has hundreds of thousands of words, some of which are very difficult to pronounce. It has confusing sayings, hidden meanings, and cultural references that even Bible scholars argue about.

So how do we know what to look for when we are reading a passage but don't have the background information or education to help us figure it out? How can you "get something" out of a verse and "key into" the right parts of the text when reading a passage for the first time?

Here are a few suggestions:

1. Read in bite-sized chunks. Don't just read until your eyes get tired. Instead of reading an entire chapter at a time, for instance, read a chapter in several pieces. Read and pray through one subchapter at a time.

2. Get the big picture of the passage. As you read, ask yourself the basic "big picture" questions of who, what, when, where, why, and how. The introduction to each book will help you answer these questions.

Some specific questions to ask yourself are:

• Who is involved in this story I'm reading? Who is speaking? To whom is he/she speaking?

- What is being said? What is the main point being made? (This might take reading the footnotes and asking additional questions.)

- When is this event taking place? At what point in history is this being said? Where am I in the Bible, right now?

- Where is this taking place? Are the people listening friends or enemies? Are they receptive or uninterested in the message?

- Why is this being said? Why was this important for the people to hear at that specific moment? Why is it important for me to hear now?

- How does this apply to my life, today? How does this truth challenge me to live differently?

Now, you might not know the answer to each of these questions immediately, but the more information you have when it comes to the big picture, the less likely you are to get confused or caught up in the little details.

3. Get the smaller picture, too. Once you get the "lay of the land" and have a feel for the who, what, when, where, why, and how of a passage, it's time to read over the section again and look for details. These details are clues that can help you uncover the buried treasure of wisdom that might not be visible at first.

- *Look for details.* For example, does the passage mention the time of day, what the scene looked like, or anything else that gives you a mental picture?

Check out the details in the following passages from Mark's Gospel: 1:32-33, 4:35-38, 5:2-5, 6:39-40. Look for details such as these to help you better understand the passage.

* *Look for emotions.* Were the people angry, confused, overjoyed, afraid, or expressing any other emotion? Again, read through these passages from Mark's Gospel and note the details he gives about peoples' emotional responses: 1:40, 3:1-5, 10:13-15, 14:33-34.

* *Look for numbers.* Numbers carry heavy symbolic meaning in the Bible and are used to convey certain truths and make a point when necessary. You'll notice certain numbers — like 3, 7, 12, and 40 — are used frequently. You'll notice other numbers — like 666 or 144,000 — are often times taken out of context and ascribed meanings that were never intended by the original writer. It's helpful to check the footnotes and other trusted Catholic resources rather than getting carried away by false teachings, ridiculous websites, or our own misconceptions. Pay attention to numbers and realize they are there for a purpose, even if the purpose is not obvious at first.

Other Specifics to Watch For

Pay attention to names, locations, colors, and verb choice. These details are important because they lend credibility to a passage, remind us of another passage, or communicate the passion and depth of a scene.

Other Sections that Will Help You

The more time you can take to read the explanatory sections — the introductions to the different books, the footnotes, the *Catechism of the Catholic Church*, and other reliable books and commentaries — the better equipped you will be to understand the little details and not get sidetracked when reading a story.

When it comes to reading Scripture, the best advice is always this: Take your time; it's not a sprint, it's a marathon. And remember, it's a fun run. If it's not fun, you might be running too fast. The idea is to put yourself "into" the story as you go. It's as if you're running alongside the characters, not watching them from the sidelines.

AN INTRODUCTION TO *LECTIO DIVINA*

So how do you put yourself "into" the story when you're reading the Bible, anyway?

One of the best parts about being Catholic is that we have many different forms of prayer that help us encounter God more deeply. For more than a thousand years, Catholics have been praying the Scriptures with an approach called "*lectio divina*," which means "sacred/divine reading" in Latin.

Have you ever had a conversation with a friend that you find yourself thinking about over and over again? Maybe you play the conversation back in your head a thousand times, remembering what you said, what you wish you hadn't said, and what you feel you should have said. You probably even remember the less important details: where you were, how hot or cold it was, what music or movie was playing in the background, and what you were wearing at the time. The more you think about it, break it down, and analyze it, the more all of those other details come to life. *Lectio divina* is similar to this; it's a slow and intentional way of praying the Bible while talking to and spending time with God. It's designed to help the story come to life in your mind and heart and (re)capture your soul. It's designed to help you become more and more contemplative.

Lectio divina is as easy as four steps. Historically, these four steps are known as:

1. Lectio (Reading)
2. Meditatio (Meditation)
3. Oratio (Praying/Speaking)
4. Contemplatio (Contemplation)

Since you probably don't know Latin, it might be easier to remember the steps as:

1. Read
2. Reflect
3. Respond
4. Rest

Whichever list you choose to remember, the steps are simple to follow. But before we dive into some passages, it's vital that you understand a few more things.

First, it's important to identify what *lectio divina* is not. When we pray through Scripture using *lectio divina*, we are not doing a formal "Scripture study." It can be helpful to know the background of what we are reading, what some of the words mean, and who the characters are, but we aren't going to take a lot of time to look at footnotes or pull out a Biblical concordance to look up the history of a location or etymology of a particular word. Again, those aren't bad things — they are important and necessary parts of learning the Bible — they just aren't things we do when we pray *lectio divina*.

Second, *lectio divina* is not about getting some Earth-shattering revelation. Don't enter in thinking that walls are going to shake and God is going to speak to you, answering all of your questions and solving all of your problems. Sometimes the greatest gifts from God are the simplest ones — a gentle nudge in the right direction, a reaffirmation of something you know but seem to forget, or a word of encouragement. When we enter into *lectio divina* (and really any prayer) with an agenda of what we want or "expect" to hear, it rarely turns out well. Approach prayer with an open mind and heart to receive whatever God wants to give you. It will be exactly what you need.

Finally, *lectio divina* is not hard to learn, but it does take practice. It alternates between being "active" (reading and speaking) and "passive" (meditating, contemplating, and receiving). In our daily life, we are accustomed to "doing" rather than "being," so we are generally more comfortable with active prayer than with passive prayer. Don't get discouraged if you feel like your prayer isn't going well or if you are having a hard time "getting it." Prayer involves practice and the more you pray, the better you will become.

Now, what exactly do you "do" in each step?

The best way to start praying *lectio divina* is to grab your Bible, find a quiet space where you won't be disturbed, and put your phone on airplane mode. Before opening your Bible, spend a few moments in serious and silent prayer. Focus on your breathing. Ask the Holy Spirit to enlighten your mind and open your heart. Now, let's begin.

1. Read (Lectio)

Select a passage or use one from the list on pages 66-67. Read it slowly, all the way through. As you read the passage, envision the scene. Watch for adjectives and pay attention to details. Really "enter into" the moment. If you're reading a Gospel passage, lock eyes with Jesus as you encounter Him in the story.

Take a breath. Inhale and exhale deeply. Put distractions out of your mind and slowly read the passage a second time. Now, read it a third time. This isn't speed-reading. Allow the words to roll over you. As you read, be aware of any word or phrase that stands out to you. What resonates with you or "jumps off the page"? It is likely that God wants to use this particular word, phrase, or image to speak to you. Hold onto it, you'll need it for the next part of the prayer.

2. Reflect (Meditatio)

Now, what is the main "point" of the passage you just read? What words jumped out at you? What words "spoke" to your heart? Were they comforting? Did the passage make you uncomfortable, and, if so, why? If nothing jumps out at you, read the passage once more and ask how it applies to life in the 21st century. If you don't think it applies to you, look harder. This is where you really "chew" on the words of the passage and ask yourself questions. Other thoughts, images, words, or distractions may enter into your prayer. It's all right — the worst thing you can do is try to ignore them. Instead, acknowledge the distraction (but don't follow it) and return to your meditation. There is no

time limit for how long this step should take, but for now, set a timer for five minutes and work to increase it one minute each day until you hit ten minutes. As you practice *lectio divina* more, you will start to feel when you need to move on.

3. Respond (Oratio)

Step three is where you and God speak to one another. If you're praying *lectio divina* alone, this is where you can ask God questions, but it's important to listen as well and not just speak. Bring anything that stood out to you in step two to Him, now. Spend some time in silence and let God speak to your heart. Remember, this is about responding to God not only with your words, but with your heart.

If you're praying *lectio divina* with a group, this is where you can discuss what the passage meant to you personally, what you liked, and what challenged you. Either way, it's important to listen to God as He speaks to your heart or through other people. This is also a great place to take out your journal and start writing. Be sure to note the Scripture passage you are reflecting upon and the word or phrase that stood out to you. These journals can be a powerful witness to the ways God has moved — and is moving — in your life.

4. Rest (Contemplatio)

During this final step, you simply "rest." This step might be difficult for you. If you're the type of person (like I am) who frequently reaches for your phone when things get "too quiet," this part will definitely challenge

you. That's a good thing — it shows that you're taking it seriously and that the Holy Spirit is growing you spiritually. Say no to the temptation and try not to let yourself get distracted.

This is where you really become a child of God, again. Resting in your heavenly Father's presence is like crawling up onto His lap and letting Him hold you. It might take some "practice" at first to just sit with God and let Him love you. It might even make you uncomfortable to be so vulnerable, trusting God does love you and wants to draw near to you, but let Him. Picture God staring into your eyes. Imagine Him telling you how proud He is of you and the person you are becoming. Let Him remind you how much you mean to Him and all He desires for you.

Allow thoughts to come and go in this fourth step and simply be mindful that you are in God's presence. It's that simple — and also that difficult. Ultimately, contemplation is about sitting with all that was given through the Word of God and allowing it to sink in. It's as though you've slowed down to realize and recognize different things (dots) in the first three steps and now, in this fourth step, God wants to connect the dots for you, but only if you allow Him to do so.

PUTTING *LECTIO DIVINA* INTO PRACTICE

Now, let's put these steps into practice.

Choose a passage and dedicate 20 minutes to praying with it. Set a timer or have a watch nearby to keep track of the time. Allot each movement about five minutes. Be mindful of where you struggle or feel tempted to cut corners and give those areas extra attention and effort.

Below are a few suggested readings with rich imagery that you can use as a jumpstart:

Mark 1:9-11 – A lot happens in three short verses. Take your time to really enter into the scene. What did it look and smell like? Is God proclaiming a truth only about Jesus or about you, his son/daughter, too?

John 2:1-12 – What do you learn about God in this scene? What about the role of His mother? Does she say anything that strikes you?

Luke 8:49-56 – What is Jesus trying to teach you in this scene? What is His response to doubters? Who does Jesus allow to enter and witness the miracle? Why?

Matthew 14:22-33 – Why didn't the apostles display greater trust before Jesus showed up? Have you ever felt like that? What can you learn from this scene with Peter? How can this story still bring hope, today?

John 13:1-9 – What does Jesus' example teach you? Why is this a vital lesson for the apostles to learn before they begin their ministry? Where are you called to do as Jesus has done here?

Luke 23:33-43 – Note the two different quotes and approaches of the thieves. When you experience suffering in your own life, which thieves' "prayer" most resembles your own? Why? What can you learn from this episode of suffering?

1 Kings 19:9-13 – This is our opening story. There is a lot to pray through, here, especially if you are thinking about how God's voice is present in your life.

Psalm 139:1-13 – This psalm focuses on how God knows us perfectly and is great to pray through if you are feeling distant from God.

Romans 12:9-18 – Saint Paul writes a list of what an ideal disciple looks like. It is convicting by itself but, through prayer, becomes even more challenging as the Holy Spirit identifies specific areas we need to work through.

1 John 3:1-3 – John's letters are quick reads, but this short passage packs a punch as it quickly identifies who we are and who we belong to.

Those are just a few passages to get you started, but there are many more. Look for them, remember them, and start your journal. Once the Word transforms your life, you will find yourself coming back to *lectio divina* again and again, and your life will never be the same.

UNDERSTANDING
SCRIPTURE

THE STORY OF SALVATION IN
THE OLD TESTAMENT

Some modern Christians believe you don't really need the Old Testament anymore, mistakenly thinking the New Testament is superior or somehow renders its predecessor "outdated."

Nothing could be further from the truth.

While Jesus is absolutely the center of the Bible, simply focusing on the New Testament is dangerously short-sighted. Jesus is the key that unlocks everything, but without an understanding of the Old Testament — its prophecy, promise, fulfillment, covenants, and "plan" for salvation and the coming Messiah — you cannot fully understand or appreciate Jesus Christ and His mission. The Old Testament is like an arrow that points forward to Jesus. The New Testament points back and "unpacks" the Old Testament, demonstrating that all of God's promises come to life and take flesh in Christ. The grace and power *concealed* in the pages of the Old Testament are *revealed* in the identity and actions of Jesus in the New Testament (CCC 129).

Beginning in **Genesis** we see that God — who is love — creates everything to demonstrate love, most especially when he creates the male and female, in his own identity, to mirror and reflect the nature of self-giving love. As the family grows, so does the potential to love or to sin. When the fall happens in the garden and sin enters the story in **Genesis 3**, we immediately hear God promise us a redeemer (Messiah) who will restore our relationship. In the pages that follow, we see God's family grow with

characters like Noah (**Genesis 6**), Abraham (**Genesis 11**), and their families. God enters into sacred relationships — covenants — with these characters. As their families grow, so does sin. We begin to see a "cycle" of our humanity and personalities: we follow God, we turn away from God, God proactively reaches out to restore the relationship through sacrifice and penance.

We see God treat the nation of Israel like His own child, guiding and instructing the people through good times and bad. By the time Moses comes onto the scene in **Exodus**, God's children are enslaved in Egypt. We see the burning bush (**Exodus 3**) and the warnings of the ten plagues (**Exodus 7-12**) before the great escape through the Red Sea and the giving of the Ten Commandments in **Exodus 20**. Then, because of their lack of faith, God is forced to correct and instruct the Israelites, again. Reading through **Numbers**, **Leviticus**, and **Deuteronomy** we hear the early lessons for God's wandering people, His first priests, and the young nation headed to their Promised Land.

These books — **Genesis**, **Exodus**, **Leviticus**, **Numbers**, and **Deuteronomy** — are known as the "Torah" or the "Pentateuch." They are the first five books of the Old Testament, the "Books of the Law." Traditionally, Moses has been identified as their author.

Genesis means "beginning" and tells about how God created everything from nothing. In addition to the story of Adam and Eve, you'll read about Cain and Abel, Noah and the flood, the Tower of Babel, Abraham and Sarah and their son, Isaac, as well as other famous figures like Jacob and Joseph and his jealous brothers.

Exodus means "going out" and tells the story of Moses leading the children of God (Israel) out of slavery in Egypt. It tells about their 40-year journey through the desert on their way to the Promised Land.

Leviticus is a handbook for the early priests — the Levites — who came from the tribe of Levi. It talks about religious and liturgical laws (how to worship, prepare for worship, offer sacrifice, etc.) and reminds them of the need to be holy and intentional in how they worship God.

Numbers tells the story of Israel's 40-year wandering through the desert. God's original plan to take His children straight to the Promised Land gets sidetracked because of disobedience and faithlessness. The decades of journey reveal several lessons about trusting God and living through hardship, reminding us that sin never pays.

Deuteronomy means "second law" and while it repeats the Ten Commandments, it also adds new ("second") laws about the way the Israelites should live to enjoy holy lives and families. It contains practical advice and wisdom as well as several prophecies about what is to come.

It's at this point in the story that we shift into what are called the **historical books**. As you may have already guessed, they are books that recount the history of the nation of Israel.

We pick up the action in **Joshua**, who rises as the new leader following the death of Moses. In this book,

we see God's people overthrow Jericho and take their rightful place in the Promised Land after years of struggle. Next, as the Israelites finally become a true nation (and not just enslaved tribes living in community), we read **Judges** to see their early system of authority and leadership. When they begin calling out for a king like all of the surrounding countries and empires, God warns them of the negatives that come with aristocracy. God wanted to be their sole leader and king, but the people "knew better." We read about how that goes —all the ups and downs that come with people fighting for power — in **1 and 2 Samuel** and **1 and 2 Kings** (and its counterpart, the not-so-exciting **1 and 2 Chronicles**).

The Kingdom splits in half, falls into ruin, is taken into slavery, and is ultimately left in ashes. Fast forwarding, we see God's children taken off into slavery (again) and, finally, returning to rebuild God's Kingdom on Earth. In the books of **Ezra** and **Nehemiah**, we hear stories recounting the hardships and victories of rebuilding the Temple, the city walls, and the God-loving culture that once existed. It's during these centuries that we are also introduced to heroes and heroines like **Ruth**, **Tobit**, **Judith**, and **Esther**. Following the period of the prophets (which you'll hear about later) and the time of rebuilding the world, power shifts from Babylon to Persia to Greece. It's at that time — under Greek rule — that the Jews are asked and forced to live as Greeks and worship false gods. In **1 and 2 Maccabees**, we read about a brave band of Israelites who, though outnumbered and out-trained, take on the mighty Greek armies and defeat them for the glory of God.

Here's a brief breakdown of each of the **historical books**:

Joshua was Robin to Moses' Batman. When the famous prophet died, Joshua led the children of Israel through their conquest of Canaan (the Promised Land). The book is filled with wars, fighting, fidelity, and faithlessness that reveal who loves God and who merely says they do.

Judges traces the story of the children of Israel after Joshua's death. The family was still "divided" into their own tribes and without a clear leader, they fell into disagreements and strife. After repeatedly disobeying God and getting overthrown in small wars with enemies, God raises up a series of different "judges" to lead them back to Him.

Ruth was a non-Israelite convert to the faith. Her deep love for family and God unveiled her strength and faithfulness in the face of incredible personal adversity. Ruth goes on to be the great-grandmother of King David and an ancestor of Jesus, Himself.

1 and 2 Samuel tell the stories of the first kings of Israel. Beginning with a king named Saul, we see what happens when you make God the priority and when you try to make yourself "god" in the eyes of all. Following Saul, the great King David takes the reigns and although he loves God, he also sins. These books demonstrate the rise and fall of kings and the dangers of earthly power.

1 and 2 Kings pick up the story of the kings of Israel who followed the great King David. Beginning with his son,

Solomon, we read of the construction of the Temple in Jerusalem, Solomon's fall from grace, and the series of kings (mostly bad) who succeeded him in the decades to come. The main event we read about is the Kingdom of Israel splitting in two, despite God's repeated warnings through His prophets. The northern kingdom would now be called "Israel" and would settle in the north, while the southern kingdom would remain centered around Jerusalem in the south and be called "Judah."

1 and 2 Chronicles recount the same history contained in 1 and 2 Samuel and 1 and 2 Kings but from a *religious* or *liturgical* point of view. In other words, 1 and 2 Chronicles spend more time talking about the building of the Temple and the spiritual aspects of the kingdoms (especially the southern kingdom, Judah, which was generally more faithful).

Ezra describes the events that occur when the Jews are allowed to return to Jerusalem after it was destroyed and their exile in Babylon was over. It recounts their efforts to rebuild the Temple and reestablish proper worship.

Nehemiah also describes the events surrounding the Jewish return to Jerusalem and their desire to live in obedience to the law of Moses.

Tobit is a story with a "happy ending." Even though times are tough, Tobit remains faithful to God and His law. Tobiah (Tobit's son) follows in his father's righteous footsteps and rejects sin as he begins his own family. The book shows how God blesses and protects those who follow Him in true love and purity.

Judith recounts one brave, faithful woman's efforts to save Israel. Her trust in God is the key and reason for her success. This book shows how important it is for us to trust in God's love and mercy, even when we don't understand what He's up to.

Esther recounts the story of another brave Israelite woman who becomes the queen of Persia. As beautiful as she is courageous, Esther risks her life to prevent an evil murderer from harming God's people.

1 and 2 Maccabees describe what happens after the time of the prophets until Jesus comes onto the scene in the New Testament. These amazing books recount the story of a family (the Maccabees) who led a revolt against the Greek rulers when they tried to impose worship of false gods on the Jewish people. They act as the "bridge" between Old and New Testaments and are not included in Protestant (non-Catholic) Bibles.

What you've read so far is a narrative re-telling of the entire Old Testament. While these stories were playing out chronologically, God continued to speak to His people through wisdom and prophecy, which we will deal with separately.

The **wisdom books** of the Bible are really fun to read. Filled with practical wisdom, still useful today, they speak to life's situations from birth to death and virtually everything in between. They don't recount Israel's history and aren't really prophetic in their tone, either. In the wisdom books, you'll read songs (**Psalms**), practical insights (**Proverbs** and **Sirach**), poetry (**Song of Songs**), philosophy (**Ecclesiastes**), and a lot more.

Each of these books answers questions about how God moves and thinks as well as how we respond to Him and one another. In short, the wisdom books talk about the beauty, majesty, mercy, and awesome power of God and how we should let them affect our lives.

Job addresses one of life's oldest questions: Why does God let bad things happen to good people? Job loses everything, is surrounded by friends who encourage him to quit on God, and actually converses with God about why life has suffering. It's an invitation to think bigger and trust in God, even when we can't "figure out" his ultimate plan.

Psalms is the longest book in the Bible. It is a collection of religious prayers, poems, and songs, many of which were written by King David. These are read (or sung) at every Mass.

Proverbs contains many insightful, wise sayings and teachings, many of which are believed to have come from King Solomon. This book is a practical guide to good and proper living.

Ecclesiastes is basically a book on philosophy. It analyzes the meaning — or lack thereof — of life and, in particular, a life without God. It discusses love of money and possessions, the emptiness and fleeting nature of beauty and material possessions and some relationships, all the while asking, "What in life is truly satisfying?"

Song of Songs (Song of Solomon) is poetry — more of a "love poem," actually — written in the form of a

dialogue between a young bride and her new husband. This book is supposed to be a reflection of the love of Christ (the groom) for His bride (the Church).

Wisdom of Solomon is a long poem about the beauty, value, and importance of wisdom in and to our daily lives.

Sirach (Ben Sira) is an honest look at the challenges that arise when someone tries to live a godly life in an ungodly world. Filled with timeless wisdom that is still applicable in everyday life and relationships, it offers advice for those seeking to be to be faithful to truth and virtue in a society that wants to reject them.

As mentioned prior to the last section, during the period where Israel's kings were good and not-so-good, listening to God and ignoring Him completely, God loved His people enough to send living, breathing "warnings" in the prophets. We hear about the adventures of famous prophets like Elijah and Elisha in the books of Kings. There are actually over a dozen books written (or attributed to) prophets, including major prophets like **Isaiah**, **Jeremiah**, and **Ezekiel** and minor prophets like **Micah** and **Hosea**. When we think of prophets, we tend to think of old, crazy guys with long beards who lived in a cave somewhere in the desert and made predictions about the future. But the truth is that prophets are messengers from God, sent to speak His words to His people. They would often warn the people that tragedies and disasters would strike if they continued to disobey God and His commands. They weren't "gloomy" all the time; when disasters or tragedies did occur, God often spoke words of comfort

and hope through these mouthpieces. Not only did they warn of things to come "in their time," but they also spoke of the coming one — the Messiah — in prophecies, details, and predictions they shared *literally hundreds of years* before Jesus' birth in Bethlehem.

Here's a brief rundown of the main themes and topics covered in the **prophetic books**:

Isaiah is the most famous and significant prophetic book, quoted by Jesus more than any other. It discusses the coming of Christ, warnings for those who do not turn from sin, the fall of the Kingdom of Judah, and God's forgiveness and promise of redemption.

Jeremiah was a holy, young man given a hard message to spread. He tells Judah (the southern kingdom) that they will be destroyed if they do not repent and turn from their sinful ways. Readers are given a very personal and intimate glimpse into the prophet Jeremiah's life in this book.

Lamentations is like listening to Blues music. The book is a collection of poems written during and after the destruction of Jerusalem (when the Kingdom of Judah fell to the Babylonians).

Baruch shares a message he receives from God that there will be a new and everlasting covenant between God and the people of Israel. It is "good news" that comes during hard times.

Ezekiel contains many mysterious symbols and images describing the judgment that will fall upon Israel. It

also speaks of great hope: God will resurrect the "dead bones" of Israel and breathe new life into them, again.

Daniel tells the story of a holy, young prophet who was captured by the Babylonians and taken into exile. Daniel is known for his ability to interpret dreams, his fidelity to prayer, and the famous story of surviving the lion's den.

Hosea describes the unhappy marriage between a man and his wife. The wife is unfaithful to her husband, but he takes her back. The story demonstrates the way in which God always takes back His people even when they are unfaithful to Him.

Joel warns the Kingdom of Judah about the coming capture and judgment, but speaks with hope for the future, promising that God's Spirit will be poured out upon all people.

Amos was pretty disliked by the people of Israel. He spoke about the coming judgment they would face if they continued in their disobedience. Although he issued a stern warning, Amos also spoke with hope about the day when all of Israel would be reunited.

Obadiah foretells the unpleasant future of Judah's great enemy, Edom. The shortest book in the Old Testament, Obadiah demonstrates how justice ultimately prevails against those who disrespect and abuse the Lord's people.

Jonah recounts the famous story about the prophet who disobeyed God and (originally) refused to preach

His message to the people of Nineveh. While most well-known for the "whale story," this book is a tremendous lesson about God's mercy and unconditional love not only toward His "enemies" but those supposedly close to Him as well.

Micah speaks of the judgment that will come to those who do evil — especially "in the Lord's name" — but also of the great hope that will come when the Savior is born in a little village known as Bethlehem (a prophecy which occurs five to six centuries before the birth of Christ).

Nahum prophesies about the end of Nineveh, which was the central city in the evil Assyrian Empire. His "bad news" was considered good news by many.

Habakkuk also speaks of the judgment that will come upon those who do evil and offers comfort to those who live faith-filled lives, following the Lord and keeping His commandments.

Zephaniah is different than the other prophets. He doesn't just speak about the judgment of God on Israel and Judah; he widens the scope to speak about the judgment of God against the entire world. Even though it is rather stern, Zephaniah is also filled with hope for the future.

Haggai was one of the leaders in the efforts to rebuild the Temple after its destruction. He was angered because some people were content to live comfortably when God's house was in shambles.

Zechariah was a peer and contemporary of Haggai and also supported the rebuilding of the Temple. He devoted his time and energy to the Temple because it was the place where God's people worshipped Him and received strength and guidance.

Malachi warns the returning Jews that external religious offerings and sacrifices are not enough — God desires righteous living as proof of our love and faith.

THE MOST IMPORTANT BOOK(S) IN THE WORLD: THE GOSPEL(S)

As mentioned earlier, there are many different types of writing and books within this big, holy book we call the Bible. Out of the 73 books, however, four books stand alone: The Gospels. All of the books in the Bible are inspired by God and are free from error, but the four Gospels are unique and supremely important.

In the Gospels, we are not only given prophecies about the coming Messiah (Jesus), we receive the Messiah Himself in flesh and blood. We see His face and hear His voice. We watch Him interact with all of humanity — sinners and saints, holy and unholy, and everyone in between. We encounter God in an entirely new way, and everything we read about in the Old Testament is now fulfilled.

Jesus is the one all have been waiting for, the one who died for us so we would not have to do so. It is with the Gospel, as the foundation of your life, that you will come to know the love of God and learn how to share that love with your friends, family, and, ultimately, a world desperately in need of it. Everything you desire to know, everything you wonder about God, every fear and every hope, every pain and every joy collide and find meaning within the Gospel of Jesus Christ.

Pope St. John Paul II put it this way: *"It is Jesus that you seek when you dream of happiness; he is waiting for you when nothing else you find satisfies you... it is Jesus who stirs in you the desire to do something great with your lives."* [2]

The same Holy Spirit who inspired these words from St. John Paul II moved through the pens of the four Gospel writers: Matthew, Mark, Luke, and John. Now, to be clear, the Christ you encounter on the pages of their Gospels is not a "nice Jesus" here to make everyone happy. Far from it, actually. When you encounter Jesus in the Gospels, you see four portraits of the one, true God who became man in Christ Jesus.

Each Gospel writer has a certain and distinct "audience" they are writing for, which explains why they go to such lengths to explain certain details and not others. You'll find many similarities between Matthew, Mark, and Luke, for instance, which is why they are called the *synoptic Gospels* (synoptic means "like visioned"). Most Biblical scholars believe Mark's Gospel came first, and that Matthew and Luke borrowed from and used Mark's Gospel as a framework and outline. Others contest that Matthew's Gospel came first. Regardless, it's obvious the three have several parallels in structure but also offer many unique stories and perspectives on the life and ministry of Jesus Christ. You'll notice, too, that John's Gospel is drastically different in structure, tone, and goal. These small differences between the Gospels should make us feel even more confident in their authenticity for if they were all the exact same, we would wonder if it was really four different writers or just one. The differences in details between the Gospels, in this way, actually serve to bolster our confidence in their historic reality and truth.

Use the sections that follow to help you better understand the differences, but also the likenesses, in the Gospel portraits. Go back to the Gospels repeatedly and you will notice something amazing. While the words and truths don't change over time, *they will change you,* and over time you will begin to experience a real hunger for them.

GOSPEL SNAPSHOTS

The Gospel of Matthew

One of the original Twelve Apostles, Matthew (also called "Levi") was a tax collector working at a customs post when Christ invited him to follow (Mark 2:14).

Key Themes for Understanding Matthew's Gospel:

- Jesus was the Messiah they had been waiting thousands of years for to come and save them.

- Jesus did not come to abolish the law of Moses but to fulfill it (Matthew 5:17). He did not render the Old Testament and its covenants null and void, but unpacked, clarified, and explained them by His life, death, and Resurrection.

- Jesus came to begin His Kingdom, one we are invited to enter by His grace.

- Jesus institutes a Church on Earth to teach His truth and administer His sacraments, to baptize and initiate everyone on Earth with a universal message of mercy and love.

- The central theme is that Christ, the Messiah and king, came to establish a Church.

The Gospel of Mark

We know little about the author of this Gospel except that his birth name was probably John Mark (John, his

Jewish name, and Mark, his Roman name) and that he was a traveling companion of both Peter and Paul (2 Timothy 4:11, Colossians 4:10).

Key Themes for Understanding Mark's Gospel:

- Jesus was a man of action, of promises not just premises.

- Jesus was powerful because He was a servant, not a conqueror.

- Jesus is our mediator (our "go between") to God. He provides us with authority to teach and preach.

- As apostles and eyewitness, began dying off, this Gospel was written to reaffirm to people the centrality and primacy of Jesus Christ within the early Church.

- The central theme is action and service more than teachings.

The Gospel of Luke

Luke was not a Jew, but rather, a Gentile convert to Christianity. We also know he was a physician by profession and as such, was quite methodical in his approach to writing both the Gospel and Acts of the Apostles. Finally, we know he was a traveling companion to Paul for at least a while (Philippians 1:24, 2 Timothy 4:11, Colossians 4:14).

Key Themes for Understanding Luke's Gospel:

• It emphasizes Jesus' compassion for the poor, needy, sick, and helpless while putting a focus on the need for humility and the power of prayer.

• It reveals God's glory, mercy, and the desire/ willingness to heal us all spiritually and physically.

• Luke focuses on the power of the Holy Spirit, God's grace, and our ultimate salvation.

• It uplifts the dignity of all women in a time and culture that often did not do so; it offers an especially detailed and poignant portrait of the Blessed Virgin Mary.

• The central theme is freedom, liberation, and healing.

The Gospel of John

John is believed to be the writer of the final Gospel, as well as of the three letters which bear his name and the Book of Revelation. He was the younger brother of James and together, these "sons of Zebedee" worked as fishing partners of Simon Peter and Andrew. John is also called the "beloved disciple" and was entrusted with Mary's care following Jesus' Crucifixion (John 13:23, 19:26). He was most likely the youngest of the apostles and lived the longest of the 12. He was the only apostle not to die a martyr. The writing of the Gospel has extraordinary detail that had to come from an eyewitness.

Key Themes for Understanding John's Gospel:

- John wasn't writing "another biography" of Jesus to add to the others; he assumes readers are familiar with the other Gospels.

- It shows that Jesus of Nazareth is (prophesied) the Son of God.

- It explains to Christians how to root their religious beliefs and practices in Jesus (through the sacraments) and how, by doing so, faith will lead to eternal life.

- It explains why Jesus came, who He is, what He did, and how it relates to the life of the early Church followers.

- The central theme is the identity of Jesus and what that means to living our faith sacramentally.

Now that we've skimmed the Gospel waters in our overviews, let's pause on each of the four and do a little deep-sea diving to see what important themes and insights lie beneath the surface.

UNDERSTANDING MATTHEW:
AN OVERVIEW WITH EXERCISES

Over the years, I've noticed that my wife and I tell stories differently depending on the person we are speaking with and the subject matter of the conversation. When I communicate, it is often in an effort to exchange information. When my wife communicates, it is more often an opportunity to share a feeling, experience, or emotion. Conversationally speaking, I opt for brevity while my wife offers depth. This is not to sound derogatory in any way, only to demonstrate that who we are speaking to and their interests greatly influence our message, tone, and approach. It is this type of "difference" that sets Matthew's Gospel apart from his synoptic friends Mark and Luke and offers a stunning literary difference from John.

Matthew was a Jew writing to Jews about a Jew who claimed to be the King of the Jews, who some of the leading Jews then hatched a plot to have killed. That being said, there are a lot of references to Jewish customs, culture, idioms, and history that would have made perfect sense to a Jew from that age but may be lost on non-Jewish readers. It's for this reason you'll see a heavy emphasis on and use of the Old Testament (Hebrew Scriptures) throughout Matthew's Gospel. Matthew quotes the prophet Isaiah, for instance, throughout his Gospel and refers to Moses more than anyone else as these two figures were the preeminent prophets to the Jewish people, considered greater than all the rest. If you're new to reading Scripture and want to get the most out of this first Gospel account, it is important to have a good study Bible with footnotes and expansive explanation sections.

The first 18 verses of Matthew's Gospel offer us an intriguing family history, called a genealogy. Since Matthew is writing to Jews, he traces the bloodline of Jesus all the way back to Abraham, the great patriarch and forefather of faith. To modern minds, this type of opening might be considered boring and "off-putting" — not exactly a page turner that inspires a soul to keep reading. One might even wonder what this has to do with life today or what purpose it could possibly serve to know Jesus' family tree. The most common tendency is to merely skip the genealogy and pick up with the birth of Jesus in verse 18. Doing so, however, is short-sighted and misses not only the importance of the Old Testament and Christ's ancestry but also, the purpose and audience of Matthew's Gospel, in general.

You might be surprised by how much you have in common with Jesus. He wasn't born into a "perfect" family. Many of the ancestors in Jesus' line lived far less than saintly lives, a reality that should give us great hope. Many know how Jesus' earthly story "ends," with His Ascension and the birth of the Church. Now, go back and see how it all began. Pay attention to names you recognize and look up those you don't. You'll notice, too, there are five women mentioned in the family tree, all of whom are very important additions to a list that customarily would have included only the names of men.

In Matthew's Gospel, we hear not of the shepherds but the magi visiting the newborn king, fulfilling the prophecies of old (Numbers 24:17, Micah 5:2, Isaiah 60:6). We are given the extended form of the "most famous sermon ever preached," the Sermon on the Mount (Matthew 5-7). Many people think the sermon is merely the Beatitudes or, worse

yet, that the Beatitudes are all about "being a nice person." But if you read Christ's sermon through, you'll soon see that perhaps nowhere else in the Gospel does Jesus say more about the reality of heaven and hell, sin and judgment, and God's justice. Christ is emphatic, pointed, precise, practical, and merciful at every turn.

It is only in Matthew that we are given the amazing conversation between Jesus and Simon as the penitent fisherman becomes our first (papal) shepherd, Peter (Matthew 16). Jesus Christ reveals not only His plan to build a Church, but also how He will build it and where His plan of salvation, brought to life through the Church, will take us.

Without the Holy Spirit breathing through Matthew's pen, we would not have the account of Peter walking on water (14:28-33), the dream of Pilate's wife (27:19), the appearance to the 11 (28:16-20), or Judas' remorse and suicide (27:3-10). Several parables, too, are unique to Matthew, including the field sown with weeds (13:24-30), the pearl of great price (13:44-46), the unforgiving servant (18:23-35), the laborers in the vineyard (20:1-16), and the foolish virgins (25:1-13). Matthew's Gospel also places a greater emphasis on money than the other three Gospels, which is not surprising given his previous career as a tax collector.

Now we are going to jump into several passages from Matthew to get a feel for his writing style and go deeper into the words of Jesus, Himself.

Exercise One: Jesus Calls Us to Follow Him Today

Matthew 4:18-22

Questions

1. What did Jesus mean when He said, "I will make you fishers of men"?
2. When do you think is the best time to start following Jesus?
3. What are you willing to give up in order to follow Jesus?

Reflection

Jesus isn't just calling the disciples in the story, He is calling all of us to follow Him. The disciples were some of the most unlikely of choices and so are we. None of us are perfect, but none of the disciples were either. Drop your nets and follow Jesus. He has an awesome plan for your life. Think about the people or activities you put before Jesus: school, friends, sports, etc. Now make a conscious effort to rearrange these in order to put God first.

Prayer

Jesus, help me hear your voice. Help me see that above everything in my life, I am your disciple. I will follow you Lord, wherever you lead me. I will depend on your wisdom, not mine, to guide me. Give me words of faith to tell my friends about you and your awesome love. May you shine in all that I do so they would know you are the reason for my joy. Amen.

Exercise Two: Jesus Calls Us to Love Our Enemies

Matthew 5:43-48

Questions

1. How does one love an enemy?
2. Give an example of someone who has shown love to an enemy.
3. Is it possible to be "perfect, just as your heavenly Father is perfect"? What do you think Jesus meant by that statement?

Reflection

"But I say to you, love your enemies, and pray for those who persecute you." These are pretty tough words to swallow. Jesus speaks clearly, however, about His expectation for us. It is really easy to love those who love and treat us well, but it is really hard to love those who hurt us. On a sheet of paper, write down the person(s) in your life who is the hardest to love. Tape the paper on your mirror so you are reminded to pray for this person when you wake up in the morning.

Prayer

Your love is perfect, Jesus. Take my heart and fill it with your perfect love. Teach me how to love and treat those I despise and those who have hated me with patience and kindness. Amen.

Exercise Three: Jesus Delivers Us from Our Fear

Matthew 8:23-27

Questions

1. Is your faith strong enough to step out of the boat?
2. What are some of the storms in your life this very moment? Has God helped you through some of these storms? If so, how?
3. Do you rely on God in times of fear?

Reflection

It's OK to worry, to be scared, and to feel fearful. But, it's important to remember: Fear is not from God. Fear has a tendency to take hold of us and consume us. If we constantly live in fear about things in our life, we will not be able to truly live as Christ wants us to. Many people worry about losing a loved one or not getting a job. They worry about their future, being lonely, being successful, or being a failure. It is normal to think about these things, but when fear steps in and begins to take over, it can paralyze us. Only Jesus can calm the storms and fears in our lives. What is your biggest fear? Allow God to give you the courage you need to face your fears.

Prayer

Jesus, help me see you amidst the "storms" in my life, that I may not be afraid of anything. I put my trust in you, my God. Deliver me from living in fear and grant me the courage to follow you. Amen.

Exercise Four: Jesus Delivers Us from Doubt

Matthew 16:15-20

Questions

1. Did you ever doubt that Jesus is truly the "Son of the living God," our "Savior"? Why did you doubt?
2. What can you do to ease or lessen the doubt you have in your faith?
3. Is having doubt about who God is good or bad? Why?

Reflection

Who do you say Jesus is? Do you truly believe He is the Messiah? There are times in our lives when we question and doubt our faith and belief in God. Even Peter, our first pope, denied Jesus. Peter quickly recognized his weakness, however, and began to pursue the Lord with a renewed vigor.

It's OK to be doubtful; if you weren't doubtful from time to time, you should worry. Turn doubt into an opportunity. Find out more about Jesus and your faith. Pursue Jesus with an open heart and learn all that you can about Him. Write down some of the questions you may have about God and your faith. Then find the answers by asking someone or looking them up yourself.

Prayer

Jesus, deliver me from doubting you and your love. Give me the eyes to see you working in my life. Give me a heart that is open to your truth and lead me into a deeper faith in you. Amen.

Exercise Five: Jesus Warns Us to be Ready

Matthew 25:1-13

Questions

1. When it's your time to enter the wedding feast (heaven) will Jesus say, "I know you" or "I do not know you"? Why?
2. Is it too late for you to prepare for the Kingdom of heaven? What can you do to prepare today?
3. What have you done this past week to make yourself one of the "wise" instead of one of the "foolish"?

Reflection

A lot of times you hear people say they'll "change after college" or "you've got to have fun now; worry later!" It has become a pretty popular idea that when you're a teenager, you can do whatever you want because you'll have plenty of time to straighten up or regain direction after college. Today, Jesus is reminding us that none of us know how long we're going to be here. He is challenging us to remain ready; which is to say, we should always try to act in a way that would make Jesus proud, in a way that will prepare us for heaven.

Prayer

I pray that you would give me the wisdom, Lord, to seek you first and not my own foolish desires. Prepare my heart, Jesus. Help me change my life for you now, not later. Transform my life so I will always be ready for you. Amen.

UNDERSTANDING MARK:
AN OVERVIEW WITH EXERCISES

"Maaaaaaaaaaaaaarrrrkkkk!" she shouted, letting all of our neighbors know that my presence was needed at home, immediately. I could always tell when my mother was worried about my whereabouts as she had the uncanny knack of turning my name — a one-syllable word — into a multi-syllable exclamation that would make even stray dogs flee.

It was in those moments that I was annoyed with my namesake, St. Mark, feeling as though I'd somehow lost out in the large Catholic family lotto for the best saint names. I mean, my older brothers could claim devil-slayers like St. Michael, snake-charmers like St. Patrick, and animal-tamers like St. Francis, just to name a few. And then there was me — stuck with good 'ol Mark, whose only endearing quality in my young, sarcastic mind was that he wrote the shortest Gospel.

It wasn't until my high school years that my eyes were opened to the gift my mother and father bestowed upon me in my name. A closer examination of the New Testament reveals that the author of the second Gospel was actually known as "John Mark" (Acts 12:25, 15:37). Though John was his Hebrew name, he became better known by his Roman name, Mark, and for good reason. Like the Greeks before them, the Romans had more gods than Cheesecake Factory has entrees. The Roman god of war was called Mars, of which "Mark" is a derivative. How blessedly different my early childhood would have been if someone would have clued me in on the fact that the name "Mark" — my name — translates to "mighty warrior."

Why, though, would the evangelist, who sought to spread the Good News, choose to go by his Roman name? Was it because he didn't want to be confused by the better known "John," the beloved disciple of Jesus? The answer actually has roots far deeper.

God designs each of us with a specific mission and Mark was no exception. The core audience Mark wrote to were Gentile (non-Jewish) Christians living in Rome. Inspired by the Holy Spirit, Mark's words would bring hope to Christians enduring persecution. Given this fact, it should come as no shock that Mark's portrait of Jesus is one of a wonder-working warrior, a perfect combination of divine power and mercy toward humanity. Put simply, if you can "understand" Mark's Gospel (which is the shortest and easiest), you will have the foundation needed to understand the other three and the remainder of the New Testament.

Several things make Mark's Gospel quite different than the others. You won't come across many long sermons in Mark's Gospel (there are only two, to be exact), nor will you find the "back story" of the nativity that you do in Matthew and Luke. In Mark, Jesus is a God of action, performing miracles and casting out demons at every drop of the hat and turn of the page. Mark's Gospel is fast-paced and power packed, which is one reason the symbol associated with Mark is the lion.

Through Mark's pen, the Holy Spirit breathes urgency into every chapter. Should you read the 16-chapter Gospel from start to finish, you'll notice that Mark uses the word "immediately" about 40 times. Note, too, that following Christ's Crucifixion, it is not a Jew or a regular Roman

citizen but a high-ranking, Roman officer — a Centurion — who first proclaimed Christ's identity as the "Son of God" (15:39). Such a bold statement from a highly trained and revered soldier undoubtedly raised the eyebrows of more than a few in the Roman audience at the time.

Perhaps the passion and urgency communicated in Mark's account reflected as much about the author as they did about his Lord. One must wonder, however, where all this passion and intimate knowledge of Christ came from since Mark was not one of the original Twelve Apostles.

Mark was the cousin of St. Barnabas (Colossians 4:10), but it was his relationship with two other VIPs that gave him his credibility and information. Mark was a traveling companion to both St. Peter and St. Paul, offering him the best of both apostolic worlds. Peter obviously had a close relationship with the young evangelist, referring to him intimately as "my son Mark" (1 Peter 5:13). Mark's Gospel was obviously heavily influenced by the fisherman turned shepherd, Peter, offering eye witness details that could only be known by Peter, himself (4:35-38, 5:38-41). In fact, a closer examination of Peter's testimony in Acts 10:36-43 reveals an "outline" of sorts for Mark's entire Gospel.

Whether a scribe or recording secretary or merely a student with pristine memory, Mark's witness to the life of Christ was heavily influenced by Peter's "behind the scenes" eyewitness account. You'll notice that Mark doesn't just say, "they sat on the grass" but rather, "they sat down in groups of fifty on the green grass" (6:39). Jesus doesn't just fall asleep upon the boat but "asleep, in the stern, on a cushion" (4:38). Christ

doesn't just calm the wind, he "rebukes" it (4:28). A large group doesn't just come to a house, "the entire town gathered" (1:33). Mark gives exact details about the possessed swine (5:13), the names of Simon of Cyrene's sons (15:21), and the healing commands of Jesus spoken in Aramaic (5:41, 7:34).

In Mark we are given the testimony of an eyewitness we can count on. Fast-paced, highly-detailed, short, and to the point, the Gospel of Mark is the "perfect place to start" if you're new to reading the Bible and want a jumping off point. Start with Mark and then you'll be ready to take on the other Gospels, too.

Exercise One: Jesus Delivers Us from Our Demons

Mark 5:1-13

Questions

1. Do you see yourself as good or bad? Why?
2. Do you believe God is more powerful than the evil in the world? Why or why not?
3. What can you do in your life to keep evil at a distance?

Reflection

It says in Scripture that "every knee shall bend and every tongue confess that Jesus Christ is Lord." Often times, we try to defeat demons in our life on our own and fail to realize that it cannot be done. We are totally helpless and outmatched. Jesus has healing power and authority over all things, and only with Jesus can we overcome the demons in our life. Do you have struggles? Are there things in your life you can't overcome? Are you weighed down by sin? Ask Jesus for help. He will always be there.

Prayer

Lord, I have made every attempt at breaking these chains that bind me and I now realize I cannot conquer the demons in my life on my own. Powerful God, deliver me from these demons; break these chains Lord, so that I may be free to live in your love. Amen.

Exercise Two: Jesus Reminds Us to Take Time to Pray

Mark 6:30-32

Questions

1. What is the purpose of prayer in your life? Is it for God, or for you?
2. Why did Jesus have the apostles go off by themselves to a deserted place and pray?
3. Is prayer a priority in your daily life? Why or why not?

Reflection

When do you pray? Do you only pray when you need something, or when things are going wrong and stress has taken over? Prayer is not all about asking for things; it's about communicating with Jesus on a regular basis. Prayer is our lifeline to God. We have to pick up the "phone" every day and spend time with Him. Whether it is five minutes or 30, we need to take time to be with Jesus. So, be consistent in your prayer and make it a priority in your daily life.

Prayer

Thank you, Jesus, for the gift of prayer. Help me take time to listen for your voice, to praise you for what you've done for me, to pray for your help, and to pray for others in need of your love. Amen.

Exercise Three: Jesus Reminds Us to be Children

Mark 10:13-16

Questions

1. What does it mean to be "childlike in our faith"?
2. Do you see yourself as being more "childlike" or "childish" when it comes to your faith? What is the difference?
3. Do you believe you are ready to enter the Kingdom of God, today? Why or why not?

Reflection

Do you have a lot of responsibilities or too many things to do, or do you constantly wish people would treat you more like an adult? Sometimes we need to just slow down and think back to when life was a little simpler. The innocence of a child is something to treasure. Children have such a simple yet sincere faith. You see, it's not until we get older that we begin to question things and turn away from our childlike faith. Allow the innocence of the child in you to be a part of your heart. Talk to your parents about things you did and said as a child or look at some old baby pictures. Get back in touch with your childhood. Remember, "whoever does not receive the kingdom of God like a child shall not enter it."

Prayer

Jesus, give me the innocence of a child. Help me run to you when I am hurt and laugh with you when I am joyful. Help me live a simple faith, always trusting and believing in you. Amen.

Exercise Four: Jesus Challenges Us to Tithe

Mark 10:17-31

Questions

1. Do you think it is harder for wealthy or poor people to enter heaven? Why?
2. What is more important to you, "treasure in heaven" or treasure on Earth? Why?
3. How do you give your time to Jesus?

Reflection

Do you tithe? To tithe is to give back to God what He has given us. As Christians, we are called to give ten percent of our income to the Church. Do you earn money but just count on your parents to contribute at church? Remember that you're a member of the Church, too. If you only get ten dollars a week, save one and give it to the Church. We should not only tithe our money, but our time. Do you take time to help others, serve the poor, help a friend in need, or help at your church? Give some of your time to Jesus. Trust that if you tithe, you will be blessed in many other ways.

Prayer

Thank you, Jesus. Thank you for the gift of your generous love. I pray that I can imitate your generosity, Lord, with my time and money. Help me give back to the Church and the poor. Save me from selfishness. I trust that you will honor my tithe Lord, and always give back more than what is given. Amen.

Exercise Five: Do an Act of Service

Mark 10:43-45

Questions

1. Do you view your daily tasks as service? Why or why not?
2. "In this life we cannot do great things. We can only do small things with great love" (Mother Teresa). What are some of these small things that can become acts of love?
3. How is God calling you to serve in your local community, home, and parish?

Reflection

Jesus came not to be served, but to serve. If we are to be Christians, followers of Christ, should we not imitate this? Admittedly, there are different types of service. We have to notice the crucial difference between serving others for the sake of getting a job done and serving others out of love. We are called to serve others not just when it suits us, but also when it's a true sacrifice. Loving and serving until it hurts is the lesson of the cross.

Think of the way a parent cares for their newborn baby. Night after night of very little sleep, a headache from the restless crying, sheer exhaustion. This kind of self-sacrificing, love-fueled service is what Christ is calling us to. It doesn't have to be a huge act of service, but rather the little things, the mundane, that are often the most difficult. The important thing to remember is to

look at where your heart is. Are you serving as Christ would, out of love?

Go out of your way to serve someone today without seeking recognition or thanks.

Prayer

Jesus, help me to want to serve you every day. Help me see your face in those around me and know that by serving them with love, I am serving you. Help me recognize that with your help, I can do small things with great love. Amen.

UNDERSTANDING LUKE:
AN OVERVIEW WITH EXERCISES

A couple of years ago, my (then) fourth grade daughter spent time reading the Gospels before bed each night. This action was neither provoked nor forced on her by yours truly, yet the quality of her observations and the depth of the questions her sacred reading elicited on the mornings that followed were incredible.

She had questions about St. Luke and — more to the point — how he could be "trusted" as a source if he wasn't one of the original Twelve Apostles. I affirmed her observation and tried to quell her concerns by explaining that St. Luke was a convert to the faith and a close traveling companion of St. Paul.

"So, St. Luke *didn't really know* Jesus?" my daughter insightfully asked. Little did I know that on this particular morning I would introduce my now ten-year-old to the glory of sacred tradition.

Luke was not an eyewitness to Christ's works (Luke 1:2). He was the product of — and an eyewitness to — the *living tradition* (that St. Paul, Luke's mentor, speaks specifically about throughout his epistles). Luke's own conversion was due, in part, to Christ's command to carry the Gospel to the ends of the Earth (Matthew 28:20). Luke obviously benefited from this great charge — even writing about its Earth-changing effects in his own Acts of the Apostles (Acts 1:8, 17:6). And while Luke didn't "walk" with Jesus during His public ministry, it becomes clear through his writings that Luke most certainly *did know Him*.

Luke knew his audience, too. Since he was writing to non-Jews (Gentiles), he took time to translate any and all Hebrew or Aramaic (languages not as familiar to Gentiles) into Greek, the language they spoke. While making Christ's words and deeds accessible to this unique Gentile cross-section of readers and hearers, Luke also made it a point to champion the rights and dignity of the lowly and oppressed, placing women in high regard although they held a relatively low social status in the ancient Mediterranean world.

Consider what a special gift Luke is to the Church. Without the Holy Spirit breathing (inspiration) through Luke's pen, we would be without the Hail Mary or the joyful mysteries of the rosary, for you cannot have them without Luke's accounts of the Annunciation or visitation (and so on). We would, likewise, be without some of the most famous parables in history — the prodigal son (15:11-32) and the good Samaritan (10:25-37) to name but two. Consider the invitation to the shepherds at Christ's birth (2:8-12) or the angelic "Gloria" (2:14) we proclaim at every Mass — again, made known to us through Luke. How about Jesus' boyhood misadventures, including when He went missing for three days (2:41-52)? Yep, that's Luke, too. Without Luke inclining his ear (and pen) to the Holy Spirit's inspiration, we would also be without the conversation between Martha and Mary (10:38-42), the raising of the widow's son at Nain (7:11-17), the dinner party with Zacchaeus (19:1-10), the exchange between Christ and the two thieves upon the cross (23:32-43), and the Resurrection story on the road to Emmaus (24:13-35), to name just a few.

In Luke's gorgeous work — his use of Greek is both highly educated and quite poetic — we are given a glimpse into Christ's mercy and compassion, as He is moved with pity and responds in kind to those most in need of the compassion only available in the Lord's sacred heart.

Exercise One: Pray a Rosary

Luke 1:41-45

Questions

1. What is your relationship like with Mary?
2. Do you find it easy to turn to her and ask for her intercession? Why or why not?
3. Have you ever been able to really reflect on the mysteries of the rosary? What mystery (joyful, sorrowful, glorious, or luminous) speaks to you the most at this time in your life?

Reflection

Mary, the perfect mother, is an amazing person to turn to. If you're happy asking friends, family, and others at church to pray for you, why not also turn to Mary with your prayer requests? What better person than Jesus' own mom to be praying for you and taking your burdens, worries, etc. to her Son! She has been and remains to be a perfect mother to turn to when we struggle with our own earthly mothers. She is a great example of humility, true beauty, grace, gentleness, and obedience. Mary, our beautiful and compassionate mother, keeps us wrapped tightly in her embrace; we should not be afraid to go to her and ask for her intercession when things begin to become too much for us to handle on our own.

Pray the rosary today. Far from a boring, repetitive prayer, the rosary gives us the opportunity to reflect on the life of Christ and seek the intercession of Mary.

It is a great prayer in times of distress, a great comfort and a great weapon. It is the weapon of Mary's' protection, the protection of a mother who can drive away anything that is keeping you from loving her Son fully and completely.

Prayer

Mother Mary, I ask for you to be present in my daily life, to intercede for me to your most precious Son. I pray that you may reveal some of the mysteries of the rosary to me and help me to pray the rosary, a gift of prayer you have blessed us with. May I come to know Christ through you. Amen.

Exercise Two: Jesus Faced Temptation

Luke 4:1-13

Questions

1. Do you have a hard time fighting temptation in your life? What temptation do you struggle with the most?
2. Temptation leads to sin. How does God help us fight the temptations the devil throws before us?
3. The Scripture passage says, "... when the devil had ended every temptation, he departed from him until an opportune time." What does that mean?

Reflection

Jesus was tempted just as we are, but Jesus resisted temptation and never gave in to Satan's antics. Jesus is our model for resisting temptation. We will always experience temptation, but we can resist any temptation with God's help. Saint Paul tells us in Philippians 4:13 that we "can accomplish all things through Christ, who strengthens us." Today, actively turn your back on temptation. Set some boundaries and don't be afraid to say, "no."

Prayer

Be with me, Jesus. In my times of temptation, hold me in your grace. Give me the strength to turn to you. I cannot avoid sin on my own, Lord. I am weak, but in your love, I am strong. In the name of Jesus, I rebuke the evil one. Amen.

Exercise Three: Jesus Delivers Us from Pain

Luke 8:43-48

Questions

1. Do you or someone you know suffer from a physical, emotional, or spiritual pain? How has this suffering impacted your faith in God?
2. In what ways does God heal our hurts, today?
3. Have you experienced the healing touch of God in your life? If so, how?

Reflection

Ask yourself this question, "Can God heal my pain?" You better believe He can. Jesus didn't just perform miracles back then; He also performs them today. What kind of pain do you have in your life? Do you have some deep hurts or wounds from things that happened in the past? Be open and honest with God about the pain in your life. Give Him a chance to heal you.

Prayer

Heal me, Jesus. Heal my heart if it is broken, my soul if it is weary, and my faith if it is weak. Deliver me from my pain, Lord, and bring me into the same joy that was felt by those you have healed throughout time. Amen.

Exercise Four: Jesus Reminds Us to Put Him First

Luke 10:38-42

Questions

1. Do you see yourself as being more like Martha or Mary? How so?
2. Is it better to be like Martha or Mary? Why?
3. What does it mean to put Christ first in your life?

Reflection

Many people think acts of service or other good things are all we need to do for Jesus. Although service is great, it's not the main priority of Jesus' "to-do" list. Are you like Martha or Mary? Both of these women had right intentions. However, Martha spent all of her time serving Jesus and forgot to spend time with Him. Mary enjoyed Jesus' company, knowing she would only have a little time with Him. So, who are you: Martha or Mary? Spend time with Jesus. Set aside some time throughout your day to pray and read Scripture. Go to your local adoration chapel or church and spend some time in front of the Blessed Sacrament.

Prayer

I put you first, Jesus. I put you above everything in my life: myself, my friends, my family, my schoolwork, my weekends, my desire for sin, my pride. Be my everything, Lord. Help me make you the first and last thing I think about. Amen.

Exercise Five: Jesus Remains with Us in the Eucharist

Luke 24:13-25

Questions

1. The lives of Jesus' apostles were changed following His death and Resurrection. How has Jesus' Resurrection affected your life?
2. Are you willing to allow Christ to be a part of your life and change it? If not, why? If so, how?
3. Do you believe Jesus is present in the Eucharist? Why or why not?

Reflection

This is one of the coolest passages in all of Scripture. It takes place after Jesus rose from the grave. The disciples never expected Him to rise, but Jesus did a lot of unexpected things. Jesus spent some time with the disciples before He ascended to heaven. The most awesome thing they did was celebrate the Eucharist together — the same Eucharist that we celebrate at every Mass. Jesus will always be present to us in the Eucharist. What a gift! Spend some time in front of the Blessed Sacrament. Reread the Scripture passage above. Reflect and journal on this awesome story.

Prayer

Thank you, Jesus. You are the Messiah, the Son of the living God. You are the king of all kings, the only true God. Thank you for the gift of the Eucharist. Give me eyes of faith that I may come to know and

feel your awesome love in your body and blood. Give me a new respect and reverence for the Eucharist. Quiet my mind and heart when I am at Mass, so I may begin to understand the incredible mystery of the Eucharist. Amen.

UNDERSTANDING JOHN:
AN OVERVIEW WITH EXERCISES

I still recall my first Scripture class in college. The professor spent the entire class telling us how "dangerous" it is to study the Bible because it would destroy many of our preconceived (and immature) notions about Christ and His Church. "Most people," he maintained, "function from what their parents and pastors have told them about the *real Jesus* rather than what the text(s) actually say... and to do so is not only dangerous but woefully short-sighted." He invited us to shed the "water wings" and the "kiddie pool" of spoon-fed Biblical study, calling us into the deep of the synoptic Gospels.

By the end of the first class, I was ready to tear into my own, and often unopened, Bible. Exiting the class, however, it occurred to me to ask one glaring question, "Professor, why are we stopping with only the synoptics and not also studying the Gospel of John?"

He pointedly responded, "Ah, you must learn to swim before you attempt to scuba dive."

The response left me wanting to know more, so rather than completing my assigned reading in the synoptic Gospel, I read the entire Gospel of John in one sitting. Several passages of dialogue were confusing, and several details went right over my head — it was as though I was watching a foreign film with only sporadic subtitles. I knew nothing about John, his history nor the fact that he was most likely the "disciple whom Jesus loved."

Truthfully, I had no background to help me navigate this deep sea of God's grace that we call the fourth (and final) Gospel. My professor was right, this was like scuba diving and to experience the depths of the Holy Spirit's inspired brilliance, the average swimmer needs some training and tools to go deeper.

John is often referred to as "the beloved disciple" because he was Jesus' closest friend. The younger son of Zebedee, John was the one who rested upon Christ's chest at the Last Supper (John 21:20), the one entrusted with the ongoing care of Christ's mother, Mary, from the cross (John 19:25), and the only apostle not to die a martyr's death (John 21:20-23). Early traditions maintain, too, that following Pentecost, the Blessed Virgin Mary went to live with John in Ephesus, where he served as bishop.

Written for Jewish Christians, John's Gospel is filled with verses from the Old Testament. It was most likely written after the other Gospels, so he includes a lot of details left out by the others. John "fills in" some of the "gaps" by sharing unique stories and moments not previously recorded. Imagine for just a moment where we'd be without John's Gospel contribution! The wedding feast at Cana (2:1-11), the Samaritan woman at the well (4:1-43), the bread of life discourse (6:25-69), the raising of Lazarus (11:17-44), the washing of the feet (13:1-17), the extended dialogue with Pilate (18:28-19:16), the episode with Mary and John at the cross (19:25-27), and the Resurrection appearance on the Sea of Tiberias (21:1-25) are but a few gorgeous passages we would not have if the Spirit hadn't breathed through John's blessed pen.

John emphasizes the fact that Jesus was not "just another guy." Christ was both God and man. God became man so that human beings could live with Him in heaven. God created the world in Genesis and now Jesus is working a new "spiritual creation" in the lives of His followers. His entire Gospel is highly symbolic, rooted in the Old Covenant all the while pointing toward the New. It is only when we comprehend the dual nature of Christ (human and divine) that we can come to comprehend the purpose of His mission and the glory of the Church He instituted on Earth.

John's Gospel is a constant invitation to advance forward from "simple" reading and plunge into the sacramental waters. For John, everything points us back to the Church and her sacraments. Different types of Biblical writing try to accomplish different things. John, however, weaves together both the symbolic and historical into an unprecedented and gorgeous tapestry of faith. The fourth Gospel is much like an iceberg, where 90 percent of its greatness is below the surface.

If Mark's gospel is considered the "easiest," John's is the deepest. It will immerse you into the Church's tradition by inviting you ever deeper into the heart of the sacraments. It will offer you a glimpse at the one who came with power and purpose, at the appointed time, to save us from our sins and from ourselves. John calls us into the deep waters for a scuba dive once we are comfortable "getting out of the boat" in the synoptic Gospels.

Exercise One: Jesus Got Angry

John 2:13-16

Questions

1. Does it surprise you that Jesus got so angry? Why?
2. Do you see your body as a "temple of the Holy Spirit," a place where the Holy Spirit lives? Does Jesus get angry when we abuse our bodies?
3. What were the people doing in the Father's house? Was Jesus angrier with the people or with their actions?

Reflection

Yes, even Jesus got angry. However, Jesus' anger was justified. He was defending His Father and rebuking the fact that people were disrespectful to God's house. When you get angry, is your anger justified? Does your anger lead to sin and cause hurt? Make peace with someone you have gotten angry with and ask them for forgiveness. If your anger has caused you to sin, ask for forgiveness in the Sacrament of Reconciliation.

Prayer

Have mercy on me, Jesus. Forgive me if I've angered you by abusing myself or others, or if my desire for material things has become a god in my life. Lord, help me seek forgiveness from those I have angered and those who have angered me. Help me give others the same mercy you have given me. Amen.

Exercise Two: Jesus is the Bread of Life

John 6:53-58

Questions

1. Do you believe Jesus is fully present in the Eucharist? Why or why not?
2. How can you prepare your heart to receive Christ in the Eucharist?
3. What sacrifices would you need to make in order to attend daily Mass? Are you willing to make them?

Reflection

When we receive the Eucharist, we are receiving Jesus into our bodies and our hearts. Our bodies, already holy because of the Holy Spirit living in us, become a living tabernacle when we receive the Eucharist. What an amazing gift — Christ giving Himself to us — and what a fantastic opportunity to be able to receive Christ in this way, daily. Not only are we in union (becoming one) with Christ, we are also in communion with the entire "body of Christ" throughout the world. What a great sense of community formed by sharing in this gift of Christ with each practicing Catholic throughout the world! Christ, the life-giving bread, gives us the opportunity to draw life from Him, who is the fullness of life. Who wouldn't want a share in this life?

Prayer

Thank you, Lord, for sacrificing your physical body so that you could become my spiritual food and drink. You are true, life-giving bread for me. Thank you for the gift of your Church and the gift of the Eucharist. Help me to more fully participate in the celebration of the Eucharist and have the zeal to want to seek you, daily. Amen.

Exercise Three: Jesus Shows Us Compassion

John 8:2-11

Questions

1. When you sin, who condemns you more? Your friends, your parents, yourself, or God?
2. Are you hesitant or afraid to go to the Sacrament of Reconciliation? Why?
3. Have you ever reflected on your own sinful ways after you judged someone else for theirs? What was that experience like?

Reflection

This Scripture passage offers us two challenges: to forgive and not to judge. Both are tough to overcome, but they're what Jesus is calling us to do and not to do. Is there someone in your life you have judged? Go to that person and ask for forgiveness. Is there someone in your life who has judged you, or who you need to forgive? Go to that person and forgive them.

Prayer

Jesus, help me see my own sinfulness before the sins of others. Show me your compassion, Lord, and take away any fear I have of the Sacrament of Reconciliation. Make me worthy of your mercy, Jesus. Amen.

Exercise Four: Jesus Delivers Us from Death

John 11:30-44

Questions

1. Do you see God as a compassionate God or a punishing God? Why do you see Him this way?
2. Why did Jesus raise Lazarus from the dead?
3. Do you believe God can transform your life? If so, which parts of your life?

Reflection

Does death scare you? It is our hope as Christians that when we die we will share eternal life with Jesus and the saints. The catch is that we can't be spiritually dead here on Earth. It's time to rise up. Jesus is saying to all of us that He is the answer to spiritual death, and like Lazarus, Jesus is calling us out of the tomb. Are you dead in your faith? Is your spiritual life non-existent or struggling? Jesus is calling you out of the tomb to experience a new life in Him. Wake up, come out, and embrace life. Give someone a smile or a hug today and when you do, remind yourself of the importance of living each day to its fullest.

Prayer

Thank you, Lord, for the gift of life. Give me the grace to live my life for you completely. Awaken my heart if it is numb or dead; fill it with faith and passion for you. Amen.

Exercise Five: Jesus Calls Us to Serve One Another

John 13:3-9

Questions

1. Do you see yourself as being more of a foot washer (servant), or someone who has your feet washed (being served)?
2. Give two examples of "foot washers" who have affected your life.
3. What are ways in which you can be a foot washer to others?

Reflection

Why would Jesus ever want to wash the feet of the disciples? Why would God want to deal with dirty, sweaty feet? "Christ did not come to be served, but to serve." Jesus knew serving God meant serving others. Serving can be tough because it means putting others' needs before our own. Clean your room and your house. Don't wait for your parents to ask you to do it. Maybe even clean out your closet and give some of your clothes to the needy.

Prayer

Lord God who created everything, you came to this Earth in human form to serve. Change my heart into that of a servant's heart. May I do good for others and expect nothing in return. When my pride gets in the way, Lord, remind me of how you washed your disciples' feet and served those in need. Nothing is beyond you, Lord. Thank you, Jesus. Amen.

THE MAIN EVENTS OF THE GOSPELS

Most people in the modern world have heard some part of the story of Jesus Christ. Even if they cannot tell you that the angel's name was Gabriel or that you can read about the angel's appearance to the Blessed Virgin Mary in **Luke 1**, they probably know bits and pieces of the story. Perhaps they know, too, about Joseph's powerful dreams (**Matthew 1**) or the angelic revelation to the shepherds (**Luke 2**) or the Magi following the star (**Matthew 2**).

You might not even know all the "wheres" these stories are found (as in which Gospel or chapter), but you likely know many of the details of Jesus' life. See how many of the following stories you recognize — these *major events* of the Gospels — and feel free to read any of them again or for the first time.

Not long after the magi's visit, the homicidal King Herod seeks to have the baby Jesus killed. As the holy family escapes to Egypt, they "disappear" for several years, at some point returning to Nazareth and to St. Joseph's trade as a carpenter/stone worker. Jesus appears, again, at the age of 12 (**Luke 2**) when He goes missing from the family caravan following their observance of Passover in the city of Jerusalem (which was 90 miles away from home and a multiple day trip). Following this episode, we don't really hear from Jesus again until He prepares to begin His public ministry.

Following Jesus' baptism in the River Jordan (**Mark 1**), He is thrust out into the wilderness where He prays and fasts for 40 days and nights. It is here that the devil

tempts and tries Jesus (**Matthew 4**) and we see the Lord defeat him handily, using only Scripture as His defense. We see Jesus meet and call His first disciples (**John 1**, **Luke 5**) and perform His first public miracle at the Wedding at Cana (**John 2**).

It quickly becomes clear this is no mere "small-town carpenter" as Jesus' fame spreads throughout Galilee (northern Israel) and Judea (southern Israel). Jesus scandalized people with His love for the outcast (**Luke 5**), sinners (**John 8**, **Luke 19**), and even the Samaritans (**John 4**), a group the Jews greatly despised. He makes a name for Himself curing the lame (**Matthew 9**), healing the blind (**John 9**), and restoring the lepers (**Luke 17**). Thousands watched and were fed as Jesus multiplied loaves and fish to feed the masses (**John 6**). The apostles watched Him walk on water (**Matthew 14**), raise the dead (**Mark 5**, **John 11**), and be transfigured before their very eyes (**Matthew 17**). Not only did this rabbi claim to have insights into the eternal, He actually claimed to be divine — to be one with the living God (**John 10**). This audacious claim demanded a verdict that Jesus actually backed up with signs, wonders, and miracles the likes of which no one had ever seen. He made prophecies and assertions no one had ever made, losing many followers because of the audacity that His flesh and blood would become literal food and drink we must receive "if we want to have life within us" (**John 6**).

His sermons (**Matthew 5**) lift the hearts of the lowly and oppressed, speaking of the Kingdom of God that was now at hand (**Luke 4**). People began to believe that Christ was the long-awaited Savior — the Messiah —

and rumors spread as to what that meant to the Israelite people. They believed He would overthrow their Roman oppressors and instill a new system of government and power (**Luke 9**, **Luke 24**). The Pharisees and Sadducees (the reigning Jewish religious leaders) were threatened by Christ's popularity and influence and began to see Him as a threat (**Matthew 12**) and not merely a harmless, unconventional rabbi.

After roughly three years of a very public ministry and after instituting a visible "head" to the apostles (**Matthew 16**) and a hierarchy to carry out His teachings, Jesus' earthly mission had fulfilled its purpose (**Matthew 28**). As His influence became too much for His opponents to bear, one of His closest followers would betray Him to His enemies.

Christ and His followers went to Jerusalem to honor the high and great feast of Passover as they no doubt did every year. As He entered the city, His followers greeted Him with chants of praise and laid down palm fronds at the feet of His donkey on a day we commemorate as Palm Sunday (**Luke 19**). As the (holy) week progressed, Jesus was tested by His adversaries as they tried to trap Him (**Matthew 22-25**) and find a charge to bring against Him.

Then, on what we call Holy Thursday, Jesus took the Twelve Apostles into an upper room of a house in the city (**Luke 22**). He washed their feet (**John 13**) as a sign of His selfless and sacrificial heart, an act of humility and service that would serve as the foundation for all who call themselves disciples of Jesus Christ. Next, He took common bread and wine, blessed it, broke

it, and gave it to them, only this Passover meal was different (**Matthew 26**, **Luke 22**). Through His priestly prayer, Christ instituted the Eucharist, transforming (transubstantiating, actually) the bread and wine into His own body and blood. His prophecy would now be fulfilled as He ushered in and created a new priesthood. The sacrifice of self He offered in the upper room was the first act — for just as He offered us His body and blood on the altar of the wooden table, less than a day later He would offer us this divine gift upon the wood of the cross!

He retreated to the Garden of Gethsemane to pray before the betrayer, Judas Iscariot, arrived with soldiers to arrest Him (**Matthew 26**, **John 18**). The apostles scattered. Jesus was abandoned, given an unfair trial under the veil of night at the house of the high priest, Caiaphas (**Matthew 26**), and then remanded to King Herod Antipas (the figurehead ruler) and, eventually, to the Roman governor, Pontius Pilate (**John 19**). Though innocent, Christ was flogged and scourged at the pillar (**Matthew 27**). He was brazenly mocked with a crown of thorns and tortured within an inch of His life (**Mark 15**). Though Pilate wanted to release Him, the politician bowed to the pressure of the crowds (**John 18**) and sent Christ to His death on the cross.

After carrying His cross beyond the city walls, Jesus was nailed to it and executed between two common thieves at Golgotha, also known as Calvary (**Matthew 27**, **John 19**). Upon the cross, Christ demonstrated perfect love and fidelity, forgiving His persecutors and reconciling one of the thieves to God the Father (**Luke 23**). As Jesus breathed His last breath, the Earth shook

and the sky fell dark (**Mark 15, Luke 23**). Creation killed its creator. Once taken down, the Lord was placed in a borrowed tomb, with a boulder enclosing it and a Roman guard stationed outside (**Matthew 27**). On the following Sunday morning, Mary Magdalene and a group of women were heading to the tomb to anoint the body when they noticed the stone moved and the body gone (**Matthew 28, John 20**). After a vision of the risen Lord, Mary Magdalene went to share the miraculous news with the apostles in hiding. Two of the apostles went and found the empty tomb but no body (**John 20**). Later that day, the glorified and risen Jesus passed through locked doors and stood in their midst (**John 20**). He came in peace and joy. He gave them a new mission and physically appeared to them several times over the next 40 days (**John 21**). At that time, He ascended (**Matthew 28, Luke 24, Acts 1**) bodily into heaven and promised them the Holy Spirit, which descended in power at Pentecost ten days later.

The Gospel message spread and the Church grew, first by hundreds and then by thousands. There are over one billion Catholics in the world today and hundreds of millions of Christians of various denominations, all of whom have these Gospel stories in common.

Take some time to read them with your own eyes and ask the Holy Spirit to help them come to life as you do.

ACTS OF THE APOSTLES OVERVIEW

The Acts of the Apostles is an incredible "sequel" to the Gospel of Luke. In it, we hear about the trials and sufferings, heroes and villains, miracles and jail breaks taking place in the days and years following Christ's Resurrection and Ascension. The two "stars" of Acts are St. Peter and St. Paul. The first half of the book focuses mainly on St. Peter — our first pope — as he navigates the confusing waters of Christianity's dawn and leading a Church under Roman persecution. The second half of Acts focuses mainly on St. Paul as he converts from being a great persecutor of Christians to one of their finest missionary leaders, speakers, and eventually, writers. The Acts of the Apostles is very powerful because it describes the heroic lives of men and women who encountered the love of Christ and were changed in a radical way. Their lives prove that following Jesus is anything but boring.

AN INTRODUCTION TO ST. PAUL
AND AN OVERVIEW OF HIS WRITINGS

Let's say you live in southern California. You're sitting on the beach one day, just you and a couple of your friends. All of a sudden, in a flash of light, you have a vision of God. Jesus appears to you and begins speaking to you. Your first inclination might be to apply more sunscreen or drink more water, thinking that you must be dehydrated, but the living water (see John 7:37) is standing before you, assuring you of His divine presence. He reminds you of your goodness, His unconditional love for you, and His limitless mercy. He also tells you to stop sinning, for every time you sin against another, friend or foe, you sin against Him, your Savior.

Then He vanishes as quickly as He arrived, and you make a promise. This won't be a pact or covenant like the others you've made and broken — you know, the kind that begin with the phrase, "Lord, if you get me out of this, I promise I will..." No, this is a promise you actually intend to keep. You are so moved by the beauty of Jesus' message that you want to share the good news of His salvation and mercy with everyone you meet.

You immediately head home to pack a couple of outfits, your iPod, Bible (you might need that), rosary, toothbrush, and ATM card. You kiss your parents goodbye, shake a few hands, and log off your Facebook account — for good. It's time to evangelize the world, because evangelize means to "share the Gospel," and the Gospel is the good news Christ

just made clear to you on that beach. Is your next stop the airport or the bus station? Nice idea, but you don't own a car and can't afford a plane ticket. It looks like you're going to have to make your way on foot. You'll be stopping at several cities along the way; cities where people not only want nothing to do with you, but where you'll be threatened with death (and almost killed) for sharing about God's love and your personal sins.

What's the total distance of your trip? It's over 2,400 miles. Would you still go?

Paul did.

He didn't evangelize because he wanted to make a name for himself. He already had a reputation, and it wasn't a good one with the people he was now supposed to call family. Paul wasn't in it for the popularity, the power, the title, or the money. Paul went out and risked his life every day because the news he received was just that good. He believed in it so deeply that he stopped at nothing to preach it to the ends of the Earth. What news was he spreading, and what truth was he preaching? The truth contained in the Gospels, printed in your Bible and sitting on your nightstand or coffee table. The same words we utter out of habit, read out of fear, study with confusion, or recite with boredom are the words that kept Paul's feet moving for thousands of miles around the ancient Mediterranean world.

According to the Acts of the Apostles, St. Paul's passport would have been stamped on just about every page. Here's a rundown of where Paul went, approximately in order:

- A.D. 45–48 Paul's First Journey (Galatia)
- A.D. 50–52 Paul's Second Journey (Greece)
- A.D. 53–58 Paul's Third Journey (Ephesus)
- A.D. 58 Paul in Jerusalem
- A.D. 58–60 Paul in Caesarea
- A.D. 60–61 Paul's Fourth Journey (Rome)
- A.D. 61–63 Paul's First Roman Captivity
- A.D. 67 Paul's Second Captivity
- A.D. 67 Paul is Executed

What Paul Wrote

Saint Paul was threatened by the elements, peers, imprisonment, death, and the evil one himself, yet he kept moving and writing.

On the pages that follow, you will find introductory information for St. Paul's writings. Each overview gives you some central themes of the epistle.

You might want to use the summaries for private study or in a group study as you begin to discuss the various themes of each book. The point is this: Use them. Saint Paul's writings are a beautiful gift from God and are meant to be explored. Prayerfully read through these sections in conjunction with the letters themselves and watch how the second reading at Sunday Mass — and, most importantly, your soul — comes to life.

Romans is St. Paul's most brilliant (yet complicated) letter. In it, he helped Jewish converts to Christianity understand that Gentile (non-Jew) converts did not need to obey old Jewish rituals and laws to now follow Jesus. Saint Paul explains, in detail, what baptism in Christ is and what it does in and for each of us. Romans speaks of grace, virtue, and the challenges of living the Christian call to holiness in a world that does not support such a way of life.

1 and 2 Corinthians are letters from St. Paul to the Christians who lived in Corinth, a city in Greece. Unfortunately, a lot of the Christians in Corinth weren't leading lives of love. Corinth was a town filled with sin and temptation and it was difficult for the Christians there to stay committed to the faith. Saint Paul reprimands those who were living double lives and inspires them to seek virtue and leave behind immoral acts. He is understanding but bold in his writing to the community there, showing sensitivity to their weakness but also being very clear that the Christian life is not easy and demands prayerful commitment.

Galatians (like Romans) answers this question: Does a Gentile convert to Christianity have to be circumcised (like the Jews were) to be a full Christian? Saint Paul is very clear about the answer: No, circumcision is not necessary. The reason for this is simple: Circumcision is not a sacrament. It does not bestow God's grace on us like a true sacrament (Baptism) does. In his letter to the Galatians, St. Paul demonstrates both his passion and his humanity in his desire to help God's children embrace the New Covenant in Jesus Christ.

Ephesians is focused on the "mystery" of Jesus Christ (1:9, 3:4, 9). Saint Paul reminds the people in Ephesus that even though Jesus rose, His presence is still very real in our Church — in fact, the two are joined together through the sacraments (and priesthood). Saint Paul is clear that being part of Christ's Church is not "optional" for a Christian but rather, mandatory.

Philippians is a beautiful letter of encouragement and thanks. The Church in Philippi was very generous to Paul and always eager to support the work of Christ no matter what the cost. The apostle writes and thanks the people for their financial support, prayers, and love. Saint Paul also encourages his readers to follow his example of imitating Jesus in all things. While that might sound "cocky," the truth is Christianity was still new and people needed living examples to follow in order to learn how to act as a Christian in everyday situations. Saint Paul knows the Christian life is not easy but insists that the joy of knowing Christ is worth every struggle.

Colossians shows a different side of St. Paul. In it he is very sensitive and reassures the Gentile Christians that they are full-fledged members of God's family by way of faith and Baptism. He emphasizes the fact that Jesus Christ is powerful and merciful and must be at the center of our lives. Saint Paul also reminds us that Jesus is the only source of true and lasting joy. Life is difficult, but God will take care of us. Even when we are tired and weak, He will fill us with His strength and power.

1 and 2 Thessalonians were written to a group of recent converts to Christianity who were experiencing

great persecution in Thessalonica. Saint Paul offers his prayers and encouragement in their time of struggle. He affirms them for their growth in faith, hope, and love and urges them to remain steadfast in the Christian journey. These are hopeful and reassuring letters to Christians who needed a shot in the arm during their difficult daily walk.

1 and 2 Timothy are very special letters from St. Paul written to a young bishop named Timothy. As a young leader, Timothy was constantly hearing from older and "wiser" leaders around him who were not necessarily holier. Saint Paul reminds the young man to stay strong and committed to prayer, and to be a good example no matter what. He urges Timothy to take courage and strength from his example of constant faithfulness.

Titus and St. Paul worked together preaching the truth of Christ on the island of Crete. Like his letters to Timothy, St. Paul is very personal in his advice to Titus. He encourages Titus to remain firm in the truth. He also gives Titus advice on who would make good priests and how to discern that properly. He warns him that holy leaders do great things for the Kingdom while unholy ones do far more harm than good.

Philemon is the shortest of St. Paul's epistles. It is a moving letter that gives a very intimate view of St. Paul's heart. It is primarily written to a slave owner named Philemon. Saint Paul wrote this letter requesting that Philemon welcome back one of his slaves (a man named Onesimus) who had deserted his master. Although very short, this is a beautiful glimpse into true Christian conversion, love, mercy, and forgiveness.

OTHER NEW TESTAMENT WRITINGS
AND THE BOOK OF REVELATION

Hebrews is a deep and kind of "mysterious" book. Many people originally said St. Paul wrote it, but he is no longer associated with it as an official author. Regardless of who wrote it, Hebrews focuses on how Jesus was "the one" everyone in the Old Testament had been waiting for. Jesus perfectly fulfilled the prophecies of the Old Testament in ways people could never have predicted. The book talks a lot about sacrifice and worship and how we interact with God through both.

James is one of — if not *the* — most practical books in the entire Bible. Filled with timeless wisdom about how to live as a true Christian (even when surrounded by not-so-Christian people on Earth), it discusses everything from trials and challenges to gossip and sin. James reminds us it's not enough to "say" we are Christian, we must live it out in our actions — those others see, and those only God sees. James is a great place to start if you're new to reading Scripture.

1 and 2 Peter are short yet powerful letters from the first pope. These two letters give great insight into the hardships and challenges of the early followers of Jesus. Both books are encouraging reminders to stay true to the Lord and to prayer, warning us of not only the devil's attacks but of the many "false teachers" and selfish voices we will encounter in this culture.

1, 2, and 3 John are beautiful epistles said to have been written by St. John, the author of the Gospel of John and the Book of Revelation. He speaks at length about

the love of God and how you can tell if someone really does love God (by how they live and if they keep His commandments). If you want to really live as a child of God, you'll need to read and put these words into daily action.

Jude is a very short epistle (only 25 verses), but it is important because it encourages its readers to be united in the truth. False teachers will be present in every generation, so all Christians must be built up in the faith, love, and mercy of God (20-21). God is in control and His love is powerful enough to preserve us from the evil power of sin and death.

Revelation is one of the most controversial books in the entire Bible. Attributed to St. John, the author describes what he saw when he was given a glimpse of heaven; it is a recap of the saint's vision of heaven and the worship that is going on there. Countless books have been written about Revelation, each pointing to "scary" end times imagery and prophecy. In reality, Revelation is a book filled with hope and urgency, reminding us all to live the proper way since we don't know when Christ is coming back for us. Many of the "prophecies" in Revelation were already fulfilled when Rome leveled Jerusalem in A.D. 70. Ultimately, Revelation is a love story where the bridegroom (Jesus) comes back for his bride (the Church) to save us and "make all things new."

MAKING SCRIPTURE
A DAILY PRAYER

FINDING WHAT WORKS FOR YOU

Reading and studying the Bible doesn't need to feel like a chore. Have fun with it. Don't worry about how fast or slow you go. Everyone is different and no "one plan" is the best plan. I usually dissuade people from just opening up to Genesis and reading the Bible straight through because, quite honestly, that's not how it was compiled to be read — as a narrative. You'll notice the Biblical books (as we've already discussed) are grouped together by "type" of writing. So, have some fun as you read. It's ideal to begin in the Gospels if you are new to Bible study. You'll already have a working knowledge of some of the stories and characters, there are fewer odd names of people and places, and less need for cultural context to most of the stories. Additionally, as you already read in the Gospel overview section, the Gospel of Mark is an ideal place to start working out your Biblical brain. Following the Gospel of Mark, there are several other books that you might want to flip through when you have ten minutes here or there.

OTHER GREAT PLACES TO START

In addition to the Gospel of Mark, I highly recommend the Book of James in the New Testament. It is only five chapters long. You could read the entire book in less than 20 minutes or take one chapter a day, spending less than five minutes per day. James is filled with practical wisdom and insights on how to get through your day in a holy way. Following James, check out Sirach (also called "Ben Sira"), Proverbs, and Psalms in the Old Testament and Philippians and 1 Timothy in the New Testament. They are all pretty straightforward and easy to "pick up and put down" when you only have a few minutes here or there.

HIGHLIGHTING VERSES YOU LIKE

It's a good idea to have a Bible you can markup — one you can underline and highlight in. When you come across a particular verse that strikes you or that you want to be sure to come across again, mark it somehow. There is absolutely nothing wrong with doing this! Highlighting in your Bible is not only allowed, it's encouraged. I know people worry that such a practice is somehow "defacing" the Word of God or being irreverent, but nothing could be further from the truth. In fact, not reading the Word of God is far more irreverent.

If the only Bible you have is a really nice one or a large, heavy one that your grandparent or Godparent gave you as a confirmation or Christmas gift, it's OK if you don't want to mark it up. Just be sure to pick up a lighter weight, paperback Bible that you can make notes in.

MY FAVORITE BIBLE VERSE

There is no question I receive more than, "Hey Mark, what's your favorite Bible verse?" There is possibly no question easier to answer, yet more difficult.

Choosing a "favorite" Bible verse, for me, is like trying to choose a favorite child. It's impossible (although, *my favor often rests* on the child who is not sugar-ed up and acting like a demoniac).

You see, different "seasons" of life bring with them different needs and struggles, joys and failures. In this way and for this reason, every season has a different verse that I tend to lean on or look to for support, direction, or just plain hope.

Here are a few of my favorites for those different seasons of life:

* After a long and tiring day of ministry, I find solace in **Nehemiah 8:10**.
* When the Lord feels distant or falls silent, I lean into **James 4:8**.
* In those times my family or I am suffering, I rush to **Revelation 21:4**.
* When I am overwhelmed with gratitude and God's goodness, I turn to **Psalm 95:2** and **1 Thessalonians 3:9**.
* In times of confusion, I reflect on **Proverbs 3:5-6**.
* When the future looks bleak, I pray **Romans 8:28** and **Jeremiah 29:11-12** until I actually trust in those words again.

Beyond all of these great nuggets of timeless wisdom, however, there is one verse that encapsulates each of these sentiments and more. It comes from the Prophet Isaiah, given to him during a time of great darkness when he (and his nation) was falling into hopelessness:

"Fear not, for I am with you, be not dismayed, for I am your God; I will strengthen you, I will help you, I will uphold you with my victorious right hand." – Isaiah 41:10

I love this verse on so many levels. It is clear and concise. It is present and unwavering. It is strong but still tender, challenging yet comforting. In short, it is everything a good father should be.

There is no command more repeated in Scripture than "fear not." The repetition of that command is not because God is forgetful, but rather, because we are. God knows we are often tempted to give in to fear. However, pay attention to the *"why."* God tells us not to fear because He is with us.

Think about the first time you were left alone as a child or lost sight of your parent in a crowded store. Fear came like a tidal wave. Yet the moment your eyes locked onto your parent again ushered in a reclaimed peace and security. How often in your life are you filled with fear? If we are present enough to the situation and aware enough to pray — and call God into the situation — that fear quickly turns to dust.

Pay close attention to what the Spirit breathes in this verse. For not only does God bid us not to fear and reminds us of His eternal (dare I even say "Eucharistic")

presence *with us*, He tells us there is no reason to dismay for He is God.

God is God; I am not. No matter how hard we try or how often we act like it, that simple truth brings freedom and peace. There is a God who cares for me and about me, who is with me, and who desires a relationship with me. What we call a storm, He calls a path. Moses didn't part the sea nor Peter tread upon it because they willed it... but because God did.

This second part of my favorite verse invites me (and you) to trust in His power over my own. God shifts the gears slightly, making three promises to us:

1. The Father will strengthen you.
2. The Father will help you.
3. The Father will uphold you.

You'd be wise to commit these promises and, actually, the entire verse to memory. Write them down in your own handwriting. Plaster them on your mirrors, walls, and dashboard. Tattoo them on the insides of your eyelids if it'll help you!

God is not going anywhere. He will fight the battle for you (Exodus 14:14). He will be your help, your rock, your fortress, and your deliverer (Psalm 18:2). He will be there to lift you up when you fall or jump into the pit (Psalm 40:2). Like a good father, He will take you by the hand and lead you to victory, as the verse promises in its conclusion.

People are often surprised when I share this "favorite verse" with them. It's as though they think that I never doubt or struggle, like the person holding the microphone or writing the book must "have it all figured out." To be clear, the only thing I've figured out is that I have nothing figured out, except this: I need Jesus. I need Jesus more and more every day. I cannot imagine my life without Him nor would I want to do so.

Acknowledging your need for God does not make you weak; it makes you self-aware and honest. Admitting you don't have it all together does more than make you merely human; it makes you humble. The more you learn to look to and lean on God's promises, the easier it becomes to trust in them and, ultimately, in Him.

I don't share these verses, write, speak, or tweet because I have nothing better to do; I do it because I have no one better to share. I don't have all the answers, but I know the answer, and His name is Jesus Christ.

I'd like to end with a challenge. I cited about a dozen verses in parentheses above. More often than not, we don't actually take the time to look up verse citations. I'd like to ask you to do it this time. Grab your Bible and highlighter. Open to each verse and let God's truth pierce your heart and penetrate your soul in a new way.

Ultimately, it doesn't matter what my favorite verse is — it's about whether or not I let the Word of God dwell in me richly and whether you do , too (Colossians 3:16). Life is not a wrestling match of "God versus you" but rather, a love story where God *verses* you — all you have to do is turn His holy page each day and let Him.

APPENDIX

Verses Every Teen Should Know and (Eventually) Commit to Memory

Genesis 1:27

Exodus 14:14

1 Corinthians 10:13

Psalm 46:10

Psalm 55:22

Psalm 119:9

Proverbs 3:5-6

Isaiah 41:10

Jeremiah 29:11

Jeremiah 29:12

Zephaniah 3:17

John 14:1

James 4:7

Romans 1:161

Romans 15:13

Ephesians 2:10

Ephesians 4:29

Ephesians 6:1

Philippians 4:6

Philippians 4:8

1 Thessalonians 4:3-5

1 Thessalonians 5:11

1 Timothy 4:12

2 Timothy 1:7

Verses for Specific Situations

The Future
- Ephesians 2:10
- Isaiah 43:2
- Jeremiah 29:11
- Matthew 6:34
- Proverbs 3:5-6
- Proverbs 16:3
- Proverbs 23:18
- Psalm 32:8

Loneliness
- Deuteronomy 31:6
- Exodus 14:14
- Isaiah 41:10
- Isaiah 43:1
- John 14:18
- Matthew 28:20
- Psalm 16:8
- Timothy 4:16-17

Fear
- 1 Corinthians 16:13
- 1 John 4:18
- 1 Peter 5:7
- Hebrews 13:6
- Isaiah 41:10
- John 14:27
- Joshua 1:9
- Psalm 23:4

Depression
- 1 Peter 4:12-13
- Isaiah 40:31
- Matthew 11:28-30
- Psalm 9:9
- Psalm 34:17-19
- Psalm 40:1-3
- Psalm 43:5
- Psalm 147:3

Hope
- Hebrews 10:23
- Hebrews 11:1
- Job 11:18-19
- Peter 1:3
- Psalm 130:5
- Romans 5:3-4
- Romans 8:24-25
- Romans 15:13

Faith
- 2 Corinthians 5:7
- Galatians 2:20
- Hebrews 11:1
- James 1:6
- Mark 10:52
- Psalm 119:30
- Romans 1:17
- Romans 10:17

Trust

- 2 Samuel 7:28
- Daniel 6:23
- Jeremiah 17:7-8
- Proverbs 3:5-6
- Psalm 9:10
- Psalm 13:5
- Psalm 31:14
- Psalm 91:1-2

Job/Vocation

- Ephesians 4:1
- John 15:16
- Joshua 24:15
- Mark 1:17
- Matthew 28:18-20
- Luke 4:18
- Proverbs 22:29
- Romans 12:6

Sex/Chastity

- 1 Corinthians 6:18-20
- 1 Corinthians 13:2-7
- 1 Thessalonians 4:7
- 1 Timothy 4:12
- Colossians 3:5
- Genesis 2:24
- Hebrews 13:4
- Matthew 5:28

Family

- Acts 2:39
- Colossians 3:20
- Deuteronomy 6:7-9
- Ephesians 6:4
- Exodus 20:12
- Hebrews 12:11
- Proverbs 1:8
- Proverbs 6:20

Anger

- Colossians 3:8
- Ephesians 4:26-27
- Galatians 5:22-23
- James 1:19-20
- Proverbs 15:18
- Proverbs 29:11
- Psalm 37:8-9
- Romans 12:21

Stress

- 2 Corinthians 4:8-9
- John 14:27
- Luke 6:48
- Matthew 11:28-30
- Philippians 4:6-7
- Psalm 55:22
- Revelation 14:13
- Romans 8:28

Doubt

- James 1:5-8
- John 20:29
- Jude 1:22
- Luke 24:38
- Mark 9:24
- Mark 11:22-25
- Matthew 14:3
- Matthew 21:21

Peace

- 1 Colossians 3:15
- 1 Corinthians 14:33
- 2 Thessalonians 3:16
- Hebrews 12:14
- Isaiah 54:10
- James 3:18
- John 16:33
- Romans 15:13

Prayer

- 1 Timothy 2:1-4
- James 5:16
- Jeremiah 29:12
- John 15:7
- Mark 11:24
- Matthew 26:41
- Philippians 4:6
- Romans 8:26

Joy

- 1 Peter 1:8
- James 1:2
- John 15:11
- John 16:22
- Nehemiah 8:10
- Philippians 4:4
- Psalm 118:24
- Romans 15:13

Quality Resources to Check Out

Ascend: A Companion to the Sunday Mass Readings. (2018). Mesa, AZ: Life Teen, Inc.

Bergsma, J. S. (2015). *Bible Basics for Catholics: A New Picture of Salvation History*. Notre Dame, IN: Ave Maria Press.

Hart, M. (2017). *Unleashing the Power of Scripture: A Guide for Catholics.* Frederick, MD: The Word Among Us Press.

Hart, M., & Cady, J. (2012). *Truth Be Told: Basic in Catholic Apologetics.* Mesa, AZ: Life Teen, Inc.

Hart, M., & Lemieux, T. (2015). *100 Things Every Catholic Teen Should Know*. Mesa, AZ: Life Teen, Inc.

Kreeft, P. (2005). *You Can Understand the Bible: A Practical Guide To Each Book in the Bible.* San Francisco, CA: Ignatius Press.

Life Teen Catholic Youth Bible. (2009). Mesa, AZ: Life Teen, Inc.

Rice, B. (2015). *Heaven's Roar: A Beginner's Guide to the Gospel.* Mesa, AZ: Life Teen, Inc.

Footnotes

[1] Homily remarks, April 24, 2013, Vatican City, Catholic News Agency, http://www.catholicnewsagency.com/news/church-is-a-love-story-pope-francis-says/

[2] Pope St. John Paul II, World Youth Day 2000, http://www.ewtn.com/wyd2000/background/2000vigil.htm

LIFE TEEN

Leading Teens Closer to Christ
www.LifeTeen.com